Art and Upheaval

Art and Upheaval

Artists on the World's Frontlines

William Cleveland

Foreword by Clarissa Pinkola Estés, PhD

New Village Press • Oakland, CA

Published by New Village Press, PO Box 3049, Oakland, CA 94609

Orders: 510 420-1361 press@newvillage.net www.newvillagepress.net

New Village Press is a public benefit, not-for-profit publishing venture of Architects/Designers/Planners for Social Responsibility. www.adpsr.org

Printed and bound in Canada.

The text of this book is printed on acid-free, 100% post-consumer recycled paper. No trees have been cut to make this paper. No chlorine has been used to process this paper. In support of the Greenpress Initiative, New Village Press is committed to the preservation of endangered forests globally and advancing best practices within the book and paper industries.

Interior book design and composition by Leigh McLellan Design

Cover photo: "Singing Body, Dancing Voice" Sanja Krsmanovic Tasic, actress of DAH Teatar, in a performance created during the Milosevic era in Serbia (see Part 6). Photo by Djordje Tomic.

Permissions

Chapter 3	*The Wedding Community Play*, The Wedding Coordinating Group and Belfast Community Arts Forum
Chapter 7	*Isithukuthuku (Sweat)*, Walter Kefoue Fikelephi Chakela
Chapter 11	p. 182, *Pimping, Leaning and Feaning*, Amde Hamilton
Chapter 12	p. 184, *Rappin' Black in a White World*, Watts Prophets
Chapter 12	p. 189, *Rappin' Black Rappin Black in a White World*, Watts Prophets
Chapter 13	p. 194, *When the '90s Came*, Watts Prophets
	p. 201, *Fighting Dogs*, Watts Prophets
	p. 206, *Hey World*, Otis O'Solomon
Chs. 15–16	(throughout), *Maralinga*, Paul Brown
Chapter 17	(throughout), *Ngapartji Ngapartji*, Big hART
Chapter 18	p. 278, *This Babylonian Confusion*, DAH Teatar
Chapter 19	p. 298, *The Legend of the End of the World*, DAH Teatar
Chapter 20	p. 310, *Documents of Time*, DAH Teatar
	pp. 316–331, *Inner Mandala*, DAH Teatar

Cataloging

ISBN 978-0-9766054-6-1

Library of Congress Cataloging-in-Publication Data

Cleveland, William, 1947-
 Art and upheaval : artists on the world's frontlines / William Cleveland ; foreword by Clarissa Pinkola Estés.
 p. cm.
 ISBN 978-0-9766054-6-1 (pbk. : alk. paper)
 1. Artists and community. 2. Art and social conflict. 3. Arts and society.
I. Title.
 NX180.A77C569 2008
 700.1'03--dc22 2008016462

Contents

Acknowledgments

I HAVE OFTEN referred to the writing of this book as a voyage—which it has been, both figuratively and literally. It has been a journey of inquiry and learning but, most importantly, a journey of friendships and stories. Many of the remarkable stories that I have encountered these past eight years have been both sobering and inspiring. They have also been humbling. When I began, I assumed gathering them would be demanding, considering the contexts of their telling. The geographical and logistical challenges were a given, as were the time and cost factors. But what I was most concerned with was navigating the unpredictable landscape of trust-making that is always a necessary precursor to sharing the most intimate of stories. Yet, somehow, these extraordinary people, citizens of a harsh and treacherous territory, came to the conclusion that I would treat their precious gifts with the respect they deserved. The openness and generosity they showed me was equal to their obvious creativity and courage. Without their help my efforts would certainly have gone for naught. And for that, I will be eternally grateful.

This journey also has had a large shadow cabinet, as it were. These are the folks whose insight and expertise have kept me honest, on track, and, most importantly, provided a firm kick when it was sorely needed. One person in particular, without whom this endeavor would have never crossed the finish line, is my wife Carla. There are very few words in this book she has not touched in some way. Carla has been the best kind of traveling partner—one who knows better than you where you are trying to go, and has the patience to let you find your own way. I hope she learned as much as I did. I hope she received as much as she gave.

Another companion along the way has been Jennifer Williams. Her work at the Center for Creative Communities in London has both broadened my global perspective and set a standard to which I aspired. Thankfully, Jennifer and my good friend B. J. Adler also introduced me to Lindsey Shea. Early on, when this book was not much more than a one-page prospectus, Lindsey provided the essential grubstake for my early research. Looking back, I can honestly say that her support gave first life to an improbable idea.

I believe some paths cross for a reason. Unpeeling the proverbial onion of this book's making, I recognize a number of my colleagues as co-conspirators. When I first met poet J. Otis Powell, I had a sense something was up—I just had no idea how high his courage and good heart would push my own. He is also a constant reminder that writers need writers, if for no other reason than to provide opportunities for a collective moan. John Bergman has had a similar effect on me. He is not only a fellow traveler, but he knows more of my multiple personalities than I do, which comes in handy when you are a staff of one.

My fellow teacher-learners Wendy Morris and Erik Takeshita have also shared this path by patiently stating the obvious, asking unanswerable questions and helping keep the bones supple and strong. And when it comes to questions, particularly hard ones, my friend and research partner, Pat Shifferd always shows up with the grace and wisdom necessary to stay the course. The same can be said of the people at New Village Press. Lynne Elizabeth and Karen Stewart have been constant advocates and supporters—as much for the journey as for the eventual destination, which has made all the difference.

Late in the process of writing this book, I had the good fortune of meeting David Korten who also believes in the power of stories. His seminal work, *The Great Turning*, helped drive home for me the necessity of working across all community sectors. Another late contributor was Andrea Stephen whose good feedback and encouragement always seemed to come at just the right time. A similar stream of good energy was always there from Linda Burnham and Steve Durland at the Community Arts Network and from my friend and colleague Mat Schwarzman at the Crossroads Project.

A different brand of cheerleading came from my own family. My mom has always been an unquestioning supporter for whatever I do, as have my daughters, Heather and Morgan. Though he passed away many years ago, I would be remiss if I did not acknowledge my dad's influence on this work. Through its creation, I have come to know that our seemingly incongruent paths were not as divergent as I had imagined.

Many of the stories in this book came to me by way of an ever-growing grapevine of generous and good souls around the world. Without their guidance I would have been utterly lost on my quest. Thanks to Kim Dunphy, Judy Spokes and Ollie Black for your Aussie hospitality: to James Arvanitakis for keeping me plugged in to all things Maralinga; to Malcolm Christian for providing a Caversham home away from home; to Pilar Palacia for the precious gift of space at Villa Serbelloni; to Wes McNair for sharing his space; to Maureen Harkins, Pat Bowen and Tom McGill for making Belfast sing; to Carol Brown, Bronwyn Findley, Vedant Nanackchand, and Choral Vinsen for Joberg and Durban direction; to Del Hamilton at Atlanta's, 7 Stages for stage direction; to Aleksandar Brkic and Milena Dragicevic Sesic for introducing me to Belgrade, and to the DAH family for making it come alive; and to Susan Hill for connecting me to the Prophets and for her constant friendship.

Each time I came back from the road I would send dozens of hours of taped interviews off to Barbara Vining who dutifully transcribed them. I am very appreciative of the diligence and patience that she brought to the task. And thanks to Christopher Miller, who joined in the transcription frenzy when we approached the summit. Another important helper has been Dawnelle Cassidy who has provided shape and consistency to the manuscript. And then I must give a special thanks to Trooper for his wise and good company.

Finally, I would also like to thank both the Rockefeller and Jerome Foundations for their critical support and encouragement. I am grateful, too, to the Nathan Cummings Foundation and the Educational Foundation of America who support New Village Press in publishing *Art and Upheaval*. I also would like to acknowledge all the individual, corporate, foundation and public funders who have supported the work described in this book.

For Andre, Sofia, and Carter

Foreword

What if...
What if no soul on earth is allowed to remain innocent forever?
What if all souls on earth will be broken? Open.
What if somewhere in life we become like an earth
that once yielded to anything that touched it,
but now, through some sudden twist of fate,
we are closed over and become hardened by grief's hammer?
What if we are now considered wasteland, even by our own sights?

And what if soul was buried beneath that hard chitin?
What if all was not lost,
but only seemed so...
and was somehow meant to seem so for a time?
What if we all walk dead,
but the time of Return is coming?
What if incubation can only occur in darkness?
What if hope and new life that truly endure
are not born from airy happiness,
but from black dirt grief?
What if we are in the eternal cycle of life/death/life,
'a night between two days,' that teaches us?
What if we either learn this and die in order
to lean against the cheek of something, someone Greater,
or else refuse to learn from this season in hell
and thereby die to life forever whilst we are still alive?

And if no one comes to break the earth open again?
What if no one misses the soul in all things,
or else pretends life can exist without the creative twin
born into each of us?
What if thereby the soul could never rise again,
because no one came seeking it,

what if we lost our sense of self?

you have to feel pain to heal. See the shadow side.

because none gave themselves
to the hard work of hauling, lifting, heaving,
the dragging, shaping and best guessing
about what might be needed next--
without ever knowing for certain beforehand--
but often enough, trusting spirit,
and being *en puente*, exactly right
about what is needed exactly right now.

What if even one person remembered
how to open the earth again?
And what if even one person remembered the soul by name?
And what if even one person came seeking
that which all others had given up on....?
What if even one person remembered
that under the hard earth in the darkest time,
new life is ever growing its hands, its feet, its eyes, its voice,
readying to be born again,
needing only one thing....

To be named.
To be called by name,
to be looked for,
received,
cared for with infinite tenderness.
To be protected with the strength of everything
that is wild of mind and deep of courage bones.

You'd like to know the name, the exact name
to call true life back again?
What is the one thing within your soul that can never die?
That is the name.[1]

Stolen by the Underworld: Return to True Home

Life as We Once Knew It, Suddenly Taken Away

To begin, Storyteller closes her eyes so she can see the tale in order to tell it....

Once long ago, in worlds more ancient than ours, there lived a young immortal named Persephone, a delight to the senses with her long gold and silver curls. She was Kore, maiden, never married in mind or spirit, an innocent who was a lover of all things carrying soul... a fixer of broken stem of hyacinth, binding up the paws of limping dogs, repairing, sturdifying, propping, nourishing all of life.

1. Clarissa Pinkola Estés, from the poem "The Splendor"

Why would she not? Her mother was none other than Demeter, Great Mother. Demeter sparked roots of maize and wheat, brought fruit trees into pink and white glories, blessed the fruits in wombs of women, and the flowering of ideas in minds and deeds of humanity.

But one day, something went terribly wrong. Into this paradisiacal existence came a terrible, bewildering darkness.

Persephone had wandered past the orchard where trees bent down their limbs to feed her their heavy fruits. On the green plain she spied a beautiful little flower, and bent gracefully to see it more closely.

But, the moment her knees touched ground, a huge crack of thunder rolled, not from sky—but rather from underground. The earth trembled like a frightened horse. Orchard trees began dropping their fruit as though terrified. Life everywhere, humans, animals, plants, paused as though a knot had been tied in the arteries of every living thing... and a giant black zigzag ripped open the earth.

Amidst black smoke and fog, rose an even blacker chariot with a muscled and oiled dark driver. He held his ebony stallions snorting fire in midair and suddenly snatched Persephone around the waist, lifting her with her sandals and hair ribbons flying, into his dark carapace. **Hades**

Abducted to the Underworld

Abruptly he turned his black steeds downward into the earth, diving down, down, down... disappearing into the dark mist completely. Earth suddenly arighted itself, closing over its open wound, until, with only malodor of phosphorous hanging in the air, all was as before. The ground was closed-mouthed. All around everything seemed almost as before....

Except Persephone was gone. The orchard, leaning in shock, seemed to say, 'Let us pass for dead now, at least that might be safer than telling what we saw...' Thus, it seemed, the trees would never come back to life again. *Feared telling the truth*

When Persephone did not return home by day's end, her mother Demeter ran through fields calling, calling Persephone's name. But, nothing. Night descended. Great Demeter in utter desperation tore out her golden combs, let down her long hair like two dark wings. She sailed through the night, seeking with fiery torch into caves, crevices whilst weeping and calling for her beloved child.

But Persephone had been stolen by Hades, God of the Underworld, a lonely God who was said to have been desperately seeking the touch of love in his unending nights. Yet, he could not persuade nor seduce any warm living soul who loved light to join him.

The Long Seeking for The Stolen Soul

Demeter continued to wander seeking her child, even attempting to co-opt mortals' children to make them immortal like her own daughter. But each time her trying to make someone else's child immortal was interrupted, and thus, she wandered on alone, bearing what any mother who has lost her child knows too well: a sorrow of the ages.

The world stopped.

Meantime, all crops failed to grow. Singers no longer created new songs, pictures were not painted, dances were not danced, words were not spoken, scribes did not scribe, flowers failed to blossom, waters lay still, no human beings were born. The world is as Demeter's heart: shocked, deadened.

World weary, covered in road dust, hair hung over her face, Demeter slumped against a stone well, staring. She had no more left in her for one more foray, not one more question about where her daughter might be. But suddenly, into her life danced an antithesis to sorrow by the name of Baubo... who is a little Life Goddess, an oddly configured Belly Goddess ever pregnant with new life.

Baubo danced, entertaining Demeter, and telling her earthy, ribald jokes... until Demeter gave a tired smile, the first mirth she had felt since her child had disappeared. This gave just enough lift of spirit to draw Demeter from her fatigue.

Next, ancient crone, Hekate, crept close to Demeter. The old wise one knew just which question to ask: '*Who* do you think took your daughter?' Demeter pondered, saying over and over that she did not know. 'Well, *who would* know?' asked old woman Hekate.

Together they decided Helios would know, for Helios was the Sun and sees everything. Helios, flaming like a thousand fiery oceans, said, 'Indeed, I saw it all! It was Hades who took your daughter under the earth. He'd told Zeus he was lonely. Zeus told him to take Persephone.'

Meanwhile, the people were grieving sore, unable to hold spoon to lips for they were in a famine of desperation. Nothing would grow because of Demeter's sorrow. When the people were told Zeus, chief God, had given Hades permission to steal Persephone, they became enraged, threatening Zeus that he would have no empire to govern, that he would no longer be held as highest God if he did not restore Persephone to her mother.

Zeus quickly decided that Persephone be immediately restored to her mother. He ordered Hades to do so, saying if the maiden had not eaten in the Underworld, she could remain with her mother eternally. Persephone had, in fact, refused to eat. She'd only sat on the throne Hades made for her... a pale rendition of her living self.

Return to True Home

Hades strapped his big black stallions into their tack and traces. Sadly he placed Persephone in his chariot and began the slow ascent to the topside world. Nearing the earth's crust, Hades suddenly produced a pomegranate from beneath his cloak. Cutting it in half with one slash of his blade, he pressed the pomegranate to Persephone's lips so that she ingested six seeds of fruit. Thunder thundered. Earth heaved open. Flames shot from underworld scorching the edges of earth's wound. Hades lifted Persephone to the ground....

There, across dry-spiked and withered fields, Persephone saw old crone Hekate and Demeter her mother. Persephone began to run toward them. Each

time her naked feet hit the earth... the land broke into flower and green right and left for as far as one could see... until at last, she was in her mother's warm embrace... and the land... the people... the singers, poets, musicians, painters, speakers, dancers, makers, dreamers, babies in bellies... and the orchards... were all brought back to vibrant life again.

Another time and place, the story would end here, the cycle of life/death/life brought full circle... except for one thing. Pomegranate seeds. Zeus declared that because Persephone had swallowed six seeds, she would be with her mother six months of the year and be with Hades, underground, the other half year.

Life/Death/Life Cycle

So it was. And so it is. During the six months Persephone was with her mother, the earth, the people, the spirit of art is ever bountiful. For the other six months, it is no longer that the world is dead or that spirit or people are diminished. Rather, it is only that they are resting, learning of matters that can only be learned in descent... but this time—being certain that true home will ever be returned to, time and again—that depth of thought learned underground will rise above ground, find root, water, harvest enough to nourish many in the topside world once again.

Thus, to end this tale, Storyteller opens her eyes, rests... until the next story...
next time....

* * *

Demeter and Persephone are a most poignant description of how we all, as human beings with souls, face challenge, crisis, sudden turns, disasters. The story speaks to the process, as well as the inner psychology of suddenly being snatched away from life as we once knew it.

There are many ways to be stolen into the underworld—a place where we of mind, heart spirit... do not know our ways.

Yet.

But, will eventually.

We are stolen through sudden disappointment, assault, unforeseen loss, abject betrayal, injustice toward soul, imprisonment of mind, spirit, devastating intrusions into creative psyche, lost opportunity to bring a gift to the world, humiliation, an assault, an excoriation, insensible acts by ill minds and hearts, natural disasters, sudden death... anything that causes loss of sense of self, sense of security, loss of natural confidence, loss of a great dream that had spiritual dimensions, loss of a loved one, loss of innocence, loss of dignity.

In my four decades of work in 'three p's'—poetry, post-trauma recovery, psychoanalysis—I coined the phrase "life/death/life" cycle to name a process we are all dragged through during and after a devastation, whether we want to be or not.

Perhaps persons facing such matters will have a more or less easy time of it, having much comfort surrounding, at least in early days not long after the

event. But, more will witness death and evil walking hand in hand crooning lies to all who will listen, or trying to cover over the roots of what really happened, what was promised... making an external show that does not accurately reflect what hideous or difficult thing came to pass.

One can be sure if whatever happened was newsworthy, that some journalists will have depth of heart to record it accurately and with compassion, but many more will not have enough depth to grasp life/death/life, and will trivialize facts and people, and then move on long before the story is complete, sometimes leaving the people in the story in a shambles with no further focus on aid for them.

That's when *the art spirit* is aroused, violently aroused in some cases: to tell the story. The real story. Each individual's story. Each group's story. Not nice cleaned up story, not legalistic story for protection's sake, but like Persephone under ground, earthy dark story, true no-holds-barred story holding the sad facts of something precious delayed, or ruined, or gone forever now.

The art spirit ever tells true. If art has no depth, it is because deeper truths have not yet been told. True home ultimately is wherever the art spirit truly lives alive... instead of muffled or dulled down to a conformity decided by others. The art spirit is that relentless creative force that prevails, even when one is stunned to muteness like Demeter at the well.

Having tried to return life to life by replacing, replicating, going back, trying to duplicate what once was... eventually one sees that none of this will work. We may go deathly silent then. The stage goes dark.

But, who shows up in darkest times? The art spirit, personified in the tale as Baubo the little belly Goddess, full of energy to 'tell story,' to dance the story, joke it, say it, sing it, create a true picture of it all.... Thus, the art spirit arrives. With love. Perhaps there is nothing the Life Force, the Creative Forces love more than a deadened person. Demeter is lifted by the creative force coming close to her. The opposite of all gone quiet: the sparkling life force.

Demeter does not come back to life all at once, nor is Persephone restored to her in ways that once were. Resurrection takes time. There will be differences, after. Most of all, there will be new life again. The pattern of life/death/life has been a core of human life and soul since time out of mind. Perhaps that is why the theme of most all stories, most all art, is some portion of life, then death, then 'the return.'

If one were to imagine all aspects of this story not as six or seven separate entities 'out there,' but as several forces or thought systems within one psyche, then you can see how the human mind and heart work their ways through tragedy and challenge: While one part is stolen away, another part is grieving, sterile, allowing nothing to grow. Yet, another part is still very much alive, in fact waiting to dance for you, to lighten your heaviness.

Too, a certain kind of depression as typified by Hades, cannot hold on to Kore, to the maiden life force. In the end, the life force will be relinquished to the light again, else entire communitas within, and in outer culture, would remain disrupted. Personal healing contributes to culture's healing, and visa versa.

Thence in psyche at same time, comes the old crone, wanting to analyze and inquire. Old wise one of the psyche asks, What really happened to this youthful, fertile part of myself? Is there part of me that sees everything, that can shed light on this? The answer is, Yes. Who can see? Spirit can see. Farther than ego. Farther than rote answers given by outer culture about why certain things happen or not. The art spirit is alive in blood stories, not in "water of the water of the water" that only wishes to wash blood away.

At the last turn, after torment, seeking, learning through all these many aspects of self, after sudden turns, tragedy or soul-stealing conflict... there is unity, fertility again. Life force comes back to show above ground. What is lost comes back. Not in same form as before, but different now, new form; one we sometimes have to learn to recognize as new life... a new way of being, thinking that may never resemble who we once were, how we once lived before.

When tragedies, conflicts occur, we do not get past them, but there is a finding and learning of deeper landmarks, groundnotes, motherlodes... all turned toward how to live with what has occurred. Somewhere during a dark time, one will likely be called, literally receiving new calling to tell, perform, do, attend, heal, help assist, give, show the world something... something genuine that comes from the time of suffering underground, that comes from the seeking again, that comes from the joy of creative spirit breaking through at last.

That dance, work, art, idea, speech, making of something using one's courage bones, will be just like Persephone returning from the underworld, wherein your special touch, a creative touch, like Persephone running to her mother's loving arms, turns the dead world and its famished people back to life again.

The ending flourish to this ancient story tells of six months above ground, six months below. This is not a penal sentence, but rather an understanding, a comprehension of the cycle of new life now. Six months above ground six months underground is the quintessential life/death/life cycle put into motion willfully, rather than us being dragged there by circumstances.

Now, this cyclical descent is made not because one is abducted, but because one wants to see from different Hagia Sophia, wisdom place, a deeper perspective that is away from the clatter of day world, that rests instead in quiet contemplation, in dim light that erases inessentials, that allows one to concentrate on meaning and being, on ways of returning self and others to true home.

Thus descent becomes strength,
instead of pitiable.
Visionary,
instead of ego's sight alone.
Massive creative spirit
incubating, and being born again,
day after day after day,
for as long as we all shall live.
No one will be left stranded.

The little life force is looking for anyone lost in the underworld.
And with true love.

So may it be for you
So may it be for me
So may it be for all of us.

Coda

I met Mr. Bill Cleveland when he came to a meeting where we who were first responders to the inner circle of teachers and young adults at Columbine after the massacre were assembled. Mr. Cleveland was writing a book about expressive arts, tragedies, and healing. It became clear that he was called to a journey of more than ego alone, to travel the world gathering stories of people who have, each in their own ways, leaned on the art spirit in order to come back to life again.

He writes at core, I think, to demonstrate that hidden faculty of human beings that knows that monetary compensations, legal wranglings, formal apologies, condolences, and all other cultural frameworks often surrounding disasters and tragedies can sometimes not even begin to soothe nor heal the chasmic wounds to psyche. But that art, in all its variegations, can give meaning to senselessness, can bless the shatters in ways that create more soul to those invested in some portion of the art spirit's work.

Most helpers of any stripe who enter the inner circle of people who have been harmed, and who stay for appreciable periods of time afterward, pay substantial costs to remain focused and close to those who suffer. No helper, healer, witness, aide, recorder, is invulnerable to being drowned in the sorrow of others, to being broken by others' heartbreak, to receive acid splashback of others' angers, ambivalences and fears.

I don't know that we can train helpers/healers to withstand such. Rather I think some are simply born with the charism and cannot *not* enter hell where others are pinned or trapped. Thus, some of us work to pull souls from the wreck and to remain with them in many spiritual and concrete ways for a long time afterward. Others tell the crucial stories of those making their ways back from isolation and torment, those finding or showing the way back to true home with the spirit of art leading.

This book would be that kind of hard won map.

—Dr. Clarissa Pinkola Estés,
Author, *Women Who Run with Wolves*
Founder, La Sociedad de Guadalupe
Holy Week, March 2008
Rocky Mountains

INTRODUCTION

"The frontlines are everywhere"

I WORK IN A FIELD broadly defined as community arts. While "community arts" may be a modern term, it actually describes an activity that is quite old. It basically involves artists and their fellow citizens coming together to make art (paintings, performances, poetry and the like) that in some way reflects their common concerns. From time to time I am asked to talk about what I do. Early in 2007, I opened a speech at the Artworks Conference in Virginia with the following:

Imagine working in a theater company for no money, 12 hours a day, six days a week, crafting performances that few will ever see that could land you in jail.

Imagine hundreds of newly minted art school graduates whose number one goal is to use their talent and creativity to advance democracy and economic justice across the land.

Imagine a solo exhibit of paintings as one of the only visual records of a reign of terror in which over two million people died.

Imagine an internationally recognized writers' program, forced into bankruptcy and burned to the ground at the hands of an undercover government agent.

Imagine street performance and graffiti art that somehow help to bring down a brutal despot and end a decade of war.

Imagine having to cancel your afterschool dance class due to local bombing.

Imagine a Supreme Court building that is an art gallery devoted to human rights with judges as docents.

Imagine having to sit down with rival militia leaders to negotiate the individual lines of your community play.

Imagine poetry readings conducted at the barrel of a gun.

Imagine waking up everyday knowing that your work as an artist, as a curator, even as an arts administrator, is critical to the survival of your people.

Imagine knowing that your art making could get you killed, but doing it anyway.

Many of those in the audience that day were surprised to learn that none of these scenes had been made up. Their surprise turned to shock when they learned that one of the more extreme scenarios from my list was home-grown. As I recounted the story of the 1973 burning of the Watts Writers Workshop by a man working for the Federal Bureau of Investigation, I could sense a subtle shift among my listeners. They had assumed that my talk about "artists on the world's frontlines" was going to be about other places, dangerous places, far removed from their own experience. Afterwards we had a lively discussion. Many commented that learning how their own fearful government had silenced a little community writers program brought home the fact that we all have assumptions that need to be questioned. Another, an artist herself, shared that she knew from personal experience that telling true stories can be dangerous. One young man summed it all up for me when he said, "We have to realize that the frontlines are everywhere."

The scenes I shared in my talk are snapshots from the voyage of inspiration and learning that led to the creation of this book. This journey has given me a new, and often unexpected, appreciation of the power and persistence of the human creative spirit. It has also taken me to some truly remarkable places, like Watts, Phnom Penh, Soweto and Belgrade—places that have come and gone from the world's headlines, places we know as scenes of upheaval and tragedy.

Hard Questions

In early 1999, I was invited to give a talk at a conference in Northern Ireland sponsored by Belfast's Community Arts Forum (CAF). While I was there, I was introduced to a consortium of community theater groups who, with CAF's assistance, were undertaking a bold and risky theater project dealing with one of Northern Ireland's most conflict-ridden issues—marriages between Protestants and Catholics.

I was enthralled. Over the years I had been associated with many community theater projects in the US that had tackled difficult, even dangerous issues, but this was different. After nearly 40 years of oppressive and relentless conflict, Northern Ireland's citizens were holding their collective breaths amidst a tenuous truce between Republican (Catholic) and Loyalist (Protestant) paramilitaries. Everybody was lying low, keeping quiet, and trying not to make waves. But the community members behind *The Wedding* had a different idea. If the peace negotiations facilitated by US Senator George Mitchell actually bore fruit, Northern Ireland's Protestant and Catholic communities would need more than a cease-fire to heal the country. People of good will on both sides of the "peace line" would need a protected space to explore common ground. They saw a cross-community theater project as worth the risk.

The production, *The Wedding Community Play*, did, in fact, come into being. In early November of 1999, I flew to Belfast to see the final two performances. The play was presented in four venues—a Protestant house, a Catholic house,

a community church and a reception hall. After assembling at the CAF offices, I and my fellow audience members were transported by bus to the first two locations where we crowded into the bedrooms, kitchens, and living rooms of the two homes.

As the play unfolded all the hurt, rage, humor, and hopefulness that had defined Northern Ireland's quest for justice and peace were shared with an audience that, by the final curtain, had become a part of a newly constituted, cross-community family. By the fourth act, it was hard to tell when the "theatrical" wedding reception ended and the post-performance party had begun. Needless to say, it was an extraordinary work of transformational theater.

The mounting of *The Wedding* was a perilous endeavor. Every line in the play was negotiated over and over with the participants and with the paramilitaries. Many members of the cast were warned that their involvement could be construed as a betrayal of one community or another. Some dropped out over disagreements or as a safety measure. But most saw it through. And in the end, in the words of one of the participants, they created a "powerful and very public symbol that had more impact on the community than all the violence that occurred during its making."

Following *The Wedding Play* through the dangerous social and political minefields of its creation, coming to know the lives and histories of the people involved, inspired me and humbled me. It opened my eyes to how little I actually knew about this thing I had studied my entire career—this simple, complex, confounding, unpredictable, magical and powerful thing we call human creativity.

My Belfast experience also reminded me that as a white American male I could choose whether or not to confront many of the "hard questions" that were unavoidable for most of my colleagues in the community art field. Hard questions like:

Whose story is this? Who defines success for this work? To whom are you accountable? Whose voice is missing? What's the downside here, and who will be left holding the bag if it fails?

I realized it had been too long since I had queried the assumptions informing my own work. Over the preceding decade, I had challenged many students and colleagues to grapple with the difficult and unsettling questions that are intrinsic to community art making. Yet, while I had been calling on others to examine their suitability and motivation, pages of my own evolving story remained unturned and unquestioned. Put another way, after Belfast, I was no longer comfortable in my own shoes. It was time to confront my own hard questions.

Search Engine

Unsettled and inspired. What better state of mind to begin reexamining a life's work. I started by writing an article about *The Wedding* for the Community Arts Network. I also came up with a series of questions to frame my curriculum, so to speak. Many of them were not new, but I felt they all needed revisiting:

tough Questions

What spurs our individual and collective creativity? Is the healing power of human creativity equal to our obvious genius for wreaking havoc? Is trauma a creative trigger—are humans wired to create in the face of chaos and destruction? Why are artists so universally feared by despots? Can the arts mitigate fear or change our perceptions of "the enemy"? How do the arts help us make sense and meaning? And, on the flip side, how can it do harm?

Searching for answers to questions like these led me to numerous discussions with colleagues and, as is my habit, I continued to write. Eventually, the idea of a book emerged as an excuse to continue the enquiry, albeit in a more structured way. After more research and discussion, a kind of focus emerged for the project. Using my Belfast experience as a template, I would explore artists working in communities facing extreme social, political and environmental crises—namely war and disaster zones. My questions would be a starting point, but, as with my earlier book, *Art in Other Places*, I would let the stories take the lead. I was not interested in doing a comprehensive survey of creative output in places in turmoil. Rather, I wanted to find individual artist's stories that somehow showed how and why the creative impulse rises up in these situations.

When I shared the idea with some colleagues and prospective publishers, some were encouraging, but others (mostly publishers) thought I was crazy. One said, "Sure you might stumble on a stray artist trying to survive in the trenches but no artist worth their salt is going to be willing or able to do serious work in these conditions." I knew the naysayers were wrong, but I had no idea how wrong until I started digging deeply into the subject. After a few months of reading, internet searches and overseas phone calls, I had found over 300 examples of what I was beginning to call "art and upheaval." Since then, many, many more have emerged. The list grows every day.

Here is a small sample of what I discovered:

- British theater workers using drama to introduce democracy to decommissioned child soldiers in Eritrea
- Conceptual artists helping homeless and hunted children in Rio's favelas to use media to tell their story
- Social Soaps (soap operas) disseminating lifesaving information on radios and televisions all over the world
- Modern dance giving voice to forgotten refugees in Gaza and the West Bank
- Artists responding to trauma victims in the immediate and long term aftermath of the Columbine shootings
- A Yemeni poet and army officer using poetry to combat gangsters and terrorism in rural villages
- A Tanzanian theatre group using drama to learn why women in that country were not participating in elections
- A traveling performance highlighting the dangers of AIDS to Vietnamese teens

- A Liberian musician's struggle to promote democracy in the midst of corruption and war
- Puppeteers in Argentina helping Las Madres de la Plaza de Mayo in their fight for justice for the disappeared

Among the swelling file folders, patterns began to emerge. Some were short-term crisis interventions. Others had longer term aims, but had fallen on hard times due to deteriorating conditions or lack of resources. A good number had been initiated from outside the crisis area by artists and/or organizations working with locals. Many of these programs, particularly in Africa and Eastern Europe, were driven by artists from Western countries. The issues and conditions being addressed ran the gamut. In these places, art making was helping to mediate conflicts, rebuild economies, heal unspeakable trauma, and give new voice to the forgotten and disappeared. Health issues were among the most prominent, with AIDs education and women's reproductive health topping the list. Another common use of artistic resources was with young people traumatized by war and natural disaster.

Six Communities

Put simply, the stories in this book chose themselves. It's not that any of them lobbied to be represented, in fact, a number of them did quite a bit to discourage my entreaties. As my research expanded, I found that the stories that held the most promise for me had a number of things in common. First, and most importantly, was whether they were ready to be told. Early on in my research, on a trip to New Zealand, I had a sit-down with a drum and dance troupe formed by refugees from the Rwandan genocide. As we began to talk, their initial enthusiasm for sharing their story quickly dissipated as they realized that they simply could not bear the telling.

One of the most important elements to me was that the central figures of each story be members of the communities in which they were working. I was also drawn to artists' stories that spanned the historical events that contextualized their work. For many of the "upheavals" in question, this meant creative biographies that stretched two or more decades. Another attraction was intense collaboration. I liked the possibility that the central narrative would, by definition, connect to others. The only question was, Could I contain the bounty?

Eventually, stories from six communities on five continents came to the fore. They are set in Northern Ireland, Cambodia, South Africa, Watts, California, Maralinga, Australia, and the former Yugoslavia. The artistic disciplines represented are diverse as well; visual, performing and literary artists are all in the mix. A few stories, like *The Wedding*, have a climactic event as a focus. Others center on a group or organization responding to unfolding events over time. Each is distinguished by deeply intense relationships among members of a close, often beleaguered group. The crises they confront exemplify a mix of issues

and conditions: war, dictatorship, human rights, AIDS, poverty, racism—sadly, the list goes on. And along the way, they all encounter enormous physical and emotional obstacles, not the least of which is an active and powerful opposition. It would be grossly inaccurate to describe the politics that permeates these accounts as anything other than "vicious."

Settling on the six narratives certainly brought greater focus to my task, and, as I began to engage the artists, and explore the complicated histories surrounding their work, I realized that *Art and Upheaval* was going to be a very long road. *Art in Other Places* had introduced readers to the newly emerging, and largely unknown, community arts movement in the US. In order to reflect the field's diversity, each of the book's 22 chapters had been written as a compact portrayal of a different artist's journey. This book would be a very different undertaking. In it, I would be crossing borders into "global hot spots." Telling these stories responsibly would require more than a summary of news accounts and a few pictures. It would necessitate knowing the people and the places firsthand. Most importantly, it would call for a level of trust and partnership that could not be forced. I understood that the messy interplay of desperate lives and communities in turmoil had to be approached deliberately, with caution, and with the utmost respect. This, I knew, would take time.

Patterns

One could argue that these artists had no option but to react in the ways they did. After all, most were literally trapped in the tumult surrounding them. Still, amidst the fear and disorder some responded creatively, sometimes with nuance and sensitivity; others with bold strokes. That they decided to push back against the toxic tides and stay the course as creators is the most indelible pattern that runs through these stories. Although the Watts Prophets clearly desired broader recognition, they persisted with their brutally confrontive poetics and spurned any number of "Hollywood record deals" that demanded a gentler tone as a quid pro quo—a persistence that eventually attracted more attention from the FBI than it did deal makers. Similarly, in Phnom Penh, Ly Daravuth and Ingrid Maun could easily have laid low in their modest Situations Gallery ignoring the culture decomposing around them. Certainly Belfast's community theater artists could have avoided a great deal of heartache and political heat by confining their work to their own communities. They all chose, instead, to defy expectation and do what artists are always doing—challenging convention and imagining a different story with a different outcome.

Without being overly dramatic, one could posit that these performers, painters and poets made difficult, even foolhardy, choices in dangerous circumstances. Yet, if you ask them, to a person, they would describe their circumstances as absent of choice. This is one of the recurring conundrums that shout out from these narratives. "Of course," they would say, "there were many possible turns, but no question as to which one we would take." And, now, knowing

these creators, their stories, and the long rough seas they all navigated, I can see the pure and unavoidable truth in that.

Another recurring aspect of these sagas is the elusive quality of the "frontlines" themselves. Given that they take place in incendiary places like Belfast, Watts and Belgrade, one might assume that the antagonists populating these stories would be familiar to us. Predictable shibboleths like Milosevic, Pol Pot, and the South African security forces appear for sure, but, truth be told, less facile demons dominate the action. In these dramas, fear, greed, indifference, denial, zealotry, bigotry, betrayal, and, most prominently, a failure of imagination, crowd the stage. They are represented by conscripted soldiers, faceless government functionaries and next door neighbors— everyday people trying to survive.

The opposite is true for the creators who make these stories worth telling. They, too, are what one might call, "everyday people." Few of them are widely known outside of their communities. Yet, these performers, poets and painters chose a starkly different path in the face of brutality, intimidation and hopelessness. They opted to speak out, to fight back, to draw the line, to recover, to heal, and ultimately to survive. And in these narratives they are joined by others: fellow artists, community members, housewives, students, veterans, shopkeepers, pensioners—fellow travelers who find solace and courage and who discover the power of their own voices.

I would be remiss if I did not point out that as unique as they are, these stories did not unfold in a creative vacuum. Surrounding each was a robust, often hidden, ecology of fellow creators responding individually and collectively to the difficult circumstances. I should also note that none of the artists portrayed here saw themselves as particularly heroic or exceptional. They took great pains to describe their work in the context of community and collaboration.

Stepping back from the intensity of current events, it is important to recognize that this form of artistic behavior is not at all a modern phenomenon. Throughout history human beings have used their creative powers to confront destructive forces. The shaman, often described as the pre-art artist, assumed the primary responsibility for healing and mediation by means of music, dance and symbolic imagery. Throughout history artists have continued their association with these roles. In the Middle Ages, artists and early physicians shared the same guild. Performances, visual art and verse have long been used to advance the aims and ideas of liberal thinkers and peacemakers. Euripides, whose *Trojan Women* is often referred to as the first anti-war and anti-misogynist play, said, "God hates violence." Though largely unacknowledged, museums throughout the world contain a huge volume of images and artifacts created by artists challenging authoritarian and militaristic worldviews.

That these alternate voices do not share space with the epic tales of military triumph and tragedy that fill our history books and museums is no mystery. Nonetheless, this impulse has always been there. I suppose that is why I was

7

drawn to these stories, as they offer such a very different picture of human potential in the face of evil.

It would not be unreasonable to argue that art has little potency in the face of violence and repression. But evidence to the contrary comes from some of our century's most brutal despots. Historically, those intent on eliminating opposition and suppressing popular dissent have made a priority of quickly eliminating creators and thinkers from their midsts. One has only to note how intently East Germany's *Stasi* (secret police) focused on the systematic intimidation of the country's artists to stifle initial opposition to hard-line communist rule. It can also be seen in Chile, where in the early 1970s dictator Augusto Pinochet imprisoned and "disappeared" so many of that country's creators in order to assure social control. In these pages, you will encounter this insidious pattern again and again, most notably in Cambodia where the Khmer Rouge took only three months to annihilate nearly all of that country's artistic community.

It is highly ironic that these brutal regimes seem so much more aware of the potential power of artistic creativity than cultures we consider more "civilized". It is even more alarming to examine how readily these tyrants used the arts to advance their own evil purposes. Hitler, history's most notorious artist, is known not only for his suppression of "degenerate art" but also his lavish and effective use of symbol and ritual to advance the ideals of the Third Reich. Slobodan Milosevic, whom you will encounter later in these pages, is often described as Hitler's equal when it comes to the theatrical manipulation of public opinion. Even Pol Pot, another character here, and an enemy of culture if ever there was one, understood the power of story and song to radically alter human behaviors and beliefs.

Eureka?

What have I discovered? It would do a disservice to the depth and complexity of these stories to try to distill their essences into bullet points. I believe the narratives themselves, particularly the verbatim reflections of the people represented, are the truest source for whatever wisdom and meaning they contain. Individual readers will, of course encounter these remarkable odysseys with their own biographies in tow. This is the reason I have tried to let these stories and their characters represent themselves—to allow readers to meet them on their own terms, with their own questions. I will say, though, that many of my own questions, the ones that informed and impelled this quest, have been touched and altered. In the end, what I come away with is not a proven hypothesis, but rather a clearer sense of what I know about human imagination and creativity and our ceaseless pursuit of meaning.

I have come to know that if you scratch the surface of a human disaster you will find creators responding to the most difficult of circumstances, making art to live, to eat, to kindle the human spirit, to bring peace or to resolve conflict. In these circumstances, you will also find art makers manifesting

beauty in the face of horror, and revealing the ugly truth in the face of denial. They are doing this to rally, or bring order, to educate and inspire, to entertain, to heal, but most of all, to tell the story—the hidden story, the story denied. And once revealed, the story's telling is never in doubt whether told directly, obtusely, in code, as a joke, as a song in a pub, a poem or a painting on the wall, as a play unfolding in a cramped living room, or as a dance of angels on the dark and sinister streets.

This is the creative landscape that I found on my journey of the past eight years. The truth is, that in the face of destruction, we are impelled to create. Upheaval begets both crises and opportunity. Shiva dances to create as well as destroy. It's a survival impulse that I am not sure we have any control over. In the face of the unfathomable, the senseless, the cruel, the devastating, we roll up our sleeves and get down to the business of making meaning.

Some would say that this is our great hope in a time of unprecedented global crises, that the only way out of the death spiral we have imposed on our planet will be the creation of a new, countervailing creation dance. I would say that one of the simple messages, repeated over and over in the following pages, is that humankind already knows this dance and practices it every day. With each sunrise these "new stories" are rising up in what most would consider the least fertile of fields. It is unfortunate that we seem to look to the safe and often sterile places (the academy, city hall, TV) for the insight needed for our most difficult questions. It is equally unfortunate that the kind of messy miracle stories that populate these pages rarely see the light of day.

So here are ten stories from six communities about art and upheaval. If the creative powers called up by the extreme crises depicted in them can be marshaled to help us recover our earth community, then I believe there is hope. Please know, however, that these stories are not presented as evidence of a second coming entitled, "art conquers evil." As I said at the beginning of this introduction, these are snapshots of sagas that, like the circumstances that spawned them, are far from over. Despite their significant histories, they are very fragile. Most are focused on keeping their head above water. In the tyranny of the urgent, getting the story out has not been a priority. I am honored to have been entrusted with that task. Considered separately, these stories are compelling and inspiring. Taken together, I believe they constitute a body of experience and wisdom from which we can learn a great deal about how human creativity can help us heal the deepest and most destructive of our self-inflicted wounds.

PART 1

The Wedding Play

Northern Ireland

CHAPTER 1

Early Days

Friday, April 10, 1998

"I am pleased to announce that the two governments and the political parties in Northern Ireland have reached agreement."

After almost 30 years of violence, and two years of intensive talks, the Northern Ireland Peace Process reached a climax at 5.36 PM on Good Friday, 1998 when George Mitchell, then Chairman of the multi-party talks at Stormont (Northern Ireland's Assembly Building) made this historic statement. While the Agreement exceeded Mitchell's deadline by almost 18 hours, it was clear that there were elements of the Agreement that did not suit each of the signatories.

—*Irish Times*, Friday, April 11, 1998

Saturday August 15, 1998

OMAGH BOMBING KILLS 28

Nine children, including an 18-month old infant are among the 28 people killed in a car bombing in Omagh. The authorities have said, thirteen women, one of whom was pregnant, and six men were also among the dead. About 220 people were injured or maimed. Fifty-three people remain unaccounted for, but this is understood to include 20 of the dead, who have still to be formally identified.

The blast, in the packed town centre, hit Protestants and Catholics alike. The attack in County Tyrone, the worst since violence began in Northern Ireland 30 years ago, brought condemnation from all of the province's political leaders.

—*BBC News Service*, August 16, 1998

THE BOMBING had been intended to drive a stake into the heart of the peace process. But as the depravity of the deed began to sink in, many recognized that the rIRA (real IRA) bombers had actually pushed the two sides closer together. All but the most radical Protestant and Catholic leaders condemned the act in no uncertain terms. More importantly, over the next few weeks, the most militant splinter groups, including the rIRA, announced their

intention to join the cease-fire. Politicians of all stripes seemed to recognize that a terrible corner had been turned in the "Troubles". On September 3, the leaders of all sides were joined by American President Bill Clinton and British Prime Minister Tony Blair in Belfast to reinforce the mounting consensus. The Peace Process was the only viable option for Northern Ireland.

Such violence always made it difficult for even the most conciliatory members of the Protestant and Catholic communities to work together. But this tragedy affected people differently. Typically, each side would retreat to the refuge of blame and recrimination. Now, there was a strong desire to fight back in some way. Not with the Loyalists or Republicans, but against the enemies of peace from either side. The prospect of peace had become too precious to turn away. This sentiment was particularly strong among those in the Belfast arts community. Northern Ireland had been at war with itself for too long. As hard as it was, it was time to find a way to join in the Peace Process.

Crown Bar, Belfast, Northern Ireland, September, 1998

Swirling smoke and Guinness. Jo Egan, Martin Lynch and Dave Hyndman sit in the corner, talking intensely, hands jabbing, heads nodding, shaking, nodding. Dave, the filmmaker, holds forth. "What if you had a different play from every community theater group, Protestant and Catholic? And you would go around, and you would see each play." Jo interjects, "Jesus, that's a long bloody day. Even if each play was just a half-hour, what with the traffic and all... But, what if the idea was something that lent itself to traveling around, like a wedding?" Martin is nodding again. Dave smiles, "Yea, we could do it about a mixed marriage..." Martin finishes his sentence, "and we could do it in Short Strand."

A Look Back

Forty years ago, Short Strand was a relatively peaceful neighborhood of Protestants and Catholics in East Belfast. At that time, while sectarian communities lived separately, members of both groups worked and played together. Sometimes they even fell in love. Now, there is a 12-foot, razorwire encrusted brick wall, called the Peace Line, separating the two.

The precipitating event for the construction of the Short Strand wall, and many others in Northern Ireland, occurred on October 5, 1968, in Derry, Northern Ireland's "second city." On that day, a civil rights march, organized to highlight Catholic grievances about housing, employment and gerrymandering, was violently dispersed by police. This gave rise to three more days of rioting and what is regarded by many as the start of the Troubles.

The Troubles has cast its shadow in a thousand insidious ways on the everyday lives of Northern Ireland's citizenry. For thirty-five years, the violence that has killed over 3600 people has manifested in familiar headlines around the world. Less obvious are the subtler and sometimes more oppressive ways the Troubles has affected its victims. Everyday activities like shopping, travel, going to school,

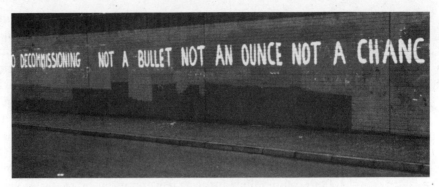

Dividing walls and partisan slogans are a common feature of Belfast neighborhoods like Short Strand and Ballymacarrett. Photo © William Cleveland

even friendships, have all been altered in some way by the cruelty of the ongoing conflict. More recently, as the violence has subsided, these distortions are persistent reminders of the wounds suffered, often in silence, by this community. And of the scars left, none are more telling than what happens when Catholics and Protestants fall in love in Northern Ireland.

This is especially true in and around Short Strand, a small Catholic quarter situated within a predominately Protestant area known as Ballymacarrett in East Belfast. This densely populated working class area has a long history of sectarian violence. The impenetrable Peace Line bears witness to the tensions that have existed here since the start of the Troubles. The multiple bomb attacks on the home of a mixed-marriage family in nearby Lisburn in 1996[1] are another reminder to those on both sides that crossing that line can be dangerous business indeed.

Notions about mixed marriages can tell you a lot about a place—what defines "mixed," how often they occur? People's reactions to a mixed marriage can give you a glimpse of a community's tolerance levels, and its fault lines. Belfast, Northern Ireland, is one of those places where the fault lines are active and run deep.

A Community Arts Forum

Conversations like the one at the Crown Bar happen often among the members of Belfast's Community Arts Forum, also known as "CAF." Martin Lynch, the Forum's founder and director at the time, says: "Its what we do. We are artists living in an on again, off again war zone. Very few of us here are old enough to have known anything different. We are always trying to figure out how our art can provoke a little peace."

Lynch and colleague Tom McGill started CAF in 1993 as a consortium of Belfast arts groups working to support art making "by people linked through neighborhood or community of interest." Their aims were modest. As Lynch says, "We just wanted to emerge from the shadows of the big institutions, tell our stories, gain some legitimacy, get our piece of the pie."

Building a partnership among community artists and arts organizations in Northern Ireland in 1993 was no small task. By definition, community art making is grassroots. One of CAF's principal aims was to reflect local culture and neighborhood issues—the community's voice. Then, as now, almost every aspect of community life in Northern Ireland was dominated by the Troubles. This is particularly true when it comes to the manifestation of "culture" which often symbolizes, or even intensifies, the divisions between Protestant and Catholic communities. The songs and pageantry of the "marching season," the poetry of Bobby Sands, and the dozens of defiant IRA (Irish Republican Army) and UVF (Ulster Volunteer Force) murals that dot walls and fences in both communities are just a few examples.

But Jo Egan had devoted her life to the idea that culture could also be a positive force. And as she left the meeting at the Crown Bar, she felt something significant was stirring. The idea of moving the audience across the dividing lines of the community was intriguing, politically and logistically complex, but intriguing, just the same. And, as volatile as it was, mixed marriage was a subject that could give rise to powerful drama. Like the ongoing violence, it was one of those issues that had affected just about everyone. But it was also touchy, very touchy.

Jo also knew from experience that the list of "brilliant," but unfulfilled community theater projects was a long one. While this one might be worth pursuing, it would take someone with a passion to make it happen. In this case, she knew that that someone would have to be her. After all, this was why she left Dublin in 1997—to work in community theater and to be with Martin. So, this was her opportunity. She describes what happened next.

So that (meeting at the Crown Bar) was on a Friday night. On Sunday, Martin came in and said, "I think we should do that play. Would you coordinate it?" And I said, "No, I don't do that!" I did do it years and years

The Community Arts Forum's aim is "to provide greater access to the arts to all people in Northern Ireland."[2] Photo © William Cleveland

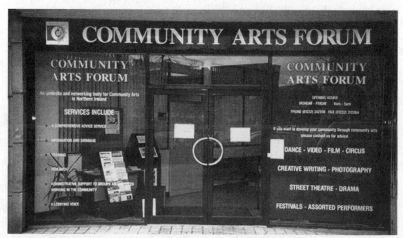

ago. When people find out that you are good at coordinating things, they never let you go back to being creative. I said, that the only way I would coordinate is if I had an artistic role, maybe directing. I knew I would be seen as a cog in the wheel without having some artistic input. But I also knew, just as I was saying it, that I was setting myself up for even more work. But the one wasn't going to be happening without the other.

Building Trust

A kitchen house is either one up and one down, or two up and two down. Traditionally, it had the outside toilet and the two bedrooms upstairs, and the living room downstairs. It was the old working class house. Protestant or Catholic, they were the same in both neighborhoods. —Jo Egan

To be credible, Martin and Jo agreed that the play would have to take place in both the Protestant and Catholic sections of the Short Strand/Ballymacarrett part of the city. As Catholics, they also needed to involve writers and directors from Belfast who were familiar with the particular history and vernacular of both the Short Strand and Ballymacarrett areas. They both agreed that playwright Marie Jones and director Gerri Moriarty, both Protestants with whom they had worked extensively, would be good additions.

Their rough idea for the story was that it would show the complex interaction of families and friends of both the bride and groom prior to, during, and after the wedding ceremony. To do this they wanted to use "kitchen houses" in both Protestant and Catholic neighborhoods to stage the first parts of the play. They would also need a church and some sort of reception hall. Both the audience and the actors would be moving from place to place. And, if they could pull it off, the ideal platform for all of this would be the Belfast Festival at Queens, the citywide arts celebration that takes place each November.

Before they began to work in earnest, though, they needed permissions. From past practice, this meant negotiating with people who had links to the paramilitaries. Given that the last theater project in the area had been a Catholic play, they felt it best to begin with the Loyalists (Protestants).

One of the events that improved the Protestant community's perception of CAF was the hiring of Maureen Harkins in 1996. Maureen is a feisty, intelligent and proud woman who has deep roots in the Belfast Protestant communities. Born in Ballymacarrett in 1955, she was the third child of a family of five. She attended local primary and secondary schools and, at 15, went to work in the local shipyards. After marriage, a move to Scotland and a separation, she returned to Ballybeen to raise her two daughters Claire and Nicola.

As her children grew, she found herself becoming increasingly involved in community activities. Maureen was drawn to the Ballybeen Community Theater Group because of its focus on local stories and customs, which she felt had not been fully appreciated. The work also gave Maureen a chance to

learn about both the organizational and artistic aspects of theater production, which she loved. It also opened a door to her involvement with CAF.

Maureen felt that a good place to start their negotiations with the paramilitaries was with the Loyalist Prisoners Aid, located in East Belfast. This organization and others like it on both sides give assistance to Loyalist (Protestant) and Republican (Catholic) prisoners and their families. They also provide an indirect connection to the secretive and illegal paramilitaries who have the last word over much of what goes on between Catholics and Protestants in Belfast. It was significant that Frankie Gallagher, the agency's head, was also a fellow member of the Ballybeen Community Theater Group. Nevertheless, prior to the cease-fire it would have been impossible for him to consider Maureen and Jo's request. But now, his response was very positive. He even suggested a number of ex-prisoners who might become involved in the development of the script. His counterpart within the Catholic community was Pod Davaney. Pod ran the Short Strand Partnership, which served Catholic prisoners. He was equally supportive.

The nod from the prisoners' support groups paved the way for CAF staff to begin contacting the community theater groups that were working in the area. Jo and Martin knew that cooperation from the paramilitaries and the community theater groups depended on the truce and peace process remaining relatively stable. In 1997, a large cross-community meeting of theater groups had been canceled when one of many cease-fires was breached. All knew that at any time a political upheaval, or renewed violence, could do the same to *The Wedding Play*.

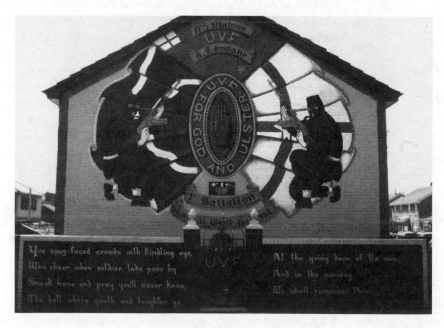

This Ulster Volunteer Force mural (a Loyalist paramilitary unit) appropriates the final stanza of British anti-war poet Siegfried Sassoon's Suicide in the Trenches (pub. 1918) near on the Shankill Road, in West Belfast. Copyright Belfast Exposed.

Devising a Play

It is 7:45 PM People begin to wander into the small school auditorium. Men and women greet and cluster. To an outsider, this could be a typical community gathering. But at 8:10 PM, when Jo Egan asks everybody to take a seat, the rhythm of the room skips a beat. The hum of voice and laughter is swallowed by a collective intake of breath. Fifty eyes search the room looking for a safe place. In the seconds it takes for people to find their seats, the crowd divides, like two families at a shotgun wedding.

On October 2, 1998, representatives from eleven theater groups from both Catholic and Protestant sections of Belfast came to a meeting at CAF to begin discussions about the project. Given the volatility of the political situation at the time, cross community discussions of this type were approached with the utmost caution. But for many in the room, this event had been a long time coming. Jo Egan explains:

> They had had a meeting themselves in 1997. Five of the bigger Protestant and Catholic community theater groups had gone away for a whole week at a hotel. They had this notion about getting a large scale, cross community play together. But the second cease-fire broke just then, and it never got off the ground. So, when we presented the idea to them, they'd already sort of cured that ground—they were just sitting there waiting for it to happen. After the initial tension settled a bit, we just sat down and planned the funding, and started sending off all the applications. That was it.

The collaborators agreed that the project's aim was to produce "a piece of work devised by participants and performed by participants with constant input and exchange of ideas along the way." They also decided to set up a sixteen member "management committee" to represent the communities and help with coordination and communication within and across communities. All agreed that it was critical that the project's "ownership" be vested totally with the groups and individuals who were involved. As such, CAF's role would be limited to providing a physical base for the development and administration of the project.

With the community partnership formed, the actual crafting of Belfast's first cross-community play could begin. The process they would use to make *The Wedding Play*, as it was now formally called, was one aspect of the project that was not new. For the past six years CAF had been working with local theater groups to create scripts based on ideas, stories and issues coming directly from community members. The process used to make these plays often combined traditional theater practices, such as role-playing or theater games, with oral history interviews and ethnographic research.

In this instance, the project's leadership knew they needed to provide a safe and comfortable way for people to discuss a difficult issue—one that was often personally painful, and usually avoided. Fortunately, because of the community theater groups, they would not be starting from scratch. Over the years, many people in Ballymacarrett and Short Strand had taken part in the creation and presentation of plays about local history and community issues. Most, though, had not been a part of a cross-community project. Given this, Jo, and Maureen, decided to begin working with individuals and small groups, separately in their respective communities. Rather than ask people directly about their experience with mixed marriage, they asked interviewees to assume the role of a parent or an aunt responding to news that a daughter or nephew is contemplating marrying outside their faith. Jo recalls one particularly effective exercise where people were asked "to create a human wedding arch for two of the young people in the group." Then they were prompted "to verbalize the kinds of warnings, questions and threats which come from relatives, friends and the community to people who decide to marry across tribal boundaries." Many responded enthusiastically to these theatrical approaches. Some were more comfortable with just telling their story. A few tried to duck the question of mixed marriage entirely. Jo describes how one reluctant interviewee responded.

> We interviewed this woman Sara Garity, a Catholic, who was 92, who had originally been from Short Strand. She had married a Protestant, and I suppose people would say that she became more Protestant than the Protestants. She went to live on Temple Avenue (a Protestant street), and she used to go visiting Loyalist prisoners in the Maze Prison. She was a very interesting woman, but she didn't want to talk about the fact that she was originally from Short Strand. She said, "You know that's a secret, and I don't want anybody to know about it." But, everybody bloody well knew. When she said "this is a secret," I was saying to myself, Sara, I'm from Dublin and I know. The cat is out of the bag Sara. But you had to respect her thing. She did give us some brilliant old songs that I'd never heard anywhere before. So it wasn't wasted.

Throughout the fall, the research went smoothly. People of all ages and persuasions had a lot to say about love and marriage in the context of the Troubles, and they shared their experiences and opinions freely. During the winter holidays, over one hundred taped interviews were transcribed. Then, the project's playwrights, Martin Lynch and Marie Jones, and director Gerri Moriarity began to read and absorb the accumulating material. And, as they did, some surprising things surfaced. When they had started the project, the CAF artists had thought they had a pretty good understanding of the prevalence and impact of mixed marriages. Their assumption was that they happened from time to time, and when they did, it was painful and disruptive for the families involved. Jo describes the more complex story that emerged.

What became quickly apparent was that nearly everybody had had a mixed marriage in their immediate family involving their children, or themselves, or a brother or sister. But the most amazing thing was that by the time we got through with the women's group in Ballybeen, we realized that there was no such thing as a mixed marriage. Once you married, you became either one or the other, particularly when children were born. There were so many people who had been lost to their families because they knew their parents wouldn't accept it. They'd gone off, they'd got married, and they'd never been seen again. A dreadful, dreadful, dreadful loss.

The dozens and dozens of stories that emerged told a tale of devastating impact. Some spoke of couples that had moved away to England and Canada. Others talked painfully about sons or daughters who lived close by, but had essentially disappeared, subsumed into the respective Protestant or Catholic community of their spouse. Which community they ended up in was most often determined by which member of the union was more religious. In addition to "losing" their children, the parents and relatives of mixed couples were often shunned and ostracized in their own communities. In some instances, the response was much worse, with the married couples themselves receiving the lion's share of the retribution. Some had literally been exiled, and for a small number of unfortunates, the response came in the form of "punishment beatings," bombings and death.

Responses to the questions about mixed marriage and the Troubles revealed the conflicting pressures at play in the respective communities. At one interview session with a group of Protestant old-time dancers, a man whose son had married a Catholic stated that he thought an increase in the number of mixed couples would be good for the peace process. But when asked if he thought these marriages were a threat to the Protestant culture, he said, "It was, and I would be dead set against them."

For Martin Lynch and Marie Jones, the artists charged with crafting a script, the messages contained in these stories were often confounding and contradictory. Sentiments of hope and distrust, optimism and despair commingled incestuously throughout the transcripts. On one hand, the playwrights could feel how deeply each of the communities had been damaged. It was very difficult for either group to think beyond opposition and victimhood. On the other hand, there was an overwhelming, and almost childlike hunger for safety, brotherhood and peace, the details be damned. But, as they say, "the devil is in the details." And, the details were unavoidable.

Devising

On the very first day of the negotiations in June of 1996, I told the participants that I was there not to prepare an agreement but to assist them in preparing their agreement …The same thing is true now, it is the political leaders acting on behalf of the people of Northern Ireland who must reach their way forward to keep this process moving…

—Former US Senator George Mitchell upon his return to Belfast, July 20, 1999, to facilitate the stalled Peace Accords.

In Belfast, it's very hard for people to think so far ahead. Our ability to imagine the future is damaged. It's just one big "Ulster says no" again and again and again. And that was what the play was up against all the time. A lot of the time, people tried to say no in many ways. And yet, there was such a lot of interest. They knew how difficult a thing it would be. But they also knew that when your stories are expressed, you are practicing the kind of future thinking a community needs. This is the foundation of empowerment.

—Jo Egan

Acts of Faith

IN A SENSE, the Troubles had stolen Northern Ireland's future. And now, the Peace Accords were holding out the faint possibility that the future could be returned—that it might not be daft to consider a new and different chapter to the Northern Ireland story. Yet, decades of chaos, death and disappointment had undermined the community's capacity to imagine anything other than "more of the same." After so many years, it was difficult to shed the protective coat of cynicism. So, for many of those involved, *The Wedding* was a significant departure, an act of faith. Others came to it with a "wait and see" attitude. The result was a project with a kind of dual personality—one that celebrated and supported its idealistic aims but could also withdraw or shut down at the slightest hint of betrayal.

Some say cynicism is the refuge of the idealist betrayed. If that is the case, the scriptwriting process certainly stimulated the community's tendencies in both directions. The interviews that had taken place during the winter of 1998 had people telling stories and engaging questions that had not been the topic of general public discussion. As a result, there was a growing awareness of the play on the street. As with any community play, questions arose about the story, the characters, and, most importantly, who was going to be in the cast.

The most critical casting decision, the one that would establish the direction and tenor of the script, was the bride. The religion of the bride would determine what kind of wedding it would be. This, in turn, would drive all of the critical elements of the plot. The pool of actors available from the six community theater companies was quite large, but finding a woman of appropriate age who was both willing and able to carry the central role in a play of this magnitude was going to be difficult. Jo Egan describes the process as "part casting and part inventory."

"We went down the list of all the girls who were of an age to be the bride and who would be suitable and who could carry it. And we came up with Clare Harkins (Maureen's daughter). So, it was a Protestant bride. So then we had to look for a groom and Joe Madoe was seen at the time as the Catholic guy who could carry it."

Jo knew that the writing and vetting of the script would be one of the most delicate and potentially volatile stages of the process. For most of the people involved, community theater had become an important vehicle for articulating and celebrating community identity. In the context of the Troubles, where both Protestant and Catholic communities often felt stereotyped and misunderstood,

The Crimestopper wagon was an iconic Belfast symbol of Northern Ireland's "Troubles." Photo © William Cleveland

this was like being a community spokesperson. But, *The Wedding* was an entirely different undertaking. It explored the complex, contradictory impulses dominating the lives of both communities. While everybody concerned understood that a credible script would have to reflect some of the more negative aspects of the two communities, it was, for many, difficult and uncharted territory.

The play's development was further complicated by the decision to have two writers create separate Protestant and Catholic stories for the first part of the production. The idea was that each script would represent the wedding day dramas roiling within the families of the Protestant bride and Catholic groom as the countdown to the ceremony progressed. These parallel stories would come together at the church and the reception. It was hoped that this structure would give each of the writers, Catholic Martin Lynch and Protestant Marie Jones, an opportunity to work productively with the respective communities.

Jo had also decided to use different directors for each of the play's four venues: the two houses, the church and the reception hall. It was understood early on that Gerri Moriarty would direct the Protestant house and Jo, the Catholic house. But it was difficult finding directors for the final two scenes. Finally, after a lengthy search and many rejections, directors were found. Stephen Wright was given responsibility for the culminating scene at the reception. Michael Paynor, a director with a music theater background, would take on the church scene. This was particularly important because it had been decided to stage the ceremony in the church as a musical. Both directors came with good mainstream theater reputations but, unfortunately, neither had had very much community theater experience.

January through June had been scheduled for crafting the script. The process began with a series of "devising workshops" that were conducted for the actors, directors and writers to explore plot lines and dialogue relevant to the wedding story. Starting out as "single identity" sessions, these improvisational workshops eventually joined up to allow both the Catholic and Protestant theater groups to work together in support of the evolving script. The schedule gave Martin Lynch and Marie Jones until April to complete the devising process and deliver a first draft. This was to be followed by a two-month period for additional work with community members on the many difficult issues that were sure to arise. Jo made it clear, though, that it was absolutely critical that they get a final script by the end of June.

A Difficult Marching Season

June 30 is the start of Northern Ireland's two-week "marching season." This two hundred-year-old tradition commemorates the most important date in the Orange Order's calendar—the 1690 defeat of Catholic King James by Protestant Prince William of Orange at the Battle of the Boyne. The marches, which traditionally pass through Catholic neighborhoods, are a flashpoint for violence and heightened community division. The previous summer, the

Royal Ulster Constabulary recorded 225 arrests and the detonation of 625 petrol bombs including a fatal arson attack on the Ballymoney home of three young brothers, who died in the fire.[1]

Given this, the summer was not a good time to be trying to build new bridges between Catholics and Protestants. It would be best for them to lay low for July and August. With previews scheduled for the end of October, they would have nearly two months for rehearsals. Unfortunately, this is not how it turned out. Jo Egan explains.

> Neither Martin nor Marie adhered to the schedule at all. I pushed, but to no avail. We didn't get the draft for the house scenes until June and the final script didn't come until late September. This meant that the first draft ended up being the finished draft in a lot of places. … At first people were just delighted to see the script, and the characters, wondering what the parts would be, and who would get what. And then people started to say, Oh, I've been reading this over, and I don't know about this.

Maureen Harkins recalls being very excited and apprehensive about the script. Its lateness was a tremendous worry. More importantly, as a community leader she felt a strong sense of responsibility with regard to the script's content. She describes her disappointment over what emerged.

> I don't think our expectations were too high at all. This was a difficult project. And it was very difficult to deliver something that would reflect what everybody wanted. … But, people involved in the project were very keen that there would be a balance. And I have to say personally, for me, when I finally read the script, I said, "I can't do this." I cannot take this script and do this performance and feel that it represents the views of the community that I come from.

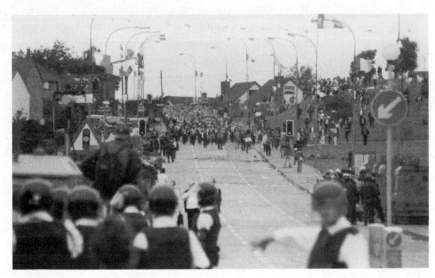

In most communities a parade is a joyous occasion. In Northern Ireland, during the summertime "marching season," many of the 4000 plus Loyalist parades pass through Catholic neighborhoods and people on both sides fear the worst. Photo © Belfast Exposed

Others in the Protestant group shared Maureen's concerns. They felt some of the members of the Protestant Marshall family had so little depth as to appear "stupid," lacking dignity. Others, though, saw the problem as one of fundamental fairness. A major sticking point was the character of Trevor Marshall, the bride's uncle. Trevor is a member of a Protestant paramilitary unit. He appears as a family outsider, cautiously slipping in and out of the house through the back kitchen door. In the early draft of the script, Trevor's dark past includes involvement in a shooting in Short Strand that took the life of an eleven-year-old girl. Appearing now, on his niece's wedding day, the central question for the family is whether he should attend the ceremony. Although they know it could invite trouble, they want him there as a member of the family.

The Trevor Marshall character personifies the brutal reality and painful contradictions of everyday life in the working class neighborhoods of Belfast. The issue for many in the Protestant group was not that the terrible face of violence had manifested in the script—it was that it only showed up in the Marshall family. They wanted the script to show how the tyranny of terror was experienced by both sides. They saw the script as giving that short shrift. This issue came to a head in a meeting convened in late June at the CAF offices. Jo describes what happened.

> The Protestants felt that their side wasn't being expressed. The lack of safety they felt in their own community with their sons and daughters being shot too. It was almost as if Marie (playwright, Marie Jones) had let them down. And, (some wondered) did she let them down because she was a Nationalist? I know Marie would be the kind of person who wouldn't wish to have confrontation. It was difficult for her to have to sit there. In the end, the guy who actually hit the nail on the head was Frankie Gallagher from the Prisoner's Aid Group. He sat down and he said, "Look, it's like this, we think you are a Nationalist." I really felt for her at the time. So, Marie turned around and she said to him, "Well, actually, you're quite right, I am." And that was it. Because then they were able to say "Well, even if you are, you should be able to see things in the Protestant perspective, you're Protestant too." It really did seem to clear the air.

Eventually, the script was revised without mention of the child's murder. Marie felt this was a major concession, but she was loath to make many more changes. She wanted to work with the cast, but resisted the notion of their overseeing the creative process. Time was short, the marching season was upon them and the completion of the full script lay ahead.

At first it appeared that the script for the Catholic house would have an easier go. After Martin Lynch made some changes based on feedback from director Jo Egan and cast, they were ready to start rehearsal. Martin recalls that it looked like clear sailing, until the final stages of casting.

…We needed to go outside the group we had been working with for one of the male parts. We got Eddie Robinson from the… Lettuce Hill Community Drama Group. Eddie is a member of Sinn Fein. After reading the script and the part, he agreed. Then a few days before rehearsal began, he said he didn't agree with some stuff in the script. I set up a meeting with him, listened to what he had to say and re-wrote, taking on board his comments. I sent him the new draft and he never got back to us. We had to contact him and he informed us that he was too busy with the assembly elections and couldn't give up the time to be in the play.

Eddie's behavior was a cause for concern. It would not be good for the play to be getting a bad name within Sinn Fein. For Martin, it was particularly disconcerting not to have heard back after changing the script. Some years back he had been very active politically and at one point been an unsuccessful candidate on the Sinn Fein ticket. After some effort, he tracked Eddie down and asked him if there were any problems. Eddie said that he was OK with the changes, but was simply overbooked. Martin took him at his word, but was still curious about what was really going on.

Locations

The main logistical difficulty was going to be coordinating the shift of audiences from house to house. Was the production manager going to have to run back and forth between the two houses? Did we signal to each other from down the street? Finally, Paula, our incredible production manager said, "Well actually it would be better if I sat at the desk here (at CAF) and people phoned in." It's very simple, we were stage managing a play by telephone.

—*Jo Egan*

The script had over 60 parts. At least half of these were major characters including the parents, grandparents, siblings and friends of the bride and groom. The large cast presented opportunities to increase cross-community interaction. But, it also gave rise to significant obstacles, particularly with regard to personal safety. By the time casting decisions were being made, early enthusiasm for cross-community casting had waned. Jo Egan describes what eventually happened.

We wanted the early rehearsals to be close to where people lived to make it easier for travel. If we exchanged religion and roles…Catholic men and young girls and boys would be traveling into a Protestant area, where they would be vulnerable, and likewise for Protestants. So we tried to keep it so people played their own religion. But, because of availability, some Protestants had to play Catholics and Catholics had to play Protestants. And we were able to approach people and ask, "Do you mind." And they didn't. Big parts, like Jody Marshall, the bride's father, a Protestant

who is opposed to his daughter's marriage to a Catholic ended up being played by a Catholic.

Early readings and cast meetings were held in venues that were nothing like the kitchen houses where the play would be performed. This was not a problem in the early going. For rehearsals, however, it would be imperative for them to see how the script and the houses worked together.

The original plan had been to try to find a vacant house in each of the neighborhoods for both rehearsals and performances. The process of finding houses began with the Belfast Housing Executive. Convincing a public housing authority to turn one of its properties into a community theater would be difficult anywhere. Asking for two houses in adjacent Protestant and Catholic areas of a sometime combat zone in east Belfast was a particularly tall order. Luckily, Pat Bowen, a cast member who was also a member of the local tenants' association, introduced Jo and Maureen to a sympathetic administrator at the Housing Executive. By early August the administrator had identified a vacant house on Templemore Avenue in the Protestant section that could be used for the Marshall family.

The Catholic house was a different matter. Given the shortage of housing in the small Catholic area of Short Strand, a vacant house was going to be an impossibility. After exploring a number of alternatives, it became clear that the only option would be to find a family who would be willing to rent their house out for periodic rehearsals and the ten scheduled performances. Jo figured that each performance would require moving at least 72 audience members, actors, and support staff in and out of each of the 1,000 square-foot houses. Given the disruption this would cause to any family, she knew they would end up paying dearly for the space. And they did. A few nervous weeks after the housing authority put the word out, a house was found on Madrid Street. It came with both a high rent and the stipulation that it be used for performances only. Luckily, the two houses had nearly identical floor plans. This allowed both casts to use the Templemore Avenue location for rehearsals.

Once the houses were rented, finding the church and reception hall needed for the final two scenes was relatively easy. The Rosewood Presbyterian Church had been used for another community play the previous year so they understood what would be entailed. The reception hall was just that—a large second floor room at a new pub on the river used for parties and the like.

Even before the houses were secured, Jo and the directors recognized the unique challenges they faced making the play work both dramatically and logistically. In addition to the typical ordeals of rehearsing a large cast of community actors, the script called for eight different scenes on eight different "sets," located in four separate Belfast venues. Each of the two houses would have three scenes enacted in different rooms. The audience would experience the pre-nuptial machinations of various family members prior to their leaving for the church. Doing this required moving the audience from room to

room, while the cast stayed put. This arrangement served the play's dramatic needs, but because each room could only accommodate about ten people, it severely limited the size of the audience.

Anticipating this, Jo had devised a complicated, but (she felt) workable plan. They could double their audiences by running the Protestant and Catholic house scenes for two different audience groups simultaneously, and then, literally, swapping audiences. After both groups had been to both houses they would come together for the church and reception scenes. Jo figured they could use this same scheme inside the houses as well. Because the scenes represented the same time period, the audience could see them in any order. The living room, kitchen and bedroom scenes could run at the same time for three different groups of ten. These groups could switch, and the scenes repeated until everybody had seen all three.

This meant that each of the house scenes would have to be repeated six times for every performance. The timing and logistical challenges would be enormous. Given the vagaries of Belfast traffic, transportation could be a nightmare, but, it would also give them a potential audience of sixty people per performance, 600 for the entire run. As small as this was, it was the minimum they needed to pay the bills and give everybody a sense that it was all worthwhile.

Loggerheads

In the North of Ireland we know that there are few neutral spaces and even fewer neutral individuals. We carry baggage, we make contracts and allegiances, we make our own choices and endure the choices that are made for us. We know we can be located within a political, social, emotional and spiritual landscape and we think we can locate others.[2]

—Gerri Moriarty

Gerri Moriarty is a rare bird in Northern Ireland. In a place where "knowing where you stand" has been elevated to a high art, her exact position is very hard to plot. And unlike most, she does not make a point of identifying herself right off as Catholic or Protestant, loyalist or nationalist. Her unique biography helps explain why.

My father's family is from Kerry in the South of Ireland; they were Catholic, became Protestant. My mother's family are Protestant and Catholic, mixed marriages through several generations. I was brought up in a small Nationalist town on the coast between Ireland and Scotland; my family was pro-Unionist and lower middle class. I left Ireland to study and stayed in England for eighteen years to live and work as a community artist. I left shortly after the beginning of the Troubles ... specifically because a friend was shot dead in the streets of Belfast. I came back twelve years ago when the confusion and hurt I felt living away from home outweighed the confusion, hurt and fear that had driven me away in the first place. ...

> I spent time working as a drama worker and community theatre director
> in Nationalist and Loyalist communities in North and East Belfast.

Gerri's intention in these situations is to give her creative relationships a
chance to transcend labels. As a result, she has gained the trust of members of
both the Catholic and Protestant communities. This is a precious commodity
in a place as divided as Northern Ireland. Particularly so, as she began her
work directing the Protestant cast of the *Wedding Community Play*.

Despite earlier efforts to clear the air, the upset over the Protestant script
had festered. By early September, it was clear that these unresolved issues were
becoming a threat to the project. Although some changes had been made,
many in the cast still felt that the script portrayed Protestants as ignorant and
unfeeling. Very few of them had ever played characters that reflected on them
so personally. There was a great worry that this project that was supposed to
contribute to cross-community understanding was going to end up being
hurtful and divisive. There was also mounting pressure from local leaders to
make sure that the play reflected well on the community. However, the time
for revisions was over. Knowing this, some cast members were questioning
their involvement in the project.

Gerri shared the cast's concerns with the script—so much so that she, too,
considered quitting. She also felt an incredible sense of loyalty to the project.
That loyalty, though, was to more than the production of a cross-community
play. For her *The Wedding* was a significant expression of a thirty-year commit-
ment to "community theatre as a collaborative creative process, owned by all
those who agree to participate in it." The potential mutiny of the Protestant cast
reflected a very different outcome. For many, she knew it felt like a betrayal.

Given its "volatility and fragility," Gerri realized that the project could
collapse if she quit. Without a director, the Protestant cast would surely fall
apart. If that happened, a year's work by dozens and dozens of Protestant and
Catholic volunteers would be dashed. And for some nay-sayers in the govern-
ment, the media, and even in the arts community, that collapse would go
down "as a small but telling metaphor for the inevitable failure of the wider
peace process."[3] After much soul searching, she decided to meet with her cast
to discuss how they might go forward.

> I talked through the situation with those Protestant members who were
> most concerned about it. I told them that I believed it was possible for us,
> through an ensemble approach to acting and through sensitive direction,
> to develop characters who were not stereotypes but complex individuals
> living and responding to a changing social and political context. They had
> lost any sense of trust in the script; I asked them to trust me. They agreed.
> I am still not certain that we made the right decision.

Rehearsals of the house scenes finally got underway in late September. The
schedule was intense because both casts were using the Templemore Avenue

house. The constant comings and goings also increased security demands, especially when the Catholic cast was working. Although rushed, Jo's early work with the Catholic cast went well. And as the Protestant rehearsals progressed, Gerri's direction seemed to soften some of the harshest edges in the script. Maureen Harkins describes how the rehearsals progressed.

> She really altered the characters. We performed the characters very different from the way they read. That made it workable. That made it feel OK. But, I have to say, I had immense difficulty learning my lines in the early run-throughs. Not that I couldn't learn them, but because I couldn't take it in my head.

Rehearsals with the complete script at all four venues did not get into full swing until early October. Jo's original two-month rehearsal schedule had anticipated the demands that the play's multi-venue design would place on the all-volunteer cast. Now, with only a few weeks remaining, the company members found their already stress filled lives going into overdrive. Rotating rehearsals at the four venues literally went on morning, noon and night. For many, juggling the demands of the play, work and family responsibilities became very difficult. So much so, that nearly every rehearsal went off with characters missing. And, at every turn, the play's unique structure posed extraordinary challenges. Even the ushers and bus drivers had to practice their parts.

To complicate matters, a week into rehearsals it became obvious that the final scene, the reception, was a disaster. This was where the simmering stew of old grudges, past loves and insinuations that had bubbled up in the two houses would collide with the inevitable river of post-nuptial revelry and alcohol. This is where this messy mix of emotions and history would be brought to boil and hopefully settled in some way. This was what the audience would be left with. But, in its current state it was very difficult to follow the action and numerous plot lines were left dangling. To all concerned it was obvious that it wasn't working.

When it was clear that no amount of directorial slight of hand was going to remedy the problem, Jo suspended rehearsals at the reception hall. She called Martin, Marie and Stephen Wright, the scene's director, together for an emergency re-write. Within 24 hours, the cast was back learning their new lines. Beyond panic and running on adrenalin, they pulled together as best they could. But, as the opening night finish line rushed toward them many were wondering if they would make it.

CHAPTER 3

A Community Wedding

NI TALKS, "TOO CLOSE TO CALL"

Talks to resolve continuing deadlock in the Northern Ireland peace process enter their tenth week on Monday amid growing signs of frustration that a deal has not been secured.

Former US senator George Mitchell returns to Belfast on Sunday and he will be anxious to ensure a successful conclusion to the marathon discussions, which have focused on differences between Sinn Fein and Ulster Unionists.

However, both sides remain committed to making the Agreement work.

A Sinn Fein spokesman described the next few days as crucial while the UUP said they are doing everything they can to reach a deal.

The Sinn Fein spokesman said: "There is still an outside chance of a deal, but it is much too close to call either way." —BBC, November 7, 1999

November 7, 1999

The office of the Community Arts Forum is packed with animated ticket holders and Wedding *staffers armed with walkie-talkies. More people mill*

Prior to boarding the bus that would take them to each of The Wedding*'s four venues, audience members received an engraved wedding announcement. Photo © William Cleveland*

Mr George & Mrs Jeannie Marshall

request the pleasure of your company

at the wedding of their daughter

Nicola

to

Mr Damien Kelly

outside asking around for nonexistent, last-minute tickets to what has become a significant event in this small town city. After a few minutes, a young woman whistles down the crowd and welcomes everyone. She issues instructions, which she says are important and a bit involved. So important and involved that she repeats them.

The audience is divided into two groups of thirty, dubbed A and B. Each group is assigned to teams of three ushers, who are actually theater students from the university. Everyone is given a colored badge—red, orange or yellow. Groups A and B are loaded into separate buses that follow each other out of Belfast Centre and into an area called Ballymacarrett.

As the buses move through the divided neighborhood, block-long wall murals scream Republican and loyalist paramilitary slogans and symbols. At the end of a particularly long stretch of the dividing wall or "peace line," bus B turns left into the Catholic neighborhood as its companion continues straight, into the Protestant side. Bus B comes to a stop in the middle of a street lined on both sides with kitchen houses.

The "B" busers spill out onto the sidewalk and follow the ushers into a cue at the front door of the house opposite. (The audience learns later that the A group is going through a similar ritual within shouting distance, a short three blocks away.) The ushers divide the group according to badge color (about ten each) and move everyone quickly through the front door of the Todd household. Once inside the reds are directed to the living room, the yellows to the kitchen.

Those with orange badges are hurried up a stairway and down a short hall into one of the postage-stamp sized bedrooms on the second floor. After they are settled, standing or scrunched on a small bench in the far corner of the room, a beautiful young woman enters wearing a thin slip and a lace top. She slides to the end of the bed, picks up a phone and dials.

Clutching the phone, Shirley, the groom's younger sister is no more than 18 inches away from the audience. She is speaking, pleading actually, with someone who is obviously her boyfriend. The people in front can actually feel her breath. She is crying as she talks. A few minutes into her quiet desperate conversation it is clear that things are going very badly between the two. This, in fact, is a Dear John phone call with the roles reversed. The audience also learns that today is her brother's wedding day. And that's not going so well either.

PESSIMISM HAS always had a lead role in the affairs of Northern Ireland. Given the record, most would agree, this is just being realistic. In some quarters, the failure of projects like *The Wedding* was seen as inevitable. Many held the same attitude about the latest peace effort. But, despite numerous difficulties, the Mitchell process had endured. And unlike the past, the principal antagonists, the leaders of the Ulster Unionists and Sien Fein, now appeared more invested in success than failure. Moving forward had replaced standing pat as the order of the day. This was uncharted territory.

A Belfast audience members cue up prior to entering a "kitchen house" for the first three acts of the Wedding Community Play.
Photo © William Cleveland

There are many ways that *The Wedding Play* and the peace process had come to mirror each other—the contentious back and forth, the impossible logistics, the fear of failure, certainly the dangers, but also the hope. Despite the flaws, the gaffs and mistrust, at some point the momentum of that hope seemed to gain the upper hand. And, as the opening came closer, the focus, for everyone, became the play. The preview performances came first. They were bumpy, but there were no major disasters. And amazingly, the house and bus logistics came together. Confidence grew but, of course, so did the pressure. And then, with the opening, *The Wedding* seemed to take on a life of its own. Onstage and off, the story unfolded.

While Unionists and Nationalists inch forward at the negotiation table, similar struggles are taking place inside the Todd (Catholic) and Marshall (Protestant) houses. The limousines for the church are to arrive in 15 minutes and both families are in turmoil. In the Madrid Street kitchen Damian's older cousin Danny, an IRA man, starts a last minute campaign to alter the course of events "by pointin' out the consequences of what you're doin'." Tensions escalate further when Brian Kelly, Damian's estranged father chimes in with a few threats of his own.

Damian.	Would y' sing at the weddin', Da?
Brian.	I don't think so, Damian. And now that y' mention it. I've just spoken to your mother and I told her too. I don't like the idea of this "wedding" one bit. If y' must know, it makes me feel sick in the pit of my stomach. You have deeply disappointed me, boy.
Damian.	I have disappointed you?

Frankie (Gideon Grieg)—on right—and Sponge (Bill Elwood) help Damian (Joe Madoe) keep his cool following an angry exchange with his estranged father. Photo © Belfast Exposed

Brian.	You are my son and I'm goin' to the wedding, okay. But I would be a hypocrite if I didn't tell you to your face I believe you will never receive proper grace from God for what you are doin' today.
Damian.	Thanks very much Da. Speakin' of the word, "hypocrite," I thought I'd give ye back this letter a found last week. (Damian goes to a cupboard, takes out an old letter and throws it down on the table.)
	Remember it? It's the one and only letter y' ever wrote to m'Ma. Fifth of October 1978. It's the one where you said it wasn't your intention to have a child and the m'Ma should have taken precaution against gettin' pregnant, and since you were just about to start up a new business and everything, you couldn't guarantee any commitment towards my upbringin'. Remember that letter? Da?
Brian.	I sent that letter a long time ago, Damian.
Damian.	We, I only received it last week, by the way, I'd love y'to sing at the weddin'. Why don't y sing, "Faith of Our Fathers"?

Understandably, these provocations are upsetting to Damian. But more important matters are imminent. So, buttressed by two best friends, Sponge and Frankie, he manages to keep his head until the limousines arrive.

The Marshalls are not faring much better as Jeannie Marshall, the bride's mother, berates her nervous husband Geordie for not trying harder to change Nicola's mind.

Jeannie.	If you hadn't been such a spineless wimp we wouldn't be in this situation.
Geordie.	I don't believe this.
Jeannie.	You could have tried to talk her out of it.

Geordie.	Jeannie, there is nothing you can do about it now, so just button it will ye.
Jeannie.	She listens to you, she always has done, she wouldn't have done anything you didn't approve of, why did you not at least try and stop it.
Geordie.	Because she is your daughter, your stubborn ways, like you, she always gets her own way, so what was the point.
Jeannie.	You were scared in case she wouldn't be daddies girl no more, couldn't hack that she might turn against you. You left it up to me to be the big bad wolf.
Geordie.	It would have made no difference, will you get that into your thick skull.
Jeannie.	Well, the day we get the news she has been hurt I hope you suffer.
Geordie.	Love, I would lay down my life for that child up there, I would do anything to make her happy. Today that child is happy (looks at her). Jeannie, please love, don't make it the worst day of her life. Try for God sake.
Jeannie.	(She sits on the settee.) I can't...I want to Geordie..its her future...that's all I can think about.

Across the street, Nicola's ex-boyfriend lurks like a festering sore, contemplating a last minute intervention. And back in the kitchen two of Jeannie's close friends debate the wedding's pros and cons.

Sylvia.	It's our culture I worry about. Ya see theirs is so strong, cos they are always spoutin about it...and next thing you know e all get swamped until it...and we get left with nothing...any dry tea towels?
Tilly.	In that drawer...Don't culture me Sylvia Maxwell, where were ye last twelfth?...Arcudi, If my memory serves me correctly...where were ye when the Ballybeen women did their play and wanted support...At Bingo near every night...what excuse did ye give when I asked you to join the Ulster Scots Society?
Sylvia.	I don't understand all that history stuff.
Tilly.	Cos you would rather have everybody else fight to keep your culture, while you sit on your arse gumming about Catholics takin' over...I accept their culture... and if two people of different walks of life want to get married, they should do the same.
Sylvia.	You're all Miss Peace Process this morning.
Tilly.	Times is different now...young ones are all mixing together now in them super pubs down the town...they luk at one another and if they fancy each other... thats it, they don't stop and worry about who kicks with what fut...we have just to accept it is gonna happen more and more... Here, clean that scrambled egg pot..that is one thing I friggen hate.

Over the course of *The Wedding's* six house scenes the anger, hate, love, frustration, hope, and humor that have permeated Belfast's struggle for peace

Sylvia (Pat Bowen) and Tilly (Maureen Harkins) discuss Protestant culture in the Marshall kitchen.
Photo © Belfast Exposed

is laid bare. By the time the audience leaves for the church they have become a temporary extended family for the bride and groom. The contrast between the crushing intensity of the Madrid and Templemore houses and the raucous musical doings at the Rosemary Street Presbyterian Church is both startling and uplifting. Most importantly, despite the dire back church exhortations of a shadowy "angry man" the sacred vows are exchanged—hope is alive—at least until the pot starts boiling again at the reception.

Reaction

The morning after the opening, Una Bradley, a critic with the *Belfast Telegraph* called *The Wedding* a joyous…production … you won't regret [seeing]. The next day the London's *Financial Times* described the play as natural and unaffected …a magnificent inspiration, and utterly wondrous. The buzz generated by the early positive notices quickly attracted critics and theatergoers from Dublin and London. Their responses were equally enthusiastic.

In the houses the rotating rooms overlapped in time as in a Kurosawa movie dealing with peace and reconciliation. In the church it was Mel Brooks in Belfast. The reception was JB Priestly meets Marie Jones and Martin Lynch. Just as it should be. Unmissable.[4]
—*Belfast Newsletter*

…this is an optimistic polemic about the future of Belfast, delivered with vigour and humour, and it's hard to argue with that.[5] —*The Irish Times*

Community theater is very often derided, but this production, about a mixed Protestant-Catholic marriage in Belfast , is one of the most affecting pieces I have ever seen.[6] —*The Guardian*

For the company, the positive critical response came as a surprise. Most felt that getting the play finished and on stage was a triumph in itself. With the raw script and an under-rehearsed cast, acclaim was hard to imagine. Over the years, community theater in Belfast had had a rough go with the critics. Amazingly, as *The Wedding* headed into its final two weekends it was the toast of Belfast.

As gratifying as this was, the response from friends and neighbors was the bottom line for the company. They had been entrusted with the community's stories to make a play. In a sense, the production was their report back. Their first concern, Would people come at all? had been answered. The show was a sell-out, and the audience included many of those who had been interviewed during the play's early stages. To *The Wedding* family, these were the critics that really mattered. And they did not have to wait long for the reviews. The intimacy of the small rooms in the kitchen houses make it impossible not to know that the audience is deeply engaged. They laugh at the funny parts, but are also very quiet, possibly intimidated, as though they are truly a guest or, more accurately, a voyeur in a stranger's house.

But, it is on the buses, between venues, where the reactions are most obvious and immediate. People recall their own experiences with mixed marriages. Some argue about the characters. Others laugh at the crazy history of two families, or reflect on the obvious insanity of it all, the unfathomable complexity. These short transits become an important part of the play—at once, a fresh air respite from the close intensity of the houses, and an incuba-tor where theater and every-day life churn their dense stories.

This was more than they had hoped for. The play seemed to be working for the audience as well as the critics. From every indication, it appeared that *The Wedding* was a success. It was too good to be true—maybe so?

On the night before the start of *The Wedding's* next to last weekend, Moya O'Hara waited in her kitchen for her husband Michael who had stepped out for a pint. It was 11:00 PM and she was tired. Her role in *The Wedding Play* as Elise, the bride's aunt, had consumed her life for the past half year. It had been a great run. But now, with only a few performances remaining she was looking forward to going back to her normal life and spending time with her family. As she started up the stairs to get ready for bed she heard Michael's voice out front. Moving back down towards the front door she heard men shouting and then an agonizing scream. She opened the door to see two dark figures pummeling

her husband on the walk. There was blood, lots of it, and what looked like a machete going up and down. She shouted for help. One of the attackers ran off, but the one with the big blade kept on. Then she heard footsteps and more shouting. The neighbors were coming. They knew what was happening. So did she. As the attacker pulled away, Michael, pouring blood, staggered about, screaming. He was hurt bad, but at least he was still alive.

Punishment attacks are a regular feature of life in Northern Ireland, especially for community activists like Michael O'Hara. Speculation following the attack was that it had been intended to foment a disruption that would damage the peace process. In this case and many others like it they were unsuccessful. Michael O'Hara survived and so did the peace process—at least for now.

Another characteristic of Northern Ireland is perseverance. Even with the cease-fire in place, sectarian violence is still a regular occurrence. Despite these threats people carry on. As did *The Wedding Play* community in the wake of Michael O'Hara's attack. In true form, the players were able to lend their support to Moya and re-focus on the play. And amazingly, Moya came back for the final performances.

Gerri Moriarity had been absent from the play for very different reasons. After the first two weekends of performance, she had pulled away. She was exhausted and still terribly conflicted about how things had played out. Her job had been to humanize the script and get a good performance from the Protestant ensemble. She was far from sure she had succeeded. Yet, despite the chaos of the final few weeks' rehearsal, the reviews had been great and the cast had been really pumped up. She did not want to dampen their spirits.

Still, throughout her career she had made a tradition of attending final performances. Although she knew she could never experience one of her own productions through the eyes of the audience, she always wanted to see how the work had meshed and evolved. For this play, she was particularly curious about how the unrehearsed intangibles would impact the audience. The city, the kitchen houses, the neighborhoods, even the bus transits were like characters whose parts would only really come to life in the actual production.

History is made when the UUP accedes to the Mitchell accords and votes to join the Northern Ireland Assembly.

On November 27, 1999, those intangibles were converging on *The Wedding* in a particularly dramatic way. As Gerri Moriarty and 59 others were boarding *The Wedding* buses for the final performance, the Ulster Unionist Party Council was meeting a few blocks away at the Waterfront Hall. There, a vote would be taken on whether the Party would accept or reject the negotiated stipulations of the Mitchell Accords and join in the Executive of the new Northern Ireland Assembly. A yes vote would be a critical step toward self-rule by Protestants and Catholics; a no vote would probably derail the peace process. The speculation was that it would be very close.

Gerri remembers that some audience members had brought portable radios to follow the events at Waterfront Hall. She recalls that at one point, as the bus sat in traffic, the volume of the radios seemed to jump up suddenly and someone shouted, "It's a yes, they're in!" With that the Peace Process took another tentative step forward and the busload of buoyant playgoers continued on their way to the Marshall house on Templemore Avenue, which, for Gerri, held another pleasant surprise.

> Something very interesting happened to me. I remember sitting there thinking, This is nice. This is a completely different piece from what I directed. It was that wonderful thing. The actors were inhabiting the play and so was the audience. The audience was willing the actors to be creative. This was not a passive audience going into their normal theater. Everyone had a stake in those scenes.

Many of the play's friends and supporters joined Gerri for the last performance. Successes like *The Wedding* are not an everyday occurrence in Belfast. Good news on the political front is even less common. So, as the audience poured out of the busses at the Edge pub for the final act, they were in very good spirits—even more so after spending time in the pub downstairs before being ushered up to the reception room. The company, too, was exuberant, but weary as well. They were more than happy to be ending the play's short but demanding run. It was time to close the curtain and celebrate a job well done. And celebrate they did. As the play concluded, it was hard to tell where Act Four (the wedding reception) ended and the post-performance party began. The company's tenaciousness, of course, carried through to the end, as many in the cast did not make it home until early Sunday morning.

Aftermaths

The Wedding Play is not a fairy tale. When the curtain falls the Troubles linger, on and off the stage. It does appear that newlyweds, Nicola and Damien, have a chance, but, they have pulled their respective families screaming and kicking to the altar with them. In the moment, humor and hope prevail, but festering histories remain unexamined, the underlying issues, unresolved. The union of the Marshall and Todd families is a truce at best. A small step

forward that Geordie, the bride's father tries to bring into perspective in his toast to the newlyweds.

Geordie. When I look around me here ta day, I see many strange faces now, not that that is a bad thing....but you know, as the man says, strangers are only friends we haven't met yet. Now if it was not for our Nicola and Damian we would never all have met each other....so, you see, some good can come out of things that ya think are wrong...not that it is wrong, its just. Its not what we all would have liked....but the die is cast and it is up to all of us to accept the situation....When two people love each other like these two young people do, it is not for us to pass judgment....they are the peace process....they are the future....they are now bound together and they have brought us all together........and the strength of their love will cancel out all the differences between them. I can see round me that everybody, despite their grievances, give these two young people their blessin'....and I know that I could stand here and say..let bygones be bygones and we could all apologise to each other for what has been done in the past...but, this is not the time nor the place to make up for all the wrongs...ya know. Why... because...I, I stand here and...well I......look round me, the strange faces, are becoming familiar..so by the end of this wonderful occasion we will all be friends. Ladies and gentlemen raise your glasses for the Bride and Groom.

Given its critical success, *The Wedding Play* project itself could be idealized as a real modern day fairy tale. Some observers have characterized it as a model for cooperative cross-community conflict resolution. Yet, like everything else in Northern Ireland, *The Wedding* story and its aftermaths are far too complicated to become the stuff of myths and legends. It might be more accurate to say that the making of the play and its continuing saga represents the multiple, shifting faces of recent times in that battered place.

There are those in Northern Ireland who would argue that everything that happens there personifies the vicissitudes of the Troubles—that today's good can become tomorrow's bad, depending on the direction of the ever-present political currents. Some say it is the curse of the place. Eighteen months earlier, when *The Wedding* was just an improbable idea, there would have been no way to predict the play's success, or the tenuous, but encouraging, crossroads the peace process would come to by the fall of 1999. In that relatively short time the tides had shifted. Both the peace process and the play had far exceeded expectations. It was a hopeful time, but who knew how long it would last.

Football Mad

One of the hardest parts of any theatrical endeavor is the intense letdown that follows the close of production. This is particularly the case with community theater because, most often, there is no "next show" to soften the landing. With *The Wedding*, things unfolded differently. Fueled by word of mouth and

As the Wedding Play *concluded, it was hard to tell where the wedding reception ended and the post performance party began. Photo © William Cleveland.*

glowing reviews, interest in the play had grown dramatically over the course of its four-week run. By the final weekend people from all over Northern Ireland and Great Britain were clamoring for tickets Even so, an extension was out of the question. The cast and crew were beyond exhaustion, the finances were depleted, and the complex web of logistics upon which the play had been built was no more.

Nevertheless, the momentum continued. Despite having been consumed by the project for nearly twelve months, many of those involved began speculating on *The Wedding's* next iteration. For some this meant mounting a new production geared for tourists. Others were sure that producers from one of London's West End theaters or even Hollywood would be calling any minute. Among the more moderately sanguine, the next logical step was a new large-scale community play involving the same consortium of community theaters. The idea being floated was a production tentatively titled *Football Mad*.

Another, less glamorous, impulse also rose up in *The Wedding's* wake. Despite, and some would say, because of its successes, growing feelings about the unmet needs of community theater in Belfast began to surface. Some felt that big projects like *The Wedding* had diverted energy and resources away from local efforts. Others saw CAF as having grown too big to focus on grassroots theater issues. CAF's response was to host a meeting in the spring of 2000 with local theater representatives to discuss the state of community theater and the way forward. Most of Belfast's Protestant and Catholic community theater companies were represented at the daylong gathering, which was facilitated by Gerri Moriarty.

The resulting action plan called for increased attention to community theater needs by CAF. Specific elements included improved training and marketing and the possible establishment of a new community theater coordinator

position. The tentative plans for *Football Mad* were also unveiled. It was to be one of the projects of an 18-month event called the Belfast Community Arts Initiative. The new play would explore "the Northern Irish football scene, its loyalties, passions and the sectarian tensions it excites."

Maureen Harkins understood the enthusiasm of those behind *Football Mad*, particularly those who had not been involved in *The Wedding*. The play had been the biggest thing to hit Belfast community theater, ever. Funders who had given short shrift to *The Wedding* were more than happy to invest in a new production. Why not try to keep the ball rolling? For Maureen, though, it did not feel right. The Ballybeen Community Players had devoted themselves to the play for over a year. They had not mounted a production in a long time and none was in the works. The company members concurred. They felt it was time to focus on local stories again. It was time to slow down.

For a variety of reasons the other members of *The Wedding* management group came to the same conclusion. They would sit this one out. Still, many of *The Wedding* cast and companies signed on to the new enterprise. Over the next few months as *Football Mad* became *Playing for Time*, it also grew to be another massive, cross-community undertaking. After an extraordinary effort by all involved, the production opened in the fall of 2000 as a part of the Belfast Festival to enthusiastic audiences and poor reviews. Ironically most of those pushing for the new, more locally oriented, community theater initiative were heavily involved. Many say both efforts suffered as a result.

Curtain Calls

Gerri

For Gerri Moriarty, the first order of business was a good long rest. She needed to spend more time at home and with her mother in Ballycastle. Professionally, she wanted no part of another major cross-community production. And while she continued to teach and conduct workshops, she found herself reluctant to take on major commitments as a director. As the immediate intensity of the play receded, though, her ambivalence about its conduct and unintended consequences only increased with time. Although the project was done, she felt a continuing responsibility to reflect on and communicate its complex story. This was particularly important to her because of how quickly *The Wedding* was becoming "a cartoon" of community cooperation. Her main worry was that the homogenized success story, "the icon," she calls it, would eclipse the hard lessons learned. She describes the dilemma.

> I don't want to take anything away from its success. We achieved things beyond anything that we could have possibly dreamt of. Within a political context, it was incredibly difficult. But, *The Wedding* became an icon. People talked about it in a very simplistic way. So, I also want to say, Don't forget. It was a fantastic community project, but it was deeply flawed.

Months after the play's closing, Gerri received an invitation to contribute a chapter about *The Wedding* for a new book called *Theatre & Empowerment*. She used the opportunity to outline the project's history and goals and discuss the full range of her concerns. While acknowledging the production's accomplishments, the article provides a thoughtful accounting of how and why she felt *The Wedding* had fallen short. In it she discusses the impact of the late script, Marie Jones's Nationalist inclinations and the difficulty finding directors for the final two scenes. But chief among her concerns was what, in retrospect, she sees as a fundamental disconnect between herself and Jo Egan as directors and the play's writers Martin Lynch and Marie Jones on the aim of community theater. Here is how she described the discord.

> My view now is that deeply entangled within The Wedding Community Play Project were two fundamentally different models of community theatre. One model sees community theatre as a collaborative creative process, owned by all those who agree to participate in it, striving to give voice to different perspectives (sometimes colliding, sometimes contradictory). This model was the one explicitly proposed in the project's written objectives as "an opportunity for individuals and groups to involve themselves in a creative process over which they had ownership and the parameters of which they could influence." The second model is predicated more on creating theatre about communities, using material such as testimony and research; it is in some senses, rather like a television documentary. The outcomes can more easily be predicted; for professionals, it feels less risky.[7]

For Gerri this was not about competing theories of community theater. From her perspective, the play had been about creating a place where trust could grow between disparate communities. She feels this goal was undermined by the discontinuity of the two approaches. The result, in her view, was that some felt compromised, even betrayed. Looking back, she also feels some degree of complicity in the matter. The principal team members had never really taken the time to discuss and agree on a set of common values for the project. Given their experience together on previous productions it was assumed that they were all working off the same page. It was the intensity of the undertaking that amplified the subtle, but unexamined, differences. In the end she feels the price may have been too steep.

Martin

Looking back, Martin Lynch is more positive about the experience. Although he felt that the script could have been improved, he feels great pride in the overall success of the production. He is far less enthusiastic, though, about the impact of the project on his personal life.

> I believe it to have been a great project. One of the very best I was ever involved in. I loved my involvement in it and I loved the outcome. It was

a sell out, the right audiences attended, theatre actually happened in our areas, we helped to develop the politics of working-class Catholic and Protestant engagement, and we got great reviews, including rave reviews in the London national press.

On a personal level, Jo and I did have a very difficult route at times, due to not really knowing each other as professional working people.... At times, I didn't trust the professionalism of Jo and Gerri as theatre directors…while at times, they didn't trust my community theatre processes. We continuously wrestled with these problems to the end. I learned that they had a more thought-out-process than me. I benefited from their wisdom.[8]

Martin also felt that *The Wedding* had altered the communities that had made it possible. The nay-sayers had been proven wrong. The Protestant and Catholic companies had crossed the "peace line" peacefully for common purpose, and, for a time, mixed marriages had come out of the closet in a healthy way. As a result, community theater in Belfast would be now viewed differently. No longer, "just" a local diversion, new productions would probably have a higher profile as well as higher expectations. Emboldened by the play's success, local companies were demanding more from each other and the Community Arts Forum. As is often the case, change precipitates even more change. For Martin this eventually meant leaving the Forum, in 2002, to devote more time to healing his relationship with Jo and to working on his new play, *The Troubles According to Ma Da*.

Jo

Jo Egan had started her *Wedding* journey with a sense of both adventure and foreboding. The project was audacious. It held great promise and also danger. She knew taking on both coordination and artistic roles would be daunting, at best. At worst, who knew, but it was the chance of a lifetime. She was drawn to both the challenge and the risk.

Even so, there was no way Jo could have known what *The Wedding* held in store for her and the others. She was more than prepared for sectarian conflict and discord. After all, that was the rough place they had chosen to explore. What she had not anticipated was being let down by those she trusted the most. She looked upon Martin and Marie as leading professionals in the enterprise. To her mind, they had not acted accordingly. That Martin was her partner only intensified her distress. At the outset, they all knew that trust would be the most critical and tenuous element in the delicate chemistry of the project. For her, the late scripts had jammed the whole enterprise. The writers had squandered the time needed to work through the conflicts and for rehearsal. In the final month it had been a struggle to keep *The Wedding* on track. She took great solace, though, that despite this, the company members had regrouped and persevered.

When the play closed she felt immense relief. At first, the respite acted as a kind of a balm for the bruising ride she had endured. The good feelings were short lived, though. The physical and emotional exhaustion she felt was beyond anything she had ever experienced. Complicating matters was the shaky state of her relationship with Martin. She knew she would need to take time to sort it all out, and, it quickly became apparent that she was going to need more than a few weeks off.

Reflecting back, she realizes that she was much more than exhausted. "It actually took a lot longer and in a lot of ways I'm lucky to have survived, mentally and emotionally." For a while just resting seemed the right thing to do. Then, in June of 2000, she began focusing on a long deferred writing project on the Magdalene houses and how their deplorable treatment of unwed mothers and their children reflects Irish attitudes towards women. She also used the time to reflect on *The Wedding*, its impact and its lessons. As the months passed, she began to see it as a mixed bag of accomplishments and cautions. The experience had taught her and the others a great deal about making community theater with integrity. But the biggest lesson was about what could not be taught.

> I can tell you all kinds of interesting stories about things that happened to me. I can tell you things to be aware of. I can tell you things to be careful of. But, no matter how many brilliant methods I share, there is something about the heart and the spirit and the energy required for this work that cannot be techniqued.

Maybe some of the "heart and spirit" Jo speaks of is the inescapable legacy of what it means to be born into the tumultuous history of the Emerald Isle. Growing up in Dublin, she was surrounded by family stories of the Irish Rebellion. Knowing that history made her proud. It also left her with an enduring sense of responsibility that in some ways led to her involvement in *The Wedding*.

> As an Irish person you cannot dislocate yourself from your heritage. You can't do it. You are in the argument. When I came out of *The Wedding*, I thought, That is the end. I may have more to do, but no more to pay. I have paid every debt I owed up to this point.

History is a curious thing. Often inaccurate, sometimes invented, forever disputed. Nevertheless, this imperfect foundation inevitably provides the rutted roadbed for our future journeys. Memory often works the same way. No two audience members see the same play. This experience can be even more acute in community theater, because the stories on and off the stage are so inherently connected. For many involved in *The Wedding*, the stories about the play often supercede the play itself. As such, the play's legacy is a work in progress. Despite this, there are very few who participated whose lives have not been irrevocably altered. The same can be said of the play's impact on Belfast. They had set out to make a play together and in the process contribute in some small way to the struggle forward. Few could argue that they had fallen short.

Epilogue

In the early months of 2000, Maureen Harkins got a call from fellow Ballybeen player, Pat Bowen. Pat, who had played Sylvia in the Marshall house, had a proposition. Would Maureen be interested in reenacting their "kitchen scene" at a series of "best practices" conferences to be put on by the Northern Ireland Tenants Association over the next few months. The Association, which supported the work of the tenant councils in public housing wanted to present the scene as an example of how the arts can be used to stimulate safe dialogue about difficult cross-community issues. Maureen was intrigued. This was one of the scenes that had been difficult for her. But as part of a conference these characters might provoke a healthy discussion about some of the nuances she felt were missing from the play.

The first conference was in late January. Martin Lynch opened the workshop with a recounting of the *Wedding Community Play*. The kitchen scene followed. Although they knew their parts, Pat and Maureen were nervous. This was community theater in the raw—no props, no costumes, just one scene, and then…reaction. But, the scene went well. When they finished they knew they had struck a chord with the audience. Maureen was delighted.

> It seemed to shine. There was something about that particular scene that got through in a way that a speech or a lecture would not. The people we talked to were very positive about it. They felt it touched on the issue of mixed marriage in a way that made it possible to listen and reflect rather than react. In the evaluation everybody felt it was the highlight.

Reaction at the next conference was equally positive. Unfortunately, shortly afterwards, Pat Bowen became ill. Rather than cancel the remaining workshops she suggested that they ask Moya O'Hara if she would stand in. Even though her family was still recouping from the attack on her husband, Moya was keen to do it. She quickly began learning the lines delivered by Sylvia, the "stuck-in-the-mud old Prod."

With Moya on board, the kitchen scene continued to provoke positive response. Initially, audiences had no idea that Sylvia's and Tilly's argument about whether Protestants should support the peace process was being delivered by a Catholic and a Protestant. Moya describes how they responded when they found out.

> They were amazed that we could get on stage and act like that together…they thought that was fantastic. They said it woke them up really. But, of course, that was the whole idea.

PART 2

Resurrection Dance

Cambodia

CHAPTER 4

Killing Culture

US ABANDONS SAIGON TO COMMUNISTS

Saigon, April 29, 1975. *Saigon* was in its death throes today. The Americans were leaving and the city that has been the centre of non-Communist Vietnam since 1954 was confused, frightened, and relieved at the same time. All afternoon American helicopters—Chinooks, Hueys, Jolly Green Giants—wheeled above, landing precariously on the tops of high buildings to take off Vietnamese and other evacuees.

The way the Americans went was a spectacle in itself. It is a long time since Vietnam has seen so many helicopters, and they swept in at speed, with Phantoms flying overhead. Orange and red flare smoke mushroomed up from the American Embassy and other pick-up points for US personnel.[1] —*The Guardian*

THE US EFFECTIVELY closed the books on its Vietnam misadventure on April 29, 1975. Unfortunately, for those who lived in the Southeastern Asian neighborhood where the war had raged for nearly thirty years, these accounts remained unsettled. Leaving, for them, was not an option and, sadly, their unceasing nightmare was nowhere near ending.

This is particularly true for those who were living in the *Khmer Republic* (Cambodia). After gaining its independence from France in 1953, this small country of less than 10 million had struggled futilely to maintain its neutrality as cold-war-fueled conflicts heated up in neighboring Laos and Vietnam. The inevitable happened in 1969, when the North Vietnamese extended the Ho Chi Mien Trail supply route into Cambodian territory. The US responded with a massive bombing campaign. To escape the bombardment, the North Vietnamese moved farther into Cambodian territory. As they pushed westward, they joined forces with a small communist insurgent group called the Khmer Rouge. Ten years earlier, the Khmer Rouge leaders had withdrawn to the remote countryside to fight an increasingly repressive political scene in the capitol, Phnom Penh. Now, with North Vietnamese support, this insurgency gradually grew in strength and influence. By 1974, they controlled much of the

ក្រូវនេះព្រះសុរិយាទៅវប្បក្រម្រឆ្កងឆ្លើមានកៃរវដ្បលិក (ផ្កោ) ភាំងអំពីទឹរសប្បាយកាយគ្រាស់ដៅផ៏សបប្ថិកាមបក្រាកុ ៃសឝរិយា កំរ្ជៀងប្រែលួលសត្ថិយារាក្រឹនាវៃលានោះទាវាៈជាទាងៃក្បែក្ក៤ ៃសកក្ក ផ្លបចេព្នាលិក ក.ស.២៤៣០ ពទាងៃ ឌុនឡ្ការពិត្រាករៃ៏សក្ក៍ឧនពសុជានៃយ៉ាងៃស្រសក់ញ្ញិក្ប៉ីមត្ថេរៈចំលើជៃយុលគេហ្ម្លានមួយ នៃទាងៃលិចឌ្យូររស្សាយៃពជា ផ្ចរៃក្ថកុ្ឌៃ្រុវេក្តពពត់ៃដុយាំ ។

ឯគេហផ្លានោៈ ជាផ្លៈចាស់ប្រាក់ឡ្ពៃ ដិយុលគិរាផៃ ជព្ចាៃឩក្ការ សសរមួល នៃរ៉េហារៃផាឆិមរៃយុវហារហ្ញៃលេប ៃរ នៃៃវ៉ាងៃក្រោមៃរុវនៈ គេ្ខា២ៃជាអុុវ្រម្ថេលគ្ផៃ ផ្ទិ 'សៃៃរិៃ្បៃ' ជាផ្លៈ៏ៃៃ៏្បៃ៏្របៃប្បុរាណ្ថៃៃៃៃលៈ សៃៃៃ៏សៃល៍ មគៈៃសៃម្ថៃៃ្ពៃៃៈ ។

Many Cambodian villages in the early 70s were not much changed from the one depicted in the comic version of the 1943 Khmer novel Kolap Pailin *(The Rose of Pailin) which was reprinted by Reyum for the 2004 exhibit "The Comics of Cambodia." Photo © Reyum*

Cambodian countryside, forcing government defenders into a small enclave surrounding Phnom Penh.

Ly Daravuth (family name first) was born in the year of the monkey (1968) in Tang Kra Saing, a small town in the province of Kampong Thum. People born under the sign of the monkey are said to be extremely intelligent, creative and headstrong. These attributes would prove to be of great value to Daravuth in the years ahead. Daravuth's home was situated on the rich alluvial plain that surrounds the fish-rich Great Lake of the Tonle Sap River. Daravuth's parents ran a small grocery store in the town's market. While they were not wealthy, they lived a comfortable life in an area that had been home to their respective families for many generations. In 1973 that began to change.

At the time, Cambodia was sliding inexorably into a decades-long period of extraordinary political and social turmoil. A few years earlier, the country's long-time leader, Prince Norodom Sihanouk, had been deposed in a coup by his Prime Minister, US backed General Lon Nol. By 1973 the General's ineffectual army was rapidly losing control of the countryside to the joint forces of the North Vietnamese and Khmer Rouge. As the hostilities pressed eastwards towards Phnom Penh, many, including Daravuth's family, ended up under Khmer Rouge control. Daravuth describes the deteriorating situation.

> Many people ran to the city (Phnom Penh). But in the areas controlled by the Khmer Rouge, people were very restricted. The liberty of movement was being curtailed because the Khmer, they didn't want people to leave. So, my parents couldn't just move the whole family out. We had to go, one by one, pretending to be going on a visit or something. So we left. Somehow we were successful, doing business in fish, and my father driving a taxi. I remember, during those two or three years, we had a good house and I went to a pretty good school.

In Phnom Penh, Daravuth's enterprising father joined with a local pilot to bring in fish from Kampong Chanang, one hundred miles north. Despite the fact that airplanes flying in and out of the capital were regularly being shot down by the Khmer Rouge, Daravuth's father felt it was worth the risk. His newly relocated family needed to establish themselves and the siege-like conditions

assured a very good price for the fish. Unfortunately, their good fortune was short-lived.

During the later half of 1974, conditions in the Cambodian capitol worsened considerably. The Khmer Rouge began shelling the city and shortages of food and other essentials reached a critical stage. On April 15, 1975, the United States ordered a hurried evacuation of its embassy in Phnom Penh. Five days later, the Khmer Rouge army marched into Phnom Penh, their victory over the feckless Cambodian army final and complete.

Fifteen days later, on April 30, a virtual replay of this scene took place some 200 miles to the east when the Americans made an equally hasty exit from Saigon. Throughout the world, the fall of Saigon to the North Vietnamese was headline news. Unfortunately, the events unfolding in Cambodia drew much less attention. That lack of scrutiny would continue on as the Khmer Rouge turned an already war ravaged Cambodia into the brutal social experiment that has come to be known as the "killing fields."

For some, the initial days of what was being referred to by the Khmer Rouge as the "liberation" was a welcome event. It marked the end of five years of war and the fall of the incompetent and corrupt Lon Nol government. The Khmer Rouge had occupied large areas of the countryside for the past few years so most people were aware that a strict and regimented style of communism would be imposed. Given the recent chaos, some reasoned that was what the country needed. But none were prepared for what ensued within days of the capitol's fall.

Phnom Penh is located west of the confluence of four rivers (Tonle Sap, Bassac and the upper and lower Mekong). This area is called the Chattomukh or "Four Faces". The same could be said of the city's convoluted and unpredictable political landscape. Before the war, Phnom Penh had been a sprawling steamy city of teeming markets, with an aging colonial architecture and a stable population of around 900,000. In the final year of the siege, the influx of refugees from the provinces had swollen the population to more than 2 million. When hostilities ended, it was assumed that the repatriation of displaced families would be forthcoming and the city would rebuild. Tragically, this is *not* what happened.

Days after their triumphal march into Phnom Penh, the Khmer Rouge implemented the first stage of their plan to purge the country of Western degeneracy and transform Cambodia into a country of massive agricultural communes. In a move that was as bizarre as it was brutal, the largely teenage army began driving the entire population of Phnom Penh out of the city into the countryside. The mass exodus was total and unforgiving, particularly for those who were suspected of having influence or position with the previous regime. Education, even basic literacy, was regarded as a sure sign of corruption. Numerous educators, artists, business owners, professionals and government workers were spared the pain of the arduous journey and summarily executed. On the long march into the unknown, many who were slowed by sickness or

In his book Painted Stories, *artist Svay Ken depicts the Khmer Rouge soldiers as they shout, "Chayo! (victory) soldiers of the revolution!" during their march into Phnom Penh. Photo © Reyum*

injury were shot along the way. Others died of starvation. In a few weeks time, Phnom Penh had emptied to fewer than 10,000.

Sadly, the redistribution of the population to rural work camps was just the beginning of the freakish new order unfolding in Cambodia. Other measures were even more xenophobic and feudal. Money was abolished and schools were closed. All aspects of social and civic infrastructure deemed to have been associated with, or influenced by, western corruption were dismantled. Material goods linked to foreign interests or ideas such as books, musical instruments, cassettes, and films were destroyed.[2] Artists and intellectuals were a favored target of the Khmer Rouge. Within months of their victory over 90 percent had been killed or exiled.[3]

Because young children were seen as oppressed by parental influence, most families were broken up. While adults were assigned to labor gangs, building dams, irrigation canals or roads, their children were taken away to be re-educated and put to work as well. The "curriculum" pressed on the children was as straight-forward as it was insidious. They were taught that individuals were of no consequence. An oft repeated saying stated, "To keep you is no benefit; to destroy you is no loss." City people were the enemy—the educated, the poets, the landlords and the teachers were exploiters of the poor and tainted by the evils of western life.[4] The message: Your blood family is an instrument of corruption. Your new family is "Angka," the communist party. Longing for ones loved ones, or "familyism" (*kruosaa niyum*), was now a crime.[5]

"Better Lives"

We children love Angka limitlessly.
Because of you we have better lives.
and live quite happily.

Before the revolution children were poor
and lived like animals.[6]
　　—"Angka Dar Qotdam" (The Great Angka)
　　A Khmer Rouge children's song

Given the harshness of life under the Khmer Rouge, Daravuth's family could be considered fortunate. Their new home was, in fact, their old village of Kampong Thum. For Daravuth, who was seven, the memories of that time are as complicated as they are incomplete.

My father was sent away. He was not with us during the Khmer Rouge time. He visited from time to time. So, I was living with my older sister who is two years older than me. My other elder sister was old enough to be working with the youth force building dams. She must've been 12 or 13. So, it was mostly me and my sister, by ourselves. My mother came from time to time to visit us. She was also in a camp somewhere

School was going to collect cow shit for fertilizer. We had these revolutionary songs but I don't remember learning anything. I do remember being quite wild—stealing fish and getting caught. The authorities were threatening my parents, because I was not behaving. But my grandfather and all my uncles, and the whole town that was like our family saved me.

I don't remember any armed forces per se. There were the black uniforms. Some of them were everyday people that we knew in the village. Of course, there were terrible things happening. I was trying to survive. I didn't have enough to eat. But I didn't really know what Khmer Rouge was. I did know that some people were executed, but the memory is more complex, than just, "It was horrible."

The terrible story of "the Khmer Rouge time," as Daravuth refers to it, now looms large in the history of the late twentieth century. Incredibly, at the time, the extent of the Cambodian holocaust was largely unknown outside of the country. This was due, in part, to the Khmer Rouge's ability to literally seal off the country. But international complicity also played a big role. The US government, still licking its wounds over its defeat in Vietnam, was loath to acknowledge in public what it knew about the unfolding disaster its actions had helped to foster.

Cambodia did not come back on to the world's radar screen for five long years. In 1979 the Vietnamese army, provoked by Khmer Rouge expansionist aggression, invaded Cambodia. In short order they captured Phnom Penh, installed a collection of Khmer Rouge defectors as puppet rulers and changed the country's name from Democratic Kampuchea the Peoples Republic of Kampuchea. While the Vietnamese were successful in dislodging their communist "brothers" from the more populated areas of the country, the Khmer Rouge were by no means defeated. The ensuing conflict made life even more tenuous throughout the countryside, deepening an already critical food crisis and displacing millions. As the Khmer Rouge retreated into the rural areas, many

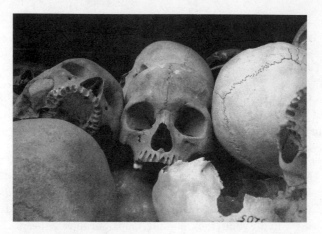

Tens of thousands Khmer Rouge victims were buried in mass graves that came to be known as the "killing fields." Photo © William Cleveland

Cambodians were forced to flee to refugee camps along the border in Thailand; others went south and east to Vietnam.

Daravuth and his family were swept up in this latest migration. They escaped to Vietnam where other relatives had found refuge. While chaos reined in Cambodia, they tried to make some semblance of a life as illegal refugees in a country that was waging war in their homeland. In Vietnam, Daravuth's father was arrested in 1980 for running a small coffee business and sent to prison. As conditions worsened, the family began to consider trying to make it to one of the refugee camps on the Thai border with the hope of emigrating abroad. As one of the older males, Daravuth was sent along with one of his aunts and her son on the arduous journey.

I went with my aunt and another woman friend of hers and her son. Her husband had died before the Khmer Rouge. I was 14, and I was like the "man" in the group. I took on some leadership. It was tough. It was a long trip—we had to walk across Cambodia. We had to pretend to be with a group of smugglers taking goods into the camp. The first camp, Nang Chan, was not an international refugee camp. It was run by one of the resistance groups, so it was regularly bombed. When shells fell in the middle of the night we'd wake up and jump into the dikes dug there.

Then we went to Khao l Dang, which was a much safer camp where international organizations were working. We didn't know the way, so my aunt hired a guide to take us from [Nang Chan] to Khao l Dang through the unknown areas of the jungle. The guide took the money and left us outside the camp. But you couldn't just go in there—it was guarded and you had to sneak in. If they caught you, they would send you back. I was sent ahead to look for a way to get in.

It was almost a full moon, and I could see clearly the soldiers patrolling around. There was a fence and a road, some more barbwire and then

the camp inside. So I passed the first fence and crossed the road. I could see the soldiers patrolling close by. Then I ran to the second fence and got into the camp. But I fell into a hole. It was like a well or something and I couldn't get out. The next morning, after being helped out, I found out that my aunt and the rest came after me. We were very lucky, we could have been caught.

"Breaking into" the Khao l Dang refugee camp brought Daravuth and his family members good fortune in a number of ways. Their new home was unique among the dozens of refugee centers that had sprung up along the Thai-Cambodian border in the wake of the Vietnamese invasion. Unlike the other camps in the area, Khao I Dang was not run by any of the Cambodian resistance groups, but rather the United Nations High Commission on Refugees (UNHCR). This not only afforded the inhabitants better care and protection, it also made them eligible for resettlement to third countries.[7] For most of the more than 40,000 refugees living there at the time, the possibility of escaping the war was truly a new lease on life. But these new beginnings did not come quickly or easily. The massive increase of refugees, precipitated by continuing conflicts in Indochina, had swamped the receiving countries.[8] A wait as long as three or four years was not uncommon.

Daravuth made the best of his time at Khao l Dang. It had been many years since he had been in a real school, so he took advantage of the extensive education program offered at the camp. Under the guidance of his aunt's new boyfriend, he also began taking art lessons. He and his teacher, a graduate of Cambodia's Royal Academy of Art, became very close. This mentorship provided an important anchor for the teenager amidst the chaos and unpredictability of camp life. The making of art also gave him a feeling of mastery and independence that he would not soon forget.

When they had first arrived, most of the camp's residents were being resettled in the US. Daravuth's aunt immediately applied for her family to settle with "relatives" there. To do this successfully, a number of significant biographical changes became necessary. Daravuth describes how he lost his name and became younger in the process.

Visas are easier to get for relatives, so my aunt started to change our names to match with some people in the US. When we didn't get a visa to go to the US, we tried for France. Again, we had to find someone in France that we knew who could be a "relative." Eventually, I had to say that this guy [Ly Yu Li] was my father's brother and changed my name to Ly to match his. My aunt changed my age too. A lot of people changed their children's age in the refugee camps so they would be young enough to go to school when they resettled. So, officially, my name is Ly and I am two years younger. But, my real name is Van. We arrived in France on January 15, 1983. It was snowing.

Refugee children enjoy a traditional dance class at the Khao I Dang Camp on the Thai border. Photo by Richard Rowat

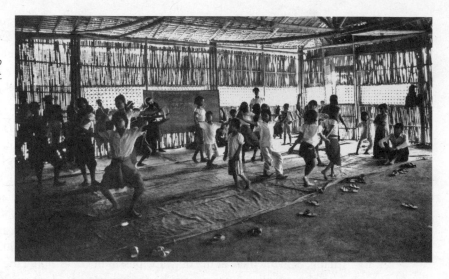

French Lessons

A TALE OF FRIENDSHIP IN CAMBODIAN WAR

Cambodia's bloody history during the last decade has, until now, been unexplored by creative artists. But British producer David Puttnam, 42, who made the Academy Award-winning Chariots of Fire as well as the Midnight Express, hopes his next work, The Killing Fields, will become a major artistic statement about the Cambodian holocaust. The core of the movie is the true life tale of New York Times correspondent Sydney Schanberg and his Cambodian assistant, Dith Pran, who saved the writer's life.[9] —*Philadelphia Inquirer*, October 9, 1983

Daravuth, his aunt and her son joined 3,525[10] Cambodian refugees who received asylum in France in 1983. They were settled in a small public housing unit in Creteil, a suburb of Paris. There, they became members of a community of refugees and immigrants mostly from former French colonies that were in various states of turmoil. Like Daravuth and his family, many had fled the continuing upheaval in Southeast Asia. Others came from Eastern Europe, Haiti, Turkey and Iran.

Creteil is located in Clichy-sous-Bois, a second-ring suburb of densely packed high-rise government built housing units. This diverse mix of displaced peoples struggling to survive was ripe for conflict, particularly among youth. On the streets, Daravuth learned the ropes very quickly. Although he was small and looked young, his life under the Khmer Rouge and in the refugee camps had toughened him. Those who tried to intimidate him usually paid a price, and learned to leave him alone. But it made for a lonely existence. (In November of 1985, tensions in Clichy-sous-Bois boiled over, precipitating many weeks of civil unrest and the declaration of a three-month state of emergency.)

Despite his aunt's efforts to change his age, Daravuth was still years behind his peers in school. Because of this, and his very rudimentary French, he was placed in a technical school to learn television repair. That this did not sit well with Daravuth is an understatement. He understood that college was the only road to advancement in his new home. His French teacher at the school, Mme. Duvernoy, recognized that Daravuth's impatience was borne of an eagerness to learn more than a technical skill. Taking him aside, she told him that his poor French would prevent his entering the university. She also offered to provide the intensive language tutoring he would need to tackle the entrance exam.

Over the course of the next year and a half, Daravuth augmented his language study with books rummaged from Mme. Duvernoy's attic. He read everything he could find, hoping, somehow, that the language would sink in. After countless hours of pouring through old anthropology texts like *La Momie* by Theophile Gauthier, Agatha Christie mysteries and even romance novels, Daravuth's French began to improve. Beyond proficiency, he also found himself appreciating the inherent power of the written word for exploring and shaping ideas. When exam time came, he passed with high marks, particularly in the writing section. While most students made do with a few paragraphs of personal narration, Daravuth presented his examiners with a densely packed, twenty-one page mystery written in green ink.

In the fall of 1985, Ly Daravuth entered college as a first year undergraduate. To be closer to the university he and his aunt's family moved in with an uncle in central Paris. The intensity of the inner city and academic life suited Daravuth. He found the discipline and hard work demanded by the rigorous curriculum particularly satisfying. So much so, that he finished each of the next few years near the top of his class. Outside of the classroom, though, things were not so rosy. Despite his success in school, he describes the period as a time of "misery."

> My uncle was really tough. He'd hit my cousin and me. He'd punish us, especially me. Like when I would come back from college he'd say, "I saw you walking around, looking at stores. You're late." He'd hit me. I couldn't watch television. I couldn't do anything. The good side of it is that I was compelled to read. But I was so miserable.

Having no other choices, Daravuth persevered with his studies while living under his uncle's harsh regime. Approaching graduation in the spring of 1989, things changed abruptly.

> I had been accepted into a good business (graduate) school. But before going there I visited a university of history, cultural anthropology and fine arts at La Sorbonne. I went to an art class and I saw people breaking chairs and painting on windows—experimenting. I thought, Wow, this is for me. I was not happy with the school where I was supposed to go, it was mostly wealthy French kids. I felt so out of it. Also, by then, I had started to date a woman, and all at once I was seeing the life I'd been missing. So, I broke.

Suddenly the studying machine I had become… just came to a halt.

So the last months at college were quite bad. I went from a 17 (grade) in mathematics down to 1. I was a machine that just burned out. The only thing I wanted to do was just hang out. Then, I ran away from my uncle's house. In French it's a "fugue." After a week of living in the park, I found a room with one of my very good friends from Provence. I said, That's it, I am going go to school and have my freedom. To pay the rent, I got work in a publishing house at night. So basically, I started to want to live.

I was 22. I got into La Sorbonne where I studied fine arts. It was a good time. I had two lives. I had an academic life and an artist's life: painting, sculpture, writing poems, singing the songs of my friends, traveling the south of France in a car that we transformed into a small theater, doing drawings in wine houses to make money, getting into underground concerts. I made good friends that I am still very close with—brilliant people. At one point, three of us decided to try to pass the national exam to be professors for high school in France. We ended up number one, number two and number three, in the nationals. But none of us went to teach. It was not meant for us.

I needed that art explosion for a while, but after a year or two, I found it was not serious enough. I wanted more serious academics, so I got more into cultural anthropology and philosophy and the history of art. The academic courses they had were mostly French, western oriented. But, I read books about Cambodia and Khmer culture and kept contact with Khmer scholars. Of course, I talked a lot about Cambodia.

I got my master's degree in art history. Then, I got the second year after the master's degree (a supplementary credential) and I started my PhD in cultural anthropology, on borders. The border that I was talking about was represented in cultural materials—the borders between identities and the borders between cultural practices. I was particularly thinking of issues like identity and displacement. The kinds of things you deal with in refugee camps. What does it mean to be displaced? What does it mean to define territory? I wrote a whole chapter on physical signs and definitions of yourself, like identity cards.

After awhile, though, I found what I was writing was crap. Part of it was okay, but in France, I did not have the original, organic materials to talk about. I wanted it to be more than just another student writing about something from a distance. Getting to that, the organic material, is why I went back to Cambodia.

CHAPTER 5

Reclaiming History

**ROYALISTS WIN PLURALITY IN CAMBODIA
ELECTION RESULTS POINT TO RULE BY COALITION**

Overcoming a violent campaign against it by the Phnom Penh government, the United National Front for an Independent, Neutral, Peaceful and Cooperative Cambodia, known as Funcinpec, has won the largest share of seats in a new parliament to be formed under a U.N.- sponsored peace plan. The election ... seriously undercuts the rationale of the Khmer Rouge for boycotting the elections and continuing the guerrilla war they have waged since being ousted from power in 1979. The radical communist group had argued that the voting was a ploy to keep the Phnom Penh government in power and perpetuate Vietnamese control of Cambodia.[1]

The party is loyal to [Norodom Sihanouk], Cambodia's nominal head of state, and is headed by his 49-year-old son, Prince Norodom Ranariddh. It campaigned for turning over full state powers to Sihanouk and returning Cambodia to its relatively tranquil days of the 1960s—before Sihanouk was overthrown in 1970 and the country was plunged into two decades of war, revolution, foreign occupation, civil strife and isolation. —_The Washington Post_, May 19, 1993

THE CAMBODIA THAT Ly Daravuth returned to in 1996 was very different from the one he had left ten years earlier. The guns were silent, save for areas on the northern border areas still being contested by the Khmer Rouge. Though struggling, Phnom Penh was once again populated and functioning as a city connected to the outside world. The country even had a new name, The Kingdom of Cambodia. This reflected the reinstitution of the monarchy as a part of the shaky Ranariddh-Hun Sen coalition government negotiated after the election. Most importantly, the country's civic infrastructure was slowly being rebuilt.

One area most in need was Cambodia's devastated educational system. Under the Khmer Rouge, nearly all of the Cambodia's educators had been killed or died in the labor camps. A small number had escaped, but few had returned. The Khmer Rouge had also done away with most of the country's educational

The street scene near the Royal University of Art in Phnom Penh. Photo © William Cleveland

facilities, and, during their short reign, over half of the world's Khmer language publications had been destroyed.[2] The Vietnamese had begun the process of rebuilding earlier but much remained to be done. Unfortunately, the lack of funds and rampant corruption among officials working for the new regime had not helped matters.

The reconstruction had also been impeded by the reemergence of Cambodia's volatile political landscape. In 1985, Vietnam had begun a four-year process of withdrawing its occupation forces. Between then and 1996, the government had changed hands three times through a coup, the 1993 election, and finally UN sponsored negotiations. Ironically, despite his apparent electoral defeat, former Khmer Rouge commander turned Vietnamese puppet, Hun Sen, still had a firm grip on the reins of power.

Of course, Daravuth had changed significantly, too. He had left as a scrappy teen, with little, save his wits and a truncated primary school education. He had returned as a well-traveled adult, mature beyond his years and one of his country's few Ph.D-level scholars. He had come home not only to learn, but also to contribute as a faculty member at the newly reconstituted Royal University of Art in Phnom Penh. His primary goal was to finish his dissertation but he was also keen to share his knowledge and experience with students and colleagues. He soon found both of his aims to be more problematic than he had imagined.

I started to teach the history of art at the university, in the department of archaeology. But it was very hard. How do you teach the history of art to

these kids? They didn't read French, they didn't read English. None of the books were available in Khmer. They had little knowledge of history, they didn't know about the Christian world. And then look at the history of Cambodian art. It has been the domain of French scholars. There was no manual on this subject in Khmer. I thought, what does this mean to think about the history of art here, at this time.

In the classroom, these questions weighed heavily on Daravuth. They also affected his work on his dissertation. The more he learned about what was happening around him—at the university and in the street—the harder it became to write. The educational system was in tatters. Corruption was everywhere, from the sprawling street markets to the halls of Parliament. Both his students and the artists he was meeting were struggling to survive—materially, psychologically and spiritually. And they had so little to work with. A millennium's worth of cultural history, much of it living only in the hearts and minds of its practioners had been destroyed, literally murdered, in the genocide. Because of this, Daravuth's students, the country's future leaders, had little sense of their own story. Given the deep trauma Cambodia had suffered, he knew that the necessary healing would require much more than an end to hostilities and an infusion of foreign aid. They would have to rebuild some sense of collective identity as well. He had little idea how to make this happen, but under the circumstances, writing his thesis felt like less and less of a priority. Eventually, he informed his advisor back in France that he was putting his research on indefinite hold.

Situations

COUP OUSTS CAMBODIAN PRINCE

Phnom Penh, July 8, 1997—After a weekend of heavy fighting, Cambodian strongman Hun Sen, the second prime minister, appeared today to have consolidated his grip on the capital, Phnom Penh. But his victorious troops rampaged through sections of the city this morning, looting shops and homes and even stripping equipment from the international airport, according to news agency reports and telephone interviews with residents and diplomats.

Meanwhile, Hun Sen's deposed rival and coalition partner, First Prime Minister Prince Norodom Ranariddh, vowed from France to organize resistance to the takeover. Diplomats in Cambodia said there were signs that Ranariddh's defeated forces are regrouping in the northwest of the country and joining forces with guerrillas of the notorious Khmer Rouge to begin a counter-strike.

With the country threatened with a renewed civil war, the capital appeared calm but tense tonight, witnesses said, with Hun Sen's troops fully in control of the major strategic points around the city, including military bases around the airport once controlled by Ranariddh's faction, the headquarters of his political party and his home.[3] —*Washington Post*

In the fall of 1998, Daravuth had been home for a little more than two years. Over that time, conditions had gone from bad to worse to tolerable. The 1997 coup had come and gone, but political tensions had not abated. In its aftermath, more than 100 officials from the ousted party, Funcinpec, had been murdered. Then, in April a disputed election had consolidated Hun Sen's hold on the government, both stability and continued repression.

At the University, Daravuth was still finding his way. While his teaching load was fairly light ("a few courses in architecture and archeology"), he spent considerable time working with students on their research and translating some of the better French books on Cambodian culture into Khmer. During this time, he met a visiting scholar from Columbia University who was doing research for a doctorate on twentieth century Cambodian arts.[4] Her name was Ingrid Muan. Like Daravuth she had been working with students outside of class on their research. She had also been trying to organize a student exhibition. As Daravuth came to know her, he found that she shared his sense of urgency about the decrepit state of education and culture in Cambodia. They each had been pushing the university administration for more resources for their students. They were both meeting the same resistance, as well. Daravuth recalls the day Ingrid came to him with a Khmer-English translation that the college Dean had asked her help with.

> It was text for the catalogue for the First Fukuoka Asian Art Triennale, in Japan,[5] representing Cambodia. Somehow it went through the university, and they appointed some teachers who wrote three sentences in Khmer. It was supposed to be a scholarly article about the history of Cambodian contemporary arts. She translated these three sentences and almost cried. And so, I told her, "Don't worry, we'll rewrite it."

Ingrid Muan at her computer portrayed by the artist Svay Ken. Photo © Reyum

So we started to work together. We spent a whole week in my apartment, because I had a computer then, which was very rare at the time. We expanded the article so it talked about how modern teaching comes from the institutionalization of traditional craftsmen and family crafts, like silverware, and into the art schools. It was called, *Cambodian Arts: The Search for Foundation.* We were a little worried about the guys who wrote the three sentences, so when we sent it to the curators at Fukuoka, we mentioned them as collaborators, to keep them happy.

After that week, we really started to work together. Apart from that catalog, we also worked together to help the curators to choose the artists. We started to discover each other, really. We discussed our frustrations, and talked about how we could work together and combine our ideas. At one point, she told me that, at first, she didn't want to work with me. At the time, I was trying to show some seriousness to my students by wearing a tie. So, she thought I was a ministry official and she did not want to get involved with those guys.

In the weeks following their collaboration on behalf of the Fukuoka Triennale, Daravuth and Ingrid continued to meet and share their thoughts about the uncertain future of Cambodian culture. As their friendship grew, so did their sense of responsibility for the artists they had mobilized for the exhibition. None of these artists had studios or even photographs of their work. Although many of them taught at the university, most had to supplement their incomes by churning out multiple canvases of half-naked Cambodian women and fiery sunsets silhouetting the Angkor temples for the tourist market. A number of the artists had created very different work responding specifically to Fukuoka's theme, *Communication: Channels for Hope.* Unfortunately, only a few had been selected, and there was no place in Phnom Penh to exhibit this type of work.

In response, Ingrid and Daravuth decided to mount a show to honor the artists and maybe help build an audience for their new work. By pooling their own meager funds, and tapping some foreign friends, they managed to raise about $500 to finance the exhibition. But they couldn't mount a show without a space. Thinking the university would jump at the chance to help their faculty members, they approached the university's Fine Arts Dean. He was definitely interested—but not in the way they had anticipated.

We asked the Dean if we could renovate one of the classrooms to show the work. And he said, "Sure, but out of the $500, I get to keep $200." I was so mad. This was for his university, for his professors. We had struggled so hard to get this money, but he just had to have his share. He was really a piece of work. I was really angry. I told him to get lost.

So Ingrid and I decided we would try to find another place, next to the university. We went to see this guy, Bill, who had started one of the very first internet cafés here (called "KIDS"). The foyer outside of where he put his computers had not been fixed up. It was very raw. So we asked

if we could renovate the wall, paint it and put lights up for the exhibition. And he said OK. He was very supportive.

The show was called, *Hope: A Channel of Communication*. I printed all the materials with my inkjet. We named the foyer "Situations", since it was a time that the political situation had virtually paralyzed activities of any sort. We sent out these small invitations. We were still painting walls and hanging work up to the very last minute. We were not expecting many people to come, so Ingrid and I were very surprised when the space started to fill up. It was really crowded, ambassadors came. I guess nothing was happening in town.

After the opening (December 4, 1998), people continued to flock to the tiny exhibition space across the street from the university. Inside the campus gates, the Dean was more than amazed, he was angry. Two of his own faculty members, bit players in his view, had pulled off one of the biggest cultural events of the year. Some of the artwork had even contained some "political content." To make matters worse, they had done it in a little internet café on the school's door step. Ignoring the fact that he had turned down the opportunity to host the exhibition, he responded in the only way he knew how. He pushed back by letting Daravuth and Ingrid know they were on tenuous grounds in terms of their employment. If he thought his threats would have a dampening effect on his adventurous minions, he was mistaken.

Ingrid and Daravuth did not take the Dean's warning lightly. Given the politics and egos involved, they had no illusions about their vulnerability. Adventurous artistic endeavors were hardly in vogue, and anyone questioning authority, even at the art school, could be branded as a troublemaker. In the larger scheme of things, if they were fired, or worse, they would have little recourse. However, they were in no mood for caution.

Building on the momentum provided by Fukuoka, they decided to mount another show right away. Given all the attention his café was getting, Bill was more than happy to accommodate them. After much discussion, they decided that they wanted to pay homage to the old craftsman. It would feature work by three of the few surviving masters of traditional Cambodian artforms: An Sok, a lacquerware mask maker; Som Sanai, a silversmith; and Chet Chan, a classical painter. This dramatic shift flew in the face of conventional wisdom—that they should follow their initial success showing contemporary art with more of the same, and, of course, market to Westerners. But they wanted Situations to be about building a Cambodian audience for Cambodian artists across a broad spectrum. They also wanted to create a credible arts institution outside the preview of the university.

Once again, using minimal resources, Ingrid and Daravuth mounted a quality exhibition that honored "master craftsmen" in a show they called *Continuity and Transmission*. They took care to provide informative, well-researched documentation celebrating the artists "commitment to their art" and making

the point that "development does not necessarily mean rupture with and opposition to the past."[6]

Although they had high hopes, they were stunned by the positive response. Notwithstanding the abrupt shift in content and style, the exhibition again attracted large audiences, including a member of the Royal family. It also drew a favorable mention in the *Phnom Penh Post*. The energy provided by the success of the two shows took hold of Ingrid and Daravuth. The question of whether they would do another show right away never crossed their minds. The only question was what would be next?

Recently, they had been introduced to an artist who had survived the Khmer Rouge time by becoming a propagandist, creating posters extolling the revolution. Imprisoned and condemned to death, Pech Song had convinced his jailers of his potential value to them by scratching a charcoal drawing of a triumphal Khmer Rouge victory on his cell wall. Daravuth and Ingrid learned that in the 1960s he had had a successful career painting traditional pictures of the King and Angkor Wat. During the Vietnamese occupation he had again adapted his work to suit the times. Highly skilled with both a paintbrush and in diplomacy, Pech Song personified Cambodia's dance of adaptation and survival. For Situation's third exhibition, they asked him to paint new work reflecting that strange journey.

The new exhibition, called *Painting History*, opened in May of 1999. Once again there was avid interest by the public and the press. The English language paper *Cambodia Daily* took pains to describe the unusually forthright content of each of Pech Song's large (2m x 1.5m) paintings.

> The picture representing the Lon Nol period of 1970–1975 is fractured with images of protesting students at the National Assembly in one corner and the Japanese Friendship bridge in flames in another. The one representing the Khmer Rouge period is painted with dark shades of black and red. People evacuate Phnom Penh at gunpoint and statues of Buddha are headless. The painting of the Vietnamese occupation tells the story of their arrival, attempts to rebuild hospitals and schools and their eventual departure. …(The) final painting in the series, of modern Cambodia, is calmer than the previous ones and the colors are lighter, but the scene it represents is of men disabled by land mines and women working as prostitutes, while portly businessmen make deals in front of their Land Rovers.[7]

Reyum

With the success of their third show, Ingrid and Daravuth began to feel the pressure of growing expectations, especially among the community of artists who recognized Situations as the country's only independent arts venue. The makeshift gallery had also received visits from police inquiring about its legal status. These visits served as a reminder that they could be shut down at any time for no reason. As they were debating their next move, Bill informed them

Reyum's wide open street front gallery attracted a wide range of wanted and unwanted visitors. Photo © William Cleveland

that he was moving the café to a new location. He invited them to join him at the new location, which they considered. They also discussed closing the books on Situations altogether. Instead, they decided to take the rash step of taking over the café's lease, albeit with no money and no prospects. They did have a name though. The new gallery would be called, Reyum, a compound of Khmer words which means "song of the cicada," a notoriously tuneful insect that periodically "disappears" only to return to sing again.

At the time, neither had had any previous experience running an organization or raising funds. They did have a good record with Situations and a few contacts among foreigners in Cambodia who were beginning to respond to the enormous needs facing the country. One of these contacts was Mark Rosasco, who, with his wife, ran the Kasumisou Foundation, a small philanthropic fund dedicated to alleviating poverty in Southeast Asia.[8] Through mutual friends, they arranged a meeting to talk about Reyum. Recognizing the potential, Rosasco agreed to provide the funding needed to pay the rent for the new organization. With this support in hand, Daravuth and Ingrid felt confident enough to register Reyum as a nongovernmental organization. They also set to work cleaning and painting their new facility.

Reyum officially opened its doors on October 27, 1999. The inaugural exhibition, *Khmer lacquer making and Lakhaoun Khaol*, featured the masks of

An Sok, one of the artists who had appeared in the second Situations show of traditional Khmer crafts. The show presented masks used by the main characters in Lakhaoun Khaol. The Lakhaoun Khaol is the Cambodian classical theatrical rendition of the *Reamker*, which is the Khmer version of the epic Hindu poem, the *Ramayana*.[9]

The show might have appeared entirely traditional, to those from outside Cambodia, but for Cambodians, there were powerful subtexts, as well. An Sok, as both an artisan and interpreter for the Lakhaoun Khaol was, literally, one of the last of his kind. When the Khmer Rouge had rounded up and killed nearly all of Cambodia's artists and storytellers they had effectively destroyed the living, breathing human archive of 2,000 years of Khmer oral culture. Despite the fact that the country had been predominately Buddhist for 800 years, the *Reamker* had remained a central pillar of Khmer consciousness and identity for two millennia. In the 20 years since the genocide, though, a new generation of Cambodians had grown up in a cultural void. Thus, this exhibition was an attempt to honor and document a remnant of Khmer cultural identity, and it was hoped, begin the long process of reviving it.

The ancient Hindu story also resonated with more recent events in Cambodia. The following catalogue excerpt describes the subtle way in which the curators used the show to juxtapose the *Reamker* and contemporary Cambodian

Nil Pech is one of 18 monkey commanders of Preah Ream (Rama in the Hindu Ramayana epic).
Photo © Reyum

history—particularly the nation's efforts to remain nonaligned in the cold war power struggles that eventually engulfed it.

> On opposite walls of the gallery, the two warring forces of the *Reamker* face each other. To the right of the entrance are the yeak or demons led by Krong Reap, the demon King of the island of Langka. On the left of the entrance are the monkey troops loyal to the hero, Preah Ream …Between these two sides, in the middle of our exhibition, are the masks of Pipaet and the hermit, figures who are either neutral in the conflict or who have interaction at one time or another with both of the warring factions.

The catalogue itself gave some clue as to Daravuth's and Ingrid's ideas about how Reyum could contribute to Cambodia's cultural resuscitation. The fifty-two page publication included scholarly text and twenty-three illustrations written in both Khmer and English. It described both the history and process of Khmer theatrical mask making and detailed the practices of performing Lakhaoun Khaol. Research conducted by a team of Ingrid's and Daravuth's students in the village of Svay Andaet in rural Kandal Province provided the background for the catalogue's text.

This first catalogue set a standard for rigorous scholarship that would characterize Reyum's future exhibits. Ingrid and Daravuth felt that it was incumbent on them to do more than just exhibit Cambodian artwork. To them, the nearly complete erasure of Khmer cultural history demanded an immediate and robust response. Nobody, not even the university, was engaged in this kind of cultural triage. As such, with exhibitions as its focal point, Reyum was on the road to becoming a kind of a hybrid art and learning center, hosting seminars, performances and artist residencies in addition to conducting research and publishing for both adults and for children. In an interview with a Bryn Mawr alumnae publication, Ingrid shared some of the rationale behind this ambitious mission.

> It's a place where you can see things that are visually interesting and, hopefully, learn something. That's what we really want Reyum to be. It's hard for us to imagine, but many children grow up here without ever having a book of their own. In order for the teaching level at the university to improve, the first step is to have a much greater culture of literacy among children. Our students (at the university) have so little to see and so little experience of exhibitions and books in which ideas are freely expressed. These are the realities of a rebuilding society. [10]

CHAPTER 6

Tilling the Fields

Legacy of Absence

**HUMAN RIGHTS WATCH CONDEMNS
REARREST CAMPAIGN IN CAMBODIA**

(New York, December 10, 1999) Human Rights Watch today condemned the widespread rearrests of people previously released from prison by the courts in Cambodia. The rearrests were ordered by Cambodian Prime Minister Hun Sen on December 3, 1999. The organization also expressed strong concern about the safety and whereabouts of some of the fifty-four people arrested. Some of the court officials, who approved the prison releases, have received threats since the rearrests began.

—Human Rights Watch Press Release[1]

January 7, 1999

The two ageing Khmer Rouge leaders had a message for their countrymen. "Let bygones be bygones," said Khieu Samphan, head of state between 1975 and 1979, when the savage rule of the Khmers Rouges over Cambodia resulted in nearly two million deaths. Nuon Chea, "Brother Number 2" to the late Khmer Rouge leader Pol Pot, offered similar advice: "This is an old story. Please leave it to the past." The two men were speaking in Phnom Penh at the end of December after surrendering to Cambodia's current leader, Hun Sen, who welcomed them with bouquets of flowers and said that Cambodians "should dig a hole and bury the past".[2] —*The Economist*

NEAR THE END OF 1999, Reyum's founders were contacted by a former Rockefeller Foundation arts program officer, named Clifford Chanin, to talk about something called the Legacy Project. The project had arisen from Chanin's experiences at Rockefeller where he had "encountered numerous artworks from around the world, addressing the absence and losses

experienced by societies as a result of past tragedies, including war, genocide, ethnic conflict, and population displacement." Chanin wanted them to consider Reyum's involvement in "a global exchange on the enduring consequences of the many historical tragedies of the twentieth century.[3] It was not surprisng that he was interested in Cambodia.

Daravuth and Ingrid were intrigued. There was no question as to whether the subject of the Khmer Rouge era was appropriate for the gallery. In fact, they knew it was inevitable that they would eventually take on the country's most avoided subject. Given the political situation, an art exhibit might be a relatively "safe" avenue for both artists and the public to explore this dark territory. Then again, maybe not.

Since the 1997 coup former Khmer Rouge commander Hun Sen had continued to strengthen his hold on both the military and the apparatus of the state. Public discourse on the subject of the genocide or the need for truth and reconciliation was highly discouraged. Although international pressure for some kind of war crimes tribunal had been mounting for years, the government had managed to avoid both its establishment and the threatened sanctions. Not that there was a ground swell of support among the people for exploring Cambodia's disturbing recent history. The proximity and enormity of the trauma was still an overwhelming presence. Anything that could tip the country toward renewed chaos was avoided by most, save a small political opposition.[4] Complicating matters even more, the country's economy was barely functioning and remnants of the Khmer Rouge were still fighting the government in the remote countryside.

All of these factors gave Reyum's founders pause for concern. They knew the gallery had gained a fairly high profile in an environment where outspokenness was considered dangerous. They were also acutely aware that an exhibition dealing with the Khmer Rouge would increase both their own visibility and vulnerability. Another worry was that as a part of the international Legacy Project, such a show might further promote the narrow, one dimensional "killing fields" lens through which the rest of the world viewed Cambodia. There were numerous reasons to decline Chanin's offer to join the project. However, in the nearly twenty years since the genocide, the subject had not been publicly explored by Cambodian artists, and given the opportunity, Ingrid and Daravuth knew many who would step up. There was no doubt that taking this on would be both a risky and grave responsibility. Nevertheless, it was a responsibility they felt they could not avoid.

The Legacy of Absence opened on January 11, 2000. The exhibit consisted of works by ten artists "pondering the absences produced as a result of the Pol Pot era." The images were provoked by a series of questions posed to them by Reyum's co-directors: How do the missing and murdered affect the living? What traces of the dead haunt the present? How can the reasons for so many absences be understood and set to some kind of rest by those who come after? As time goes on, how are killings and their causes remembered or forgotten, repressed or made into myth?

Phy Chan Than's "Angkar" depicts the vicious machinery of Khmer Rouge tyranny. Photo courtesy Reyum

While the works varied greatly in style and form, they all confronted Cambodia's disturbing recent history squarely. Svay Ken's vivid narrative compositions displayed a uniquely Cambodian rhythm of color and composition to explore subject matter that was disarmingly explicit. In *The Accusation*, a green clad commander sits on a lotus leaf before group of villagers accused of wrong doing. As he raises his right hand in judgement, he is the new Buddha dispensing the Dharma of the Khmer Rouge. In another, entitled *The Harvests of War*, Ken's canvas was filled with an endless wallpaper-like field of blind and limbless men, suggestive of the exhibition's title. A companion canvas was populated by row upon row of widows.

Phy Chan Than's vividly colored *Koh Tree* presented a highly abstracted form of a native tree whose name also translates in Khmer as mute, or silence. To describe the nearly 4x6 foot canvas's jagged discharge of reds and blues as intense would be an understatement. The accompanying label referred to a common saying from the Pol Pot era, "If you want to live, plant a koh tree in front of your house"—a very clear message that opening your mouth will land you in the killing fields. Phy Chan Than's equally large *Angkar*[5] portrayed a huge, mechanistic, multi-limbed god figure, dripping blood and wielding agricultural implements.

Describing his motivation for participating in the exhibition Phy Chan Than said, "I know what happened during this time. I made this picture because I want all the world, especially Khmer descendants, to know about the Pol Pot time."[6]

Although most of the artists in the show had lived through the Khmer Rouge era, much of the work did not contain aspects of personal narrative. In an interview at the time, Ingrid noted the absence of the personal in artwork coming out of Europe after WWII. Characterizing the *Legacy* exhibition as " …a first step," she added that she felt that the artists were …"now understanding for the first time, that it is okay to paint and discuss these things. As they get more confident, more personal work will be created."[7]

In that same interview, Daravuth elaborated on why it had taken so long for an exhibit like the *Legacy of Absence* to manifest, and why it was important.

The artists do not want to contemplate it. Sometimes when you have a shock, you don't want to talk for awhile. They just want to look back with nostalgia and create these Angkor Wat paintings. I am slightly afraid that it (the Khmer Rouge era) is becoming mythologized, that the personal experiences are being lost to a more general idea of what happened during

those years. Just the other day, I was talking to a 20-year-old who had no idea what the KR sandals [made from rubber tires] looked like. I found it amazing—just twenty years on, the younger generation are already forgetting. How do we deal with this heritage? With heritage like Angkor Wat, you have conservationists, the picture painters, and so on. But with the KR regime, you can't classify it as a UNESCO world monument —there's nothing there. You have to find another way.[8]

One artist whose work was intensely personal was Ngeth Sim. His *The Last Look* depicts the terrible moment of his father's abduction by the soldiers of Angkar. The painting is a blood red portrait of searing anguish and fear. A ragged line of prisoners trudge across the canvas, faces twisted and bodies bound. In the tableau's center, Ngeth Sim's father's eyes, framed in the glasses that likely marked him as "an enemy of the state," penetrate the crimson shadows. His son, the recipient of that beseeching gaze described his own deep sorrow in an accompanying statement.

My poor father, at the moment when the Khmer Rouge led you away, I fixed on your face intently. At the bottom of my heart, a thousand thoughts clashed and overwhelmed me. I couldn't speak. I remained mute in front of them and only the tears flowed down my cheeks. I sensed that I was going to lose you and life left me at the same time that they were taking yours. I did not have the force to protest in front of these torturers, to prevent them from taking you and killing you. Today still, this memory beats against my chest and keeps me from complete happiness. When I think of it, the feeling overwhelms me that I did nothing to return the love that you had given to me. I am truly an ungrateful son. Dearly beloved father, I pray every night that your soul will pardon me.

Daravuth's *The Messengers* also made a strong impression. The work, his first since his return to Cambodia, was unusual in a number of ways. First, as a multi-disciplinary installation of photographs and sound recordings, it was strikingly different from the other work in the show. Of greater significance, though, was the subject matter, which explored the raw and painful issues of complicity and truth during the Khmer Rouge time. The images, spreading across the walls of a small cubicle, appeared to be old archival photos of children, ostensibly victims of the Khmer Rouge. Below the photos, which were numbered, a metal loudspeaker spewed martial type songs, sung in Khmer. In the exhibition catalog Daravuth describes the more complex and confusing story represented in the little room.

During Pol Pot time, certain teenagers and children delivered messages for Angkar all over the country. The photographs used in this installation… show such Khmer Rouge messengers … set amongst similarly doctored images of children from the present. Because of the blurred black-and-white format and the numbering of each child, we tend to read these

photographs first as images of victims, when they are "really" messengers and thus people who actively served the Pol Pot regime. ...My installation wishes to question what is a document? What is "the truth"? And what is the relationship between the two? If upon entering, we are seduced into easy sadness, we leave uneasy, recognizing the difficulties of ever discerning "the truth" retrospectively.

The show and Daravuth's installation, in particular, pushed the envelope for some officials. They made their displeasure known. This pressure added stress to Ingrid and Daravuth's increasingly complex partnership. Daravuth elaborates:

My work was controversial, because I used pictures of the messengers and played revolutionary songs from the Khmer Rouge. I also put the speakers outside. The police came and looked at the show and asked me questions about what we were doing. They were very serious with me. Our law doesn't allow a foreigner to be a director of an NGO. Ingrid and I were working as co-directors but, as Khmer, I was legally responsible. So, I started to be more and more sensitive to the politics which, at the time, were really tense. But, Ingrid said, "Lets challenge them." I said, "Maybe we need to make some compromise with the country, to allow us to set up this institution (Reyum), not attack frontally."

This situation was made even more complicated by the fact that we were also starting to live together and share a relationship. Sometimes we fought. She would say, "It doesn't matter what we do, they (the government) will always be looking for trouble." I was feeling more cautious. We had different perspectives. She tended to be more interested in contemporary artists. I wanted it to be broader. But, of course, we were both right, because our strength was in our combined forces. And, most of the time, it was really beautiful. She used to laugh at me because I was always trying to find a problem to address.

Following the *Legacy* show, Reyum's most pressing problem was its growing reputation as an independent and outspoken cultural institution. Reyum's popularity had become a liability. The curators responded by dramatically changing the subject, quickly and often. The gallery's schedule for the remainder of 2000 included shows on classical Cambodian ceramics,[9] contemporary batik, traditional tools and practices from the countryside and an exploration of a Khmer fertility totem called the *Neak Ta*. Each of these exhibitions was accompanied by both scholarly catalogues and a series of lectures. On top of this, the Institute published an illustrated children's book of the Khmer alphabet and a graphic novel depicting the clash of traditional and modern marriage customs originally written in 1943.

Needless to say, during 2000, Reyum's co-directors literally did little but work, sleep and eat. Most importantly, the pace and diversity of their programs made it hard for government critics to pigeonhole the institution as a

troublemaker. And while the depth and range of their output continued to attract audiences, it had also established Reyum as a national asset—a true Institute of Art and Culture.

Visions of the Future

The orange blush of sunset spreads across the iridescent surface of the Tonle Sap River. Phnom Penh's life-giving river is crowded with the long thin fishing trawlers that ply its water daily. Along its edge, a stream of pedestrians, motor scooters, tuc tucs, cars and trucks moves noisily down Norodom Boulevard. At the intersection of Norodom and Rue 178, the mass of humans and machines momentarily clogs and then somehow transforms into a four-way convergence of miraculous permeability. It's a pattern that repeats itself every few minutes with the same kind of chaotic regularity that appears to govern the power cuts that are one of Phnom Penh's most consistent evening rituals. This night, surprisingly, there have been only two. So now, as if on cue, the lights flicker and the ceiling fans start to slow, but no one seems to notice. After a moment's pause, candles appear everywhere. In the golden glow of this temporary galaxy the city's twilight dance resumes.

Further down Rue 178, next to the National Museum and the Royal University of Fine Arts, is an area of tightly packed storefronts, Phnom Penh's "arts district." Fifty or so narrow, open studios crowd the broken sidewalk. A jumble of art implements and materials, mostly stone and canvas, lay scattered amongst hundreds of artworks in various states of completion. Despite the dense urgency of this creative warren, most of the art is strangely uniform, even repetitive. The paintings are nearly all either romanticized technicolor sunset images of the Angkor temples or westernized Cambodian women in revealing costumes. The sculptures replicate the carvings of Hindu deities, asparas and the stylized creatures that decorate the great temples and palaces of Angkor.

In the middle of the block, a milling crowd spills out of a white two-story stucco building and onto the street.. The sounds of live music and animated conversation mingle with the hot thick evening air and waxy smoke. The crush is even greater inside the building, where one can glimpse rows of paintings illuminated in a flickering dance of candlelight. On the walls is a riot of styles, colors and subject matter. People are crowded around the artwork talking and gesturing intensely. A woman in a bright green sari holds what appears to be a catalogue in her left hand. On the cover, superimposed over a photo of the Tonle Sap at sunset, it says, "Visions of the Future."

The *Visions of the Future* exhibition marked another milestone for Reyum. Rather than build a show around a particular subject, Ingrid and Daravuth invited a group of artists to make work responding to a theme of their selection. They chose the future. The result was an exhibition of extreme contrasts.

Some of the artists painted images of a healed and productive nation—a transformed landscape of new opportunities and fresh beginnings. Others, like Prom Vichet's portrait of a starving baby monkey and its mother, titled *What Hope*, imparted a profound sense of sadness. The most prevalent sentiments, though, mirrored the harsh reality of present day life in Cambodia. These paintings revealed a deep sense of pessimism about whether Cambodia could ever escape the pervasive injustice, corruption and environmental degradation endemic to Cambodia's "reconstruction." In Hen Sophal's *Work of a Government Official*, a self-satisfied brandy-drinking bureaucrat leans back in his executive chair, oblivious to everything but the bulging moneybags on his desk. Chan Vitharin's *Opposites* questioned whether a Cambodia that avoids its past can even have a future. Her simple painting of a walking figure leaving footprints which point in the opposite direction effectively makes the point.

In their curator's statement Daravuth and Ingrid reflected on the "melancholy" that seemed to permeate the show.

> …Many of the pictures in the exhibition testify to quite dire views of the present, and offer little hope for a better future… But hope is hard to kill. It creeps back into the most disillusioned perspectives, cajoling and seducing us to think that tomorrow will be different. And so we offer this exhibition in the name of hope that still lingers, for us, for Cambodia, for the future.

Given Reyum's meager resources, both physical and financial, it would be hard to imagine that the program could expand further. But over the next two years, along with a full exhibition, lecture and publishing schedule,

Chan Vitharin's "Opposites" explores the tension between confronting and denying the past.
Photo © Reyum

Reyum began publishing other scholars, hosted resident artists, presented performances and even sponsored a touring troupe of traditional Cambodian puppeteers. The stimulus for each new initiative was largely organic, fueled by a combination of opportunity and need. Though formal planning did not figure prominently in Reyum's development, its founders had a clear sense of purpose and an ambitious, but fairly straightforward, agenda. They felt that Cambodian culture was dying. Reyum's purpose was to help in its recovery. To do this they had created a safe place for artists and scholars to learn from and share the precious remnants of one of the world's great cultural legacies.

That safe space would not have been possible without Reyum's unorthodox approach to finding resources. Alan Feinstein, a Rockefeller Foundation program officer, recalls how Ingrid and Daravuth would often "start a program with nothing more than a conviction that it was the right thing to do. Unlike most NGOs in Cambodia they just went ahead. The money might or might not be there but they just kept on doing things." Such was the case with the Reyum Art School.

Ingrid and Daravuth knew firsthand the difficulties being faced by Cambodia's youngest citizens. Every day they would encounter children on the streets who were sick, begging or being exploited in menial jobs or the sex trade. War and starvation had killed so many adults that Cambodia was one of the youngest countries on the planet.[10] With half of the country under the age of eighteen, the struggling education system was overwhelmed. The lack of adequate facilities, trained teachers and the costs associated with sending children to school severely limited the quality and accessibility of basic education.[11] And, given the large number of school-aged children, classes were only available for half a day. This meant that most children spent a good part of the day with nothing to do and no one to look after them.

Students of the Reyum Art School pose proudly with their paintings. Photo © William Cleveland

In response, Daravuth and Ingrid decided to establish an art school as an alternative to the university of the streets. The idea was enthusiastically embraced by one of their earliest supporters, the Kasumisou Foundation. In the summer of 2000, The Kasumisou Art School opened its doors in a building adjacent to the gallery. It provided classes in drawing and painting free of charge to thirty students who were willing to make a commitment to regular

...Ingrid's work was still unfinished, and she was about to start a new phase of her life with joyous anticipation of the birth of her first child next month—a girl to be called Lili. Despite her sudden loss, many friends are committed to honour her memory by carrying forward her work to research and encourage the revival and development of the Cambodian arts and especially to continue the Reyum Institute.

Cambodian Stories

The Reyum Art School, February 2006

Sweat beads the faces of the foreign guests who crowd into the Reyum Art School garden. The group clusters next to a broad expanse of red sand that fills the better part of the small outdoor space. Yellow light pours down from above. Looking up one can see spotlights hanging on bamboo poles and the branches of trees. Buildings rise up on all sides, their glowing windows revealing unintended shadow plays of evening meals and family disputes. Black canvas draperies frame the makeshift proscenium that marks the border between the garden courtyard and the sand.

As the visitors awkwardly settle into the tiny space, a tall black curtain is drawn across the stage front. When the lights dim, the sound of crickets fills the thick air. A line of eight saffron draped young men and a young woman file in and face away from the audience. The first on the right steps forward, holding a bowl in one hand and a brush in the other. Facing the next in line he swipes the brush across his mate's back and shoulders in a gesture not unlike the sign of the cross. The anointed performer turns and steps forward, his shoulders glistening. He speaks, "I am Chivalry. I have one brother and two sisters. In the future I want to be an artist." As he steps back, the process is repeated for the next and the next all the way down the line. After the young woman introduces herself, they turn and face the curtain. In an instant, sixteen hands rise together. They grab the black drape and rip it to the ground.

This performance has been a long time coming. When Daravuth had seen Eiko and Koma perform in New York three and a half years before he knew immediately that they would have to come here to work with the students. He also knew they were famous; recipients of a MacArthur "genius" award and celebrated as living treasures. But that did not deter him. He asked, and they came, six months later.

That first visit had been extraordinary. Despite the language barrier, and their unfamiliarity with abstract dance, the students embraced the two dancers as members of their extended family. In their first classes, Eiko and Koma, who had both grown up in post-war Japan, immediately felt a strong connection to the young art students. They were also "profoundly surprised how receptively and beautifully" they moved. After a month in residence, their workshops and

Cambodian Stories begins with each artist's introduction and anointing. Photo © William Cleveland

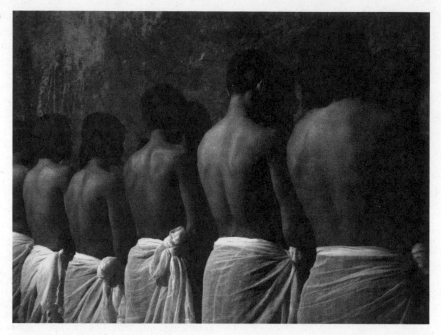

performances had introduced a new creative language to the school community. That bond had been affirmed when Eiko and Koma proposed a longer collaboration with the students, to make a new performance work.

It is quite early in the performance, but the audience is clearly beguiled. The dancers move in slow liquid rhythms across the sand, sliding in and out from behind 12-foot paintings of asparas (heavenly nymphs[12]) that define the sides of the stage. The melancholic pulse of a Cambodian pop song floats above them in the thick night air. It's hard to believe these performers have never danced prior to their time with Eiko and Koma.

The stage empties as the sound of a bowed double stringed tro signals a shift in mood. The young woman appears from the left rear. She is strikingly beautiful. Her elegant sarong, or "sampot," is shimmering and ornate, befitting a goddess or princess. Her movements are both classic and abstract, flowing and angular. She seems to be searching. When a young man in white appears, the prince maybe, they draw together very slowly and begin a duet. The pair moves as though bound by an invisible web, acting, reacting, never in unison, but always together. It is stunningly beautiful, and. at the same time, sad.

When Koma returned to Phnom Penh in January of 2005, everyone at Reyum was excited in anticipation of what was to come. This was particularly true for those students who were taking part. They now called themselves the Reyum Painting Collective. Eiko and Koma, who typically worked and per-

formed alone, were also energized. This would be new for all involved. So, when the workshops began, everyone seemed to be floating on air.

It was then that the darkest of clouds cast its shadow on the Reyum family. In the aftermath of Ingrid's passing, the community came together to grieve for the precious soul that would no longer be present. Daravuth had been deeply saddened—sure of nothing but the knowledge that there was no way to go but forward, each day. He also knew that the school was one of Ingrid's passions. The students would miss her deeply—all the more reason to continue the teaching and the healing.

A large white canvas has been rolled out over the red dunes. Two young men move quickly to the pebbly surface and begin sketching furiously. As the nearly invisible rendering nears completion, others rush in to construct intricate bamboo scaffolding around and over the massive canvas. The intricate framework rises, just in time to receive a crew of returning performers armed with paint buckets and thick long

The young woman (Charian) moves with a slow liquid grace across the sandy stage.
Photo © William Cleveland

Reyum artists Charian (on left) and Peace move as though bound by an invisible web, acting, reacting, never in unison, but always together.
Photo © William Cleveland

handled brushes. Launching themselves onto the scaffold, they begin to spread paint in seemingly random splatters of yellow, red, blue and white. Thick viscous pigment splatters across the canvas, onto the sand and all over the bodies of the climbing painters. In a matter of minutes, the glistening splash of merging colors is hoisted on the back wall of the stage. The audience gasps as the painting comes into focus. A reclining figure of a female goddess spans the entire back of the stage.

Koma had begun the workshops by asking the students to do what they knew best. After they had painted the ten monumental aspara figures that would form the set, he asked them to dance what they had created. This simple approach guided the entire project. From that point on, they worked back and forth from painting to movement, one feeding the other. It had taken a year of hard work, and now they were honing the finished piece. A few months earlier, Koma and Daravuth had brought news that had been as thrilling as it was frightening. In March they would travel to the United States with Eiko and Koma to begin a three-month, eleven-city tour of their performance. It would be called *Cambodian Stories: An Offering of Painting and Dance.*

The evening's performance is reaching its conclusion. The sound of crickets again fills the air. The princess has performed a final dance. Her body lies at the center of the sandy stage, mirroring the prostrate goddess in the painting behind. Two dancers approach, carrying a basket, which they use to form a mound of sand next to her. Kneeling together, they lift her limp form up on to the mound. As flute music swells, the young prince emerges, crawling slowly across the sand, reaching out to the slumped form of the princess.

In a matter of a minutes Reyum's young artists clamber across a makeshift scaffold to render a glistening goddess. Photo © William Cleveland

The moment his fingers touch hers he too collapses. After the two are carried slowly from the stage, the rest of the young men return to kneel together in solemn prayer. The lights dim.

As time for the tour approached, Daravuth became apprehensive about the impact the journey would have on his students. Like a father, he worried about all the negative influences they would encounter. Many of them had been at the school for years and had, in a sense, grown up there, so he knew they were well grounded. He was concerned, though, that they were not prepared for the superficial and material world they were about to enter. Would they be treated as artifacts? Would they come to think of themselves as stars? And, then back home, how would all of this affect their fellow students? Unanswerable questions all, and, as was his nature, he fretted just the same.

Throughout his own life's passage this constant probing and reflection had been a valuable companion for Daravuth. It had helped him avoid many hazards on a very dangerous and unpredictable path. It had also made it possible for him to imagine another Cambodia beyond the tyrannies of upheaval and trauma. His deep concern for his Reyum family reflected the landscape of this fragile dream. A dream he described in a short film documenting the making of *Cambodian Stories*.

It is very rare to see real emotion here in Cambodia. I would be glad if *Cambodian Stories* results in others seeing Cambodia as more than Angkor or the Khmer Rouge. If we show that Cambodia is about different things, especially these young people who struggle in a very subtle and emotional way it will be a great reward.

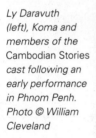

Ly Daravuth (left), Koma and members of the Cambodian Stories cast following an early performance in Phnom Penh. Photo © William Cleveland

The Art of Human Rights

South Africa

CHAPTER 7

Walter Kefue Chakela

The day is still warm, but the sun is beginning its quickening descent into the green hills on the horizon. Walter walks purposefully down the red dirt roadbed that links his township with Vryburg. In his right hand he swings the leather bag that will hold the liter bottle of brandy on his return. It's a small errand, but he is proud to have been sent and excited to be going alone into the white town. Since he turned ten it seems that his father has been relying on him more, giving him bigger jobs. It makes him feel good.

As he passes onto the bush road leading into the distant town, he glimpses a white man and two white boys moving in his direction—a father and his sons, maybe? One appears to be about his age—the other is a head taller. He can hear their chatter as they come closer. The younger boy is running in circles, taunting his brother, who chases after him. The father lags behind. The boys scamper like hyena puppies in a cloud of dust, only noticing him as they come abreast on the opposite side of the pathway. They stop, and for a brief moment two pairs of eyes lock onto his, curious, wondering. Walter's impulse to smile evaporates in an instant as he senses their curiosity succumbing to something more sinister.

He looks away and picks up his pace.

The older one yells, "Hey, you, come here!"

Walter feels them rushing toward him over his left shoulder.

The big boy yells again. "Stop!" Walter keeps moving, but they circle in front, blocking his way.

Before he can open his mouth he feels a dull thud on the side of his head, then another on the opposite side. He staggers back, instinctively covering up with his arms. He is totally disoriented. There is no pain, just confusion and fear. As he retreats, he realizes that he is being punched. In fact, both boys are hitting him. What is this? It doesn't matter. He needs to defend himself and get away. He swings out hard at a blurry presence on his left. His fist hits something in mid-swing. The force of the collision surges up his arm like an electric shock. He swings again. He hears a cry like a hurt animal. The blows stop. He turns to run. A few steps into his retreat he crashes into something. What's

going on? He looks up from the ground into the face of a man—a white face. He feels a rush of relief. It's the dad. It's OK. He will stop this.

In the next instant, his breath is blasted outward through his mouth and nose in an explosion of pain. He sees a dusty boot pulling back from his mid-section. Sucking air and tasting dust he feels another blow smash hard into his ribs. He can't breathe and he can't see. He can't think either, but he knows one terrible thing. The man is not helping. He is joining in.

In desperation, he rolls away from the lethal boots. Somehow, he crouches and stands. The three stand facing him, backlit by the falling sun. He sees an opening in the fence line formed by their long shadows. He breaks and sprints through. He can barely inhale but he runs and runs in the direction of the township. He knows the man can easily chase him down, but after a while he senses that he is not being followed. They have had their fun.

Township

WALTER KEFUE FIKELEPHI CHAKELA was born in 1953 in Huhudi, a black township near the town of Vryburg, in what is now known as the Northwest Province of South Africa. At the time, the newly ascendant Nationalist party's "apartheid" program was in its early stages of development. It was only that year that the Reservation of Separate Amenities Act had forced the segregation of all public facilities. Even so, by the time young Walter entered school most of the strictures of what Desmond Tutu would call "a crime against humanity"[1] were firmly in place. For Walter and the rest of South Africa's 13 million "blacks" and "coloureds," this meant that the desires and fears of 3 million whites[2] would hold sway over every aspect of their lives. Walter recalls a toxicity that was "pervasive and unremitting."

The contrast between the town of Vryburg and our township was quite stark. A few kilometers away from our home, Vryburg proper was all aglitter. The electricity, the street lights, the houses were significantly better than anything we had. But in our township, where there was no electricity, no running water, no paved streets, no sanitary facilities, no sewage system to speak of, for us, life was very very hard. I recognized very early on that life was much better across the road from us. Basically, I became aware that if you are white you get a better deal in life than if you're black.

My being attacked by those two boys and their father was my first encounter with white violence. When I made it home, I was angry, I was crying. I didn't understand how an adult could do this—could join with these kids to beat me, another kid. I thought, When my father finds out he will go out looking for them. But my father could do nothing. I didn't realize that it would be impossible for him to get those guys. He couldn't even go and report them at the police station. They would just laugh at him.

My mother knew this was a critical moment. So, she set me down and explained what it means to be black in South Africa. She described what white people see when they see a black person. She said, "When they see a black child, they see an enemy. They see somebody who is an object of their contempt, an object for them to vent whatever cruel streak they feel within them." She told me that it was important for me to begin to be very careful when I'm around white people. She also told me about apartheid. She said, "As you grow up, you have to be aware that there's a whole program in the country that has a bearing on black/white relations and that there's a struggle against that program." This is when I got to know about The African National Congress (ANC) and Mandela. She explained why Dr. Mandela and Robert Sobukwe were in prison on Robben Island and why a whole range of other people were banned. This was the moment I began to develop a real consciousness about the politics of South Africa. It took a clobbering, but it's probably what politicized me.

My father came from the mountain kingdom of Lesotho which was and still is a sovereign entity within the borders of South Africa. He had attended Fort Cox College, a special school of agriculture exclusively for black extension officers where he received a diploma in agriculture. After moving to the Vryburg area and marrying Harriet Mbonyana, my mother, he found a job with the government as an agricultural extension officer. This meant that he traveled out into the various communities teaching farmers the latest agricultural innovations. Like many of the men who lived in the township his work took him away from home quite often.

My dad had a great passion for Shakespeare. When he had a few shots of brandy he would quote from Shakespeare's plays. When he was home he would quote from *As You Like It, Merchant of Venice, King Lear*. But he was away a lot. There were very few private sector jobs for blacks so employment came mainly through the government. If you had a profession you had to go to bigger towns or cities. The only black professional people we knew worked for the police or in sanitation. You hardly ever saw a black lawyer or an accountant. Johannesburg, where the mining industry was located, absorbed vast amounts of excess labor from the rural areas. Also, Kimberly, about two hours from Vryburg was where the diamond mines were located. This operation was very labor intensive. Many families were fragmented because the menfolk had to travel to these areas to find work.

Walter's early education took place in what was called the township community school. The Bantu Education Act, which put all of the missionary schools under the central control of the apartheid government, had come into effect in 1952. In Vryburg and many other townships, there weren't even any missionary schools. So, faced with the government's unwillingness to provide any educational infrastructure for black people, the community members themselves

contributed money to build their own schools. Walter feels this and his family's strong commitment to education was a blessing.

> For us it was the community schools or nothing. All in all I think we benefited from going to our own schools. I also benefited because my mother was a teacher. I grew up in an environment that put a premium on education. At that time, even radios were not prevalent in black homes. So for me, the main way that you had to employ your time productively was through reading. When I was still quite young I had worked my way through most of my parents' books. My passion was literature. I think that was what gave me the key to an artistic life.

Stories and Plays

Storytelling—the communal sharing of family and community history and tribal wisdom—has been a well developed part of African culture for hundreds of years, particularly in the South. Beyond the mere transmission of information, these stories carry vital history and cultural mores through song and spoken word during ceremonies, family gatherings, royal courts, festivals and rites of passage.[3] Though weakened by forced tribal dislocations and the advent of electronic media, the pulse of this essential cultural element nonetheless persisted in rural South Africa in the later half of the twentieth century. For young Walter Chakela, this oral tradition provided access to both a rich cultural history and a powerful way of connecting.

> My mother was a great storyteller. With no media to speak of, storytelling was very important, a fixture. She would tell many traditional stories. A particular story might feature ten characters. She would take on all these voices. She would sing the music, she would play the giant, she would play the little girl, it was amazing. This was quite a contrast to the disembodied voices I encountered in the books I was reading.
>
> Most of what I read was Eurocentric. This was one of the great ironies of living in a post colonial, apartheid environment. I grew up on the likes of Shakespeare, Thomas Gray and George Eliot, which were the staple diet at secondary and high school. Then, purely by accident, I stumbled on *A Man of the People* by Chinua Achebe in the school library. That was the first book that I read by an African. That book opened a new world to me. Through it I discovered that there was a body of vibrant literature by African writers.
>
> When I was fourteen, I discovered more literature beyond the prescribed curriculum. One day I was in a used book shop in Vryburg and I came across a book entitled *The Laying Days* by Nadine Gordimer. This was a book by a white person about a South Africa with white people who were upset about the racism in our country. It taught me that there were other people other than us who were concerned about what was happening here.

I was also fortunate to have some very good teachers in literature who nurtured me. One high school teacher in particular who made a big impression was called Edmund Maretela. In high school you didn't study literature per se. It was part of the English curriculum. But because he was so passionate about poetry and literature, Mr. Martela could break down a story or a poem in such a way that students would be enchanted by it. With him, books ceased to be a piece just for the intellect. He was an intellectual, but he also helped make the books we read relevant to our life experiences. That's what made him succeed with me and many other students he taught.

Around this time I was also exposed to the work of the South African playwright Gibson Kente. At the time, he was considered the guru of black theater in South Africa.

He had a touring company that traveled all over South Africa to black villages and towns. His work was very popular and he, basically, had no competition. I saw this play of his called *Lifa* at the community hall in Vryburg. It was about a young guy who left the Transkei, where Nelson Mandela grew up, to go to Johannesburg to make his fortune. But he is swallowed up by the city and loses all communication with his home and parents. The play is about his mother's trials and tribulations searching for her son in Johannesburg—which was like trying to find a needle in a haystack. This was a story that was repeated over and over in real life. The book *Cry, the Beloved Country* tells a similar tale.

That play introduced me to the magic of theater. After I saw it, I knew that theater would be a big part of my life. With Mr. Martela's support, I started writing and producing short skits at school. We had no money so everything was done by student volunteers. We picked up props either in the schools or in the communities where we produced a play. My first play was called *Jozi*. It was an adaptation of the legend of the prodigal son in the Bible. Even though I was a student, we attracted audiences from the larger community. After that my work became quite popular and I was thrilled to have that acceptance by the people. From that point on I never looked back.

Walter's next play, *Let This Be a Lesson*, was more political in nature. In it he explored how age-old tribal antagonisms reinforced the apartheid rationalization that black Africans could not live together peacefully and therefore needed to be separated from each other as well as whites. Walter had picked a hot issue to begin using theater for social commentary. It was one thing to take on the government, but to criticize elements of the black community as well was asking for trouble from both sides. The reaction from some quarters was strong. Walter remembers being "both excited and fearful."

At one point some members of the community called me aside and said, "If you tackle these issues you will go to jail." Some of my teachers were

particularly uncomfortable. They were sure that the strong political overtones in *Let This Be a Lesson* would get me in trouble. But, it turned out that I was already in trouble. I was already being watched by the security police.

The first I knew about it was when I was called in to the principal's office. He sat me down and said that he had just had a visit from two gentlemen from the security police. They had asked him to warn me to desist from politically oriented work because it would get me into trouble. They indicated that they already knew the kinds of things that I was writing and that I must stop. The principal was a very conservative person and he basically told me to acquiesce. The only person who took a different view of the circumstance was Mr. Maretela. His position was, yes, some of these things could get me into trouble but the work that I was doing was important. He did not deceive me about the danger, but he supported me.

The intimidation was subtle and pervasive. They would talk to my parents, they would talk to my friends. The idea being that I should forever be aware that they are lurking in the background, that they are forever watching me. So I had to be very careful of what I did. To protect me my mother had to be very careful with whoever went into my room, who might look at some of the books that I have been reading. If she was worried about a particular book she would take it away and burn it to make sure that nobody saw that I had been reading it. She was always on the lookout for me.

They touched every part of my life. If I was going out with the young lady these security guys would somehow get word through to her to tell me "we know that you are a political leftist and we are coming to get you." But I think the fact that my dad was a drinking buddy with some people who were on the police force who were also in the security police might have helped me. The kind of brutality that we have come to associate with the security police during apartheid was absent from some of these guys. They were not the kind of bloodhounds that killed [Black Consciousness leader] Steve Biko.[4] Coming from Vryburg, their sense of their duty to entrench apartheid was not as acute as that of the security police in the bigger cities where political rhetoric was much louder. In places like Vryburg it was significantly more subdued. That's the only thing I can think of that explains why I was not taken in and tortured while I was in Vryburg.

Black Consciousness

March 21, 1960

Sharpeville was a small township about thirty-five miles south of Johannesburg…The demonstrators were controlled and unarmed… No one heard warning shots or an order to shoot, but suddenly the police opened fire… When the area had cleared, sixty-nine Africans lay dead, most of them shot in the back. All told, more than seven

hundred shots had been fired into the crowd wounding more that four hundred people, including dozens of women and children. It was a massacre...

—Nelson Mandela, *Long Walk to Freedom*[5]

The imposition of apartheid was both brutal and insidiously adroit. Sanctioned murder, like Sharpeville, torture and imprisonment showed its brutal side, but the real teeth of the apartheid regime was embodied in its legislative behavior. The Popular Registration Act of 1950 was the first legislation passed by South Africa's newly ascendant National Party. The "pass laws," as the statue and subsequent expansions came to be known, classified all South Africans according to race. It also gave the government the tools needed to assert control over the movement and habitation of all non-whites. Nine years later, the creation of geographically defined tribal homelands, or Bantustans, was seen as the final, enlightened step needed to bring about the full and efficient segregation of the races. The Nationalists also felt these ethnic enclaves would exacerbate the country's tribal divisions, undermining the potential for a cohesive opposition. While the forced relocation of over 3.5 million people (ultimately 9 million) did wreak havoc on the lives of its victims, it also challenged the growing anti-apartheid movement to find new ways to define common ground.

In the early sixties the fifty year-old African National Congress (ANC), driven by new young leaders, like Walter Sisulu, Oliver Tambo and Nelson Mandela, began to take a more aggressive stance against the Nationalist government. They also forged new alliances with other opposition forces, including trade unionists, the South African Indian Congress and the white-dominated Communist Party. Reaction of another sort came from the Pan African Congress and, later, the South African Students' Organization (SASO), which advocated anti-apartheid action

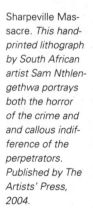

Sharpeville Massacre. *This hand-printed lithograph by South African artist Sam Nthlengethwa portrays both the horror of the crime and and callous indifference of the perpetrators. Published by The Artists' Press, 2004.*

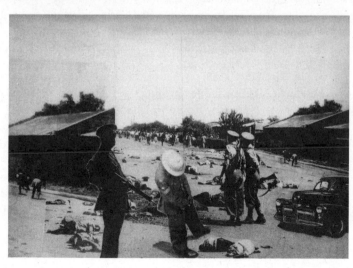

by South Africans of color exclusive of other groups. Despite their differences, all the tributaries of the growing anti-apartheid movement had one thing in common; they were all being pushed by the rising tide of frustration and impatience among members of Walter Chakela's generation.

When we turned sixteen in high school we had to get our passes. The school had to make sure that we went down to the government office that administered the passbooks. The passbook indicated whether you were black or coloured and where you lived, which, in turn, determined everything about our life. These laws were passed in the early fifties, but they were introduced gradually. At first the menfolk had passes and then the second phase was when the womenfolk had to get passes. The resistance to these passes was strong from that time on. The people killed in the Sharpeville massacre were protesting the pass laws.

Our resentment was fertile ground for new ideas about freedom and resistance. Those ideas came from all fronts. They came from writings that circulated in the underground. They came from the music of Miriam Makeba, they came from theater. They came from Gibson Kente plays as they became more and more openly political and landing him in prison. Later it came through Radio Freedom which was broadcast from Lesotho. Most importantly it came from activists.

It was around this time in the late sixties and early seventies we started to interact with some folks at the university who were involved in the black consciousness movement. Our political consciousness was significantly raised by this exposure. This is where we learned about the diabolical complexities of all the statutory instruments that regulated our lives—the pass laws and statues that determined where you lived, where you worked, who you could marry and where you go to school. We learned about the full range of the laws that separated blacks and whites and coloureds—that defined apartheid. Our interest in black consciousness was sparked off by these interactions.

In Kimberley, Walter was introduced to Jerry Modisane who was then the president of the South African Students' Organization (SASO). Inspired by the ideas of black identity from thinkers like Marcus Garvey, WEB Dubois and Frantz Fanon, SASO had been founded by Steve Biko and others in 1968 to advocate a resistance movement separate from the influence of "white liberal paternalism." For Walter and many other black, coloured and Indian youth, SASO provided both sanctuary and guidance for their explorations of black consciousness and activism. Modisane's persistent mentorship over many months introduced Walter to ideas that were both rousing and challenging.

I was just a high school student but he had the patience to explain black consciousness to me. He would sit for hours with me and describe what being an activist meant and how the lives of other people depend on how

you conduct yourself. He talked about being vigilant and how to discern when someone's interest in you is coming from the police.

Most importantly, I came to understand the necessity of resolving issues of identity within myself. If I was to challenge South Africa, with its racist politics and its whiteness, I needed to define and be comfortable with who I was as a black person. I was already an assertive person because I came from a family that inculcated that. But on a wider plane, even from an ideological standpoint, I became a lot more affirmative through the meetings with Modisane. Eventually, I became a student leader of the black consciousness chapter in the Northwest. I worked with many students in the secondary and high schools.

Thinking back to that time, I don't really remember being a teenager. In those days I had to be so careful about what I said or did. I had to make sure that the people that I worked with politically did not behave in a way that would expose them to the security police. I had to take care that the written material that I had did not fall into the wrong hands. At that time, there was a lot of literature in what we called the underground libraries. People would print books or buy them or smuggle them from neighboring countries and pass them on. Needless to say, these were not normal teenage activities.

But you know, there is a clear distinction to be drawn between my political activities and the activities of people who were in the underground attached to the ANC or the PAC. Those people were functioning much more consciously as cadres of a political movement in the underground. They had handlers that they reported to. They had particular objectives with particular missions to achieve. I was functioning as a young intellectual, as a young activist. I had no handler. I did not necessarily have to report to anybody. I did things because I believed in them.

Middle Passage

SOUTH AFRICAN RIOT EVOKES SHADES OF SHARPEVILLE

In the worst racial clashes since the shootings at Sharpesville 16 years ago, at least eight people died today during riots in the Johannesburg African township of Soweto. The riots began when 10,000 high school pupils marched through the huge township (with a population of over 1 million) to demonstrate against the Government's ruling that Afrikaans be used with English as a medium in the teaching of subjects like mathematics, history and geography. Pupils at the Phefeni secondary school in the Orlando West area of Soweto have been on strike since mid-May against the directive. —*The Guardian*, June 17, 1976

The seventies was a turbulent time for South Africa. For white or black or coloured, change was in the air. The order of all things was being challenged

and the government's response was swift and severe. Black union organizing and work stoppages early in the decade were met with brutal repression and the imprisonment of labor leaders. Demonstrations, first in Soweto and then spreading to townships in other parts of the country, became lethal confrontations with hundreds of demonstrators killed and thousands sent to jail. As tensions rose anti-apartheid leaders, such as Black Consciousness leaders Steve Biko and Duma Kokwe, were banned and imprisoned, driving many underground.

For young people like Walter Chakela these were also confusing times. Many, like Biko and Mzileleni Ganda, went underground to work in support of the struggle. Some were captured and imprisoned, joining leaders like Mandela, Walter Sisulu, Oliver Tambo, Robert Sobukwe. Others, like Walter, supported the movement by working within their communities. After finishing high school, Walter felt he had an obligation to help his parents financially. This desire and his growing obsession with theater led him to find work in nearby Kimberly in a clothing retail store called Burgers LTD. The work suited him well. He liked interacting with the public and was able to devote all of his off hours to learning more about theater and writing and producing his plays.

> I got my early theater training largely through reading and workshops. Whenever I had an opportunity I would travel to Johannesburg to attend an advertised workshop on either directing or acting. When I finished a script I would produce it myself. I learned a lot this way. I never waited for anybody to produce my work and if I was interested in doing anybody else's work I would just do it. I never waited for permission or outside resources to come my way. I always had a plan.

Coupled with learning the nitty gritties of retailing and continuing with black consciousness activities in Kimberley, Walter always found time to write poetry and plays. It was while he was in Kimberley that the idea of a new play (*Crisis of Conscience*) came to him. This was a play about a black consciousness activist who strikes a close friendship with a white Afrikaner university student while both were on vacation. Unfortunately his stay in Kimberley lasted only four months before the security police got a scent of his whereabouts.

> My time there was cut short though. One day in the summer of 1977 two guys came to the store where I was working and said, "We understand you like literature. We have a collection of books that you might be interested in that we would like you to come and look at." They gave me the address and a time to come. My colleagues were quite surprised that I was invited to this particular building and wanted to know why. I told them the story and they said, "There is no literature there." They told me that the building was occupied from the ground floor to the top by the security police.
>
> About two weeks before a political activist called Phakamile Mabija had been dropped from the fifth floor there to his death. Needless to say,

I didn't go. They came back the following day to ask me why I did not come. I said I had just been busy. My training as an activist told me it was time to duck. So I left Kimberley. Fortunately I got myself transferred to another town called Kroonstad. So it bought me a bit of time. My stay in Kroonstad was also quite short. I was moved by my company to Welkom, where I stayed about two years.

On September 13 we learned of the death of Steven Bantu Biko. It was a devastating blow to all who knew him, whether in the black consciousness movement or outside. My personal reaction was one of profound grief mixed with anger and a numbing realization that "the system" was capable of the most extreme measures in its bid for self-preservation.

My stay in Welkom gave me the opportunity to continue my theatre activities. I organized a group of aspirant actors and actresses and conducted workshops on acting and creating narratives for the stage. Most of them were very politically conscious, and as a result we spent a lot of time discussing the political situation in South Africa. Additionally there was a lot of interest amongst many in the group in African and black literature generally.

In the meantime the relationship between my employers and I became increasingly tense. The Scottish fellow who was responsible for employing me in the retailing chain in the first place was transferred to Cape Town, leaving me with a bona fide Afrikaner regional manager! He made an issue of my use of English in my communication with him, and my studies with the University of South Africa. I knew as a seasoned activist that my stay with the company was over, and that it was just a matter of time before the security police would be on me again. It was time to move!

Walter made a calculated decision to move to Mafikeng, which at that time was the capitol of the Bophuthatswana, Bantusan. His parents had moved there and the nominal independence of the place protected him for a time from police harassment. The fortunate thing was that he was never beaten like other comrades. He considers himself "lucky" to have avoided imprisonment and torture at the hands of the security forces as many of his comrades were known to have "languished in solitary confinement for up to 365 days!"

Immediately after his arrival in Mafikeng in 1978, Walter founded a new company called Molopo Experimental Theater. METGRO, as it was called, was the first black theater company established in a rural district in South Africa. Because it was new and lacked even the most basic resources, everything was done by the seat of the pants. Walter also learned very early that the company would have to tour to survive. Eventually METGRO established itself as a professional repertory company taking original work into communities throughout the region. Walter describes how the company's bare bones approach allowed him and his colleagues to grow both artistically and politically.

The work we toured was very different from what people had seen before coming from the likes of Gibson Kente. His work was colorful, spectacular, large scale and very urban. By the time I formed METGRO I had a more international perspective about what theater was all about. I was much more aware of contemporary world theater. I understood what Broadway was about and the West End and I was pursuing my own style. There was a preoccupation with the challenges of the politics of the time in the Northwest and in the country. My sensibilities were quite clear. I felt my responsibilities were to promote and give form to a new voice. To do this we created a kind of a theater laboratory for ourselves in a place where very little theater existed before.

When we rehearsed a play my artists understood that we were going to bring a lot of other texts to the table. I did this because I felt that we needed to create a broader context of understanding to the material—to own it and internalize it. So, sometimes our work went beyond theater. Instead of rehearsal we just had discussions about literature. We would read a book and then we would spend time critiquing it. A lot of the people who became a part of the theater company had never had an opportunity to explore the world of ideas. So we became a kind of a university—a community of learning. Many people even became a part of the group just to learn, not to perform. It was more like theater as education—theater as social development. And, of course, many of these conversations turned to political issues.

The apartheid government was very sophisticated. They understood exactly what was going on, and, of course, they tried very hard to close the avenues through which these political messages filtered. They did this through intimidation, putting people in jail, torture and sometimes killing people. Later on, they even attacked neighboring countries to quell the movement. And, they infiltrated all walks of life. There were teachers who were police informers. There were priests who were police informers. There were artists who were police informers. They were everywhere.

I had many of my plays banned. They would allow me to rehearse productions. At that time, because I wasn't getting any money from any funding source, I was using my own money. They would allow me to rehearse, and on the eve of opening the production they would slam me with a banning order. "Your play cannot be launched." … The idea was to frustrate me. … I did this Kenyan play based on the history of the Mau Mau uprisings by the Kenyan playwright Kuldip Sondi called *The Encounter*. We rehearsed it for four weeks. Two days before it was to open, the Department of Internal Affairs came over to me and said to me, "Look, your play cannot be opened. There is a banning order." They said, "If you like, you can appeal the banning order."

Ultimately, it became very dangerous to write scripts at all. If you look at black South African theater in the 1980s, you find that there were

a lot of workshopped and improvised plays—plays that were not scripted anywhere because it became too dangerous to write plays down. But, sometimes, we would have to produce a script for a bureaucrat who would say, "There is no play that can be workshopped. Blacksmiths and such people have workshops, artists don't! We are not fools." We would then write something down that was safe and then give this to the guy to read. There would be nothing about apartheid or anything. And he would say, "That's fine. You can perform." Of course, the play that goes on stage is completely different from the script that we had given the guy to read.

But, sometimes they would turn up (at the theater) and then we would have big problems. You would probably not even be able to go to the next city with your play after betraying them like that.[6] Over time, we established a reputation for high quality original theater. I was then able to get work produced by the Market Theater in Johannesburg. We had a full four-week season there with Zakes Mda's play, *We Shall Sing For The Father Land*. I also took my work to Grahamstown Festival. But still I had to keep my day job at that time. I worked as an insurance consultant of all things.

In 1989, largely through the work that I did with METGRO, the province that I lived in, the Northwest, started an arts council and I was asked to form the drama company of the arts council. That's when I first got my job as a full-time artist/art administrator and I was also their playwright-in-residence.

Windybrow

On February 2, 1990, F.W. de Klerk stood before Parliament to make the traditional opening speech and did something no other South African head of state had ever done: he truly began to dismantle the apartheid system and lay the groundwork for a democratic South Africa. In dramatic fashion, Mr. de Klerk announced the lifting of the bans on the ANC, the PAC, the South African Communist Party, and thirty-one other illegal organizations; the freeing of political prisoners incarcerated for non-violent activities; the suspension of capital punishment; and the lifting of various restrictions imposed by the state of Emergency. "The time for negotiations has arrived," he said.[7]

—Nelson Mandela, *Long Walk to Freedom*

Nelson Mandela's autobiography is aptly titled *Long Walk to Freedom*. The struggle for justice and equality in South Africa was, and in many ways continues to be, a tortuous one. Many outside observers perceived the country to be a caricature of good (i.e., anti-apartheid) and evil (i.e., the National Party government and its supporters). There were, of course, dissidents and changelings of all stripes in every camp. This simplistic view was probably a blessing, for if the true complexity of the situation had been known, it would have been even harder to bring international pressure on the regime. (As it was, it took over a decade

for the United Nations to impose a mandatory arms embargo in 1977.[8]) By the same token, some have imagined that the changeover from minority to majority rule in South Africa manifested abruptly the day Nelson Mandela was elected president. But the period between Mandela's release in February of 1990 and the ANC electoral victory in April of 1994 was one of protracted negotiation and slow transition. During this time, there were many incremental steps taken on the final leg of the dangerous and difficult trek from apartheid to democracy.

Thus far in his career Walter Chakela's contributions to that struggle had taken place in and around his home in the Northwest Province. Then, in the winter of 1993 he was invited to play a larger role in the unfolding story of the new South Africa at a place called Windybrow.

Pier Von Platen, the artistic director for drama at the (South African) State Theater was on my advisory council at the Northwest Arts Council. He was an Afrikaner guy, a progressive artist with a big voice in African theater. In the early nineties, he saw that country's democratic evolution was inevitable, and he started having conversations with me about the challenges of transforming the State Theater. He thought I could assist. He talked specifically about the Windybrow Theater, a historically white theater in the predominately black Hillbrow area of Johannesburg, operated by the State Theater. I was wary. The whole State Theater enterprise was a political hot potato at the time. The cultural boycott was still intact and a lot of performers and directors would not work at the Windybrow. But, around June of 1992, he started becoming very serious about this.

At the time I was also one of the presidents of the Congress of South African Writers (COSAW). We were engaged in conversation about developing a cultural policy for a democratic South Africa in the context of the negotiations. Initially, there was nothing about the arts and culture on the agenda. We felt we needed an agency to intervene, so we formed a group made up of members of the COSAW, the Performing Arts Workers Equity, and other formations. This group was drawn on a nonracial basis, even Afrikaner writers and performing arts workers became part of this.

In a previous incarnation the Windybrow Theater was a grand residence and a nursing home.
Photo courtesy Windybrow Theater

So, I raised the issue of the State Theater and the Windybrow with my comrades in this group. I said, "You know I'm having this conversation." Their advice was, "Well, since we are engaged in the process that will drive the transformation of the arts sector of the democratic South Africa you would be well advised to consider this seriously." Then, of course, I consulted with the culture department of the ANC. I told them I was interested in being in Johannesburg as a theater practitioner but I wanted to make sure that it made political sense, too. They said, "Why should we wait for the new government to be in power? A lot of things could be happening in the interim period, so go."

In February 1993, Walter Chakela became an assistant director of the State Theater and the artistic director of the Windybrow Theater. (From this point on Windybrow would be called the Windybrow Arts Centre.) Given that this was one of the lead events in his country's transformation, Walter felt a great degree of responsibility—and apprehension. The government of South Africa was still firmly in the hands of the National Party. Although the "secret" talks between Mandela and de Klerk were underway, the negotiations were in constant turmoil, as dissidents on both sides sought to disrupt their tenuous course. One particularly egregious provocation was the government's clandestine support for the disruptive activities of Inkatha Freedom Party.[9] Led by KwaZulu Bantustan leader Chief Mangosotho Buthelezi, machete wielding Inkatha followers had been regularly attacking ANC rallies and meetings leaving hundreds dead.[10] A few weeks after Walter arrived at Windybrow, the assassination of the respected leader of the South African Coloured Peoples Organization, Chris Hani, threatened to plunge the country into civil war.[11] Needless to say, tensions were high, and at the State Theater not everybody was happy with the stranger in their midst.

The first meeting I attended was in the State Theater boardroom at a table that seats forty people. The only other black person was a security guard. The meeting had no agenda. The CEO of the State Theater, an Afrikaner guy, a powerful fellow, went around the table and asked, "What are your issues?" Most said nothing. A few said something minor about their department. When they came to me, I said "Well, I find this all very, very strange. I'm still trying to understand what's going on here." In no time, they went completely around the table. A meeting of forty people lasted about twenty minutes.

The reception at the Windybrow was mixed as well. At the time, the company had an ensemble company of maybe 15 or 18 people. There were 5 black actors. The rest were white. They had medical leave, they had pensions, they were quite secure in their jobs. Some were really great performers, some quite progressive and quite hungry for a new South Africa. Others were petrified by the challenges and worried that I was going to engineer their departure.

The Windybrow was regarded as the State Theater's platform for avant-garde experimental work. Some productions would have one or two black people in the cast. Although they thought of it as the progressive arm of the State Theater, the cultural boycott was firmly in place. My colleagues in the Congress of South Africa Writers and the Members of the Performing Arts Workers Equity would have nothing to do with it. But I had been released by my comrades to go in there. I had the responsibility to start working for a new kind of theater as we prepared for a democratic South Africa.

To do this we had to change the goals of the Windybrow. This meant that the programming was going to be very different. But it wasn't easy. We took some inspiration from my friend John Kani who ran the Market Theater. We both confronted vested interests resisting change. Some of the struggles were against the structures of apartheid, but others were dealing with the conflict between new emerging black power and entrenched white liberals. The most difficult part was that you never knew who your friends were. Some people made all the correct sounds, but in practice their behavior was rather curious.

Ironically, democracy posed a dilemma for some who had been creating art in opposition to apartheid. The Market Theater, in particular, was a place where white liberals created the space for South African protest theater. But all of a sudden, protest theater disappeared. It was here yesterday, and today, it's all gone. It came to an abrupt halt. And the question, of course, was what would take its place?

But a lot of new work was being developed—work that grappled with the idea of transition and the moment of the release of political prisoners from Robben Island—what that moment meant. Also, work that dealt with the process of the negotiations. Writers looked at all that, and tried to unpack it for what it truly represented, what the struggle was about. When the first black president of South Africa was inaugurated—Dr. Mandela—some of the literature was about, "This is wonderful. Let's celebrate this moment. It's a moment we have all been waiting for and fighting for." Others said, "What is this? Is this authentic? Is this true liberation? Is this true democracy?"[12]

When I met the media, they asked, "What will you be bringing?" I said, "I come from a tradition that is mainly theater of resistance, but also theater with a very strong African sensibility." I said, "I am schooled in the theaters of the world. I can engage with Europe. I can engage with England. I can engage with America. But, I will also bring in the theater from the third world—something that has been missing in the education of most of my white compatriots." They asked, "Will you still continue to do Shakespeare?" I said, "I have a bit of a Shakespearean sensibility, but I also want to bring Soyinka, Joy Degrafe, Gibson Kente, Zakes Mda, into the theater."

Princes and Spiders

If they knew everything that he knew they would not have torn him to shreds some time ago to keep the world the way it was where secrets and evil bore the same name. —*Maru*, by Bessie Head[13]

Walter Chakela knew that politics was always going to be a big part of his new job, but his primary aim for the Windybrow's 1995 season was to change the nature of the theater being produced there. The previous director had mounted productions that used most of the white actors. One of Walter's first productions was *Maru*, by Bessie Head, which he adapted for the stage. *Maru* tells the story of a Tswana prince, who marries a Bushman woman named Margaret, and of their struggle with Tswana prejudice towards the new princess's San tribe. Most of the characters are black, but there was a part for a white woman as well. Walter recalls that there was a lot of skepticism toward the "new direction" that he was taking the theater.

People were particularly worried about how the play would impact the theater's traditional audience. There was an impact, for sure. *Maru* brought in more black people than the theater had ever seen. In fact, you know, *Maru* continues to draw audiences because it was prescribed for the schools. That production kicked off what turned out to be a great first season. We followed *Maru* with *Kweku Ananse*.

The Ananse legends figure prominently in traditional storytelling throughout Africa. In South Africa they are not known as Ananse stories, but the main character is a spider just the same. The theater based on these tales, called Anansesem, plays an equally important role in African culture. Walter's adaptation is a trilogy of traditional Ghanaian spider tales presented with music in a contemporary South African context. Each story, told by a village elder to a group of children explores how the surprisingly mischievous Kweku outsmarts his more powerful adversaries, the tiger, the snake and the leopard. Along the way the prideful Kweku Ananse learns some important lessons as well. Walter's Windybrow production was the culmination of a life-long effort to bring his childhood stories to the stage.

Kweku Ananse was sparked by my memories of my mother and dad and storytelling. You see, these moments were not exclusively for children. When my mother told her stories, I was quite aware that my dad enjoyed himself as well sitting there with us, listening intently. And if there were any other adults with us, I could see that they were equally enchanted. So, later I thought, Why can't we create theater with the same qualities? Why can't I create theater stories that the whole family will enjoy, where everybody, child and adult, is able to find their level in the narrative?

This is a play I had worked on in the Northwest. I thought if we do *Ananse* as a musical everybody will enjoy it. The music was written by a

The cast of Kweku's Ananse on the stage of the Windybrow Theater. Photo courtesy Windybrow Theater

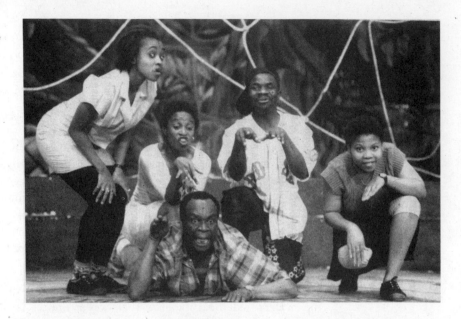

Canadian jazz musician called George Lee. We did the first trial run of the thing and people loved it. Whole families came. People would phone me and say, "You know, we saw the show yesterday, but the music and the images refuse to leave us. We've been whistling the music the whole morning." Somehow these elements persisted. Not because they are complex, they are very simple. I suppose, great theater is a theater that does not seek to be too clever. I think *Ananse* is such a play.

As the season unfolded, it became very clear what it was I was bringing. I picked up a Nigerian play by Segun Oyekunle called *Katakata for Sofahead* in pigeon English (*Katakata* is about the experiences of inmates in a prison, and about the social environment that sustains poverty.) It was a great first season.

As Walter's inaugural season was unfolding at the Windybrow, democracy was having its tenuous debut on the national stage. One of the key elements in the settlement negotiated between the ANC and the government was the scheduling of elections. Although the outcome of the vote was not in question, many worried that militant opponents of the agreement, like the Afrikaner Resistance Movement or the Inkatha Freedom Party, would push the country into civil war to prevent them from taking place. On April 27, 1994, despite numerous threats and provocations, South Africa's first democratic election was conducted peacefully. With almost two-thirds of the vote, the ANC swept the election. Although the National Party and the Inkatha Freedom Party only garnered 20 and 10 percent respectively, there were no significant disruptions. As President of the country's transitional government, Nelson Mandela would preside over a cabinet that included representatives from all parties that received

at least five percent of the vote. This transitional arrangement was created to minimize discord in the changeover from minority rule. Despite the potentially cumbersome nature of the new government, a new South Africa had emerged and the Windybrow was a part of it.

We started the Windybrow's second season with an adaptation of a book by Bloke Modesane entitled *Blame Me on History*. Bloke was one of the legendary creative characters from Sophiatown, which in the 1940s and 1950s was the cultural heart of black South Africa. Sophiatown is where artists like Hugh Masekela, Miriam Makeba and Abdullah Ibrahim flowered artistically. Nelson Mandela practiced law there during the 1960s, just before the government destroyed it and forced its sixty thousand inhabitants to a place called Meadowlands. The book, which was adapted as a musical called *Bloke*, tells the story of Sophiatown in the context of Bloke's life.

Plays like *Bloke* continued to bring new audiences. They broke rank with the negative past and embraced the new spirit of the country. If you wanted to see theater based on the African narrative, if you asked anybody, they would say, "Well, go to the Windybrow." It became a laboratory. New work was incubated and showcased there. If a young person said they had an idea, then we wanted to listen to the idea. We would ask, "Can you write a play based on this idea? If not, well then, we will match you with a writer."

The Windybrow also became a cultural center not just for theater specifically, but also a space where the artists in Johannesburg convened, where writers met to have workshops, to have discussions, to have meetings. We became an intellectual hub for Johannesburg, for South Africa. All of a sudden, it became normal to see Amiri Baraka in the theater, to see Nadine Gordimer in the theater—people you never dreamed would set foot in the Windybrow. It was not unusual to see Wole Soyinka walking through the lobby or August Wilson who came and conducted workshops.

An important aspect of our new mission was the nurturing of new talent. So we started a series of workshops run by playwrights like Zakes Mda and Matsemela Manaka. Others were run by poets like Keorapetse Kgositsile. Some of the plays that came out of those workshops have been quite successful, picking up the highest theater awards in the country. We also produced work by accomplished writers who had never had the opportunity to have their work on stage. We eventually created an ongoing platform for new work called the Windybrow Arts Festival.

As he settled into his work at the Windybrow, Walter felt a sense of both accomplishment and frustration. By 1996, The Centre had begun to fulfill its mission to become a home for the emerging dramatic and literary voices of the new country. Each succeeding year, new works, some incubated in Centre workshops, were being introduced to audiences. Actors, directors, poets and

musicians from Africa and Europe and the US had come to the Centre to perform and teach. These included Amiri Baraka, August Wilson, Nadine Gordimer and Dennis Brutus. Many of the South African writers, directors and actors, such as Emily Tseu, Julian Mokoto, Duma Mnembe, Martin Koboekae, and Gcina Mkhize had cut their teeth at Windybrow and were helping to establish a new South African presence in international theater scene. The two-week Windybrow Arts Festival had become one of the country's premier theater events. The Centre's impact offstage was significant as well. Programs created with surrounding communities took theater into local schools and prisons.

Administratively, things had not gone as smoothly, however. The new government was struggling to make ends meet, so each year's allocation never met the actual need. In addition, under the transitional government, the break with the past had not been as clear-cut as the election results. In some quarters, the separatist attitudes and resentments of entrenched bureaucrats still influenced many decisions. Some individuals at the State Theater, which continued to oversee the operation of the Windybrow, admonished the Centre for not being more self-supporting. Walter, on the other hand, was trying to create new theater and build a new audience, in a new country. Both affordability and easy access for community members were critical to that effort. As he and his colleagues saw it, the Windybrow was nurturing a South African creative resource that had been neglected and repressed for centuries. They felt that the work being done at Windybrow was as essential as the building of new roads or the extension of the electric grid, and should be supported as such. Walter was passionate in his advocacy for the Centre and its mission. For this he attracted many friends—and some enemies.

Despite the pressures, or maybe because of them, Walter continued to put energy into his own creative output. Each year, his adaptations or original scripts appeared on stage at the Windybrow or other venues, often with Walter as the director as well. Although he was extraordinarily busy, he also found time to work on his poetry. This creative work was particularly important because, at his core, Walter had always seen himself as an artist. He knew his creative side could easily be lost in the tumult of the political infighting that so consumed the country. As the millennium approached, Walter was pushing hard on both fronts.

Sweat

When they are detained without trial, it may be for what they have written, but when they are tried and convicted of crimes of conscience, it is for what they have done as "more than a writer." "Africa, my beginning ... Africa my end"—these lines of the epic poem (banned in South Africa) written by Ngoapele Madingoane epitomize this synthesis of creativity and social responsibility; what moves him, and the way it moves him, are perfectly at one with his society's demands. Without those demands he is not a poet.[14]
 —Nadine Gordimer

2001 Atlanta, Georgia

As the audience buzzes around him, Walter sits quietly, staring into the cover of the playbill in his lap. "7 Stages Theater Presents ISITHUKUTHUKU (Sweat) By Walter Kefuoe Fikelephi Chakela. A play in narrative verse and dialogue." Atlanta is a long way from Joburg. Nevertheless, it is exciting—waiting for the curtain to rise on this play, this figurative and literal "Sweat," this child that he has shared with Del and his company these many weeks. It is exciting to see this magnificent theater filled and bubbling with the music of small talk and laughter. How many times has he done this, sat in the audience waiting for the lights to dim, waiting for another of his creative children to emerge from the shadows? Waiting in Antwerp, waiting in Norway, waiting in Hillbrow. It's the same everywhere, almost— except for the sounds of the audience. The voices of his homeland are different, distinctive. He misses the rough rhythm of sentences woven in layers of seTswana, English, Xhosa, and Afrikaans. He misses the mélange of magic and story this ragged chorus evokes in him. This is one of the reasons he has made this play—to provide a place where the sweet cacophony of his homeland comes alive. A place where the poetry, the rhythm, the mix of contradiction and harmony of that inconceivable place, this impossible history are seen and heard by other people.

As the house lights dim, he resists the urge to turn around, knowing that the actors and the chorus will enter from the back, singing. The blended voices feel distant at first, as though someone has forgotten to shut a radio in the back of the hall. But slowly, methodically, the procession moves forward down the aisles and the rhythm of his words fills the theater. Walter feels the poetry push him a bit closer to home.

In 1999, Walter was invited by the Walker Art Center in Minneapolis, Minnesota to participate in a four-year initiative designed to broaden the museum's understanding of the cultural environment "outside of the European context." His membership in the initiative's seven member advisory committee introduced him to colleagues from around the world, and brought him to the US twice a year over a four-year period. Walter used the opportunity to visit artists and arts programs in other American cities. During a visit to Atlanta, Georgia, to look into that city's Black Arts Festival, he was introduced to Harriet Sanford, then head of the Georgia Council for the Arts. Sanford, who had just come on board at the Council was very interested in cultural development in the new South Africa. She and Walter hit it off immediately. Although he was officially representing the Windybrow, she related to him more as an artist, particularly when she heard about his new play, *Sweat*. The play, which had been produced in Brussels and Johannesburg, was a montage of storytelling, dance and a capella harmony that dealt with the plight of South Africa's farm and industrial laborers during apartheid and the painful road to reconciliation. Excited about the potential for a US production of the piece, Sanford put Walter in contact with Del Hamilton, the Artistic Director of Atlanta's 7 Stages Theater.

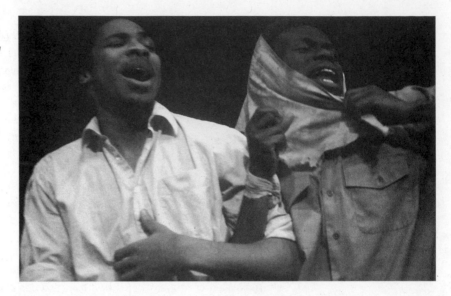

Atlanta actors Duain Martin and Mathew Johnson sing out in the 7 Stages Theater production of Sweat. Photo Yvonne Boyd © 7 Stages Theater

Founded in 1971 by Hamilton and Faye Allen, 7 Stages is a theater company with a reputation for staging new work dealing with social and political issues and a commitment to international collaboration. Del recalls that the "subject of an exchange between 7 Stages and the Windybrow came up immediately" when they were introduced. The partnership that emerged from their ongoing discussions bore fruit in a number of ways. In 2000, 7 Stages partnered with the Youth Ensemble of Atlanta (YEA) to premiere *Soweto! Soweto! Soweto! A Township is Calling* at the Windybrow Arts Festival. Created by the ensemble members and director Freddy Hendricks, the musical production commemorates the death of Hector Peterson, the first youth to die in the Soweto uprising of 1976. In addition to winning a Best at the Festival Award, YEA's work through Windybrow with young people in Soweto Township prompted the creation of the Soweto Youth Ensemble. In 2002, Robert Earl Price, the 7 Stages playwright in residence at the time, took his play about the life of Thelonius Monk, *Blue Monk,* to the Windybrow.

In between the mounting of *Soweto!* and *Blue Monk,* Walter brought *Sweat* to 7 Stages. The piece, which had as its genesis a eulogy for a legendary poet, ended up as a testament of grief, love and exaltation for all of South Africa.

Making *Sweat* was a unique experience. It was probably the most unorthodox creative process that I've ever followed. It started with the death of a very close friend of mine called Ingoapele Madingoane in 1996... He was known as the poet laureate of Soweto. He was a great artist and an amazing character. One time in the 1970s there was a poetry reading dedicated to the writers of Zimbabwe in a place called FUNDA Center[15] in Soweto. As was often the case, he was on the chair presiding as the MC.

Just as we started, the security police came marching in there with their guns. Madingoane did not skip a beat. For that whole poetry session we all recited poetry at gunpoint.

Madingoane wrote an anthology of poetry called *Africa My Beginning*. This work was banned by the apartheid government because it became so popular among township youth in Johannesburg. The banning had little effect. School kids and students all over Soweto could recite the entire poem from memory.

I was very shocked when he died. He was not an old man. I wrote a tribute to him to read at his funeral, which eventually was called, "Death of a Poet." But at the funeral, something told me that I was going to do something more with it, so I kept it back. Later I shared the poem with a friend, Charles Kone, in Antwerp. Charles runs a very leftist-oriented theater company there. When he read this piece he said, "This reminds me a lot of Pablo Neruda." As we talked back and forth we started envisioning a play.

So, I started writing. Different parts just came out. The first was about creation—the mix of African creation stories. As I wrote, I started to explore the duality of my different artistic identities—the language of the poet, the language of the playwright. I wrote about the South African labor struggle, the land question, the truth and reconciliation process, and, then, there was the part I started with, "the death of a poet." These were the four movements in the play. They seemed incongruous, but I felt they belonged together. It came to me, that this play would not have a linear story line at all—it would be a stream of consciousness made of these many parts of the South African story—the through line would be the arduous toil, the "sweat" of the struggle.

The first movement is under way, and Walter is literally sweating. He worries that the impressionistic sequence of stories will confuse the American audience. But, so far, so good. The singing sounds magnificent in this theater. He is thankful that his good friend Prince Lengoasa was able to obtain a visa so he could direct the music. He is also thankful that the American cast seems to be taking this play to heart.

Eugene, the narrator, steps slowly into the footlights on the barren stage, staring intently into each of the 300 pairs of eyes before him. He pauses, like a wary jaguar at a waterhole. Like him, the audience is focused, listening. At first, the creation story flows with an easy rhythm. The deity's various names are recited—Nkulunkulu, Thizo, Somandla,—and the world is made un-lonely for the creator. Beast by beast, mountain by mountain, stream by stream, mother Africa appears. Almost imperceptibly, though, the narrator's pace quickens. As the story tumbles forward, his insistent baritone seems to reach out and seize the audience by their collective lapels. In the dimming lights, Walter can

almost see innocence slink from the stage as the narrator describes the coming
of labor and ownership and the terrible genesis of his homeland.

The fruits
of labor brought about wealth
to man and woman
Labor brought about
Prosperity
for them
Large tracts of land
were brought under the hoe
Trees
that once swayed in the air
with carefree abandon
came under the ax
The earth,
once vast and wide
and
life sustaining
came under the mortar machine.
Large jungles
fashioned from cold concrete
emerged
and darkened the horizon
Shutting out
the rays of the sun
and dulling
the brilliance of the moon
The stone-cast jungle
became the abode of
man and woman
the alter
at which they worshiped.
But
They
were not alone anymore
Large number of faces
drooping faces
wreathed with hunger and thirst
for a share
of what man and woman possessed.
This cannot be
asserted the couple.
This was for

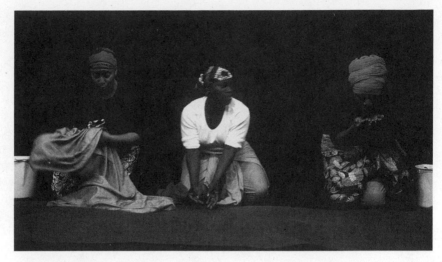

Three township women wash and share secrets in Sweat (Left to Right) Adrienne Renyolds, Kimberly Geter, Robin Smith.
Photo Yvonne Boyd © 7 Stages Theater

their exclusive use.
This was for
their exclusive enjoyment

Many outside South Africa marveled at the relatively non-violent nature of the South African revolution.[16] How, after so much brutality and degradation, did these people not descend into an orgy of vengeance? How was the inevitable bloodbath avoided? One of Walter's intentions with *Sweat*, was to reveal the hidden tributaries of the story that had taken his country to this seemingly surprising place. He wanted to reveal the "other struggle," hidden in the space between the headlines. This was the struggle that had been carried on the broken backs of slave-wage mineworkers, separated from their loved ones for years at a time. This was the struggle sustained by the mothers, who nurtured the remnants of broken villages and ruined families, the struggle borne on the souls of the young ones who sacrificed their innocence and their lives on the streets of Sharpeville and Soweto, the struggle chronicled in the words of street corner philosophers, neighborhood scholars and township poets. This was the everyday struggle of 400 years and 14 million people, paid for with patience, dignity, eloquence and sweat.

Before *Sweat* I'd read a lot of plays by American playwrights like August Wilson, Amiri Baraka, and Robert Earl Price. These showed me that other artists were grappling with similar issues outside of South Africa. Even though there were areas of difference, the brutality was almost the same.

Walter has lost all sense of time. It seems as though the curtain has just gone up, but the play is nearly half done, approaching what he feels are the hardest parts for the audience. The action on stage is brutal. A young mother struggles

with two black South African soldiers bent on taking her baby. As she is clubbed into submission, her screams of "Murderer, Pig!" speak truth to the unthinkable, as she is dragged off to bear witness to her child's fate.

Her place is taken on stage by another young woman, who struggles defiantly with two more soldiers, before she is taken off to be raped. The sounds of her struggle and mortification lays siege to the barren stage. Walter feels the anxious breathing of the audience members around him as they brace for more. Then, from the shadows, the first young woman, the mother, emerges slowly, cradling a small bundle. When one of the soldiers moves to intercept her, she stops and pulls back the covers, revealing a lamb. The soldier screams, "What the hell, what is this? Are you mad?" She replies rapturously, "He is such a lovely child? His name is Buntu. Isn't he a lovely child?"

After an argument over whether to kill the crazy woman, the soldiers move on. The woman who has been raped rushes to the mother's side, comforting her, she speaks slowly.

> They mowed down our youth
> Like they were mowing down a cactus field.
> Oh! That we have to endure so much pain
> Before the dawn of our day
> Which will come
> As surely as tomorrow will come
> But why must freedom cost so much
> Before giving anything back?

Then the disembodied voice of the narrator descends over the darkening stage.

> Man and woman
> Were given freedom on the earth
> They were given lordship
> Over much that was good
> But they sowed pain
> That tugged at the heart strings of
> Even the Creator
> When the new dawn broke
> It came like a storm
> And caught many unawares
> The man
> The woman
> And
> The many in the land
> The moment
> Of truth

Was upon
The man
And
The woman
The moment
Of truth
Was upon
All of us
The mighty
And
The weak
Were called
To account.

Even to this day some people still think that the Truth and Reconciliation Commission did not go far enough—that it was a ploy to gloss over the inequities of the past. But there are far more who, like Walter, believe that it has served its purpose.

Even I have come around to understand the significance of it. In whatever I do in the new South Africa, whether it is still dealing with my own anger at apartheid, my own personal experiences, or the experiences of my wife or my friends who are alive and those who are dead. With the Truth and Reconciliation Commission at the back of my mind I have a bit of a balance as I engage with contemporary South African life.

Sahr Ngaujah (Left) and Mathew Johnson animate the stage in Sweat. *Photo Yvonne Boyd © 7 Stages Theater*

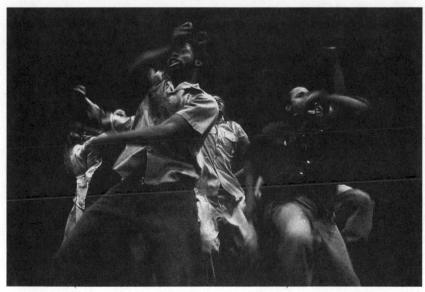

The Truth and Reconciliation Commission has taken over the theater. Chronicles of abduction, torture and murder swirl like specters in a wash of blue klieg. With each account, the uncovered pain multiplies and propagates, as actors playing ghosts of the victims mingle in the audience, repeating the testimony over and over. "All I want to know is where they have taken my son. All I want to know…?" Each iteration pulls Walter back into the open wound of his homeland. He wants the people around him to feel the raw edge of the hot scar still forming from the liberation of these stories. He wants them to know the roughness of the healing. He wants them to know that there is no perfect justice and that the struggle continues.

Most of all he wants them to touch the source of his own healing—the words of Madingoane, his beloved comrade, the poet of the people who is gone, but never forgotten.

> *I*
> *Remember*
> *Poet*
> *the spirit*
> *you instilled in the people*
> *when you read*
> *Africa My Beginning.*
> *I don't remember*
> *any poem*
> *in the history*
> *of our literature*
> *that so stirred the people*
> *as this one*
> *In that sonorous voice*
> *you bellowed:*
> *"Freedom*
> *is the law of nature.*
> *Justice*
> *is deeply rooted*
> *in the universal order of things.*
> *I am*
> *because*
> *you are.*
> *Because you are*
> *I am."*
> *This*
> *was how*
> *you whipped*
> *your audience*

into a poetic frenzy.
The relationship
between
people and their poets
is much distorted these days,
but
I suppose
the poetry
written by true poets
will live
after them.

CHAPTER 8

Artists for Human Rights

HUMAN RIGHTS DAY ARTS EVENT ANIMATES IDEALS

A Human Rights Day event in Durban last Saturday went well beyond its original aim of commemoration. It projected a kind of animated symbolism and illustrated graphically some of the very ideals embodied in the Universal Declaration of Human Rights (UDHR). The celebration marked the 40th anniversary of the Declaration.

Apart from the visual art aspect—an exhibition to which artists from all over South Africa had contributed—the days programme included active participation in a number of activities. Organized by the Black Sash and Lawyers for Human Rights who had called on artists," art lecturers and art teachers to help them, a massive children's workshop was held in which no fewer than 400 children expressed their feelings about freedom and human rights. —*Daily News*, Dec. 10, 1988

FOR SOUTH AFRICANS fighting apartheid the 1970s and 1980s were tough times. In the early 1970s, a worldwide financial downturn had exposed the weakness of the South African post WWII economic "miracle." As unemployment grew, hundreds of thousands of striking black workers in Natal and Gauteng Provinces filled the streets. The economic paralysis that ensued made it clear that the slave-like exploitation of black labor could not be sustained. While some token work reforms were instituted, the NP regime, threatened by a resurgent labor movement, also tightened the screws of apartheid repression and intimidation. Many in the movement saw the Soweto Uprising in 1976 and the murder of Steve Biko in 1977 as inevitable blowback from an increasingly desperate regime. Predictable or not, these tragic events precipitated a decade of escalating tensions and conflict that marked the great turning point in the long anti-apartheid struggle.

By the mid-1980s South Africa was being treated by the international community, save the US and Great Britain, as a pariah state. Internally, turmoil ruled the day. Following the 1984 election, new Prime Minister PW Botha's NP government responded with the passage of a "comprehensive reform" program

they called the Total Strategy.[1] Two years later, as matters continued downhill, a state of emergency was imposed. Despite these efforts, by year's end, work stoppages and protests had spread throughout the country and Total Strategy had collapsed under the weight of its own hypocrisy. To make matters worse, in early 1988, the South African Army was defeated in an ill considered "police action" in Angola, while at home the government's clandestine support for the Inkatha Freedom Party nudged the country closer to civil war. As the end of the decade approached, it was becoming increasingly clear that the National Party's hold on power was no longer unassailable. The stage was set for change of one kind, or another.

Black Sash

Black Sash members, with few exceptions were white women. The Nats (National Party) didn't like to harass, imprison or kill white women, you see. It didn't look good. We were an organization that the security police were very anxious to infiltrate. We found that the more activities you engaged in, the stronger you got. Originally, we were allowed to do mass "stands" (silent vigils), then they passed a law that you could only stand by yourself, one person, so far apart. The regime tried very hard to make you vulnerable. I remember doing a stand one day and a young policeman came to take a picture of me and to question me. I could see he was frightened of me and that gave me a lot of courage. He was shaking because he felt nervous about Black Sash women. That kind of thing made us stronger. In the big white South African population, most wives just kept quiet and enjoyed the benefits that the party brought to them. But of course, today, you won't find anybody who wasn't against the government.

—Coral Vinsen

By 1988, the Black Sash organization had been pushing for change in South Africa for over three decades. Founded in 1955 by a white middle-class housewife named Jean Sinclair, the "Sash" was a rallying point for many white women involved in the anti-apartheid movement. Its members "used the relative safety of their privileged racial classification to speak out against the erosion of human rights in the country. Their striking black sashes were worn as a mark of mourning and to protest against the succession of unjust laws."[2]

Black Sash was always on the lookout for powerful anti-apartheid symbols. The UN Human Rights Day exhibition was the brainchild of Coral Vinsen and fellow Sash member Lorna Ferguson, the curator of the Tatham Art Gallery in Pietermaritzburg. The two thought the fortieth anniversary of the UN Human Rights Declaration was the ideal moment for a party, of sorts. They decided to mount a national art exhibition to shine a light on the government's human rights abuses and remind the country that, in 1948, National Party-led South Africa was one of only six countries that refused to sign the accord. The event

would be the perfect opportunity to involve artists from around the country in their anti-apartheid effort. Most importantly, though, they knew that the provocative image of 400 black, white and coloured children making art together would both rankle the government, and produce a striking reminder of apartheid's inherent inhumanity.

The event, held on December 10, 1988 (International Human Rights Day), at the Durban Exhibition Centre did just that. Artists from all over the country provided work for the exhibition. Press coverage of the event was widespread both in and out of the country and the regime was indeed provoked. Coral recalls that it was a particularly dicey period for human rights activists. "This exhibition was especially scary because we were in the last throes of apartheid. Earlier in the year, 17 anti-apartheid organizations, including the Durban Detainees Support Committee (of which she was a member[3]), had been banned. So, this was a tense time."

Encouraged by their success, Coral and her cohorts continued to incorporate the arts into their ongoing work. Eventually, the group responsible for the exhibition joined with others to form a separate committee called Artists for Human Rights (AHR). In the final years of National Party rule, the group continued to use the arts to advance Black Sash's anti-apartheid work. As it became clear that the country's pro-democracy majority would at last prevail, the group turned its focus to social issues and the advancement of democratic values.

The Bill

In his inaugural address on May 10, 1994, Nelson Mandela proclaimed that the historic election was a "common victory for justice, for peace, for human dignity." But that victory was just the beginning of a long and arduous road for the new South Africa. The first task for the interim government was to write, and gain the approval of, a new constitution. Over the next two years, a Constitutional Assembly, co-chaired by the ANC and NP worked to bring form to the values and ideals of the new South Africa. One of the most intriguing aspects of the process was a campaign soliciting citizen input that generated over two million submissions. Those charged with the task found the constitutional birthing process nearly as complicated as the painstaking negotiations that made it possible. The greatest difficulties that arose during the multiparty deliberations were over such issues as the death penalty, land rights, official languages, local government autonomy and proportional representation. Despite many stops and starts, the final draft was finally approved by the Parliament in early 1997.

Touted as one of the most progressive of constitutions in the world, the document emphasized cultural as well as civil rights. It established education and economic and environmental justice as basic human rights. It also abolished the death penalty, outlawed hate speech and recognized eleven official languages. The cornerstone of the constitution was its Bill of Rights. Each of the Bill's twenty-seven clauses articulated specific freedoms and/or rights guar-

anteed by the constitution. Universally recognized principles such as freedom of expression, religion, privacy, association and assembly were represented in specific clauses. Other articles reflecting South Africa's bitter history included freedom from slavery and forced labor, the right of workers to organize, the right to health care, children's rights and the rights of language and cultural participation.

The new South African constitution was a monument to 350 years of struggle. Nonetheless, the country's leaders understood that the real work of building a republic lay ahead. As visionary as it was, the constitution was only a document—a fragile dream of an emergent democracy. Without the understanding and active involvement of its citizenry, the ideals and principles it embodied would not be practiced and tested, the dream would wither. There was ample evidence of this around the world.

Even before the constitution's final approval, Artists for Human Rights had begun thinking about how they might contribute. The freedoms articulated in the Bill of Rights had been the focus of their work over the past decade. For AHR (along with the majority of South Africans) the twenty-seven clauses were not mere abstractions; they were an itemized inventory of justice denied. While the Bill's creation was a critical step in the transition from tyranny to democracy, its realization would be the true antidote for apartheid's poison. To do this, these principles would have to move from the printed page into the consciousness of the country's vastly expanded citizenry.

In early 1996, as the interim Bill of Rights was being debated, Coral Vinsen approached muralist Terry-Anne Stevenson about creating tee shirt images to promote and celebrate its anticipated approval. She had come to the right person. In 1992, when an early draft of an ANC version of the Bill was circulating, Terry-Anne had coordinated a mural project that portrayed each clause as a separate panel. While the project was celebratory for some, Terry-Anne recalls that others were less sanguine about it.

> We painted it at Old Central Prison (in Durban) which had been decommissioned as a prison and had become a military camp. When we went to the commandant and asked if we could store our paints there overnight, he said, "This not a circus. I'm a small peanut in a big bowl and I can't give you permission." He was very much against what we were doing. As we were painting, all the soldiers would swear at us and say, "It's against the law, it's against the law." Two days after we finished, it was defaced. ... Where it said, "the right to vote," someone had scratched in, "whites only." But for us, as artists, there was an amazing vibe, to say the least—all of us working together for a new South Africa. It was very powerful, very strong. That's why the images were so strong. You can see it.

This experience taught Terry-Anne a great deal about the power of images to both teach and provoke. For many in the community, the twenty-seven panels not only represented the Bill of Rights, they were the Bill of Rights. When she

heard the tee shirt idea, Coral recalls, Terry-Anne had another thought. She said, "Why don't you do a print portfolio? I'll introduce you to Jan Jordaan."

Images of Human Rights

> Very soon after I arrived in Durban I organized a workshop with a mixed group of 30 artists. Each one took a canvas one meter by one meter and we made a collective painting. It was like celebrating art and creativity. We painted on all of the canvases so there was nothing like an individual canvas or anything like that. That was, I think, the first time that artists from all sectors and societies actually came together and did anything like that.
>
> We were young, so it didn't occur to us really that what we were doing might be considered out of line or political. But, in retrospect it's apparent that given our situation, this was very unique. I also think it contributed to the model that emerged later. Every artist receiving the same size paper, where the playing ground is level, where the objective is the same and, most importantly, where it is one work. It was a visceral reminder that we are a part of humanity at large and that we were not out there by ourselves. This was a very powerful thing in a place that was not only alienating one from the other, but also alienating one from the self. —Jan Jordaan

Jan Jordaan had come to Durban in 1975 to teach printmaking at the Durban Institute of Technology (DIT). As a progressive Afrikaner with a background in both the fine arts and anthropology, he was an interesting fit for the Institute. DIT was one of eight technikons in South Africa that emphasized a hands-on, technical approach to post-secondary education and training. As such, the liberal arts were not its strong suit. However, DIT did have a relatively strong program in the arts, particularly printmaking, which was Jan's forte. And, while it was an all white institution, like many of South Africa's colleges and universities, the DIT faculty harbored a good number of anti-apartheid sympathizers.

The DIT administration was a different story and Jordaan was not one to let this go unchallenged. In 1982, he and a colleague on the faculty had the temerity to ask the Technikon's Rector for funds to attend the ANC Cultural Congress to be held in Botswana.

> We were in a state of emergency, the ANC was banned, and the bombings had started up again.[4] He probably picked up the phone to call the security police, but then I was already being looked at because of my involvement with the trade unions. I suppose it was a bit rash, but we also wanted to make a statement. We obviously didn't get the money, but we got onto our motorbikes and went anyway.
>
> This conference was the first time that South Africans locally and South Africans in exile openly got together. It was a very intense week exploring how culture could assist with the struggle. We also partied and

really just had a very good time. When we came back we were all stopped at roadblocks and our papers were taken away. We got home and we were all raided.

Despite his continued agitation at the Technikon, Jan's activism and his art making had never really joined up until 1996 when Terry-Anne Stevenson and Coral Vinson contacted him about the Bill of Rights project. As a labor activist, he was always sharing his artistic expertise. More recently, he had been at the forefront of DIT's transformation into a majority non-white institution. But the possibility of linking his creative livelihood and his politics in a formal way had never presented itself. In fact, his enthusiasm for the Bill of Rights project was just that, he liked the project and wanted to support the effort in any way he could. He never imagined that they were launching an international arts-based human rights organization.

Terry-Anne's idea for the project was fairly straightforward. Using the model she developed for the Human Rights mural, they would ask individual artists to create a print image reflecting one of the twenty-seven clauses of the Bill of Rights. The key difference, of course, was that in the print format, there would be multiples of each image and the resulting collection of prints, or portfolios, could be exhibited anywhere and even sold. To keep the portfolio manageable, Jan felt that they should limit the size of the black and white prints to no larger than 600 millimeters (23.6 inches) by 400 millimeters. (15.7 inches). He would do the actual printing at the DIT studios. Unfortunately, since they only had enough money (left over from previous AFHR projects) to pay for the printing, there would only be token compensation available to the artists for their work. The payoff for the artists, though, would be inclusion in a historic collection that would be exhibited at home and abroad. The organizing group, consisting of Coral, Jan, Terry-Anne, Riason Naidoo, Joan Deare, Virginia MacKenny, Sabine Marschall, Carey-Anne May, Prem Singh, Avi Sooful, and Annie Webber, agreed that the twenty-seven artists should reflect the diversity of cultures and experiences of the new South Africa.

Even though the "Bill" was still being debated, they were confident that any changes would be in language and not subject. Each of the twenty-seven clauses had roots that went back to the early days of the struggle, particularly the Freedom Charter adopted by the Congress of the People in 1955 and its precursor the 1948 UN Universal Declaration of Human Rights. For the organizers this history was critical. They wanted the portfolio to reflect both the evolution and the content of the Bill of Rights. While the legal document would establish the statutory foundation for democracy, the *Images of Human Rights Portfolio*, as it came to be called, would literally show the link between the story of the struggle and the ideals that had driven it.

The artist selection process was delegated to galleries and studios throughout South Africa's nine provinces. The invited artists responded enthusiastically. A number of the country's most prominent creators were included. Among them

were Dominic Thorburn, Azaria Mbatha, John Roome and Philipa Hobbs. But, artists whose careers had only just found breathing room in the transition to democracy, such as Samkelo Bunu and Pieta Robin, were also featured. Many were connected with universities. Still others, like Jonathan Comerford, David John Yule, Nhlanhla Xaba and Ezekiel Budeli, were affiliated with studios such as Artist Proof in Johannesburg and Hard Ground Printmakers in Capetown. These grassroots ateliers, along with community arts schools like the FUNDA and Rorkes Drift Art Centres and Ruth Prowse Art School, were a part of an "alternative" arts network that had recently emerged from the shadows of apartheid.

Most of the artists were assigned clauses through random selection. A few were matched by other means. William Zulu asked for *Clause 3: The Right to Life*. His fine-lined rendering shows a woman and child he described as symbolizing "the building block of any national family." *Clause 20: Children's Rights* was contributed by Sinuses Sabela, a thirteen-year-old high school student. His linocut had won a competition organized by the Images of Human Rights Committee among school children throughout the Kwa-Zulu-Natal Province. The frontispiece, which served as the cover art for the catalogue was also chosen

The frontispiece for the Images of Human Rights Portfolio *was Nathan Kaplan's image of democracy in action.* Photo © Art for Humanity

William Zulu's Clause 3, The Right to Life. Photo © Art for Humanity

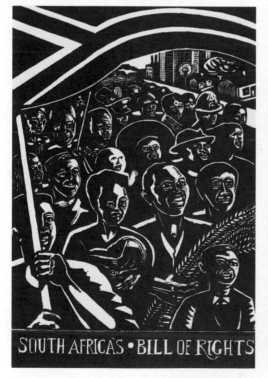

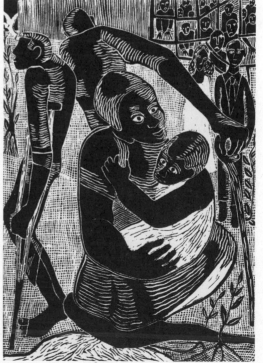

James Mphahele, a victim of torture, created Clause 4: Freedom and Security of the Person. *Photo © Art for Humanity*

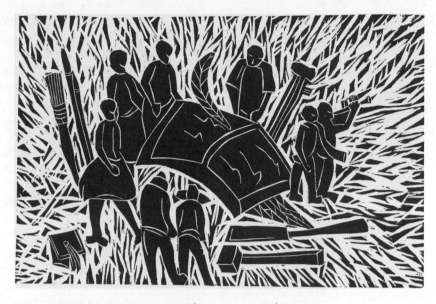

Vedant Nanackchand's Clause 26: Access to Courts. *Photo © Art for Humanity*

through a national competition. Norman Kaplan's image shows an expectant crowd of South Africans marching forward under the banner of the nation's new flag. Jan Jordaan was requested by the committee to contribute and (in this instance) assigned himself the portfolio's end paper, which he called *Birthright*. The woodcut he produced is truly an image of a new beginning.

The twenty-nine prints comprising the portfolio exhibition, opened by Justice Albie Sachs of the Constitutional Court at the Durban Art Gallery on December 10, 1996, more than fulfilled AFHR's desire to reflect the complexity of South Africa's history and makeup. Azaria Mbatha's, *Clause 12: Citizenship* uses a traditional tribal design motif to articulate a constitutional cornerstone born of the bitter past; that "no citizen may be deprived of citizenship." The Bill's *Clause 26: Access to Courts,* a right denied to many under apartheid, stipulates that "everyone has the right to have any dispute that can be resolved by law, decided in a fair, public hearing ..." Vedant Nanackchand's image for this clause shows a South African legal landscape informed by African and Asian as well as Western ideas of due process. James Mphahele's masonite cut depicts *Clause 4: Freedom and Security of the Person.* This article states that freedom and security includes the "right not to be detained without trial or subjected to violence, torture or inhumane treatment." Mphahele,

125

a victim of government torture himself, uses an image of an enormous book of rights that is being constructed and protected by artists to depict the fragile interdependence of freedom, law and active expression.

Though it is celebratory and optimistic, many of the images in the Portfolio also reflect the vulnerable state of South Africa's new democracy. In his forward to the exhibition catalogue, Bishop Desmond Tutu reinforced this point saying… "The images powerfully complement the words of the Bill of Rights. Given our history, they serve as an apt reminder that words, however inspiring and lyrical, have been used as much to subvert as to create. It is therefore necessary to portray our commitment to human rights in pictures which are less open to corruption."

Bishop Tutu also lauded the fact that proceeds from the sale of the portfolio would support Amnesty International's work in the country. He concluded with a benediction for the new nation. "Nation building needs a willingness to bridge the chasms that divide: be it between rich and poor, urban and rural townships and suburbs. In capturing the essence of our humanity, *Images of Human Rights* weaves together the dreams and aspirations of us all. It is a dedication to the spirit of hope, and a celebration of South Africa's place among the nations which respect and uphold human rights."

CHAPTER 9

Kim Berman
Prayers, Paper, Fire

Judith Mason's The Blue Dress 1 both memorializes a courageous victim of Apartheid and bares witness to its senseless brutality. Photo by Ben Law Viljoen, courtesy South African Constitutional Court Trust.

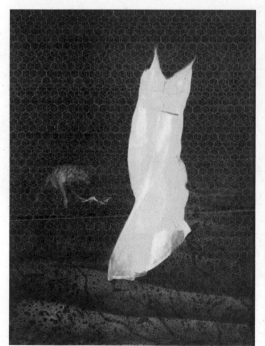

Human Rights Day, Sunday, March 21, 2004[1]
Johannesburg, South Africa.

 A cooling breeze flutters the South African flag waving above the new court building on Constitution Hill. It's been nearly ten years since Mandela's election but many in the queue forming for the building's official opening are still not used to the uncommon amalgam of their homeland's new standard—six colors rippling in the wind joined and apart. For South Africa this is a time of changing history and changing symbols. And, here today, the Constitutional Court joins the new pantheon with a new home—a courthouse that looks like an art museum, built from the bones of a prison—and not just any prison.

 Nearly one hundred years before, the British had built the Johannesburg Fort to house prisoners appearing before the Crown Magistrate. During apartheid, the prison's Number Four section held the "most dangerous of the state's enemies"—Albert Luthuli, Nelson Mandela, Joe Slovo, even Mahatma Gandhi had all done time there awaiting trial. It is likely that Joburg Fort had served more meals to more Nobel Peace Prize winners than any of the world's finest hotels or restaurants. It certainly had served up more pain.

 The plaza begins to fill with guests for President Mbeki's opening address. Some of them are artists whose work has been made a part of the courthouse. This is because South Africa's Constitutional Court Justices decided that the new building would have to be a work of art that would literally give voice to the country's values and aspirations. Justices Albie Sachs and Yvonne Mokgoro had made sure

127

that artists would leave their mark on every inch of the building. They knew their young constitution was born of a history and culture that were inextricably intertwined. They also knew that to survive the rough road ahead the law would have to become a living thing that was understood and embraced by the people. Here they are today, magistrates and artists, legislators and storytellers, come to celebrate the architecture, the paintings and prints, the sculptures, the gloriously crafted windows, floors and walls, all created to help bring the new constitution to life.

NO MATTER HOW YOU approach it, South Africa's Constitutional Court Building does not shout "courthouse," or even "government." Those attending the Court's opening on International Human Rights Day in 2004 encountered a building that incorporates remnants of the old Fort's "awaiting trial dock" into a cathedral-like structure of sharp angles and glass. Designed by Andrew Makin, Janina Masojada and Eric Orts-Hansen of Durban, the Court is set in the middle of an open plaza containing dozens of sculptures, such as Dumile Feni's "History" and Orlando Almeida's "Moving into Dance."

Entering the central foyer one is surrounded by 30-meter-high glass walls that illuminate a cluster of slanting columns rising up to the periphery. This web of support elements is representative of the building's central metaphor, "justice under a tree," a reference to the place where South African villagers have traditionally resolved their legal disputes. The curtain of 512 multihued leaded windows are among the over 200 works of art that have been integrated into the building's design.

To the left of the foyer is the building's main exhibit space. Over one hundred meters long, the art gallery is by far the largest space in the building. Its

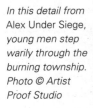

In this detail from Alex Under Siege, young men step warily through the burning township. Photo © Artist Proof Studio

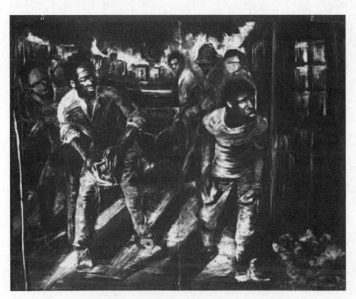

walls contain over 100 works selected from the Court's substantial permanent collection. One piece that stands out is Judith Mason's *The Blue Dress*. This mixed media piece is comprised of a dress of delicately stitched blue plastic wrap flanked by two large paintings showing a blue dress being attacked by a pack of snarling dogs. The disturbingly beautiful triptych commemorates the death of a young woman described by a policeman appearing before the Truth and Reconciliation Commission. Her executioner stated how "impressed" he had been when she had asked to kneel and sing *Nkosi Sikelele, iAfrika*, the ANC anthem,[2] before he had put a bullet in her head. Her naked body was discovered in a shallow grave with small pieces of blue plastic covering her genitals.

Further on, on the right wall across from a vitrine containing Nelson Mandela's Robben Island diary is Kim Berman's *Alex Under Siege*. The eight 600 millimeter by 400 millimeter black and white monoprints stretching down the gallery wall feel more like a live news feed from a war zone than a work of art. While *Alex* refers specifically to the 1986 uprising in Alexandra Township[3] near Johannesburg, the collage of chaos and violence spread across the wall evokes the cycles of siege and resistance that characterized township life throughout South Africa in the middle 1980s.

As one passes from image to image the impact is visceral, almost battering—moving to the right or left hardly matters. Though the eight panels constitute four separate scenes, they are held together by a constancy of motion and a horizon that is literally on fire. Despite the material destruction that pervades every view, the central feature of the piece is the human narrative that unfolds frame by frame. In one scene, a half-dozen black youth scatter, escaping gun fire from an armored police van or "caspir." The middle two frames show people from the township navigating warily through the burning rubble seeking sanctuary from the marauding police. In one, a young man peers cautiously around a corner holding a rock. In the final scene, two powerful women rush forward carrying an injured child while a man in the background raises a clenched fist in defiance. Clearly, there is nothing static or documentary in these images. Despite the vastness of the piece there is no refuge for the viewer, in either the dense rendering or the stories told—every inch of paper reeks of smoke and burns with the heat of fear and rebellion. A stark reminder of what many considered inevitable.

Leaving

Kim Berman's departure from her homeland, in 1983, came at a low point in her life. The struggle to which she was so intensely committed had turned very ugly. In 1982, the South African Defense Forces had raided ANC offices in Lesotho and Mozambique. Shortly thereafter, Ruth First, an activist and wife of ANC stalwart Joe Slovo, was murdered with a letter bomb. In response Umkhonto we Sizwe[4] (MK), the ANC's militant arm, had detonated a car bomb at a military intelligence office in Pretoria. The result had been disastrous, with many

innocents killed and injured. All the while, Nelson Mandela, Robert Sokowe, and hundreds of other opposition leaders continued to languish in prison.

It had been a particularly difficult time for Kim personally, as well. In some ways, her involvement in the underground student movement was the least of her worries. But, given the level of repression in South Africa at the time, separating the personal and the political was next to impossible and any sort of difference was suspect. Kim recalls feeling "incredibly squeezed" and coming to the realization that as a white, anti-apartheid, Jewish, lesbian artist she was far "too different."

> I was involved with another woman and living in an open relationship felt impossible at the time. Coming out was very difficult. During the height of the repression in SA, the gay rights struggle was very underground. We hardly knew anybody else who was gay at the time. We had just graduated from university, worked for a year to save some money, and then decided to go away to the US to participate in a summer school program in Boston. A planned visit for a few months turned into an extended stay of seven years.

For Kim and her partner, Boston was liberating. For the first time in their adult lives they felt "open and free as a couple." The absence of external scrutiny and judgment was as palpable as its sinister South African opposite. It was also a creative stimulus. A summer job at the Artist's Proof Cooperative print studio gave her an opportunity to both learn printmaking and make new work. Recognizing both her talent and a willingness to work hard, the studio kept her on as an apprentice and years later, helped her to obtain her green card. Feeling some stability, after a year in Boston, Kim also applied and was accepted into the Tufts/School of the Museum of Fine Arts, Master of Fine Arts Program.

Despite her new found sense of freedom, events taking place at home were never far from Kim's consciousness. But, given the sporadic and superficial coverage of South Africa in the US, keeping well informed was difficult. She relied mainly on reports from friends and family, particularly her sister, who had gone underground with the ANC in 1984. Kim also began volunteering for the ANC in exile and the Fund for a Free South Africa (FREESA) in Boston. She was committed to finding ways of using her art as a form of activism to expose the truth about the violence of the repression in South Africa.

> During the mid-eighties, a State of Emergency was declared in SA. No photos, videos or images of any political unrest could be shown in South Africa. As part of our volunteer work for FREESA, my partner and I co-edited a publication called *Uncensored*. We combined news briefings from the ANC in exile as well as images from the South African photographic collective, Afrapics, and distributed the paper to solidarity groups and anti-apartheid organizations in America.

After she received her green card, Kim began returning home for visits. Her colleagues at the ANC and the Fund for a Free Africa had made a point of not using her name, in order to protect her. Nonetheless, the state of emergency made it risky for anyone working actively against the government. During these visits, her relative anonymity made Kim a valuable ally for her sister who was on the run from the security police. In return, her sister also helped Kim make the connections she needed to access images, video footage and books that were banned in South Africa.

My artwork for a master's degree at the Museum School reflected images relating to the state of emergency. The silence I experienced in my safe haven in Boston was difficult to live with. I tried to reinterpret the images that were being smuggled out of SA and give them a personal voice. I redrew the media images on recycled off-cuts of aluminum plates and printed them at black and white drypoints trying to infuse them with emotional and personal content. In SA at the time, even drawings depicting "unrest" were against emergency regulations and the artist could be subject to arrest or a banning order. I also started working with the format of artist's books, because books containing any information about police repression, according to the repressive apartheid regime at the time, were subversive and, therefore, banned. Books, therefore, became a medium of defiance and resistance for me. I started to print images and then bind them in concertina type books. These images then evolved into large, life-size standing screens. Perhaps the larger scale reflected my frustration at the silence and unwillingness of American society to acknowledge the horror and devastation of the criminal activity perpetrated by the apartheid state to the activist and black population in South Africa.

Kim's sense of frustration was manifold. Excellent as it was, the Museum School's curriculum focused primarily on "form, not content." For Kim, though, separating her art from the struggle was "an impossibility." Another frustration for her was the passive complicity of the American media with regard to South Africa. They were reluctant to air the smuggled video footage showing the depth and depravity of the police brutality in the townships—a regular occurrence that the South African government denied was even taking place. Her other option was to use the images in anti-apartheid exhibitions, newsletters and demonstrations in the US. She was particularly disappointed when some of the black American activists she was working with were only able to see her through the lens of American racial politics, and had difficulty accepting her as a "white South African."

I experienced negativity from black American activists in a way that I had not experienced from black South African comrades. The ANC struggle was to achieve a nonracial democracy in SA. For example, when Winnie Mandela

came to Boston before Mandela's release, I was part of a women's group organizing the event. I produced a portrait of Winnie to use on the posters. However, some of the African-American women on the committee objected and refused to use any public image made by a "white South African" as it "would not be authentic." They objected to my partner's involvement at all. In the end we called in a comrade who was the ANC representative for the US to come in and mediate. The issue was resolved and we eventually participated fully in spite of divisions.

However, a similar thing happened when my artwork was exhibited for Black History week. There were objections to the issues of "whites speaking for blacks" which, instead of initiating valuable debate and foregrounding issues of racism, it provoked a further polarization of black versus white. My frustration living in the US was that I could never find a balance, or feel that I could make a meaningful political contribution. Art became my outlet.

Artist Proof Studio

FREEDOM FOR NELSON MANDELA

Leading anti-apartheid campaigner Nelson Mandela has been freed from prison in South Africa after 27 years. His release follows the relaxation of apartheid laws—including lifting the ban on leading black rights party the African National Congress (ANC)—by South African President F.W. de Klerk. Mr. Mandela appeared at the gates of Victor-Verster Prison in Paarl at 16:14 local time—an hour late—with his wife Winnie. Holding her hand and dressed in a light brown suit and tie he smiled at the ecstatic crowds and punched the air in a victory salute before taking a silver BMW sedan to Cape Town, 40 miles away. People danced in the streets across the country and thousands clamored to see him at a rally in Cape Town.

—*BBC*, February 11, 1990

Kim Berman recalls seeing Nelson Mandela walk out of prison on Boston television and thinking, "What the hell am I doing here?" For her, it was the right time to return. Mandela was free, the National Party was negotiating with the ANC and the other opposition groups, and her relationship with her partner had ended. Within a few weeks, Kim had sold her few belongings and her car and had purchased a large American French Tool Etching Press to ship home, and, like many South African expatriates, heeded Mandela's call to come home to help build the new South Africa.

It was so exciting to be back—to be part of building a new democracy. One of the first challenges I faced coming back was the struggle for gay rights. I was soon invited to be part of the organizing committee for the very first South African Gay Rights march in 1990. I remember it vividly,

as many of the 200 or so participants marched with paper bags over their heads. Yet it was a significant beginning of a highly successful movement that has led to one of the most progressive policies on gay rights that are enshrined in the South African Constitution. At the time I was also invited to co-edit a book of stories of gay life in the townships, as there were very few lesbian women willing to be visible. For the first two or three years of my being back in SA, I was involved in gay rights activism.

But my dream was to build a cooperative print studio like the one in Boston. My imported etching press arrived in Johannesburg and I set out to find a home for it. My mom ran a little art framing shop and gallery in town. When I came home she introduced me to some local artists whose work she exhibited. One was Nhlanhla Xaba. Nhlanhla was a very shy young man but a very talented painter. I told him about my idea of starting a cooperative printmaking studio, that I had a press and needed a venue. I also showed him some of my artwork, and he showed me his, and we immediately "clicked." We became friends and partners in this venture. He and I found this little place on Jeppe Street in Newtown that was big enough to house the press. Neither of us had any carpentry skills, but we managed to put together shelves and tables, and then he invited some of his artist friends to work with us.

Our model, Artist's Proof Cooperative in Boston, was a collective co-owned by four women. They each contributed equally to the rental every month and shared the cost of the presses and their facilities. Membership fees of outside artists also helped pay the costs. I had been living outside of South Africa for over seven years and I did not know the artists well. However, what I experienced was that the white artists whom I approached to join up as members shook their heads and said, "No way, this kind of facility is not going to survive." The black artists however were very keen to join, but had absolutely no money.

Nhlanhla was a very remarkable person. He came from a very politicized black consciousness background. Many in his circle were highly suspicious of this white woman coming from America with a big etching press and big ideas. But, Nhlanahla and I found common ground and broke through the baggage of our history. It was, however, a huge learning curve. I was his first white friend and he was my first real black friend and we kind of found our way together. I didn't have the contacts and he did. He would bring his group in and I'd teach workshops. The studio grew from a very collaborative and cooperative effort. Its members defined its shape and spirit. Our challenge was funding. I also worked as a field officer for the Boston-based Fund for a Free South Africa, which supported the rent and basic expenses. I went back to Boston to teach the summer school printmaking session at the Museum School. That money kept us going, but it was a struggle. We called it Artist Proof Studio (APS).

Although barely surviving financially, Artist Proof quickly became a hotbed of creative fervor for Johannesburg printmakers. While the concept of a cooperative was spurned by the more established white artists, Nhlanhla's network of black artists felt right at home. Many artists, like Vincent Baloyi and Charles Nkosi, were linked to FUNDA Community Centre in Soweto, and others, like Muzi Donga, were founding members of the Federated Union of Black Artists (FUBA). Most of the artists had received their training at the Rorkes Drift Swedish missionary art centre in the eighties, or the younger artists at FUNDA. Working together and the pooling of resources was a given, as was the idea of the place as both a studio and a learning center where talented community artists could hone their craft in a disciplined manner.

Early on, tuition paid by white women students from the Johannesburg's northern suburbs helped keep the studio afloat. It also provided what Kim describes as a "little microcosm of this rainbow nation" where "they were surrounded by black artists and teachers." However, the multicultural nature of the studio was a sore point, with some black artists not associated with the studio. These artists felt that the time had come for South Africa's blacks to establish their own institutions. Although some opposition persisted, the Studio's reputation for high quality art work and training, and progressive activism, trumped the criticism. In 1995, the Mandela government helped establish a larger studio space for a growing Artist Proof as part of the redevelopment of the Newtown section of Johannesburg. The project was in anticipation of South Africa's hosting of Africa's first ever visual arts biennial.

The Biennial was a cultural turning point for both South African visual artists and the new South Africa. The event itself was a massive undertaking, showcasing work by visual artists from around the world and re-asserting South Africa as a dynamic cultural presence. It was also the subject of significant controversy. Many South African artists and arts organizations felt they were ignored by the event's organizers as they rushed to capitalize on the world's romantic view of South Africa's recent transformation. Interestingly, the open presence of this vocal criticism also stood out as a poignant reminder of how far South Africa had come in such a short time.

During the Biennial, the new Artist Proof Studio facility housed *Volatile Alliances*, an international exhibition of prints co-curated by Kim and her colleague, Peter Scott, from the Boston Museum School. The exhibition's subtitle, *Print Exchange and Community Collaborations*, gives an indication of how Kim used the show to explore "issues of working together, across cultures and boundaries, globally and locally."

We had artists from ten countries in a print exchange with 20 South African artists. Peter and Craig Dongoski from the Museum School in Boston curated the international participating artists and I co-curated the African artists. We had 40 artists participating from places like Iceland,

Belgium, Holland, US, Canada, Mozambique, and others. Each artist had to produce their work in an edition of 60.

A second part of the *Volatile Alliance* project was community workshops. We brought white students from the University [of Witswaterstrand], where I was also teaching, to work with the black students from Artist Proof, to collaborate on large mural size prints. The groups developed multiple dimensional prints called "exquisite corpses" where some participants worked on one part of the figure, and others worked with different parts. The group then swapped parts, and dissolved notions of individual identities and expressions.

The work and process becomes an exploration of collective identity. To enhance the diversity, we included our northern suburban "housewives" print class who joined in on the collaborative group projects. For many in the group, it was their first opportunity to work across race, culture and class in these "volatile alliances."

This was quite a huge project for us and a turning point for the Studio. Nhlanhla and I, together with students whom we trained as edition printers did all the printing, which amounted to thousands of multi-plate, multi-colour etchings. The Ford Foundation acquired one of the portfolios, and they subsequently became our first major donor. We received an operational grant from Ford for three years which meant APS could hire an administrator, a full-time studio manager and teachers, who were our graduates. This really stabilized the organization to enable growth and the development of new leadership.

Hope and Fire

Throughout the world, the five-year Truth and Reconciliation Commission (TRC) process that concluded in 2001 was hailed as a miracle of forbearance and healing—an iconic testament of hope not only for South Africa but for humanity itself. But, for many in South Africa the TRC was a terrible, but necessary, chapter in their country's continuing struggle with the indelible stain of apartheid. It was also a reminder that the pain of healing is often deeper and more excruciating than the original wound.

Kim was deeply affected by the devastating stories that emerged from the TRC. Like many artists in post-apartheid South Africa, she found the freedom to respond openly to political and social events both liberating and challenging. How, she mused, do artists transcend a lifetime of reflexive opposition? What roles do creators play in the transformation of civil society? Are there boundaries or limits?

Kim's creative response to the TRC was both visceral and reflective. *Playing Cards of the Truth Commission: An Incomplete Deck* is a literal rogue's gallery of some of apartheid's most vicious criminals. In the catalogue introduction

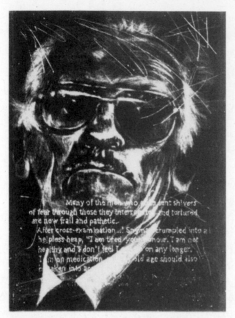

Many of the men who [...] sent shivers of fear through those they interrogated and tortured are now frail and pathetic.
After cross-examination...[Snyman] crumpled into a helpless heap, "I am tired... your honour. I am not healthy and I don't feel I [...] on any longer. I am on medication [...] old age should also [...]

Waterboard torture specialist Eugene de Kock was portrayed on Card 1 of Playing Cards of the Truth Commission: An Incomplete Deck *(Mezzotint and drypoint on paper). Copyright 1999 Kim Berman*

to *Resistance and Renewal*,[5] a 2006 retrospective of Kim's work at Tufts, Brandeis University art professor Pamela Allara describes some of the "major players" portrayed in the nine image portfolio.

These include Eugene de Kock, "Prime Evil," Jeffrey Benzien, purveyor of the "wet bag,"[6] Joe Mamasela, ANC turncoat, and Harold Snyman, Steve Biko's torturer. In justifying his actions to the TRC, Snyman testified that the government ordered him to take ever more drastic steps to restore control over the black populace. "Fire must be fought with fire," he was told.[7]

Kim knew that some of these men would avoid prosecution and punishment for their crimes because of their participation in the TRC. The "Deck's" revealing portraits were borne of both a deep anger at their casual depravity and an appreciation for art's capacity to create powerful symbols that outlive the headlines. Through them, she wanted to create an enduring and unvarnished chronicle of these despicable acts. Kim describes how the techniques she employed also reflected metaphorically on the TRC process.

The portraits were also an attempt to come to terms with the idea of amnesty in exchange for truth. The medium is mezzotint, a way of carving light out of darkness to reveal the image. A metaphor for the TRC process. The dark portraits have two overlays; layer of transparent colour…green or pink to evoke a toxic or poisoned light and another layer of expressive scratches printed over the faces that literally refer to "scratching the surface."

Much of Kim's work in the years following was less direct. A persistent theme was fire as both a destructive and regenerative force. The images contained in *The Fires of the Truth and Reconciliation Commission* (1999) and *After the Fires* (2003) portray the fires set each year by farmers on the grassy plateaus or "highvelds" that define much of the South African countryside. These intense, but controlled burns, are used to both clear and renew the land. Reflecting on these images for a 2004 exhibition, Kim described them as "… an expression of anger, disappointment and hope for a country in transition."

Apartheid…created a legacy that pervades every aspect of our lives. It has been said that sometimes it often seems to us as if the dead are coming back to haunt the opportunities of the living. South Africa's apartheid past intrudes on the present. Artistic expression of all kinds assists memory to emerge.[8]

The fire symbolizes a process of burning and purging to make way for new growth, while the smoke chokes and suffocates the truth. The introduction of barbed wire in this series represents a barrier that recalls the symbolic landscape of apartheid. There is a tension between the transparent layering and political deception or betrayal of the broken promises of a "new South Africa."

The smoldering remains and the smoke after the fire conceal and pollute the clarity of the truth. There is always the belief that smoke will lift and clear, sometimes revealing a scorched and tragic beauty. Fire transforms from one state to another. I have learnt that healing and regeneration can emerge from the ashes. I have also learnt that the sparks that ignited the blaze are also sparks that fuel new beginnings. Some seeds need fire to germinate. Perhaps Mandela's rainbow nation is a dream worth dreaming.[9]

The images are both beautiful and threatening. Under different circumstances they might be considered classic studies of one of nature's most powerful and awesome forces. But Kim's conflagrations are a juxtaposition of both natural phenomenon and human intention. In the South African context, they evoke some familiar, but insistent questions: Is this nature "tamed" or hubris? Must the garden burn in order to grow? For Kim these inquiries were as personal as they were universal. Unfortunately, they were also an ominous portent.

On March 9, 2003, Kim Berman was awakened by the insistent ringing of a telephone. The conversation that ensued tragically and forever deepened her personal relationship with the earthly element that had figured so prominently in her artwork. Sometime in the middle of the night the studio had caught fire. The ensuing paper and solvent fueled conflagration reduced Artist Proof to ashes. Worse still, Nhlanhla, who had been staying at the studio, had perished.

"Must the garden burn in order to grow?" A question posed by Kim Berman's Highveld Fire 1. *Photo courtesy Kim Berman*

In the aftermath of the fire, mourning and recovery for the Artist Proof community became intertwined. While Kim and the studio's family of artists were "devastated by the enormity of the loss," they vowed together that they would not be defeated. It went without saying that the only possible way they could honor Nhlanahla legacy was to rise up again from the ashes.

Devastation is an understatement. These artists lived off their work. They didn't store their work at home, so over 100 artists lost their portfolios—their prints, their materials, presses, everything. Beyond the material though, Artist Proof is a home, it's a security, it's stability, it's about life and livelihoods. The fire, and the loss of Nhlanhla as a mentor to most, just brought up every other trauma in their lives—the loss became compounded for so many people.

So we never saw starting again as a choice. We had learners just enrolled on our training program which had a government subsidy. For their sakes, we had to continue those lessons. The city of Johannesburg allocated us basement space in the building we now occupy, and the students carried on with their learning. People lent us presses and materials. The loss of Artist Proof Studio brought out the most amazing and generous response from the community. People just all rallied, came together. A few of our members left, but for most it was about how to rebuild and start again.

A few weeks after Nhlanhla's funeral the studio members decided to have a print marathon to begin the difficult process of healing and rebuilding. Artists from all over the region brought small presses and materials to the small

makeshift studio that had been created in the basement across the road from the burnt-out Artist Proof building.

I took a whole folder of work made from our print marathon to Boston where I attended the Southern Graphic International Print Conference. Friends and printmakers in Boston affiliated with the conference mobilized support and decided to use the opportunity to put together an exhibition and fundraiser for APS at the Museum School of Fine Arts. We also had embroidered tapestries depicting the history of our Paper Prayers AIDS Awareness campaign. These were sent ahead for the conference exhibition so they escaped the fire. However, the combination of the burnt fragments of work remounted into new works by students contributing their time and talent resulted in a very remarkable exhibition. We called it *Out of the Fire*. The sale and fundraiser was a huge success and US printmakers and friends raised enough money to purchase a beautiful new state of the art etching press for APS. This is one of the largest presses in the country at present.

While she was in Boston, Kim met Cynthia Cohen, director of the Recasting Reconciliation through Culture and the Arts Institute at Brandeis University. Cynthia encouraged Kim to apply to the program for a fellowship to look at the Studio's work and rebuilding as a model for engaging social change in South Africa. Kim and Stompie Selibe, a printmaker and musician and one of Nhlanhla's mentees, was a collaborator on (co-wrote) the successful proposal. One aspect of the project, which they called Ubuntu, explored the idea that the ashy remains of fiery destruction embodied life as well as death. This abstract notion was translated into a creative collaboration at Artist Proof that Kim

In honor of his memory, The Artist Press, an affiliate printmaking studio, published Talk to Me, *Nhlanhla Xaba's final lithograph as an unsigned edition. The proceeds of the sales went to his family. Courtesy Artists' Press*

describes as "reconciling the APS's past, present and future." Through a series of workshops, teams of artists and students came together to sift through the studio's wreckage, collecting charred fragments of thousands of prints destroyed in the fire. Using these remnants of the past, the teams created the first works to emerge from the "new"Artist Proof Studio. These six images represented a creative rebirth. Kim recalls that they also marked a significant shift in the organization's focus. In a journal from the time, Kim described the process.

The students and their teachers begin scratching around in the burnt rubble, prying and peeling the prints buried under the waste. Dust is released as each sheet is pulled out and shaken off. There are moments when the dust and ash clog the surrounding air, making it hard to breathe. Our coughing and choked stammering contrasts with the clarity and delight of uncovering a new layer and discovered treasure. We laugh and sing and then abruptly become silent in the shock of discovering something of Nhlanhla's. The artists gather fragments and lay it at the spot that Nhlanhla was found, with a sign traced in ash "I'll miss you bra." I uncover one of my prints from the State of Emergency '86 (a body lying in the rubble, assassinated by the apartheid regime). The irony is eerie, the pathos palpable.

Then we lay out all the fragments we had chosen and reflect on finding meaning in overwhelming chaos. The work begins with Stompie rolling out a very large sheet of white paper. He lies down on that paper, curling his body but reaching out with one arm. Someone takes a marker and does a body tracing. The discussion of healing through peeling off layers, unraveling of the bandages when the wounds start to mend, becomes the theme for one of the images. The group decides to look in the

Artist Proof Studio members search through the ashes gathering pieces for the Reconciliation Collages. *Photo courtesy Artist Proof*

The Reconciliation Collages were created using the charred remnants of work from dozens of the Studio's artists. Photo courtesy Artist Proof

burnt books and papers for fragments and words that have to do with celebration and joy, growth and change, and begins to glue them over the wounds of the healing body.

Marjorie, with her beautifully clear and resonant voice, begins to sing a song and the group responds in chorus. It is spontaneous and rhythmic. There is harmony in both the song and work that begins. Prints are torn up. Each group gathers around a body tracing, others go back into the rubble to scavenge. The artists collage onto the paper, there is laughter and discussion, disagreement and debate. Everyone understands the purpose of the art form that is being created.

The resulting collage emerged three months after the fire—months of despair and mourning, months of displacement and anger, months of nightmares and trauma. The act of collaging is reconstructive. It is sticking bits and pieces of fragments to make a whole. It is finding beauty in damage and loss. It is a metaphor for reconciliation.[10]

As they worked, the teams of artists were also asked to think about the future of the Studio and their own process of reconciliation. The questions that emerged were profound. How does art contribute to healing, well being and empowerment? What is the relationship between the reconstruction of the new South Africa and the reconstruction of the new Artist Proof Studio? Can the studio sustain its programs while cultivating new black leadership? In its first incarnation, Artist Proof was a creative collaboration between members of two historically estranged South African communities. The new organization, they decided, would be built on a different model. The focus would be on developing black leadership in a mentorship program, and a reduced leadership role for Kim. A model she saw as appropriate for an organization built in 2004, ten years after democracy in South Africa.

We received funding from the Arts and Culture Trust to develop a mentorship model at APS in order to grow black leadership from within and not only hire "outsiders." This was part of a three-year rebuilding strategy. All of our units in the studio, such as teaching, printing, gallery, outreach, computer skills and others, are led by the unit managers who are mostly graduates of APS. Our educational manager is Lucus Ngweng who started at APS in 1997; the printing manager is Ponsho Sikhosana (started in 1995); the gallery manager is Marjorie Maluleka (2002); Chris Molefe managers the computer unit (1997); founding member Charles Nkosi is a Director on the Board of APS and a mentor to some of the emerging managers.

Healing

...What I heard as that story was told, was that extreme poverty is the world's biggest killer and the greatest cause of ill health and suffering across the globe... As I listened longer, I heard stories being told about malaria, tuberculosis, hepatitis B, HIV-AIDS and other diseases. ..As I listened and heard the whole story told about our own country, it seemed to me that we could not blame everything on a single virus.

—Thabo Mbeki, President of South Africa, from a speech at the opening session of the 13th International AIDS Conference, July 9, 2000

The poor who on our continent, will again carry a disproportionate burden of this scourge—would, if anybody cared to ask their opinions, wish that the dispute about the primacy of politics or science be put on the backburner and that we proceed to address the needs and concerns of those suffering and dying.... We need to Break the Silence, banish stigma and discrimination, and ensure total inclusiveness within the struggle against AIDS.... We have to rise above our differences and combine our efforts to save our people. History will judge us harshly if we fail to do so now, and right now.

—Nelson Mandela, from his speech at the closing session of the 13th International AIDS Conference, Durban, SA, July 9, 2000

The 13th International AIDS Conference was a watershed event for South Africa and for Africa. This was the first such gathering on the continent. Since the convening of the first AIDS conference, in 1988, the epicenter of this modern plague had shifted from the US and Europe to Africa, where South Africa was bearing the greatest brunt. The country, quite literally, was being laid to waste by the epidemic. With the highest AIDS infection rate in the world (4.7 million in a population of 45 million), 40 percent of all adult deaths in South Africa were AIDS-related. Worse still, one in two born in 2000 would be struck down by the disease before reaching adulthood. Conservative estimates were that by 2015, South Africa's population would only grow to 49 million—"12 million lower than without AIDS."[11]

Despite the seemingly civil tones of Mbeki's and Mandela's rhetoric, the conference's opening and closing speeches represented a struggle of tragic proportions that was taking place in South Africa. Simply put, Mandela's successor was questioning the consensus scientific view that AIDS was caused by the human immunodeficiency virus (HIV). This "AIDS debate" was having a devastating impact on the streets. Understandably, given the lack of a clear message about the causes of the disease, many South Africans paid little heed to prevention campaigns. On the medical front, the government continued to question the efficacy of a proposed national treatment plan to distribute anti-retroviral drugs to AIDS sufferers. According to many, the rapid spread and pervasiveness of the disease could be tied, in part, to the government's equivocation and inaction.

An important point of agreement between the two presidents was the significant role poverty played in the AIDS crises. In Africa, the poor were by far the most vulnerable and hardest hit. Countries with already crippled economies and massive global debt loads also lacked the medical and social infrastructures to respond effectively. Although South Africa's economy was among the most robust on the continent, nearly 50 percent of its citizens lived in poverty.[12] The gap between its richest and poorest citizens had not improved significantly since the revolution, due, in large part, to the devastating impact of AIDS.[13]

For the artist activists at Artist Proof, the link between poverty and the spread of AIDS was not a new subject. In 1998 they had created a small program in the Johannesburg region called Paper Prayers. Its goals were twofold: to promote greater AIDS awareness and to help AIDS-infected women become more economically self-sufficient. The program, inspired by the Japanese tradition of placing healing prayers on paper strips,[14] was an ambitious enterprise for the small atelier, particularly given the government's reluctance to confront the epidemic head-on.

Workshops conducted by Artist Proof staff provided arts instruction while the AIDS education component was provided by qualified counselors. The participating women, many of whom were destitute, not only earned money but also became proficient in paper and printmaking and micro-business practices. Their artwork, the beautiful prayers themselves, came to be regarded as carrying a powerful healing message. This was deeply important for women who were not only struggling with the lethal disease, but were often shunned by their own communities.

In 1998, Stephen Sack, the Chief Director of Cultural Industries and Creative Crafts at the South African Department of Arts and Culture, came to Kim with a proposal to significantly expand Paper Prayers. She remembers feeling both excited and overwhelmed.

The health department had given each ministry half a million rand ($65,000) for AIDS programming. Stephen wanted to give the whole arts

and culture AIDS budget allocation to Artist Proof Studio to "implement Paper Prayers on a national scale." But he said, "you have seven months to spend the money by year's end to culminate in an Exhibition for World AIDS Day on December 1, and all nine provinces of South Africa have to participate." We accepted the challenge and jumped right in. One of my recent master students, Carol Hofmeyr, was appointed as the coordinator for the National Campaign (Carol has since founded the Keiskamma Trust and has extended the idea of using embroidery to create support for HIV positive women through the Keiskamma Alterpiece and a 100-meter-long tapestry.) We called on our colleagues all over the country to collaborate with us. We teamed up with Malcolm Christian at Caversham Press near Durban and Hard Ground Press in Cape Town. We went to the FUNDA Arts Center, and Dakawa Art Centre in the Eastern Cape, BAT Centre in Kwa Zulu Natal. In provinces where there were no printmaking centers we collaborated with cultural centers or rural health facilities. Each group was given 50,000 rand, with a workbook on how to make paper prayers and in many cases we traveled around the country providing skills training. The Paper Prayers team consisted of AIDS councilors, the Township AIDS project, NAPWA (National Association of people living with HIV and AIDS) as well as the ART Therapy Centre, who collaborated on the *Paper Prayers Workbook* for teachers.

Each regional partner had to team up with a local AIDS counseling center in their region and work with artists. The format of a workshop required that the AIDS councilor first provides the participants with an awareness workshop; then the printmaker provides a skills demonstration using a technique of printmaking appropriate to the group. Participants are asked to respond in a way where their awareness can be shared actively with the public. The paper prayers can be exhibited in schools, churches, and community halls as part of creating awareness. Members of the public are asked to give a donation and take a paper prayer. Each group can decide on donating funds to a care group in the region, or the work is bought to provide income to the rural women from the embroidery groups. The campaign took off very quickly and effectively. Hundreds of people around the country started making paper prayers, and raising money to support local AIDS networks. Thousands of paper and embroidered prayers were made.

For World AIDS Day in 1998, when the Campaign was unveiled by the Ministry of Arts and Culture, we built an AIDS memorial wall outside the old Artist Proof Studio The wall curved in front of a memorial garden so extensions to the wall would appear like arms embracing the garden. People came to APS to engrave a name on a copper or brass plaque, which we etched in acid and installed each plate onto the wall. The idea was that each year more names could be added onto the extending arms of the wall. Unfortunately, after the launch, the government ended the

funding. It was as if the Ministry of Arts and Culture had done their bit for AIDS and after that year there was no money for AIDS programming. It was an abrupt pullout by the government, but we decided to keep on with the campaign without them.

As the teachers and staff at APS focused their attention on the enormous task of rebuilding and reorganizing the studio, Kim began thinking about how the success of Paper Prayers could be leveraged and expanded upon. This was critical for a number of reasons. Given her commitment to make space for new leadership at the Studio, she needed a next chapter as well. Beyond this, she was inspired by the development potential she saw arising out of her experience at both the Studio and the Prayers project.

Still, Kim was acutely aware how important timing would be for any future endeavor. They had been lucky with the Studio. Creating it had been the right thing at the right time in a newly democratic South Africa. The arts environment under apartheid had not only been racist, it was hidebound and elitist as well. The printmaker's ability to create multiple images was helping to democratize the relationship between artists and audience.[15] For a population hungry for authentic symbols and fresh vision, the art form was a perfect fit. It had also proved to be a potent human and economic development strategy. The Studio had both established itself as a center for artistic excellence and had been in the forefront of the development of new markets for a uniquely South African aesthetic. As such, many of the young men and women who had graduated from Artist Proof's rigorous three-year training program were making a good living as artists and teachers.

Paper Prayers had taken a different tack, but its impact was no less significant. While the Studio nurtured the untutored, but obvious talent, of young street artists and township-based artists, Prayers, in essence, started from scratch. For many of the women involved in the affiliated projects, learning embroidery skills led to a range of commissions and new product development. The women who found refuge used the creative process first to heal, and then to empower themselves. Although the program was intended to benefit the women, the immensely positive outcomes were a revelation to Kim. She saw how critical self-sufficiency was to women who had suffered so much under the thumb of both apartheid and an age-old patriarchy. She also saw the potential—and a responsibility—to take it to another level.

Phumani

In retrospect, Kim Berman has found herself marveling at how seemingly disparate pieces of a life's puzzle can come together at the exact right moment to make a coherent whole. When she and Nhlanhla started out building the Studio, Kim certainly never imagined that she would eventually become a community developer or a micro-industrialist. But, as an artist, she did know

that you did what you had to do—you learned whatever you had to learn to see a project through. That's what had happened in Boston when she took up papermaking.

Papermaking and the graphic arts have always been allied fields. Printmakers need a ready source of fine papers in a wide variety of textures, thickness, sizes and colors for their work. They also need to be intimately familiar with the materials they will be incorporating into their art. Many university printmaking departments include paper-making in their training for this reason. While studying at the Museum School, Kim had particularly enjoyed this aspect of her training. When she returned home, she was keen to find a way to pass it on.

While the Paper Prayers workshops had included some basic papermaking, an opportunity to expand on that experience presented itself when she joined the arts faculty at Johannesburg's Witswaterstrand Technikon (now The University of Johannesburg) in 1995. With the change in government, all secondary training programs, even in the arts, were being asked to contribute to the advancement of the country's post-apartheid economic transformation program. When she arrived at Wits Technikon, Kim found a conservative, all-white art department struggling to diversify its student body and integrate "community and economic development" into its curriculum. Although her contract included initiating community engagement there was no related curriculum.

> The problem I had with the Tech training is that we didn't teach our students vocational skills other than to prepare them to become artists. We decided to start a teacher training course for the art students. The idea was to train senior students as teachers who could contribute to the community and introduce art into township schools as a part of their course. Various teaching staff participated in teaching the course, including David Paton and Bronwen Findlay. We also opened the course to two to three senior Artist Proof Studio students annually, who received a sponsorship to attend the course.
>
> One of my graduate students, Sister Sheila Flynn, who was also a nun in the Dominican Order, participated in our teacher training and outreach program. The Sisters of Mercy ran an adult education and training center in a community called Winterveld, northwest of Pretoria. Winterveld was set up as an apartheid dumping ground for displaced people. Winterveld is a wasteland, with almost no employment, and no industry. Sister Sheila Flynn started an outreach project with some of the teachers who were training there. They desperately needed income generation projects, and through Paper Prayers we had initiated a small papermaking project. The interest to develop this further was very high, so I wrote a grant that won a 100,000 rand inter-university prize to set up a larger papermaking unit in Winterveld. I was teaching my senior printmaking students papermaking, and they did their experiential learning practice teaching paper making to the unemployed women in Winterveld. The project developed very well and became our pilot community engagement project. Sheila Flynn ran

the project for the two years she was a student, and, subsequently, was contracted as a trainer.

Teaching papermaking skills was more than a make-work enterprise for the Winterveld women. At the time, South Africa had no art paper industry. All the handmade paper in the country was being imported from India and Thailand and printmaking papers from Europe and America. Thus, there was a ready market capable of supporting the emergence of a new industry.

As the Winterveld project was establishing itself, Kim received a research grant to learn more about various papermaking technologies from micro-development models around the world. On a visit to Getsemani, Ecuador, she met a group of artists from Rutgers University who were teaching villagers how to create hand-made paper products. They introduced her to an innovative process using the cubaya plant, similar to the sisal plant found in South Africa.[16] This, in turn, led to the creation of an ongoing paper research unit at the former Wits Technikon. Experiments with art papers made not only from sisal but from plant vegetation waste and invasive plant species provided a foundation for the next opportunity to surface from the government.

In 2000 the government began making funds available through the Department of Science and Technology (DST) to support the development of technology based economic development projects, particularly in rural areas.[17] Shortly thereafter, Steven Sack (still strategically positioned in the government) again contacted Kim with an interesting opportunity. According to Kim, the series of events that gave birth to what would be called "Phumani Paper" transpired very quickly. In 2005, she spoke about it.

> Steven Sack found himself appointed as a deputy director in the Department of Arts and Culture, Science and Technology (DACST). At his recommendation, Wits Technikon was offered the opportunity to submit a proposal for poverty relief funding. In response, they turned to us with the challenge to institute a papermaking program nationally, and create no less than 460 jobs (countrywide). It is not often that one is given the opportunity to explore a dream and also given a budget to realize it. But that's what happened to us. The budget was three million rand ($360,000 US) for the first year, and the challenge was that the programme use appropriate technology for the development of a new cultural industry.
>
> There was no provision for a needs assessment, very little [product] research done or capacity among staff and students. But what we had was a dynamic and inspired team, with shared passion and a commitment to make it work. My team of graduate students, community trainers from Artist Proof Studio, printmaking networks across SA and in the USA, all helped to visualize a model that created 21 manufacturing units in rural communities, each with a focus that is linked to the local resources and industries of their regions, in the first year.

A colleague called Julie Ellison has spoken eloquently about how cultural activism needs to link to what she calls "the public soul." What she said makes particular sense for what happened with Phumani.

The defining factor of engaged cultural work is a determination to do it all, to undertake complicated projects that join diverse partners, combine the arts and humanities, link teaching with research, bring several generations together, yield new products and relationships, take seriously the past and the future. The driving philosophy is one of both mind and soul, both local and universal.

This description characterized the essence of the Phumani Paper-making Poverty Relief Program of the Technikon Witwatersrand. The link between creative and ideological imaginings in collaboration with community, social justice, positive values and research has created a fluid environment loaded with possibility.

After nearly three years, Phumani Paper is currently sustaining 240 jobs from economically impoverished communities and 17 small enterprises in seven provinces. It has employed students and community artists in work-study placements, and has generated six master students' innovative research projects. These students are mostly printmakers who understand the application of visual arts as social engagement. The aim is technology transfer and the establishment of papermaking as a new cultural industry. The research is fluid, action based and creative, and struggles to fit into a conservative framework of academia at the University of Johannesburg.

Reclaiming the Future

November 15, 2005, The Bus Factory, Newtown, Johannesburg

For much of the twentieth century the Bus Factory was a parking shed for Johannesburg's trams and double-decker buses. Now it is part of a growing arts district that has transformed the Newtown section of Johannesburg into the city's cultural nerve center. Inside the factory, in the foyer of the Artist Proof Studio, students are gathering for the opening of an exhibition of work by third-year students. This is the second such exhibit to be held at the reborn Artist Proof Studio. Kim Berman feels the new setup is turning out well. They have worked hard to become an accredited training center for South African printmakers. Though money has continued to be a challenge, the new team of artist/leaders had learned the ropes and grown the organization at the same time. The new facility includes a huge teaching studio, a state of the art professional production studio and an exhibition space.

Students and alumni sit together in a semicircle of folding chairs. Lining the walls are the final portfolios of four third-year students. The space is lit with smiles and the pride of accomplishment. One would imagine that Nhlanhla Xaba would be proud of these young artists.

Kim Berman (third from left) joins third-year students at Artist Proof Studio for their final portfolio exhibition. Photo © William Cleveland

The Nhlanhla Xaba Gallery

These exhibiting students have a lot to be proud of. They came to the studio with talent and potential but very little in the way of formal education or resources. They had persevered through a thorough and rigorous curriculum. Now they were moving on—some to the Technikon for further study, others to internships and jobs. None, though, have forgotten the continuing struggles with poverty and AIDS that so profoundly impact their families and friends.

A few months earlier (in November 2006) one of the studio's former and most brilliant, students had died of an AIDS-related illness. Artist Proof had been his second home for nearly four years as he trained as a printmaker and art teacher. Over that time, he had taught art to hundreds of children in the inner city, many of whom were street children. Despite the encouragement of close friends, when he started to get sick he refused to get an HIV test. By the time he reached the hospital it was too late for treatment. He had wanted to spare his family the horrible stigma that was still inexorably attached to the disease. He died from fear and silence.

Ever since his funeral, Kim's sense of urgency about the AIDS crises increased. Paper Prayers and Phumani Paper both were helping to address the crises of loss and stigma through awareness and skills training. Yet the epidemic was killing up to 1,000 each day (UN statistics). Unfortunately, the government's tepid response had become part of the problem, not the solution. Many had come to the conclusion that to save itself, South Africa would need another revolution. But, this time, the revolution would have to be focused on changing attitudes and behaviors rather than changing the form of government. To do that, they would have to change people, one at a time. For artists like Kim Berman, this was not new territory.

In the spring of 2006, Kim was one of five artists selected for the Sasol Art Award, one of the most prestigeous art awards in SA. Each artist was awarded a prize of 20,000 rand and tasked with producing five works for the juried exhibition. Kim's proposal was ambitious. It aimed to answer the question, Can art save lives? She proposed collaboration with 100 Artist Proof Studio artists to create a work that, "will not only help to *Break the Silence* (around AIDS) but will be an agent of change." Her project description begins with a stark depiction of the epidemic's devastating landscape.

> South Africa is facing the greatest challenge of our age. The AIDS pandemic is claiming 1,000 lives each day. Of the 6–8 million infected it is believed that only 10 percent know their HIV status. Although the SA government has developed a Comprehensive Plan for the Care and Treatment of People living with AIDS, its failure to accompany the Comprehensive Plan with unequivocal and effective leadership has meant that access to ARV treatment through the public health system is reaching only a small proportion of the population. The positive result of an HIV test is still seen by many as the equivalent to a death sentence. This perpetuates the fear and silence engulfing HIV/AIDS in SA, resulting in on-going stigma and denial.

In response, Kim goes on to describe a unique project that combines both individually rendered and collaborative artworks with community engagement.

> The first two parts of the project for the Sasol Wax exhibition will be solo artworks (my own etchings). The first, called *Mourning Our Future*, will be a large format screen consisting of five two-meter by one-meter diptychs of sunflowers and gravesites. The second series of prints will be mounted in the same format on the back of the screen. These images, called *Reclaiming Lives*, will be made by 100 artists currently working at APS and will act as a counterpoint to images of death and dying portrayed in the front panels. Each of these individual portraits will pay tribute to someone who has died of an AIDS-related illness. This concept is drawn from the AIDS quilt, an ongoing homage of quilted panels celebrating the lives lost through AIDS. The second collaborative component will consist of a Tribute wall made up of the 100 etched plates used to print the portraits.

One of the biggest stumbling blocks to controlling the AIDS epidemic in South Africa is a widespread resistance to testing. Kim decided to use her Sasol project to tackle this issue head-on. In addition to making art, "participants involved in the project, will be provided with counseling and encouraged to participate in voluntary AIDS testing program so that, through the project, they will know their HIV status." In her proposal, Kim goes on to describe how this experience would be incorporated into the work.

> The 100 plates will be mounted on both sides of a freestanding wall panel. Each plate will have a hinged cover with a second layer of imagery cre-

ated by the same artist in response to their testing experience. Those who prefer not to be tested will be asked to create an artwork about that fear. This paper cover print will be dipped in wax, making it translucent and providing a partially obscured window to the metal plate below.

Kim sees these juxtaposed layers as a visceral restoration of the essential relationship between grief and hope. By lifting the top layer the viewer touches a lost life through the image on the bottom plate. When they replace it, the potential of a life reclaimed by testing completes the image.

She concluded her proposal with her own testimony of grief and hope.

Silence and fear was palpable during the recent burial of a young and talented artist and educator, and member of the Artist Proof Studio community who died of AIDS. His loss is profound as he touched the lives of thousands of street children. It's a loss to his 5-year-old son who will never know his father's gentle kindness, his laughter and generosity, as well as his passion to make a difference to his society through art. As fellow artists we failed him. At his funeral I pledged to use every opportunity I had to *Break the Silence* and to point the way to a more informed future with access to testing and treatment. This proposal is an explicit and far-reaching action towards keeping this promise.

On July 14, 2006, the Sasol Trust granted 30,000 rand to Kim Berman for the creation of her proposed work. In her acceptance letter she reiterated what she sees as her role as a creator in the new South Africa.

Because I see myself as an artist, an educator, an activist and citizen in a post-apartheid South Africa, I feel that it is my role to help change perceptions in our society. Art does not excuse us from the messy engagement with life. It provides us with another tool for creative engagement and participation in life.

CHAPTER 10

Art for Humanity

Durban, South Africa, December 1999

Jan Jordaan looks across the dinner table at his guest, listening intently. Marisa, his wife is captivated, too. One of the world's leading AIDS research-ers, Nigel Collins, is as passionate as he is well informed. They had been dis-cussing the epidemic all night, but Nigel continues to press his point.

"I'll say it again. People are dying and the government is on the sidelines. The toll is growing every day but these deaths are preventable. We have a whole host of medical options for those who are infected, but to get a handle on this we have to stop the spread. And for that, we know that the best strat-egy with this disease is information."

"What about those Love Life billboards that I see all over town?" Jan asks.

Nigel frowns, his deliberate reply seems to deepen his Irish brough, "The Love Life billboards have nothing to do with South Africa. They were created by Americans for Americans. It's like their TV. You've seen what's on those billboards, do you think it speaks to the people we're trying to reach in Umlazi or Soweto? They've spent two years and a lot of money trying to get people to recognize their logo and they haven't touched a soul. We need something that speaks directly to people, something that hits home."

Jan glances at Marisa and, almost reluctantly, takes his cue, "And you think that's something we could help with?"

"Yea, I do, I definitely do!"

JAN KNEW THAT Nigel was right. The AIDS epidemic was out of con-trol in South Africa. The government's foot dragging and obfuscation in response to the crisis was unconscionable. On the street, panic and fear had become a secondary symptom of the disease. Only recently, AIDS activist Gugu Diamini had been stoned and stabbed to death after divulging that she was HIV positive.[1] What should have been a consensus issue was dividing the country, and sapping the vitality of the revolution. The lack of health security for non-whites had been regarded as one of the most onerous symptoms of the

apartheid regime. Article 26 of the South African Bill of Rights, "Health Care, Food, Water and Social Security" was born of that sordid history. But now, on the eve of the millennium, South Africa's democratic transformation was on a collision course with a global plague. AIDS was not only a healthcare crisis; it was an issue of human rights, as well.

Jan had not anticipated mounting a new print project so soon. Following the success of *Images of Human Rights*, Artists for Human Rights (AHR) had revisited its roots by initiating a similar effort in conjunction with the fiftieth anniversary of the United Nation's Universal Declaration of Human Rights, in 1999. This project had involved thirty artists, all from countries identified by Amnesty International as particularly indifferent to human rights. Each had created an image reflecting one of the articles in the Declaration. The idea had been to continue to advance human rights awareness in South Africa, and support similar efforts around the world. It was also hoped that the international scope of the project would boost South Africa's reputation as a "facilitator of human rights."

Notwithstanding these lofty goals, the response to the *Universal Declaration of Human Rights International Print Portfolio* (UDHR-IPP) was beyond expectations. The project's endorsers included UN Secretary General Kofi Annan, South African Writer Nadine Gordimer, Justice Albie Sachs, Chairperson of the S.A. Constitutional Court and Nobel Laureates Daw Aung San Suu Kyi of Myanmar and Wole Soyinka of Nigeria. The opening exhibit at the Durban Art Gallery was presided over by His Holiness the Dali Lama. Inquiries from prospective exhibit sponsors had been received from galleries and museums around the world. By all measures, the UDHR portfolio was an enormous success. It had also been exhausting. It was hard for Jan to imagine gearing up for another major project so soon.

But AIDS would not wait. Before he committed to anything, however, Jan would need to bring the rest of AHR on board. The organization had evolved from an ad hoc committee to a registered trust. Now housed at Durban Technikon, and administered by Jan, the AHR Trust operated as an independent, nongovernmental organization with its own governing board. The Trust's board was hands-on and highly committed, so they knew how much work went into these kinds of projects. Nevertheless, when Jan took the AIDS campaign idea to them they were highly supportive.

Despite their record of success, though, Jan knew this new undertaking would be risky. They would be dealing with the scientific, social and political turmoil associated with HIV/AIDS in South Africa. There was also a great possibility of

butting heads with the government. With this in mind, one of the first activities in what became known as the *"Break the Silence"* campaign was the assembly of a small advisory group with the expertise AHR would need to navigate the potentially rough terrain.

In addition to Jan, the advisory committee included: Dr. Nigel Rollins, pediatrician and AIDS researcher; Dr. Jane Lucas, psychologist; Uma Prakash, artist/ journalist; and Vedant Nanackchand, a printmaker and lecturer at the University of Durban-Westville. The group was asked to commit to the project for its duration, which, based on past experience, would be about two years. Given the lack of staff at AHR, they were also asked to become actively involved in the project. After agreeing on the name, *"Break the Silence,"* the group's first task was to help select the artists. A mix of South African and international artists seemed appropriate, considering the global spread of AIDS. In the end, two-thirds of the 31 chosen were South African. The remainder came from Bolivia, Egypt, Ghana, India, Namibia, Peru, the UK and the US. Most had been personally affected in some way by the disease. The guidelines for the artists were quite simple. But, as Jan recalls, they were broadly interpreted.

> We told them our primary goal was to use the art in the public media (billboards) to increase awareness and address the stigma of HIV/AIDS. As before, we said we would pay their material costs. We asked for color in the A4 (210 millimeters by 297 millimeters) or A2 (420 millimeters by 594 millimeters) format, but the image was entirely up to them. We also asked for a preliminary sketch, if possible. Some artists sent them, but others didn't. But that was OK. Some people assume that a project like this is about artists working in service to an advocacy effort, and, because of that, we should be in control of the images and content. But, no, that's not the way we work. It is the artist in the driver's seat here … We work for them.

REALITY HITS THE ROAD

Since the scourge of HIV/AIDS raised its lethal head over a decade ago, its insidious reach has been fought every step of the way in song, dance, drama, film, art and literature. … The new project of a Durban-based international art initiative, the Artists for Human Rights Trust, "The HIV-AIDS Billboard Portfolio" is… aiming to make contemporary art accessible to the South African public on a grassroots level and simultaneously strike a blow for the fight against HIV-AIDS. Currently, four billboards are already located in the Durban communities of Kwa Mashu, Umlazi and Clermont, as well as in Harrow Road, Johannesburg, with plans afoot to mount an armada of billboards in urban and rural areas across the country.[2]
—*Mail and Guardian*, South Africa, September 8, 2000

For maximum impact the *Break the Silence* billboard campaign and the official opening of the portfolio print exhibition were held on December 1, 2001,

at the Durban Art Gallery. The thirty-one color images in the portfolio ran the gamut from high abstraction to visual storytelling. Many were personal reflections on the disease. Ghanaian Daniel Ohene-Adu, in his artist statement, called it a "murderer, eating away mankind." Although diverse in style and composition, the images produced by the black South African artists seemed the most willing to confront the horror and immediacy of the crisis. It is not surprising that many of these prints were chosen for billboards around the country. In her catalogue essay, Dr. Sabine Marschall reflected on these works.

It is interesting to note that almost all Black South African artists have chosen a realistic style and narrative format that includes explicit references to death and suffering, and it is mostly these images that have thus far been enlarged and mounted onto billboards. It seems that these artists are inspired by their personal experience of living in, or interfacing with, communities in which dying from AIDS has become a daily reality.

Perhaps the most drastic image is the black and white linocut by Vukile Teyise from the Eastern Cape. A gigantic skeleton, prominently displaying the sign "AIDS kills" and recalling medieval representations of the Apocalypse, sweeps through the streets of a typical South African town with urban colonial structures on the right and squalid shacks on the left. In its path, the skeleton encounters anonymous crowds of people, some of whom may be warned, others already doomed.

Even the most negative and deterrent images usually contain at least a small message of hope or deliverance. Many artists see the salvation in education. Sthembiso Sibisi's black and white linocut … shows high school pupils in a classroom being educated by a nurse, who has brought along a box of condoms. Gabisile Nkosi's print features a rural village

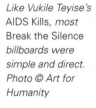

Like Vukile Teyise's AIDS Kills, *most* Break the Silence *billboards were simple and direct. Photo © Art for Humanity*

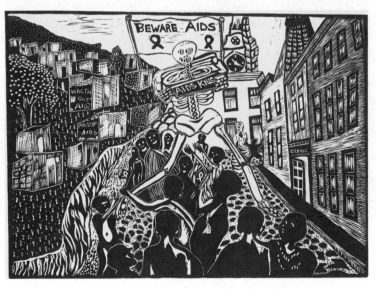

Tinus Boshoff's, dancing figures deliver a straight forward message.
Photo © Art for Humanity

surrounded by graveyards. A nurse, equipped with free condoms, is paired off with a traditional elder who addresses the chief of this community, many members of which are already visibly affected by the disease. Showing the reality of death and disease is thus balanced with the central issue of prevention through education and condom use, but all this with the consent and co-operation of the traditional leadership...[3]

The billboards were placed in high traffic areas in urban centers, whenever possible.[4] The images displayed were selected for visual readability and clarity of message. The six-foot by thirteen-foot displays were hard to ignore. Many were placed at busy intersections or gathering places, including taxi ranks, train stations, markets and schools. In the Klipspruit in Soweto, four abstract figures rendered by Tinus Boshoff dance across a roadside billboard with a starkly contrasting written message: "Adjust irresponsible behavior or Destroy Society."

Another, by Daniel Ohene-Adu from Ghana looming over a well-traveled thoroughfare in Capetown, showed a massive missile-like condom aimed at the lower bodies of an embracing couple. To emphasize the point, the image was repeated three times. To the right, twenty-inch high text read "HIV/AIDS is deadly! Use a condom." By the end of 2001 over 30 billboards had been sited around the country. To date 2006, 95 billboards and giant banners have been displayed of *Break the Silence* images.

Breaking the Sound Barrier

At present, almost 25 percent of children in South Africa are born to HIV-positive mothers. About 15–20 percent of these children will, in turn, become infected with the virus. It is likely that the mortality rate of children under five years will double by 2010. This represents an increase from 48.5 deaths per 1000 children to 99.5 per 1000. Furthermore, it is

When Daniel Ohene-Adu's HIV/AIDS is deadly! *hit the streets it attracted a lot of attention. Photo © Art for Humanity*

estimated that there are 700,000 AIDS orphans at present. This will increase dramatically in the next ten years.

...If we permit this present injustice to mothers and children to be perpetuated, their fundamental human rights to be violated, who will apologise on our behalf? And will the children who survive this holocaust today have the will and benevolence to forgive us tomorrow?[5]

—Dr. Nigel C. Rollins, Department of Paediatrics and Child Health, University of Natal, Durban, and Africa Centre for Population Studies and Reproductive Health, Durban

Break the Silence was hardly the first project to use large scale artwork for mass communication in South Africa. Murals and graffiti art had been used to great effect as a part of the anti-apartheid movement. Sabine Marshall's catalogue essay also references numerous AIDS mural campaigns conducted over the previous decade, but these previous efforts had had very little impact on attitudes and behavior. AHR understood that the message they had delivered though the billboards was just a starting point. Young people, in particular, would need a more in-depth approach. While ideas for responding to this need were not lacking at AHR, resources were. Luckily, Johanne Roussy showed up.

Johanne Roussy came to Durban from Montreal, Canada, in March 2000, specifically to work with AHR. Sponsored by the Canadian government, her aim was to contribute and learn. And that she did! Within weeks the 27-year-old artist was at work in the Mason Lincoln Special School for Disabled Children in Umlazi Township. Her experience helping Canadian first nations communities establish their own arts programs put her in good stead. Created along with Durban's Artworks Trust, what became known as the AIDS Linocut combined training in printmaking with AIDS awareness. Roussy describes the difficult environment and how the students responded.

The school is on a high hill; the township huge. The strength of these young people is incredible. They have less than nothing, yet they make art. The walls of the small, dark room are broken; the ceiling collapsing, the windows broken by anger and hate. But the group is focused. They make linocuts, and their work is magnificent. A young girl in a wheel-chair is busy printing. She is confident, calm, reassuring and strong. She is a mother. She is young, but a mother all the same. She sings a gospel song in isi-Zulu. Her neighbor responds in a sweet, attentive voice. I close my

eyes to hear the good news. Now, I know the trick. Eternity begins with closed eyes, ears and lungs open.[6]

During her time with AHR, Johanne also developed a drawing and writing project for the AIDS-infected mothers and children served by the Bambani Support Group at Durban's King Edward Hospital. The Sketch Pad Project gave these women an opportunity to reflect on their "lives, hopes, joy and disappointments" through art and writing. Another program developed with Artworks Trust and the Thuthukani Art Group joined artists, school children, AIDS workers and community members to make an immense *Break the Silence* banner. In July of 2000, the 500-meter banner was wrapped around Durban City Hall as a part of the 13th International AIDS Conference.

Another significant artistic contribution to the AIDS conference came from AHR's collaboration with an unlikely community of artists. The children at the Ningizimu School for the Severely Mentally Handicapped are mainly from poor township families. Many have been orphaned by and/or infected by AIDS. Despite this, making artwork for a major international conference was no big thing for them. This is because Robin Opperman, the director of the schools unique Department of Art and Technology, had established the Ningizimu as a center of extraordinary creative output.

When he arrived at the school in 1993, Robin had immediately recognized the student's creative potential. In response, he developed a studio environment that both nurtured and rewarded their artistic capacities. Using found and discarded materials, he and the students set about designing and fabricating a line of craft objects that included mats, basketwork and wall hangings. The proceeds from the sale of these items went back to the students. As the program matured, the studio's repertoire grew to include sculptural objects and banners.

"We decided to reinterpret the theme of AIDS prevention as a celebration of life." Robin Opperman, speaking about the AIDS Banner created by Jeanne Roussy and students at the Ningizimu workshop.

By the time Jeanne Roussy contacted Robin about a piece for *Break the Silence*, the Ningizimu workshop had established a reputation for stellar craftsmanship and innovative design. He and the students saw the invitation as an opportunity to join the fray, so to speak, against their common enemy. Robin described their uniquely affirmative approach in the *Break the Silence* exhibition catalogue.

> We decided to reinterpret the theme of AIDS prevention as a celebration of life. We decided to access a broad range of colourful and exciting high-quality materials for the students to work with, to produce a banner that would be therapeutic for the students and would stimulate their creativity. It celebrates the beauty of the environment in which we live and which we so often take for granted. The result is a colourful banner. It not only reflects this theme but also displays how the considerable talents of our pupils combine into a powerful creative force.[7]

Making the Case

During and after the AIDS conference the billboards and the community development projects generated positive attention for AHR. Notwithstanding the enthusiastic feedback, some questioned the effectiveness of the *Break the Silence* effort. Anticipating such skepticism, AHR undertook a study to gauge the campaign's effect on understanding and attitudes towards HIV/AIDS and its causes among young men and women who were most likely to contract and spread the disease. The study focused on the impact of large posters of the *Break the Silence* images that had been distributed to schools. Conducted by AHR and Ms. Joy Kistnasamy, of the DIT Department of Environmental Health, the study showed that three-quarters of those who had been exposed to the images had a positive reaction. Most importantly, the study's report concluded that the "majority of respondents, 54.08 percent, retained and took ownership of the information communicated."[8]

For AHR, the "internalization of the message" was a central tenet of the campaign. Jan believed that culturally imbued arts-based communication could open the door to, what he terms, "moral ownership."

> To change behavior, we needed people to go beyond simple awareness of HIV/AIDS issues. Knowledge was not good enough. They have got to take it in. Straight advertising is not going to do this. With *Break the Silence* traditional culture was being transmitted through art. This happens because art induces a sense of moral ownership of the message embedded in it. Our hope with *Break the Silence* was that these images would help provoke moral ownership of the epidemic. And then, by taking ownership, one would hope that they would express the same kind of responsibility to the epidemic as they would to anything else that they own. So they say, "It is

me. It is mine. And those who are infected are also part of my responsibility. And the only way I can take responsibility for it is by changing my lifestyle in recognition to the fact that the virus is out there."

By the end of 2001 some evidence of what might be characterized as community ownership began to manifest. Although most of the billboards were scheduled to come down after two months, many remained seven months or longer. Not surprisingly, AHR found that the longer a billboard stayed up, the more impact it had. After awhile, they began hearing stories about how the signs were being used by others to spark dialogue and discussion about HIV/AIDS issues. They followed up by sending DIT art students to the five Durban billboard sites to conduct interviews with community members. Jan Jordaan was gratified by what they found.

A number of things emerged. One, people liked having art in their neighborhoods and they wanted more. Another was that health workers from nearby hospitals were using the billboard sites to workshop with their clients about HIV/AIDS. We also found that teachers from nearby schools used the site of the billboard to workshop with the kids both in the arts and in health issues. Then, when we put the posters up around in the schools, they started disappearing. We discovered that the kids were taking them home so they could put them up in their bedrooms and such. The last thing we found out from a small minority of those we talked to was "if it has anything to do with AIDS, we are not interested." It was very important for us to be aware of this response, because it came more from the youth than any other segment.

Less expected was the impact the billboards had on the contributing artists. Most visual artists are limited by cost and market forces to relatively small formats for their work. Printmakers are further restricted by such things as the size of presses, plates and paper. The sheer magnitude and power of the *Break the Silence* billboards was a different story entirely, particularly for the South Africans. Their small, intimate, gallery-appropriate prints had been exploded twenty-fold. They were being seen by thousands of their fellow citizens every day. Experiencing their art as both a public and political event was daunting for some. Others, like young Gabisile Nkosi, relished the opportunity to expose her work and speak her mind.

Gabi

A young black woman stands on the side of the gravel road waiting with her arms crossed, pacing. The morning sun, pulsing in the thin overcast, is close to burning through. Shielding her eyes, the woman looks up at the massive billboard towering behind her, considering the scene. She knew this road well. She had probably passed by this sign a thousand times on her way to the

market or to catch a "combi" into Durban. Still, she had never really noticed it—not like today. She thinks to herself, It's really quite intrusive, rising up on those skinny poles, the tallest thing around. And now my art is up there for all to see. Yes, seeing it here now, there was no doubt in her mind—the message would be seen.

A dark green Camry slows and pulls on to the narrow shoulder opposite her, kicking up dust. A young white man rolls down the window and takes off his sunglasses. He squints and smiles, "Morning," he says, not quite shouting. "You don't happen to be the artist I'm supposed to meet here for a photo shoot…?" The woman grins, thinking to herself, Yes, that's right, the artist. She speaks the words out loud, "That's right. That's me." He raises his hand, "Hi, I'm Peter Duffy, from the Daily News.*" "Pleased to meet you," she says, "I'm Gabisile Nkosi—the artist."*

Gabisile Nkosi always dreamed of being an artist. Becoming one had not been as easy as imagining it, however. In fact, it had been extremely difficult. While she had had some art in the township high school in Umlazi, she was mostly self-taught. Art was not considered a particularly promising career path, particularly for single mothers like her. She knew, in her heart, though, that it was the right path. Others were not so convinced. Her application to the Technikon in Durban was rejected twice in 1995 and 1996, because of her poor English; in 1997, for the lack of a portfolio. After each rejection, she had worked hard to strengthen her application, all the while caring for Sandile, her young son, and living in her crowed family home in the township. The rejections and the waiting were frustrating, but the toughest part came unexpectedly from another quarter.

Gabisile Nkosi's Break the Silence billboard dominates the view on the outskirts of Durban. Photo © Art for Humanity

During the time she was building her portfolio for the Technikon, Gabi became involved in a mural project at a community art center on Durban's waterfront called the BAT Center. The Centre, named for the Bartel Arts Trust that supported its creation uses the arts to "promote local talent, create jobs and develop markets." The Centre's BATshop, established by Jan's wife, Marisa Fick-Jordaan, promoted innovative design and marketing of South African craft, most notably telephone wire basketry. Gabi describes how quickly good fortune can turn bad.

> At the BAT, I was introduced to Jan Jordaan who told me that his wife, Marisa, was looking for somebody to work in the shop she ran there. It was a craft shop for traditional art. Working there really helped me learn a lot more about art. It was a great place to work.
>
> Then something horrible happened to me. I had separated from the father of my child. One day, in October in 1998, he came to the shop and stabbed my son and myself. This was a Sunday morning. It was really horrible. The blood was all over the shop. We were very lucky because both of us survived and were able to heal.
>
> From that point on, my art changed a lot. I started using my art for healing myself. My art is where I am able to express what I can't express in words. By making images, I am able to get through those hard feelings. It helps me take my anger and make a negative into a positive so that it doesn't stay in my head. It also helps to be able to talk about it when people want to know where a particular image comes from—to be able to take the anger out. It heals me a lot.

When she was finally accepted at the Technikon, Gabi, as she is called by her friends, had no money for tuition. At that point, though, some good fortune came her way. Funds manifested from a British couple who had seen her work when she was in high school and had fallen in love with it. While she was excited and proud to be finally entering the Tech, as the only black person in her class, she also felt a great deal of pressure to succeed. Pressure also came from the continuing struggle to make ends meet. As she approached the end of her first year, she had no idea how she would pay for her second year. Luckily, that same British couple invited her to travel to the UK at the end of the term. She describes what happened next.

> They organized an exhibition for me in Durham and Gateshead Library, Newcastle in the UK and I sold everything there. So I was able to pay my second year at Tech. During that year I went back to England again for three weeks. The main guy who had sponsored my exhibition was named Professor David Bellamy. He was a botanist. He gave me a £1000 commission to create two or three pieces about Zulu traditional women. So I did the commission and I was able to pay for my third year as well.

Beyond the financial boost, Gabi was coming to recognize that there was something special about her work. As her confidence grew, so did her willing-

ness to try new things. In her third year, she took one of Jan Jordan's printmaking classes. She took to the art form like she had been doing it all her life. As he came to know her and her art, Jan was impressed by both the quality and intensity of the work—so much so that he invited her to create a piece for the *Break the Silence* campaign.

> When I involved her in the portfolio project I could see that there was real talent, a natural talent, and an incredible determination. The interesting thing is that Gabi was very conscious of the fact that, traditionally, Zulu women aren't allowed to work with chisels or knives or axes or things like that. That's men's work. So, for a Zulu girl to do printmaking… it was just not done. I think these very strongly defined gender roles in traditional Zulu society motivated her more to continue what she was doing, and made her more aware of herself as a woman.

Gabi took the billboard commission very seriously. Since the attack on her and her son, much of her work had been about healing. The roots of this work had been very personal, and her "canvas" relatively small. *Break the Silence* was an invitation to "go large" and speak directly to a wider audience on a subject that touched everyone, but was often avoided. As she contemplated the work, she challenged herself to create something that would teach as well as gain attention. She also reminded herself that images have a much greater impact when they tell a story.

> I think art can have a great influence on the way people think. In the place where I grew up, storytelling was an important part of people's lives. And I know many people in the township who don't like to read so much, but can learn a lot from looking at something visual. Even when you have a book, and you are often looking for pictures to help you understand what is going on. I think it's particularly important for people who do not read very much about HIV and AIDS to get this information by looking at images, or making stories, or asking their views about the issue.
>
> In my billboard, I was trying to speak to the Zulu people, my people. The billboard has two men who have many wives. I am trying to say to them "Be careful in your families and in your relationships." I am also saying that this polygamy is not good. To the younger men I am saying, "It's important for you to take care of your bodies." When I was growing up it was common for older women to tell the younger women to take care of themselves, and to be careful of the young men. But I never remember the boys being told to take care of their bodies in this way. For them using condoms is something new and interesting to hear about. So the image shows this information being shared.

When the first billboards were rolled out AHR had not idea what to expect. Posters and signage shouting public service and advocacy messages were a common sight all over the country, particularly in urban areas. The hope

was that the first wave of twenty or so sites would create a buzz that would set them apart within the visual cacophony surrounding them. Jan Jordaan recalls that Gabi's billboard more than filled the bill.

Gabi's was one of the first billboards we put up. It was on the main entrance and exit to Umlazi, in the commercial center where all the taxis are coming and going. Her billboard has this nurse with a box of condoms facing a group of old men sitting under a tree. Now, the connotation is, obviously, one of a young woman addressing the Indunas (elder men from the local community or tribe). Now that's already a big no no. So, she actually got taken to task by a group of men in Umlazi who confronted her on that, very clearly. They said, " This is not a place for a young black woman. It is not good for you to publicly participate in this kind of campaign."

On the other side of the coin, the students coming in and out, recognized her name and the word quickly spread that the Gabisile Nkosi in Fine Arts at the Technikon—that's her billboard there. So in the student community she became quite famous. But then, Radio Zulu picked up on the story. They did an interview with her about the incident with the men in Umlazi criticizing her. So, she had to defend her involvement, publicly, on Zulu radio.

That was where the Love Life campaign picked up on this story and gave her a job to do AIDS prevention arts workshops in schools. In the meantime, her career was taking off. Then she started going overseas and exhibiting. She really grew in stature. One of our goals has been to support artists in their careers. Gabi's story is a shining example.

One Desk, Many Windows

All of the publicity surrounding *Break the Silence* increased the profile of the small, "one desk" Artists for Human Rights. It also created a growing demand for information and programs. With little funding, Jan and his colleagues on the board did what they could to respond. Luckily, what the organization lacked in funding was supplemented, in part, by eager art students who helped with office work, exhibition logistics, and surveys. They, in turn, gained valuable experience working with, and learning from, the *Break the Silence* programs and community partners.

One source of funding for AFH came from the sale of the *Break the Silence* print portfolios to galleries, museums and corporate sponsors. Of the twenty-five portfolios that were produced, twenty were made available for purchase. During the first few years of the project, *Break the Silence* portfolios were added to prominent collections of international and South African communities, including the National Gallery, Cape Town; Durban Art Gallery; University of Kwa-Zulu Natal; United Nations, Geneva, Switzerland; and the Fowler Museum at the University of California at Los Angeles. While these periodic sales were a

great boost, they were so unpredictable that they could not easily be factored into AHR's long-range program plans. But for Jan these sales represent far more than a capricious revenue stream.

> This is the difference between art and advertising. For the advert, the graphic designer designs a picture concerning breast-feeding and infection for World AIDS Day, to be used for three weeks in a particular area. He does it, it goes out, it is used, and it goes into the trash when he is done. Art is different. The artist contemplates, does the picture. The picture goes out there and makes its mark in a way that I think is more powerful than the advertisement. Because, rather than going in the land-fill, it goes on tour and into the collection and it lives to be seen and reflected upon again and again. The art continues to share the values of creativity, freedom of expression, excellence, individuality, dignity, pride, reflection, etcetera, across humanity and future generations.

In August of 2001, Artists for Human Rights received the Medaille d'Excellence from the International Human Rights Consortium in Geneva for the *Break the Silence* campaign. They were also invited to exhibit the portfolio at the 14th International AIDS Conference in Barcelona in the summer of 2002. This, in turn, led to opportunities to show the portfolio in Africa, Europe and North America. Over the eighteen-month run-up to the Conference, the *Break the Silence* traveling exhibition was presented in Bangladesh, Botswana, Germany, Namibia, Switzerland, United Kingdom and the United States.

The next year, Artists for Human Rights changed its name to Art for Humanity (AFH), describing the new name as "a more advantageous description of our activities and a true reflection of our aims and objectives regarding the very broad nature of the term *human rights*." In August of 2005, a second billboard rollout of the *Break the Silence* HIV/AIDS Awareness Campaign was initiated. A few months later AFH launched the organization's fourth campaign, *Women for Children*. Combining print images with poetry, the project was created to "raise awareness around the issue of children's rights and to inspire a sense of "moral ownership" and social responsibility towards the rights of children. Each of the resulting portfolio's 25 works is the product of collaboration between women visual artists and poets primarily from South Africa and the developing world. Billboards of the combined work began showing up along South Africa's roadsides in 2006.

Jan Jordaan and his colleagues know full well that works of art alone are not going to assure the success of democracy or stem the tide of AIDS. They do believe, though, that these daunting challenges can be met by influencing one person at a time, and, if a critical mass of individuals assumes collective stewardship of the journey, tides will slowly turn. Their continued commitment to this work lies in the conviction that art can not only move people to action, but also help to instill moral ownership. Jan describes one of AFH's primary goals as promoting "greater understanding and acceptance (i.e., ownership) of

the self and the other in the spirit of *ubuntu*."[9] AFH sees this powerful idea, that "one can only exist because of the other," as a cornerstone of African cultural and social regeneration. In this regard, AFH operates in concert with many others in South Africa, including Walter Chakela and Kim Berman, who are using their art to rekindle *ubuntu* consciousness in the country and beyond.

At its essence, AFH operates as a crucible for art, ideas and action. Since their first *Declaration of Human Rights Portfolio* in 1986, this amalgam has derived its potency from the enthusiastic collaboration of its contributing artists. Jan has been adamant that these creative partnerships be "win-win." He reinforces this point by asserting that "the organization belongs to the artist. They are the moral learners. They educate in the organization, so we owe them a lot."

To that end, AFH has worked as hard promoting its artists as it has soliciting billboards and prominent sponsors. The benefits to artists have been significant. Their works are represented in important collections around the world and viewed by millions at home and abroad. This is no small thing for a creative community that endured many decades of internal censorship and international boycott. For emerging artists working with AFH the most significant "win win," may be the path to service that has opened up for them. Many of these artists have had their first experiences working in community settings through AFH-sponsored outreach programs. Others have gone on to community-based work with other arts and social institutions.

Supporting these artists is more than an obligation for AFH and its supporters. They regard these respectful two-way creative exchanges as an antidote for the lingering shadow of apartheid's cultural paternalism. They also see "win-win" as a potent manifestation of an interdependent, "I am, because, you are," worldview—an everyday realization of *ubuntu*.

Postscript: A Moral Learner

Gabi leans forward into the soft breeze as it wrinkles the surface of the stream at her feet. She breathes deep, for a moment, feeling settled, content. The air stills, and seems to disappear. She muses, "This is Caversham—the perfect temperature, the perfect place, between warm and cool."

She reflects back. Coming to Caversham had been a big step. Maybe the biggest, after getting into the Technikon. It was hard saying goodbye to everything she knew—Umlazi, her family, her mates at DIT—to come to this little studio in the country to make art. It was her dream, but it was scary all the same. Scary, but right. For her and for Sandile.

She looks up the green sloping hill to her right at Sandile playing with Malcolm in the garden. Over the last year the boy has grown so much. So have I, she muses. Everything seems to be coming together here. She knows how lucky she is to be working with an artist of Malcolm Christian's stature. His wife too, has taught her so much. Then, there is her own teaching at the

local school. These days she is as excited about working with those kids as
she is about making a new image. What was it that someone said the other
day, that she had found her "calling"?

 She sees the little school where she teaches in her mind's eye. Every
time she walks into the narrow classroom she is greeted by the smiling faces
of the students, eager to draw. Their enthusiasm makes her happy. So does
knowing how much they look up to her. She thinks to herself, *They love mak-
ing things, but their respect for me is the reason they listen, particularly when
I talk about taking care of themselves and avoiding AIDS.*

167

Gabi (on left), her mentee, Senamile, and friend, Oprah. Photo Gabisile Nkosi

Gabi tosses a pebble into a calm eddy on the edge of the stream. The ripples fan out and then disappear into the rushing current. She chuckles inwardly. Given the journey of her life, she never thought she would be the one giving guidance. But now, she considers it her responsibility—to mentor these young lives—to give them a chance to survive long enough to imagine and discover their own calling.

In the June of 2007 Gabi sent the following message to share some good news.

I was selected as a visual artist to run a creative workshop at Oprah Winfrey Leadership Academy for Girls in Johannesburg. I also had an opportunity to meet Miss Oprah and Anna Deavere Smith (the stage performer) and met other Americans who came with Oprah to run different workshops. I decided to bring Senamile (she is one of my students) as my assistant because I see her as another future Gabi. She is remarkable, talented, a great storyteller and performs her poems with confidence. She is in grade 12 (17 years) and wanting to pursue drama as her career. I want to contribute towards her fulfilling her dream as so many people who believed in me did, in different ways. —Gabi

PART 4

The Watts Prophets

USA

I learned the power of words in the insane asylum. My doctor was a midget. He had this little seat turned as high as it would go and a very low couch, so you would always be looking up at him. When we first met, we hit it off wrong. He told me I had a problem. I said, '"No, I don't." He said, "Explain then, why you don't have a problem..." I thought I had a pretty nice gift for gab so I started laying it out about living in a black community and living in the ghetto in LA and this and that. When I got through, he took every word that I said, and tore them into little pieces and threw it back into my face. He destroyed me with my own words. It made me see the power of words. I walked out of that room and I said to myself, "some day I am going to learn how to use that power.

—Amde Hamilton

Poets

Richard

I am a child of segregation. We couldn't go into Sears and Roebuck. We stood outside and ate. We couldn't sit down in the cafeterias. Back in those days you had to know what size you wore because if you put it on, it was yours and you bought it. I saw a lot of mean-spirited things when I was young.

—Richard Dedeaux

WHEN HE FIRST ARRIVED in Los Angeles Richard Dedeaux was excited and a bit overwhelmed. After his mother had passed, he'd been shipped west to join his father. Even the train ride had been a revelation. He had never been anywhere outside of New Orleans. His second day on the train he awoke to find that one of the most persistent tyrannies of his 14-year life had disappeared overnight—the train was no longer segregated. The rules had changed in the middle of the night as the train crossed the Texas state line into Arizona.

Life in LA heightened his sense of dislocation. It was big and spread out, and blacks seemed to be everywhere. His father had settled in an area of Los Angeles called Watts. During WWII, LA had become a magnet for Southern blacks looking for war work and a respite from Jim Crow. The work was plentiful, but areas with housing available to blacks were not. During the 1940s, many migrating blacks ended up clustered on the unrestricted southern edge of the multiethnic working class suburb of Watts.

By 1958, when Richard Dedeaux's train was pulling into LA's Southern Pacific train station, Watts was changing. The community was growing, as more and more Southern blacks migrated west, in search of the good life. Unfortunately, the war-related jobs were long gone, and unemployment, exacerbated by discriminatory hiring practices, was high. Because no one would sell houses to blacks outside of Watts and a few other "red-lined" communities, even black families of means could not relocate. The Federal government made matters worse by turning the temporary WWII military billets that had been built in the Watts area into LA's first low income housing project. At the same time, the

As a young man, Richard Dedeaux was "just getting by." Photo © Watts Prophets

construction of the world's largest freeway system provided a ready pipeline for massive white flight to suburbia.

The result was both a ghetto and a mecca for LA's blacks. And as Richard Dedeaux soon discovered, the mix was both enriching and dangerous. Palm-lined working class neighborhoods were nestled in next to acres of high density public housing. Churches and mom and pop stores were everywhere, as were liquor stores and pawn shops. The crime rate was high, but the street life was constant and vibrant. Even though the largely white police force operated like an occupying military, it seemed that anything could be had. Alcohol, gambling, drugs and easy women were all available, and being underage was not a liability. And like New Orleans, the music and dancing were everywhere. For an impressionable teenager, Watts presented a great opportunity to both learn and to make mistakes.

Unfortunately, for Richard, his mistakes far outpaced his learning and he followed a path well worn by many other young black men in LA at the time. He describes this period of his life as being dominated by a "D" mentality. "I just got by… I didn't have any confidence in myself. My spirit was beaten down. I muddled through high school, managing to get a D or C minus and after awhile, I just dropped out. Then people started treating me like a 'D' and I started dealing with lesser people."

Dealing with those "lesser people" led him to gang life, which at the time was more about defending territory than the drug trade and gun violence. Nevertheless, drugs were a part of the scene and in no time Richard found himself addicted and in jail.

By the summer of 1965 Richard was back on the streets, an ex-con and unemployed. He was not alone. At the time, fully 30 percent[1] of the young men in Watts were in similar straights—without a job, deeply frustrated and angry with few options and little recourse—a bomb looking for a fuse.

Rebellion

NEGRO RIOTS RAGE ON; DEATH TOLL 25
21,000 TROOPS, POLICE WAGE GUERRILLA WAR;
8 P.M. CURFEW INVOKED

ROUNDUP OF CITY'S WORST RIOT—It began Wednesday when California Highway patrol officers stopped an auto in the Watts area. This minor traffic incident kindled the spark for the worst riot in city history. (See Charles Davis Jr.'s story on Page A.)

JOHNSON OFFERS U.S. AID—President Johnson, expressing shock at the Los Angeles riots, urged local officials to do everything possible to restore order and offered full U.S. help. (Story on Page 1.)

RIOT SLOGAN: BURN, BABY, BURN—Negro Arsonists raced through otherwise deserted Los Angeles streets hurling Molotov cocktails into stores and shouting

a hep slogan borrowed from radio disc jockey: "Burn, baby, burn!" (See Robert Richardson's story on Page 1.)

RUSH ON GUN STORES—Dealers reported a heavy demand for guns and ammunition from residents of all parts of the county, fearing spread of: violence from riot-torn areas. (See Harry Trlmborn's story on Page C.)

—*Los Angeles Times*, August 15, 1965

Officially, and in the mainstream media, what took place in Watts in the late summer of 1965 has always been called a riot. But, if you lived in Watts at the time there is a good chance your description of the six day conflagration that ignited that August would include the word "rebellion." Most white Americans have a hard time imagining twentieth century America as having ever been in a rebellious state. It would be harder still for them to see themselves as potential insurgents. That was probably the case for most black Angelinos prior to August 11, 1965.

But that evening, a seemingly inconsequential traffic stop pushed Watts from slow burn to firestorm in a matter of minutes. For CHP officers Bob Lewis and Lee Minkus the stop was routine—an apparent drunk driver, a missing license, a little resistance. At first, even the driver, Marquette Frye, didn't think it was too big a deal. But the combination of a ninety-five degree, "to hot to stay inside" evening, a little alcohol, and an over-reaction by a CHP officer turned a crowd of bystanders into an angry mob and triggered a violent eruption of historic proportions.

Six days later, as 21,000 National Guard soldiers began their withdrawal and the curfew was lifted, Watts' commercial district lay in ruins. In the surrounding neighborhoods, grieving loved ones from thirty-four families were preparing for funerals, while at hospitals all over the city over 1,000 people lay recovering from their wounds and injuries. Four thousand more sat in jail awaiting the dispensation of their cases. Up and down the area's palm-lined boulevards dozens of white shirted claims adjusters picked through the rubble of hundreds of businesses and residences. Their verdict: property damage of

Four thousand people were arrested and hundreds of buildings were burned during the Watts Rebellion. Photo courtesy California African American Museum

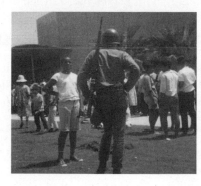

$40 million ($230 million in 2005 dollars) was a devastating blow to this community's already anemic economy.

Other post-mortems tackled more complex questions about how and why Watts became a war zone literally overnight. California Governor Pat Brown's investigative task force, the McCone Commission, concluded that many mistakes, missed opportunities and outright incompetence made a bad scene much, much worse. They also determined that the precipitating conditions were a "trouble gathering under the surface calm." The Commission's report went on to predict that the "situation was so ... serious and so explosive ... that, unless it is checked, the August riots may seem by comparison to be only a curtain-raiser for what could blow up one day in the future."[2]

This was not news to the citizens of Watts. Their repeated warnings about the desperate state of their community had been ignored at City Hall and in Sacramento, the state capitol, for years. However, this cataclysm had everybody's attention. The people of LA were scared. They wanted to know how this could happen. So, for a brief moment a spotlight was focused on the raw and festering wounds of decades of economic and institutional racism.

It was not a pretty picture. When compared to the rest of the city, practically every recognized indicator of community health was significantly lower for citizens of Los Angeles's "black ghetto." Fully one-third of the area's residents lived in public housing. Nearly two-thirds of the students entering the three high schools in the center of the curfew area did not graduate.[3] The 19.7 percent unemployment rate for blacks in LA was nearly four times that for whites. Those who did graduate high school and find work were earning 30 percent less than whites with the same education in the same jobs. For college graduates the pay difference for blacks was 40 percent less than whites. The health statistics were even more alarming. Although they only comprised 18 percent of LA's population, blacks were contracting 42 percent of the rheumatic fever, 44 percent of the epilepsy, and 100 percent of the polio, diphtheria and brucellosis.[4] Despite the fact that these conditions resembled those in areas of the developing world, for the most part they had been ignored. To outsiders, ignorant of the facts, the "riot" appeared irrational. And while most of Watts was aghast at the burning and looting, they had a different perspective. In a letter to the *Los Angeles Times*, "C.M.A.," a newspaper editor and long time Watts resident, shared views held by many black Angelinos.

>Down through the ages when men have been oppressed and denied the simple necessities enjoyed by other men, they have revolted. Whether such revolts are justified has no bearing on the fact that they have occurred and will continue to occur. They are inevitable.
>
> I am afraid that... If politicians pursue their present course of denying facts which every Negro knows but cannot prove in court ... the result will be a greater or complete separation of the Negro and white communities. This would be a disaster...

> I view this not as a Negro riot, but as a revolution of men and women
> who are tired of too few jobs, too little food and no hope for the future.[5]

A Writers Workshop

In the fall of 1965, many politicians and celebrities came to tour the devastated cityscape of post-rebellion Watts. Never had so much attention been paid to the place. For some who lived there, it was a welcome change. For others, though, the increased scrutiny only heightened their sense of separation and isolation. Inevitably, after a few sober words for the trailing press, the visitors would depart. Few returned. But the smoky smell, the rubble and 650,000 residents remained.

One visitor who did come back was a white Hollywood screenwriter named Budd Schulberg. Schulberg's screenplay for *On the Waterfront* had recently earned him an Oscar. He saw himself as a socially active writer who was acutely aware of the inequities suffered by non-whites in America. But, watching the Watts conflagration unfold on his television had confronted him with his ignorance. He realized he knew very little about life in Watts or America's other urban ghettos. He had no idea what level of rage would drive people to destroy their own community.[6] But he felt a responsibility to understand how this could happen and maybe do something to help.

So he came. The scene on his TV had been one thing, but this was something else. Walking down the debris strewn sidewalks of "Charcoal Alley No. 1," as 103rd Street had been dubbed, evoked the ruined terrain of the German cities he had toured as an OSS officer in the final days of World War II. He likened the "terrible silence" he encountered to "battlegrounds on the day after battle."[7] What, he wondered, could any one person possibly do here that could make a difference?

The answer came from a young social worker named Bobbi Holland who suggested that he start a writer's class at the Westminster Neighborhood Association where she worked. The association had quickly become the triage center for the 103rd Street area. The screenwriter responded by posting a notice on the association's bulletin board announcing a creative writer's class. But, instead of attracting students Schulberg faced a steady stream of epithets and derision. He stuck it out though, and after three weeks of empty classrooms, Charles Johnson showed up.

The first thing out of Johnson's mouth was a challenge. "Are you a cop? People think you are the police." Schulberg told Johnson he was a writer. Then he picked up a copy of *Manchild in the Promised Land*, and started to read.[8] Claude Brown's explosive tale of his 1940s Harlem up-bringing resonated with Johnson who decided to stick around. A few weeks later, one more appeared. Leumas Sirrah (Samuel Harris, spelled backwards) came with a poem called "Infinite" that started with the line "Never know a begin of me." Schulberg's first response to Leumas's work was to correct his grammar, but after awhile,

175

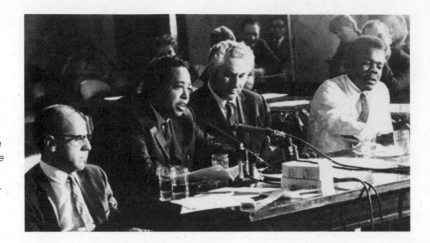

Screenwriter and novelist Budd Schulberg (center) with Watts Writers Workshop members Harry Dolan (left) and Johnnie Scott (right), testifying at a 1966 Senate subcommittee on social justice. Photo courtesy of Rauner Special Collections Library, Dartmouth College

he realized that the eighteen-year-old dropout also had some things to teach him. Harry Dolan followed. A janitor at the time, he arrived with a powerful body of autobiographical work that from Schulberg's perspective only lacked an editor. Then, Birdell Chew brought her tough stories of fifty years in the rural South, and Johnnie Scott came with his harsh street poems.

Within nine months the Workshop had 20 participants, had outgrown two temporary homes and garnered the attention of the national press. Schulberg came to Watts to do some good and to learn. However, as the class grew, in both numbers and skill, so did his appreciation for the depth and capacity of his students. Given the paucity of educational resources in the area, the talent and potential was astonishing. But so was the promise that had been squandered. He had naively assumed that material poverty would portend all else in this devastated place. He was dead wrong. And with that realization came another—this potential could not be nurtured piecemeal.

In early 1966 a nine room house around the corner from Westminster on Beach Street became the Frederick Douglass House. Named after the runaway self-liberated slave whose writings and oratory propelled the abolitionist movement, the new home of the Watts Writers Workshop was now a permanent fixture—a true literary center for the community.

The Douglass House became a magnet for writers of all kinds. For some it was an introduction to the power of words. For others it was a needed way station to a life of writing. The work rising up was helping to reveal the voices of Watts. Long stifled, long ignored, the chorus of stories, ideas, and images was thunderous and resounding. Douglass House became an incubator, a reactor actually, for every imaginable literary tongue. Workshops were available for poets, fiction and screen writers, playwrights and essayists, at all levels. Readings, discussions, debates and critiques raged from morning to night. As they did, the complex stories, the polemics, the poetry that emerged began to insinuate the voices of Watts into the cultural landscape of America's largest city and beyond.

The tenor and content of those voices were as diverse as the community that spawned them. Some told stories of loved ones far away or of the South and the journey west. Others described life on the street, and many, like Johnnie Scott in "Watts 1966," were filled with intense anger.

Watts, a womb from whence
has been spawned Molotov
cocktails and shotguns, but most
of all, a lack of care:
for care has been exposed

as fraudulent and so deserving
of no due other than that
accorded burnt newspaper wafting
away in the blackened wisps while
mothers hang out their clothes

and talk on telephones of the
danger and their children
and the nightmare that has descended
… and how hopelessness,
helplessness, is their

young one's due
The man named fear has inherited half an acre,
and is angry

very (x?) publicity

Some observers enthusiastically embraced the Workshop as worthwhile, inspirational and hopeful. *Time Magazine*, the *New York Times* and dozens of other local and national publications sent reporters who wrote positive stories. Schulberg asked writers from around the world to contribute to the cause and many did. Among them: James Baldwin, Irving Stone, Claude Brown, Paddy Chayefsky and John Steinbeck. The newly minted National Endowment for the Arts provided additional funding. Even the US Congress took notice. Harry Dolan, Birdell Chew, Johnnie Scott and Schulberg were invited to testify at congressional hearings on the causes of urban decay.

It was inevitable, though, that others would view the eloquent ferment emanating from Douglass House as a threat. The American political psyche of the period was mired in Cold War paranoia. As such, there were powerful forces predisposed to see the long arm of the Communist conspiracy at the root of every internal upheaval. The simple fact that a center for creative discourse and dissent had risen up in the "ghetto" was proof enough for some in local law enforcement and at the FBI that outside forces were stirring up trouble. In the short term this antagonism manifested as harassment of the writers and their regular venues like the Watts Happening Coffee House. But, the enduring impact, would be a dark surprise to even the most pessimistic of the Workshop members.

Amde

At his first writers workshop Amde was "just visiting."
Photo © Watts Prophets

Early morning heat rises up from the sidewalk as Amde Hamilton looks through a dirty window across the intersection of 103rd Street and Crenshaw. Not much has changed for the neighborhood in the five years since the rebellion. Vacant lots and half-burnt buildings are still as much a fixture as the lack of jobs. The life he had imagined during his time in the Federal drug program had not come to pass. He is clean and he and his wife Shirley are safe, but the job thing is wearing him down. He feels like he's starting to disappear, again.

As he scans the Employment Development Office, a tableau of frozen lives and squandered industry spreads out in the pastel heat. Everyone is stuck. He realizes that a stranger would find it impossible to distinguish the helpers from the helpees. He looks over at an older man sitting by the window, chewing his pencil, staring hard into the pages of a composition book. He muses, I know that guy is a counselor, but you sure couldn't tell it by lookin' at him. The man catches Amde staring.

"You a writer?" the man asks.

Amde is startled, "Am I a what?"

"Are you a writer?"

"What you mean, a writer, what are you talking about?"

The counselor closes his book, and leans forward. "I've seen you here every day sitting over there, scribbling, crumpling pages, throwing them away. I just thought you might be."

"No man, I'm no writer."

"Well, would you go with me to a writing class?"

Amde is taken aback. "For what?" he stammers.

The man pauses, and patiently repeats, "Would you go to a writing class with me?"

Amde looks down at his feet, wondering what is going on with this man who is supposed to be a job counselor and sits around all day writing. He is wary, but curious too. "Are they going to have something to eat there?"

"Yeah, they'll have food. Come on, be here at eight. I'll come by and pick you up."

Ode Hawkins met a lot of interesting people in his day job as a counselor at EDD. Every once in awhile, another writer or potential writer would surface. When they did, he would invite them to come to his workshop at the Douglass House. Sometimes they'd stick around, sometimes they wouldn't.

Looking back, Amde really isn't sure why he agreed to go to the Watts Writers Workshop. He had no idea what to expect. He just figured, that if he could get some food, what could it hurt. He, after all, was just a visitor. He describes the experience.

When we walked in, there were all these people sitting around with their little pencils and notebooks and pieces of paper. Each one would read

their poem and the rest would critique it. When it got to me everyone stared and someone said, "Well, what you are going to read?" I said, "I am just visiting. This guy, Ode asked me to come and I just came to hear. I don't have anything." Then Ode says, "Yeah you do have something man," and he goes into his notebook and pulls out a stack of those little pieces of paper that I had been throwing away. He said, "Read these." So, I read them. That poem changed my life, saved my life actually, because at that very moment, I was injected with a poetic spirit. A spirit that had probably been in me for years and was dormant and was probably a cause for many of my problems. I was in search of myself and that very day I found myself. I began to use poetry as a tool to do anything that I wanted to do, and to heal.

By 1971, when Amde Hamilton joined the Watts Writers Workshop, it had come a long way. The writing center had been expanded to include performance. A theater, built with funding from the Hollywood community, now provided a home for readings and the production of original scripts. On stage was a beautiful grand piano donated by Sammy Davis, Jr.

Even Marge Champion, the legendary hoofer was conducting classes. After Bud Schulberg had moved on to start another Douglass House in New York City, Harry Dolan had taken the reins. Over the preceding six years, hundreds of writers and performers had come and gone. Among them were Quincy Troupe, Stanley Crouch, Ojenke, Kamau Daa'ood and Jimmy Sherman.

The weekly workshop Amde found himself attending quickly became the center of his life. As he grew more comfortable with the idea that he was a writer, he came to know that this was about more than writing. It was demanding, it took enormous amounts of time, there was no pay, no boss, and yet, he chose to do it. Every day, he would write. Eventually, it became an obsession. The best part, though, was that he was not alone. He was involved in something that was bigger than himself that was safe, and fed him in ways he could not have imagined before the day Ode enticed him with a free meal.

Otis

People would ask me, "How long have you been a poet." I'd say, "I was born a poet." Writing poetry is not something I decided to do. Making poetry is something I have to do. It has always been here inside of me. Truly, I am doing my love and loving my doing. That's what has kept me going—doing what I was born to do and loving it.
 —Otis O'Solomon

Otis O'Solomon knew he was a writer at an early age. The rhythms and rhymes just came into his head and he wrote them down. When he shared them with people in his hometown, Flat Creek, Alabama, they told him he had a talent and encouraged him to keep it up. And he did. As a child he was always reciting and performing. When he arrived in LA in his late teens, among his few

Otis O'Solomon was "born a poet."

possessions was a collection of notebooks from the Thrifty Paper Company that contained his poems and lyrics. One motivation for moving west was the dream of becoming a songwriter. Another was learning about life outside of the South. And learn he did.

> I was the youngest guy at the Y. A lot of the guys came from different cities. In fact, everyone was called by their city or state names. Cleveland, New York, Hey Bridgeport, Hey D.C., Hey Alabama. Some of these guys were making these second attempts at life. They would take me into places that I shouldn't have been in, like clubs and stuff because I really wasn't old enough. It all worked out. And they just kind of taught me and showed me around and I learned the city.

As a writer though, Otis was mostly self-taught. In junior and senior high school he was always reading and reciting the poems of Paul Laurence Dunbar, James Weldon Johnson and Langston Hughes. Throughout his life libraries had always been a refuge—a place where he'd spend hour upon hour commiserating with the likes of Richard Wright, Kahil Gibran and Shakespeare. But neither Birmingham nor LA had any community programs for aspiring writers. That changed in 1965. In the aftermath of the rebellion, a number of writers workshops had emerged. KCET Public Television, UCLA, the *Los Angeles Times*, The Screenwriters Guild, Open University established "outreach" programs in the late sixties. Most came and went, but Otis took advantage of as many as he could.

In early 1969 Otis found his way to the Frederick Douglass House. From the very beginning he noticed a difference. "It was a fixture, a Watts institution. Everybody there had come up through the workshops. Harry Dolan, the director, all the workshop leaders, they all cut their teeth there."

The level of support he felt there was different, too. At some of the other workshops the instructors had pushed free verse but Otis had always been attracted to the musicality of rhyme. Nobody at the Douglass House questioned this. In short order, he discovered a number of kindred spirits among the workshop attendees. One who stood out was an actor from Douglass's theater project named Richard Dedeaux who dropped in on the writers' circle from time to time. Another, Anthony Hamilton (later Amde), was introduced by George Boland, a local newspaper editor and radio personality, who thought the two had a lot in common. It turns out they did.

> Amde and Richard were both really good, but the thing that made me take notice was their theatricality. Richard had training as an actor and it really made a difference in the way he delivered his poetry. He would stand up and perform the poem. It made you hear and feel what he was saying. Amde was dramatic, too, but in a different way. He was so intense the power of his words would take over the room. Sometimes we would be physically exhausted after hearing one of Amde's poems.

Sidewalk University

The attraction was mutual. Over time, Otis, Amde and Richard found themselves connecting in the workshops. They also started showing up at each other's readings, being supportive. It was good to see someone from the workshop in the audience at the Mafundi Institute or the Watts Happening Coffee House, nodding and smiling, even shouting.

Sometimes they read at the same event. It was a good scene. Audiences were beginning to respond enthusiastically to their poetry, particularly to the way it was being delivered. Unlike many of the writers appearing at the time, none of the three actually read their work. Reciting from memory was freeing. They could move about, connect with the audience, even improvise. Each, in his own way, was becoming a poet-performer. Otis, at times would almost sing the words, emphasizing his internal rhythm and rhymes. Richard, the actor, inhabited his verses with his body and voice, taking listeners with him. And whether there was a stage or not, Amde's prowling presence would mark his territory while his staccato delivery laid siege on the audience.

Still, for the people of Watts in the early 1970s the most important thing coming from this new generation of poets was the words, the testimony embodied in the poems themselves. The McCone Commission had handed down its official findings on the "crises" five years earlier. For many in the Watts community, though, the real verdict was being articulated to standing room only crowds at places like the Watts Happening Coffee House and Mafundi Institute. In the years after the Rebellion the promised revitalization had not manifested. Now the poets of Watts were setting the record straight on makeshift stages from Florence Avenue to 103rd Street, from Alameda Street to Avalon Boulevard. The community's grievances were being shouted out at Mafundi, heroes were being celebrated at the Inner City Cultural Center, and the bullets and knives of outrage were flying at Douglass House. Poems like Amde's "Pimping Leaning and Feaning" led the charge.

Pimping leaning and feaning
Some say I'm dreaming
But I know I'm scheming
Scuffling and hustling
Slipping and sliding
Always hiding
Heats around, underground
Hanging blacks in the courts
Hustlers trying to stay off
them white folks jail reports

Pimping Leaning and feaning
White folks cold,
black folks getting bold

like, lets blow up the world
and send everybody to the moon in a blasting way
in little bits and pieces
like blood and guts,
blood and guts spread on a volcano
everybody smashed up

Pimping leaning and feaning
Shit I ain't dreaming
Like I said before,
I'm just scheming
Shooting dice for my life
Survival is my thing
Trying always to win, but always losing
Cause of white folks choosing
Crackers constantly misusing blacks
Abusing life, nature, babies, truth,
the written word
Destroying the song of a bird, the air
Hooking people on horses

Pimping leaning and feaning
Some think my thing is rest, dress and request
Sometimes I don't have a permanent address
I'm a thinking man
Forced to play a survival game, lame
I'm an educated man
With a doctors degree
From SWU, Side Walk University

Pimping leaning and feaning
Shit, I ain't dreaming

For most poets of the time getting published was the ultimate. For Amde Hamilton and his fellow writers this was not always the case. A poem like "Pimping Leaning and Feaning" was written to be performed. At Douglass House, you were always reading and getting direct feedback. These performances at Mafundi and other venues were just a wider, public extension of the Douglass writers' circle. And everybody was into it, especially Otis, Richard and Amde. Sometimes when the rhythm and the rhyming really got hot they would even join in on each other's poems for a line or two. Richard explains how it went.

When one person got up to do the poetry, rather than just standing there in the background, we would throw out a couple of picture words and bring in a call and response. This was nothing new; it was African lingo all the way back. Sometimes, the shit didn't work because we were throwing

out whole sentences. If you are not sharp, it is like upstaging. But, when you actually listen to the piece like we teach the musicians, then you can further it. Like the old folks say, If you can't say something good, don't say nothing.

After awhile this verbal interplay became a regular feature at readings where the three would appear. Sometimes it worked spectacularly, other times it didn't. At some point the three recognized that they had something going and decided to take it to the next level.

Saturday, July 13, 1973, 9:30 PM
The hard yellow sun strobes sideways through the dancing throng.
A sweaty shining soup of arms and legs make a syncopated soul train Shiva.
The music moves in a grove so deep that its hard to tell if the bass beat is leading or following. But nobody cares; they are all in it, beyond listening.
And the band is turning up the heat.
Standing in the wings, Jack Jackson is all smiles. These musicians and dancers and comedians are easily the equal of acts appearing at the Apollo or the Howard Theater talent shows. It was getting unbearably hot, but that's OK. This! This is why he started the Inner City Culture Center—to make a safe place where the Watts culture could cook, burn even, if that's what it takes.
The band is winding down. He looks over at the next act. The four young poets are looking nervous. They should be—after what just went down, they'll have their work cut out .
Otis O'Solomon scans the crowd, trying to remember who it was that suggested that they sign up for this contest for their first gig together. Its not that they weren't confident. They knew their stuff, but this crowd did not come here expecting to hear poetry. There was no backing out now, though, so that's what he and Amde and Richard and the new girl Helen were going to give them.
The MC motions them over. "Who are you?" Otis says, "We're poets."
"No, man, I got to announce you, what do you call yourselves?" Richard speaks up, "We're poets from the Writers Workshop." Helen jumps in.
"Wait a minute, you guys aren't just poets, you're prophets. You're the Watts Prophets." The MC is back in front of the mike introducing them before any of them can say a word.

CHAPTER 12

Prophets

John Daniels grabs the mike stand and tilts it back. As the spotlight narrows, his sweating face fills the center of the room. He waits one, two, three beats. When the house settles he nods to the house DJ who starts the music. As the beat swells he shouts the words everybody has been waiting for.

"Ladies and gentlemen, the Watts Prophets are in the house."

The Prophets stride into a blooming blue spot in the center of the room. The well dressed audience leans forward as one. Crowded tables rise up three tiers in every direction. Further back, last minute arrivals jam the cavernous club's back wall. The place is packed. Otis is thinking, "This should be intimidating." But it's not, to him or the others. They are the Watts Prophets, and they are hot.

A lot had happened over the past few months. After their surprising second place finish at the Inner City Cultural Center talent show, they had worked hard, learning each other's poems, building their performance. Helen had gone, but she had been replaced by Dee Dee McNeil, a singer and songwriter fresh from a stint with Motown Records. They had worked together at every opportunity, for little or no money. Then, Cassius Weatherby had put in a good word with John, the guy who ran Maverick's Flat, and, incredibly, here they were opening for Earth Wind and Fire at LA's hottest club!

Richard, Amde and Otis stride to the center mike. The spotlight narrows and shifts slowly from blue to purple, then to red.

The Prophets jump into their regular intro.

"We're the Watts Prophets rappin' facts
Rapping black
Rappin', rappin' facts."

Then Richard steps forward and spits out the first line of "AMERIKKKA"

"Nat Turner died fighting for freedom."

Heads are nodding in the crowd.

"Emit Till was lynched for sassing."

Someone yells out, "that's true."

"Bessie Smith bled to death in front of a white folks' hospital."

More voices, of assent.
"In a nation, under god, indivisible, with justice for all."
The spot widens to include Otis, Amde and Dee Dee, who join in singing
the next line, terribly off-key.
"Oh, say can you see"
Then they take it home, shouting together.
"Ask not, what you can do for your country
But what in the fuck, has it done for you?"
The Watts Prophets are, most definitely, in the house.

MAVERICK'S FLAT HOLDS a unique place in the musical history of Los Angeles. Part nightclub, part community center, it was the club on the west side of the city where blacks went on special occasions, dressed to the nines, to see acts like the Four Tops, Richard Pryor or the Fifth Dimension. Although the space was large enough to hold 400 people, it was also refined, with tables and waiters and the like. And, even though the performing space was large enough to accommodate the bands of stars like James Brown or Joe Tex, it felt intimate. On weekends, the line in front of "the Flats" stretched down Crenshaw Boulevard and halfway around the next block. Amde remembers the experience as a turning point in the Prophets' development.

Maverick's Flat was a place where you would see all the top acts, everybody. And there we were, a bunch of poets. It was beautiful, one of the first discos in America, with the lights and all of that. But there was no drinking, so the audience was adults and teenagers and kids, all together. It was the hip place to be.

Casius Weatherby, who originally suggested we perform together, told John Daniels, Maverick's owner, that he should book us. John liked us and kept bringing us back. It really polished us. We had been going to colleges and stuff, but with the stage lighting and the club atmosphere, it's so different. You have to be very, very entertaining at a place like that, because people didn't come to hear poetry.

For sixteen weeks in the spring of 1971 The Prophets were regulars at Maverick's Flat. Even though they played no instruments during that period you could almost call them the house band. Appearing there pushed them to a new level. Their natural performing abilities had separated them from the pack at poetry events, but sharing the stage with major acts like Richard Pryor and The Love Machine made performance paramount. This meant rehearsing. To move things along, Richard, Amde and Dee Dee decided to move in together. Though Otis was living with his wife and kids at the time, he spent much of his time with the others. Sometimes the four of them would spend days on just one piece. The hard work paid off, though. Audiences loved it. Another thing people seemed to like was the diversity of their work. While all three reflected the incendiary politics of the times, each had a "distinctive

diversity of this work— contrasting to others?

185

From the left, Otis, Dee Dee, Richard and Amde at Maverick's Flat. From the documentary film This Is the Watts Prophets

groove." These contrasts made for a great show, but that also caused some friction within the group. Richard describes how they came to terms.

> Amde was not happy with all the poetry. He said these were revolutionary times and he wanted more fire. Some of my poems were saying that the world is going to be all right so let's kind of hang on and Otis is talking about love. But Amde wanted more intensity. So, one day Harry Dolan, (the director of the Watts Writers Workshop) sets us down and tells us, "You guys are so diversified—that is what makes you so unique. Don't mess with that." That made sense, so, we stuck it out.

After their appearances at Maverick's Flat, the Watts Prophets found themselves with more and more opportunities to perform. Clubs in town that would never have given poetry a second thought invited them in. Even in the grittiest places, the mix of hard rhymes, heavy truth, and tough love had audiences responding enthusiastically. And when the opportunity arose, they would jam with the house musicians. The crowds loved them.

Still, some club owners outside of Watts were having second thoughts. Nightclubs and bars in the city made their living promoting themselves as places to party and have a good time. Performers were hired to entertain, not agitate. Since the rebellion, many businesses were loath to identify with the radical politics fomenting in the streets. Despite good audience response, after hearing poems like "AMERIKKKA"[1] and "Kill, Kill, Kill"[2] a number of promising gigs ended up as one-night stands for the Prophets. Otis recalls one audition particularly well. "We went to this audition at the Etcetera Club. A nice club in Hollywood, and the guy, he saw us and he said, "You guys are really great. You are going to make a lot of money, but not in this club."

Controversial lyrics were not a problem at college campuses, though. Across the country colleges were roiling with activist politics fueled by the growing unpopularity of the Vietnam War and the draft. Protest marches, sit-ins, and

teach-ins were a regular feature at the dozens of private and public campuses located in southern California.

But the Prophets were also unique in these settings. They were not radical professors or student leaders railing against the injustice of the war. They were not visiting representatives from Students Non-Violent Coordinating Committee (SNCC) or the Yippies blasting university research on behalf of the military-industrial complex. The Prophets were something else entirely. They were poets from over the hill—neighbors actually, long invisible, until they appeared suddenly on campus. They were local, but from another country too, a country that very few of these students had ever visited. These poets were not recruiting or organizing, but rather reporting on significant events and hard feelings from this forgotten land a few miles down the road.

By the end of 1971 the Watts Prophets were doing quite well, in terms of audience and reputation. Financially, they were barely scraping by, but very few poets in America ever supported themselves through their work. Appearing on the same stage as Martha and the Vandellas and Rufus Thomas was intoxicating, though. They wanted more. And others appeared ready to accommodate them. As they became more comfortable and polished on stage, "suits" from the recording industry started showing up at their gigs. Like the audiences, they were blown away at the intensity and power of their performances. Often, after a gig, recording "reps" would corner them, proclaiming the group's uniqueness, and their plans for reaching a larger audience. It was encouraging, to be sure, but invariably, there would be suggestions about how the act would have to change. Richard recalls one memorable encounter at a record executive's home.

> This guy has us come to Beverly Hills. I was pissed off because he served us chicken. We come all the way to Beverly Hills for chicken. It should have been steak. Chicken is the way I live in my neighborhood. Anyway, he wanted to take the Watts Prophets and mix a little James Brown with it and kind of spice it up. We cursed that man out. That is how serious and passionate we were.

Despite the attention and the increased demands on their time, the Watts Prophets still considered the Watts Writers Workshop their home base. In many ways, the Workshop was like a family for the Prophets and the hundreds of other artists who congregated there. It provided a safe space for trying out new work and discourse and debate. And while the poetry and prose and plays reflected the foment on the street, the place was about words and performance, not guns. Otis describes the scene.

> There had always been people with a lot to say but no place to go to develop their talent. It gave us an opportunity to follow people in the community who were highly creative. These were the folks that were considered strange in the community. But when all these strange people—the writers, the dancers, the singers, the actors, the directors, the technical people—when they got together at the Watts Writers Workshop we made magic. That is why it

was such a happy place. You spent sixteen, seventeen, eighteen hours a day there, and you'd go home, and you couldn't wait to get back.

The house also functioned as a kind of cultural crossroads for the Watts community. Artists of all kinds gravitated there to share their work and connect with their peers. In addition to the workshops, Douglass House also provided help to men and women trying to make their way in the community as artists. Whether it was a meal, or help copying a manuscript, somebody there could usually provide a helping hand, a tip or a connection.

The support went both ways. All of the leadership and staffing at the Workshop came from the community of artists who had found sanctuary and support there. Harry Dolan, the director, had been in one of Bud Schulberg's original writers' circles. Ed Riggs, the Workshop's in-house video expert had started out as a volunteer janitor. Over time, Amde, Richard and Otis each assumed new roles at Douglass as workshop leaders and mentors. Harry Dolan eventually made Amde assistant director and asked Otis to take over as the poetry and creative writing instructor. They also put time into working with young people for other community programs, such as the Mafundi Institute, Inner City Cultural Center and California Poets in the Schools, where Otis was made coordinator for the Los Angeles/Orange County region.

Dee Dee

When writer/singer Dee Dee McNeal hit town early in 1970 she made her way to the Watts Writers Workshop. She had just left Detroit after a three-year stint with Motown records as a songwriter. Between the relocation and her two kids, she had her hands full, but in no time she became a regular in the writers' circles. She also became involved in the production of a new play penned by Harry Dolan called *The Iron Hand of Nat Turner*. The play recounted the story of an 1831 Virginia slave rebellion from the point of view of its leader, preacher and slave, Nat Turner. Dee Dee adapted one of her songs for the play. Otis remembers the Prophets being impressed by both the play and McNeal. "The tune was called 'Black in A White World.' Helen had left and we still wanted a girl in our group and Dee Dee was the chosen one."

McNeil jumped in with both feet. With her musical background she only added to the group's capacity to meld poetry and performance. Her melodic tunes and supple singing added further contrast to some of the harder edged material. Having worked at Motown with such groups as the Four Tops and the Temptations, she also knew a lot about how movement and staging could bring a story alive.

Rapping Black in a White World

I think they're trying to get something started
I'm talking about SNCC and us and the Black Panther Party

Is anyone listening to what I'm sayin'?
cause it sure looks to me like dem niggers ain't playin'

18 billion so far is the claim
of damage done by looting and flame
yet look around there ain't nothin' changed
I sure hope somebody is listening to what I've been saying
Cause it sure looks to me like dem niggers ain't playin'

—Richard Dedeaux
From album *Rappin' Black in a White World*, Watts Prophets, 1971

Some talk about their roots as something connected, but left behind. The Watts Prophets were their roots, and they knew it. They also knew that that their name-sake, the community that spawned them, was seething and coming apart at the seams. Since the rebellion, many programs and initiatives aimed at healing and community development had come into Watts. Many had been good faith efforts aimed at local economic development, improved health care and education. Others, though, had been outright scams, diverting public funds from community investment to personal enrichment. Regardless of intent, for the average citizen of Watts, "the rebuilding" had altered very little since the summer of 1965. In fact, given the promises and reported high level of investment in the area, the lack of real change left many feeling missled and betrayed. The precursors to the rebellion had been isolation, repression and a lack of opportunity. In the early 1970s these conditions not only persisted, for many they appeared to have gotten worse. In actual fact, the most significant transformation taking place on the streets had been attitude. While in the sixties, many in the community had suffered in anonymity or pushed for integration and non-violence; the post rebel-lion stance, particularly among young people, was one of militant outrage.

This sense of anger and injustice made its presence felt thorough organiza-tions like the Black Panther Party and Black Muslims. The predominant focus of these and other factions of the growing Black Power movement was Black Nationalism or separatism. Their position was that if the black community was going to be cut off from resources and opportunities available to the broader community, then blacks might as well take care of their own. Educa-tion, counseling and nutrition programs sponsored by these organizations emerged in black communities in many US cities. Some in the movement, particularly the Panthers, also took the position that the community had the right to defend itself. The Panthers confrontational style was personified by the rifles and bandoliers they brandished at public appearances.

While Watts Prophets were seen as a part of the movement, they made a point of not "locking in" with any one group. Otis describes the delicate dance they executed to keep from being appropriated by one group or another.

Everyone wanted to claim us. We worked with any group but we didn't com-mit totally to any particular one. We worked with the Brotherhood Crusade.

189

We did things with the NAACP. We worked with the Red Cross. We gave performances with the Muslims and the Panthers, but we didn't lock in with them. If the community had some kind of problem, or an affair we would go and help with it. We would deal with everyone who had a positive program for the community. In the process, we became community poets.

Very little about the Watts Prophets repertoire in 1971 could be considered funny. Nevertheless, their first "real" recording opportunity came from a black comedy label, Laff Records. Because of their often raunchy content, the label's catalogue was not carried by mainstream record distributors or record stores, but was sold "under the counter." Despite this, black comedy records were very profitable at the time. Earlier in the year, The Last Poets (from New York) had produced a recording that had done very well. Laff saw this new style of performance poetry as an opportunity to cash in on its growing popularity and broaden their market. They thought the Watts Prophets could fill the bill. According to Otis, the Prophets were interested, but they also had concerns as well.

Several weeks in a row the owners of Laff Records came to Maverick's Flat begging us to sign with them. Friends started suggesting that we should sign with them. We finally agreed to it among ourselves but we didn't like the image of Laff Records. We demanded that they create a new label if they wanted us to sign…which they did immediately …creating ALA Records.

The Dirtiest Meanest Trickster

The arts have always been a bit suspect for Americans. At times too snooty, often too wild. This was particularly true in the early 1970s when the turbulence of the anti-Vietnam War movement and counterculture merged in a new stew of audacious expressive dissent. Overnight, it seemed, urban walls became the billboards of the left, displaying images of guns and marchers screaming "Seize the Time" and "Off the Pigs." Street performers dramatizing the war's carnage were regularly insinuating themselves into middle-class living rooms via the evening news. In cities and towns across the country, young people in rags were singing songs of protest and screaming anti-establishment verse punctuated by profanities. Even Leonard Bernstein and the Black Panthers were partying in New York's upper West Side[3]. For a society generally indifferent to cultural doings, these disturbing eruptions made a strong impression. For many, that meant that the arts and turmoil were becoming intrinsically linked. Those on the extreme ends of the political spectrum thought they were catching a whiff of revolution. Some were ecstatic, others terrified.

One of the unfortunate symptoms of paranoia is the chimera of the well oiled, fine-tuned, impeccably synchronized enemy—i.e., the conspiracy. For some in the government, the persistent and growing volume of strong black voices of dissent from the heart of the previously muted ghetto was not only troubling, it was proof that something sinister was afoot. They had been moni-

Rappin' Black in a White World *introduced the Watts Prophets to a wider audience and helped establish "rap" as a new musical genre.*

toring the situation since 1965. The pattern they were seeing was becoming increasingly clear—artists and revolutionaries had been brewing up trouble for some time in the black communities of Los Angeles. Now, with dissent on the rise, it was the time to act before it was too late.

In the eight years since its inception, the Watts Writers Workshop had become a cultural nexus for a community in upheaval. As such, the place was a constantly evolving amalgam of learning and creating, debate and reflection, stirred up by whatever was happening in the street and whoever showed up on a particular day. Of necessity, some of the trappings of organization had taken hold. There was a regular schedule of classes, workshops and events. Over time, various workshop members had taken on the needed roles of leadership and coordination. For the most part, however, the place had maintained the open, ad hoc, laissez faire atmosphere that had characterized its beginnings. Aside from the fact that it had kept its doors open for six years in the middle of one of the poorest communities in America, there was nothing well-oiled or conspiratorial about the Watts Writers Workshop.

Nonetheless, the Workshop's ability to function and survive did require trust. It was assumed that if you were there, and contributing in some way, your intentions were good. Given the desperate times, some might say that that was naïve, but desperate times were nothing new to Watts and that attitude had served the organization well for more than eight years. Another assumption that had helped hold the place together was that when times were lean, as they often were, something would eventually come along to save the day.

Unfortunately, in the spring of 1973 the Workshop's lucky star appeared to be setting. The loss of a Federal grant they had counted on hit them particularly hard. Then, several pieces of very expensive audio-visual equipment had broken down and had to be replaced As a result, the organization's deficit had ballooned. Their only option was to turn to the Workshop's community of supporters. They decided to hold a fundraising dinner. Dozens of volunteers worked long hours to make the event a success. A thousand invitations went out to people who had been regular contributors. But, on the night of the dinner, very few people showed up. The event that Harry Dolan had counted on to bail them out had actually put them deeper in the hole. He reflected, "All of our hopes had been riding on that event…I couldn't figure out why people who had supported us for so long would let us down in our hour of need."[4]

A few weeks later the US post office delivered a large sack of mail to the Workshop's offices. Inside, unopened and undelivered, were the benefit invitations that Ed Riggs, their audio-visual man, had taken to the post office the month before. Dolan was shocked and perplexed. "We'd barely gotten over

this when we discovered that our fundraising mailing list of 15,000 names had suddenly disappeared. The next thing we knew, two $15,000 TV cameras were lifted, and then three out of seven Workshop typewriters disappeared."[5]

Workshop members felt like they were under siege. What had appeared to be a run of bad luck was looking more and more like a deliberate assault on the institution. Whatever the cause, with a large and growing deficit and no funding in sight, Dolan had no choice but to begin cutting staff and programs. A few weeks later, as bankruptcy loomed, he even terminated the building's insurance. In no time, it seemed, what had been one of America's most vibrant black cultural centers, barely existed. Given how far they'd come, though, nobody was ready to give up. Unfortunately, the forces at work against the Watts Writers Workshop probably knew that.

A few months later, Harry Dolan was awakened in the middle of the night by a call from Ed Riggs. He said that the Workshop was in flames. By the time Dolan arrived at the scene, the building, the theater, everything, was smoldering ashes.

By now, everybody was convinced that the demise of the Watts Writers Workshop had been orchestrated. But, who and why was a mystery. Sometime later Amde Hamilton received a frantic phone call from a friend at LA's Pacifica Broadcasting Network station, KPFK.

> He said, "Hey man, there is a cat named Ed Riggs down here telling everybody how he did in the Watts Writers Workshop." It seems Ed Riggs (real name Darthard Perry) had started with the FBI up in Sacramento. He got busted for a check or something and they let him slide in exchange for his undercover services. Then he started destroying black institutions in Los Angeles. He had infiltrated Jesse Jackson's institution, SCLC, and KPFK and more. Some people got killed during some of the incidents that happened with this cat. He was behind all that bad stuff happening at the Workshop and as a final act, burned it to the ground.

The path of destruction described by Darthard Perry in his KPFK confession, in subsequent interviews and court testimony[6] stunned even the most jaundiced observers of American injustice. At the behest of the FBI's COINTELPRO[7] program, he had spent years insinuating himself into the black community's cultural nervous system. He had served the Justice Department by stealing documents, making recordings, planting evidence and destroying property—reeking havoc at every turn. Harry Dolan was amazed at the tenacity of the government's assault.

> Even though everything he was saying added up, I just couldn't believe that we were so completely naive. I mean none of us at the Workshop were dummies. And besides, what would the FBI have against us? Our people weren't blowing anything up. I could never figure why they would ever want to stick spies on us. But when he explained how the Workshop credentials gave him access to other organizations, I understood.[8]

Too Hot!

The Prophets viewed Ed Riggs's treachery and the burning of the Watts Writers Workshop as part of a more personal, but continuing pattern, that seemed to become more insistent as their fame grew. Major recording companies continued to express their interest, but always seemed go from hot to cold in a hurry. Amde and the others were convinced there was something more than bad luck at work.

> We were discovered by every major record company in the United States. Capital, RCA, you name it. Scouts would see us and they would say, "Oh man, we have never seen anything like this. Here is my card. Give me a call Monday morning." That would last for about two weeks and then all of a sudden we would get the cold shoulder. Things would change. Those government folks can be very efficient when they want to.

Despite their troubles with recording companies, the Prophets made inroads in other arenas. Richard Dedeaux's, "Doin' It at the Storefront" was a regular feature on Los Angeles PBS affiliate KCET. This scene, featuring Otis O'Soloman, is from the 1972 KCET special, "Victory Will Be My Moan."

In 1975, though, it appeared their luck had turned. The Prophets had been asked to perform at a Brotherhood Crusade benefit in honor of legendary musician and producer Quincy Jones. Jones was so impressed by the Prophets' work[9] that he called looking for romantic lyrics for an album he was working on. As a result Otis's, "Beautiful Black Girl" ended up on Jones's album *Mellow Madness*.

Afterwards, Jones initiated discussions with the group about producing an album. Meetings with Jones at his home to discuss the project were extremely encouraging. So much so, that the three poets began preparing for their first major label recording project. But when their conversations ended abruptly and phone calls stopped being returned, the Prophets feared the worst.

CHAPTER 13

Griots

For 20 years … our presentations have been about the things we've experienced, like living conditions in the neighborhood—police practice, frustration, joblessness. Some of the poetry may be 20 years old, but it anticipated Rodney King and gangs and even the concerns about the ecology. This is because truth doesn't spoil. What we felt and saw then you can still feel and see now. But it looks like no one has been listening.[1]
> —Otis O'Solomon, 1992

Malcolm had been reduced to a commercial X
the Panthers to a movie…
The world psyched into an ethnic fight/
while gun runners grow in economic might.
> —Amde Hamilton
> From *When the '90s Came*

Poetry is the tool we use. It's easy to make kids understand there are no mistakes in poetry.[2]
> —Richard Dedeaux

SOME SAY THAT the more things change the more they remain the same. This may be particularly true for Watts. Since its rise from obscurity in 1965 it has maintained its status as an icon for all that can go wrong in the American urban environment. As with all stereotypes, the true story of the place is more complex. Watts is a community of families and businesses striving to be safe and productive. It is the center of a vibrant and evolving mix of culture and ideas. But it is also a very difficult place to make those things happen. If Watts were a fighter some might say it's a miracle it is still standing, considering the blows it sustained in the final decades of the twentieth century.

Despite all the solemn promises and urgent declarations, the post-rebellion redevelopment never truly manifested. In the eighties, Watts became the epicenter of a crack epidemic that devastated much of the country's urban landscape. Conventional wisdom assumed that poverty and drugs were inevitable bedfellows, especially in Watts. Still, there are those, including Congresswoman Maxine Waters and Senator Barbara Boxer who are convinced that there are

US government fingerprints on LA's crack explosion. They point to credible evidence that links the CIA's backdoor funding for the Nicaraguan Contras and the sudden emergence of a burgeoning crack market in South Central LA.

The wreckage was overwhelming. Thousands of families were devastated by the epidemic of drug abuse and associated dysfunction. Gang violence manifested in turf wars that left hundreds dead and terrorized the entire community. Near the end of the decade a national recession further crippled the area's economy. By the early nineties the underlying conditions that had provided a fertile ground for the 1965 rebellion had deteriorated even further. The crime rate had risen, poverty and unemployment were more widespread and a good education less available. The community's relationship with law enforcement was at an all time low. Otis remembers the sense of foreboding that pervaded the community. "Hope was in short supply. The old timers could feel it coming."

On April 29, 1992, after an all-white jury acquitted the police officers accused in the brutal beating of Rodney King, rage again boiled over into violent upheaval. The result was even more destructive and deadly than the 1965 rebellion. In just 36 hours, 51 people were killed, 2,328 injured, and 17,000 arrested. Property damage was estimated at more than $1 billion.

After smoke and the troops were gone the people of Watts again hauled themselves back into the ring. As the scar tissue formed over the latest wounds, the place became a bit tougher, the residents more alienated, less trusting. But toughness takes different forms. In the midst of the crack poisoning and the second "rebellion," a few young men and women in the community found a way to make something powerful out of turmoil and pain. So, while others raged in the street they turned their anger into a new generation of hard rhythmic verse. This time it was called "rap."

The album When the '90s Came *continued the Prophets' penchant for airing hard truths.*

The popular history of hip hop holds that rap was born in the early 1970s in the Bronx. Most point to the improvisations of two young DJ's named

Herc and Africa Bambattaa and the recordings of Grand Master Flash and the Sugar Hill Gang. Others, with a wider view, also trace a lineage back to jazzman Gil Scott Herron, The Last Poets and the Watts Prophets—and ultimately to the rituals and celebrations of the early black church, the African slave diaspora and thousands of years of African cultural tradition.

The Watts Prophets have always been proud of their connections to these deeper roots of African-American culture. Some music and literary critics see their blend of poetics, music and politics as the foundation for the work of many contemporary West Coast rappers. Hip Hop icons, like Tupac, DJQuik and

Coolio, have acknowledged these links through their liberal sampling of Prophet recordings in their own work.

Yet the Prophets cast a dramatically different shadow from the parade of commercially successful LA based rappers that emerged in the nineties. Undeniably, their seminal work was uniquely reflective of the time and place that was Watts California during the tumult of the 1960s and seventies, but more than two decades later, their hip hop-influenced CD, *When the '90s Came* (1996), continued to call America on the exclusivity of its dream, bearing witness to "smiling billboards," "high tech killers" and "law and order lies." But their sustained influence is evidence of far more than their popularity as poets or performers. First and foremost, they were and are community artists. As such, their ongoing presence in Watts as storytellers, teachers, and activists has made as much, if not more, impact as their work on stage.

Full Circle

Given their incendiary early history, it might be reasonable to assume that the Watts Prophets would eventually burn out or self-destruct. To be sure, the chaos of the 1980s and early 1990s made it particularly hard to maintain fragile careers as writers and performers. Many of their regular venues closed or turned to disco and other pre-recorded music. As the years passed, all three had to find avenues outside of the group to make a living, but like Watts, their community, they persevered. They continued to perform, teach and record when the opportunities manifested. Their performances took them all over the US and Europe for solo gigs and in the company of such artists as Ornette Coleman, Sarah Vaughn, Billy Higgins, and Don Cherry. In the mix, they grew as artists, but also as advocates for Watts' rich culture and as respected mentors for many young people in the community.

Their evolution as community leaders was, of course, a reiteration of their own history. Three decades earlier, a community of mentors and peers had helped three young men make something powerful and lasting from their newly empowered imaginations. It was only natural that they return the favor by nurturing new blood. Their increasing focus on youth was also rooted in an acceptance of a difficult truth. Somewhere on the path between their youthful fury and the slow graying of hairs, they recognized that their creative power would not be enough to turn the corner for their community. The job was not going to get done by one generation. So, the revolutionaries would become griots, passing the seeds of wisdom and inspiration to unhardened hearts—hearts with the same terrible questions that had nearly destroyed them as young people. How do you make sense in a world that does not nurture you, that even seems bent on destroying you? How do you make meaning in a world that confounds your sense-making capacities? Here they were again—the same set of hard questions, confronting another generation of young warriors. And here were the Prophets, come full circle, preparing the grandchildren to take them on.

Griots in front of the legendary Watts Towers. (From left to right Otis, Amde and Richard) Photo by Ed Colver, courtesy The Watts Prophets.

This was not a new role for the Prophets. Throughout their history, individually and as a group, they had spent time mentoring young people. While they always did this out of a sense of responsibility, as they got older, they realized the situation for young people in the community had gone from bad to worse. As the millennium approached, one in every five children in Watts was growing up without a positive male presence in their lives.[3] The gap between adults and young people in the community was widening. More and more of the community's young people were ending up dead or in prison. Richard makes it clear that these were not abstractions for him and the others—that it was reflected in the everyday events of their lives.

I look out my window. The kids across the street come home from school, they can't go any further than their porch. It's too dangerous. That's where hopelessness comes from. I lost a grandson. He was just 24 years old and he had been shot four different times. Back in '86 I lost his mother. I lost a niece. Standing in her yard, just coming from work, in the prime of her life, 21 years old. I draw from my experiences and I see the hopelessness. Violence is everywhere. But art just cleans out everything so everybody is on the same page. That is why I go into the prisons. I say, One of you killed my child. I am working with all you bad asses because I got a hole in my heart. We can work this out. I am here because you still have a chance to straighten things out. You've got to catch up now. But it's going to be hard.

Back Inside

"They said you were the lady who could get me into prison."

The caller was polite and as elegant as one could be on the telephone. He had a deep sonorous voice and spoke with a gentleness that was in stark contrast to the subject of his enquiry. But he had called the right place. Susan Hill could, indeed, get people into prison. She had been doing it for almost twenty years as the director of ArtsReach in LA. She remembers the call.

He said, "My name is Amde Hamilton. The folks at Watts Towers told me that you were the lady to call if I wanted to go teach poetry in prison." I get calls like this every day from all kinds of people, but there was something about him that I just trusted.

ArtsReach had been sending artists into prisons, mental hospitals, schools and all manner of community institutions since 1978. While some see the marriage of the arts and institutional life as incongruous, in Susan's world view, it is fundamental. "People need to express themselves to make sense of the world, to make meaning. This is probably truer in a youth detention center or a mental hospital than it is anywhere else."

Amde's call to Susan Hill in 1997 was prompted by recognition that some of the brightest kids in Watts were ending up in the "joint." He and the other Prophets had always worked with young people, teaching and counseling. They saw it as part of their job as writers. They also knew, from their own experience, that these kids in prison often held the greatest promise. They were also the hardest to reach.

Susan referred Amde to Shelly Woods, the arts program coordinator for the California Youth Authority. The Youth Authority is essentially the state's prison system for young people aged twelve to twenty-five. Like its adult counterpart, it is big and overflowing. A visual artist herself, Susan had taught many classes in Youth Authority institutions throughout southern California. She and Shelly Woods had worked together for years to establish the arts programming systemwide. Neither was easily impressed. A few months after Amde's call Shelly invited Susan to come down to the Fred C. Nelles Youth Correctional Facility in Whittier to see what Amde was doing. Shelly described it as "remarkable."

The workshop was just starting as they arrived. Amde stood in front of a sea of prison blues. There were fifteen or so boys—black, brown, yellow and white, big and little—scattered about. Unlike most classrooms, there was very little interaction. Amde was quiet and focused. The boys were anything but. Some were fidgeting, some fussing with their adjustable desk tops, some just looking anywhere but at the elegantly dressed man waiting for them to settle. After Susan and Shelly found a place to sit in the back, Amde began. Susan was "mesmerized" by what she observed.

Amde distributed the lyrics of a Tupac Shakur song. He asked the boys if they knew it and of course they did. They had heard Tupac's songs a million times. But then he said, "What about the lyrics, do you know the lyrics?" They didn't. They knew the beat but they didn't know the lyrics.

So, that is how he began. His voice was wonderful, confident and calming but with a rhythm. In no time at all, they were in rapt attention. I could see they were thinking, Something very interesting is going on down here, and it is magical, and it is creative, and it has a beat. The song he passed out was about pride, and not being taken down, about living in the city and hearing the babies cry and the sirens scream, and looking to tomorrow and keeping your head up. The kids were amazed at this man. He was wise and funny and full of heart.

What I saw that day was someone who reached these kids immediately, on every level. He had been where they were. He knew what their houses

were like. He had been in their neighborhoods. He had been the young man on the corner. But he was also the wise father who was doing his best to keep his kids out of trouble. He knew the music. He was doing that music before Tupac was born. He was there not to lecture, but to teach in the best way possible. It was more like an initiation, like an invitation, all underscored with a tremendous sense of possibility. You can do this. You know. You are going to do a poem. It is going to be great.

Susan Hill felt she was seeing something special. But she also had too much experience with "one time wonders" who would beguile a group of kids for a few hours but could not sustain the connection. She decided she would follow Amde's work over time. What she found was that Amde and Richard, who would later become involved, were committed to helping these kids change the way they saw the world and themselves in it.

Their process was slow and deliberate, focusing on what the kids knew—their environment and their lives. They would start with a challenging question like, "What are the most significant things that have happened to you in your life?" Together they would build poems from the jumble of words that would follow—picking the keepers from the throwaways, to reveal the essence of a story. Invariably, the early poems would be filled with profanity, and descriptions of violence and victimhood. Amde and Richard felt it was important to let this happen, to "allow them to throwup" the toxicity built up in their systems. But they didn't let them wallow. They pushed them to go beyond the surface story, to examine their place in it. They also asked them to do something extraordinary for a youth corrections program. After the second or third class, Amde asked them to write outside of class and come prepared to share their work. Uncharacteristically, they complied. The volume and depth of the work showed exceptional effort.

More surprising, though, is what happened when they read their poems. One after another, in a circle of poets reminiscent of Douglass House, each stood and performed his poem. As ordinary as this may seem to an outsider, this is an uncommon act of courage for young prisoners, who live in a violent, predatory culture, where sensitivity is seen as weakness. Following each reading, one of the Prophets would offer a critique and invite comments from the other students. At this point, a young prisoner is most vulnerable to feeling ridiculed or attacked. But the thoughtful and supportive responses consistently transform these potentially incendiary moments into ones of intense learning. The circle was safe.

Susan knew that the easy magic of these classes was not what it seemed. She characterizes working with young prisoners as "more akin to scraping barnacles and old paint off the bottom of a wooden boat, than waving a wand." It takes time and patience and extraordinary care to really get through, and these are rare qualities on the "inside." But over time, she saw that when Amde and Richard had regular contact with these young prisoners, poets emerged, performers emerged. In some cases, these accomplishments would be enough to alter a young man's

downward trajectory. They would, in Richard's words, "look up, not down" both literally and metaphorically. This was what Susan had devoted her life to. She decided she would do what she could to support the continuation of the Prophets' work "inside". She also began to look for ways to collaborate with them.

Over the next few years, Susan Hill worked with the Watts Prophets in a variety of community and institutional settings. In addition to her skill as a visual artist and teacher, she also brought her ability to raise money for hard-to-fund projects. One workshop series took them to Imperial Courts, a public housing project on the southern edge of Watts next to the 105 freeway. Depicted in the Denzel Washington movie *Training Day* as an out of control nest of violent gang activity, Imperial Courts is also home to hundreds of families struggling to survive. In this environment, they decided to focus on the younger children in the community. Susan describes it as "more like a celebration than a class." "They brought drummers and dancers. The kids played and danced. They wrote and recited poetry. It was a fun, integrated, multimedia event—a fabulous, rhythmic experience—just a safe place for them to explore and play."

The program at the housing project was in stark contrast to the Prophets' continuing work with the California Youth Authority. Kids who have spent a good portion of their lives in the juvenile justice system are not so amenable to celebration and play. Susan recalls how Richard's presence made all the difference in one particularly difficult class at the Ventura School for Boys.

> Boom! In walks this six-foot African prince/grandfather who is taking no nonsense at all. He said. "This is about respect and this is about the work, so sit down." He didn't say this in a mean way, but with all of the authority that his talent and his life experience has given him, and they could sense that. The class mellowed immediately. Most importantly though, Richard listened really closely to their experiences and validated them: heartbreak, loss of a girlfriend, the feeling of being a child that gets lost in a family, missing your father, not having enough money to get through the week, being worried about the child that is two siblings down. He got all those nuances, and over the course of the class allowed them expression.

Fighting Dogs

Just like a fighting dog.
At a very young age,
you have your first small fight
and get caged
and trained
for bigger and tougher fights.

You are chained up
and they beat you,
tease you

and feed you bullshit.
You just take it.
The mad dog barks fiercely with anger.

Stubbornly the dog attempts
to attack the cruel man doing this to him
until finally he is let loose in the rain.

Soon as he is let loose, he releases his anger
on the first being in sight
but its his own kind that he has to fight.

Not knowing how to react,
he goes back.
Now the master is satisfied,
by the way,
Without knowing it
he makes his master's pay day.

The dog is still getting trained
but again he knows there is nothing to gain
but still he goes through the cycle
again and again
doing things that he thinks would cure his pain
without realizing
he is victimizing.

He don't know any better.
Could it be he knows better,
he just let it be.
Just like a fighting a dog in every characteristic
not being realistic
just another statistic.

—Writing Workshop participant,
Fred C. Nelles Youth Correctional Facility

In the summer of 1998 Amde and Susan were winding up a class at the Fred C. Nelles Youth Correctional Facility in Whittier, near LA. It had gone very well. It had been a tough bunch, but the trust they had developed teaching together helped them though the obstacles and challenges thrown out by the young men. Susan and Amde had responded by challenging them back, artistically. It was clear that they all had grown, students and teachers, alike.

For the final class, they decided they would sit in council. For this special session, representatives from various parts of the juvenile justice system would join the circle of students and teachers. The students would not only share their work, but they would also be allowed to ask questions of their guests. Most importantly, the students would run the council process themselves. At some point during the

class the Warden stopped by. It didn't take him long to recognize that this was not a typical Nelles classroom experience. He was impressed. A few weeks later, one of the institution's administrators called Susan to ask if she and Amde would be interested in doing some work with the young men in the Nixon Unit.

The Nixon Unit is a separate maximum security prison set inside the Nelles facility. Its residents are considered the most dangerous youth offenders in the state of California. As such, they live in perpetual lock-down. This means that other than sixty minutes a day for exercise and showers, the young prisoners never leave their cells. When they do, they are moved one at a time, chained ankle and wrist—otherwise they will fight. After a visit to see the Unit, Amde had second thoughts about the project.

> When I first saw that, I came back home and I told Shirley. I said "I am not going out there, those kids are in cages. They are breeding killers. They have whole wards full and they keep them there like animals and then they let them free on the community. It is really something to see." And she said, "Well Amde, if you don't go, then no one is going." So, I went.

Susan and Amde decided to approach the unit's residents as they would any group of young aspiring artists. This meant teaching the young men as a group using the council process. This idea was not well received by the institutional authorities. While they were open to bringing the arts into the unit, they felt that mixing the boys would surely lead to violence. The two artists knew this was not an idle concern. They, in fact, shared it. They felt strongly too, that if fear characterized the structure of their encounter, it would also define the relationships they formed with the boys. Whatever chance they had of connecting would require a place where being vulnerable was safe. They would have to risk trusting the young men to get them to respond in kind.

The Warden resisted the plan. He felt it was too dangerous. But the artists persisted. What started as a simple invitation to work in the Nixon Unit became a protracted negotiation that lasted for months. During that time, Susan's diplomatic skills were put to the ultimate test. In the end, a compromise was reached. They would be allowed to work with three prisoners. Susan describes the first class.

> It was me and Amde and we brought in a beautiful African drummer called Marcel Ajivi. We were in a double locked room with a guard on the second floor looking down on us. We were only supposed to have three boys but we had eight. We started the circle with the drumming. Out of the rhythm would come poetry and then out of the poetry would come the image. At the end of the session the boys stood up and spontaneously held hands. They were supposed to be fighting, but they held hands.

During the fall of 1998, the artists became a regular feature at Nixon. Every time they entered, it was like an archeological expedition to hell, stopping at gate after gate, getting inspected and passed on to the next, each time moving a bit farther into a fathomless neon lit-maze of bars, guards and prisoners—finally

coming to the little room where the boys would be escorted in one at a time in chains, and seated, still fettered, in the council circle.

The aim of the Nixon workshop was simple. Introduce the boys to poetry, music and drawing as forms of expressions and give them a safe space to say something with it. Susan describes how one project melded their work.

> Here were the eight most violent kids in the state. We gave them beautiful French oil pastels and beautiful paper and I asked them to draw a heart. Then we asked them to rip them in half so this became a book that was hinged left and right like French doors. So the heart would open and you would get to a poem and the poem would open and you would get to a deeper heart and then you would get to a deeper poem and so on.

Although Amde knew they were making a strong impression on the boys, he worried it was not enough to make a difference. So he started going in solo as well. The more he went, the more he learned about the prison world, and himself. He came to recognize that in their own ways the boys loved him. He also saw their violence first-hand. He recalls that some of the boys were like trained pit bulls, "where you open three doors and you've got three fights." Even the correctional officers knew the place was toxic. One day one of them confided to him that they had "created a prison that we are all afraid of." In time, Amde realized that he, too, had become infected. Going there week after week was turning him bitter and deeply sad. He knew he would be no good to anyone if he didn't do something more hopeful.

Choir

> Why haven't the Watts Prophets ever been to UCLA? One of the great crea-
> tive forces and acknowledged precursors of rap music that I know from
> London is a bus ride from my venue. —David Sefton, Director
> UCLA Performing Arts, *Los Angeles Times*,
> Oct. 17, 2000

In his two years as Chief of Contemporary Culture at London's South Bank Centre, David Sefton had garnered an international reputation as a gifted, cut-ting edge, trouble-making impresario. When he took over as the new head of the prestigious UCLA Performing Arts Program in the fall of 2000, he boldly stated his intention to "take the program down some different roads." Adding that, "as an outsider … I can get away with murder."[4] One of his first forays down those "different roads" was to invite the Watts Prophets into UCLA's premier performance venue, Royce Hall. Sefton also likes to challenge artists creatively. In that vein, he not only booked the Prophets into the hall, he commissioned them to make something new.

After years of sporadic performance and a lot of solo work the Prophets were keen to respond to Sefton's offer. Amde immediately saw it as an opportunity

to serve the community, as well. They could use the commission to boost their efforts to mentor young people. The new work could be a collaboration between the community's "grandkids" and the Prophets. The vehicle could be a kind of chorus combining the Prophets' voices with those of the hip hop generation—a Hip Hop Poetry Choir.

Sefton liked the idea. The Prophets' commission, which was also supported by Susan Hill's ArtsReach, included funding for a three-month series of youth workshops that would lead to a collaborative performance. The Prophets had no trouble attracting a rambunctious and talented group of a dozen teen poets and rappers from all over the city. They also enlisted the assistance of Brett Blair from the University of Southern California's School of Theatre to help them design and produce what would be a large-scale main stage show.

The project challenged them in a big way. Each had been mentoring young people for years, but never as a team. Their evolving approach flowed from their experiences at the Writers Workshop and the natural call and response rapport they had developed through decades on stage. A set of bedrock assumptions set the tone. Each young person had an active imagination, a creative spirit and something important to say. They also assumed that this amalgam of talents, experiences and energy could somehow combine to make a coherent show. It was their job to help make it happen.

The driving force for the workshop was the writing. The greater part of each session was spent writing and sharing the outcome. The kids were also encouraged to continue working in between sessions. They responded with poems and raps and dozens of ideas about the music and dancing for the show.

The Hip Hop Poetry Choir debuted by kicking off UCLA's highly-respected International Performing Arts series at Royce Hall in October of 2000. Susan Hill describes what happened.

They were on first, followed by a two-segment concert by the Prophets. One of the highlights, of course, was Amde's little grandson, Jeremiah, who took the lead in certain pieces. He also performed one of Amde's signature pieces—"Speak Up".

They were simply dressed—tee-shirts and dark pants. They'd come from the simple rehearsal hall/ basketball court near Central Avenue in South Central. Before the show they were nervous. Understandably, since they were backstage in a green room bigger than my house, getting ready to perform in a phenomenal hall that was opening UCLA's season of international performing arts.

The house was full downstairs. My guess—six hundred to a thousand people. Their performance was about promise and hope. It was energetic. It was authentic. Each young poet got featured. The audience responded with warmth.

When it came time for the Prophets to come out, they commanded the stage. Amde took a mike and said, "The Watts Prophets are IN THE

HOUSE!" to fabulous applause. In the second portion of the evening, they wore full African garb ... impressive, authentic ... princes of spoken word performance.

Lincoln Nebraska, Winter 2004

Backpacks and backwards caps. Students spill into the high school's theater like a river swollen by a hard sudden rain—bouncing together, breaking apart, a swirling mix of bobbing heads and limbs, one moment bottlenecked, then released.

Amde, Richard and Otis cruise the space, pressing flesh, campaigning. "How are you doing?" The young people are surprised when they realize that it's a real question. These guys don't settle for a nod, an OK. The Prophets plow through the crowd, Richard beckons to a cluster of students in the corner. "Who has poetry?" They are strangers, but they know these kids. Richard keeps pushing. "Who's sitting on their poetry?" They know it's here. It always is.

Amde moves to the front fumbling with the video player. He says, "This is thirty-five years of our history compressed into thirteen minutes."

Lights dim and the video rolls. They are all listening now, curious, heads up, mostly white, a few blacks, a few brown, all wondering. Who are these old guys—grey but incongruously hip, boisterous and smiling ambassadors from the hard history of the American shadow—indigenous, Hip Hop originals?

The video ends. The Prophets have slipped away in the dark. A voice from the back of the multipurpose room shouts, "The Watts Prophets are in the house!"

Otis' baritone fills the space, "Hey World."

He moves forward out of the shadows. "Hey World"

A one man call and response Growling, ranting. Prowling and pacing arms stretch out—fingers pointing out at the audience.

Then "Hey World" again, his firm, practiced voice skips like a flat hard stone into the brief calm waters. Heads turn to its source, coming down the aisle. Then, another voice from the opposite corner. "Hey World!" More a question than a statement. Two beats of stillness stretch out and then it comes again from a third voice deep in the back. "Hey World."

Three poets stride purposefully to the front. As they turn to face the sea of widening eyes, Otis delivers the next lines in a gush.

"Hey World, ain't you afraid?"

Richard interjects, "Ain't you scared?"

Otis again, "that this fool called man Is gonna' kill you dead?"

Then Amde and Richard together, "Dead!"
Each succeeding line poses another question, another exclamation.
Amde creeps forward, Richard pleads, Otis preaches—now one, now three,
asking for an answer. The students shift shyly as Otis takes the lead again. His
hands thrust out, a question in each. He is an advocate taking his summation
to the jury, as his co-counsels reiterate each devastating point.

"Hey world, Wake up World
Man's going crazy," *"crazy"*

 "crazy"
 "You better wake up"

"He is destroying everything" *"You better wake up!"*

 "You better wake up!"
"Wake up World!"

 "Wake up world"
"Wake up World!"

 "Wake up world!"

"Wake up world!" *World?*
"Because tomorrow," *"Tomorrow"*
"World, tomorrow," *"tomorrow?"*
"World, tomorrow,"
"might be," *"tomorrow!"*
"might be?" *"tomorrow?"*
"might be," *"tomorrow! might be,"*
"Too late!"

The Prophets have come to Lincoln, Nebraska, at the behest of the University of Nebraska's Lied Center for the Performing Arts. The Center is the principal performing arts venue for both the university and the city. They also have an educational arm that works with the area's school districts. Lied has been presenting the Watts Prophets since 2002. On this visit, they have come to build another Hip Hop Poetry Choir.

This is their third trip to this quintessentially midwestern city. In Los Angeles, they are well-known, here they are not. It doesn't seem to be a liability though. As incongruous as it may seem, the situation is similar to what they have been dealing with for years in schools in Watts and Compton. The two high schools they are working in are big and institutional. East High School is suburban and middle class. At North Star High, the majority of the students qualify for the subsidized lunch program This distinction is the educational bureaucray's way of identifying schools that serve poor neighborhoods. The issues faced by both schools, however, are indistinguishable: truancy, drugs, teen pregnancy, low graduation rates. It's familiar territory for the Prophets.

They know these are good kids, with great potential, but their job growing up in twenty-first century America, is a tough one.

The next day, they begin in earnest. At East High, two English teachers have committed their classes to two weeks of daily workshops with the Prophets. The students file into the school's cavernous and frigid assembly hall theater. They sit and fidget, pretending not to notice the three older gentlemen adjusting microphones on stage. The Prophets introduce themselves poetically, trading lines back and forth.

> *"We are"*
>
> > *"The Watts Prophets"*
> >
> > *"Rappin black"*
>
> *"Some say between the young and the old"*
>
> > *"there's a generation gap"*
> >
> > *"Because of the gap?"*
>
> *"What gap?"*
>
> *"gap between what you are and what you can be"*
>
> > *"A gap between what you hear and what you see..."*
> >
> > *"A gap between the money I got and the things I need."*
>
> *"A real big gap between charity and greed"*

Richard (left) and Amde encouraging a North High student.
Photo © William Cleveland

By the time they finish the place has warmed considerably. The students are smiling and curious, ready for what's next. But the Prophets are not here just to entertain.

Richard turns to the students.

"Who are you? Tell us about yourself. What are you going to be?"

One student raises his hand. Before he utters two sentences, Richard starts to coach.

"Stand tall, now. Don't shuffle. Get your hands out of your pockets. Project your voice—you have a beautiful voice." His is firm, but gentle. And despite the prospect of receiving a similar tutorial others follow, one by one, sharing their dreams.

One kid says, "I'm going to try to..." Amde shouts, "No, no, we are not here to try. I want to know what you are going to do!" He has become a stealth career counselor. "Find your passion," he says. "Do something you love and you will never work a day in your life. Einstein would never have split the atom if he had never been creative." A girl named Valerie says, "I like to make people laugh." Everyone laughs.

Otis asks, "Any poets in the room? Who wants to read a poem?"

A young woman in dreads stands to read. Amde asks, "How long you been working on those dreads?" She shrugs and smiles. The poem is untitled, they are lyrics actually. A sophomore boy rises and shares another. The Prophets hover, the poems are raw, some scraps, some gems; but the grandfather griots hang on every word, encouraging, cajoling, coaching. Otis shouts from the back. "I can't hear." Another shy one rises. He says, "I play drums and write songs." Richard says, "Bring your lyrics and your drums tomorrow."

When everyone is finished, Amde turns to the group, "Do you all know why we are here?" No one answers. They are having fun. No one seems to care.

He answers his own question. "We are building a hip hop poetry choir." Richard finishes the thought. "The idea is for you to come up here on stage with what you have got to share. We will work on some stuff; some of you already have some material. In a couple of weeks, we are going to have a show at the Lied Center."

The workshops at North Star High School are scheduled for after school, so the students have to come on their own time. The Prophets' appearance the day before has peaked enough interest to get about 30 students into the school's black box theater. Again, the Prophets begin by introducing themselves and asking questions. And again, poets and performers raise their hands and take the plunge.

After awhile, Amde asks them to take out paper and pencil. He introduces a three minute, "spontaneous" writing exercise. "The subject is 'tomorrow', just write whatever comes into your head. Don't edit, don't stop writing. If you are stuck, write about being stuck."

"OK now, everybody reads. We are going to have 105 percent participation." Otis is cheerleading, exhorting, comforting—embracing. As each stu-

dent comes forward, the three poets deliver one great hug of enthusiasm after another. Everyone is going to be a part of this hour-old community, even the ones who are at sea. One young man has a single line. "I don't know what to write, cause when I write, I have to think on my own."

The last to come up is a thin girl in an ankle-length dress. In the stage lights she is blue from top to bottom. She hugs herself hard, trying to disappear, murmuring her name. Otis coaches. "Turn up the volume," he says. She pushes forward, haltingly, one word at a time. "OK, good, but this time slow down a bit, bring in a rhythm? And, don't judge yourself, just do it." She talks about angels in the sky. Amde says, "Talk to the paper." Otis adds in, "Think the thought, feel the feeling." On her third try, she gets it. The last lines are very strong.

During a break in the workshop, Amde comes across a step team practicing in the hallway. After introducing himself, he convinces them to come in and check out the workshop.

The team clusters in the theater, wondering what the deal is. Amde invites them to step. They go into their routine. Stamping and clicking in syncopated rhythm. They are very good. They finish to applause and whistles. Amde turns to a young self-identified poet in the wings. "Can you work with that rhythm, can you make a poem for us to that beat." She nods yes. Then Amde turns back to the steppers.

"You know, the slaves had drums as their primary means of communication. The slave owners banned the drums because they feared them. They were the community's voice, but using them could get you hung. Without the drums, the slaves adapted and improvised, using their hands and feet and their bodies and utensils to keep the community's rhythm. When I was growing up we used to call it hambone."

In a matter of minutes, the step team has become a part of the journey to the main stage of the Lied Center. How it will all fit together remains to be seen, but the sense of community is infectious.

The workshops go on for the next two weeks. Each day, at both schools, the process continues—exhorting, challenging, coaching, building a momentum of belief, a critical mass of standing straight, speaking clearly and turning up the volume—surfacing the secret poets, musicians, dancers and generating a buzz that keeps the first day's students coming, and spawns new recruits. The Prophets are fomenting a kind of a coup. They want the students to assert their own power so they can join the revolution. They do this at first by not pushing back, and then pushing back with a smile and an easy pressure. Otis says, "This is not a class, these are not assignments. We are on this journey together, and the performance is around the corner."

On February 21, 2004, the Lincoln Hip Hop Poetry Choir makes its debut before a packed audience on the main stage of the Lied Center for Performing Arts. The evening is a collage of group and solo performances, interspersed with the Prophets doing some of their own pieces. Everything that happens

High school step
dancers strut their
stuff in Lincoln,
Nebraska.
Photo © William
Cleveland

over the course of the ninety-minute show is original, created by the perform-
ers. And perform they do. Amazingly, when the lights hit the stage, lines and
marks and cues are remembered. The last number has the whole cast doing a
group poem about choir and their work together. When it ends, the audience
stands and claps for five minutes.

As the clapping fades and the curtain falls for the last time, everybody
on stage knows that the real triumph has been the trip itself. Over the course
of ten days they have been prodded and cajoled by these three old men into
doing something inconceivable. They have taken a terrifying and exhilarating
journey to make something new, and put it out there for everyone. Along the
way, they have risked being open and vulnerable to each other, but in the safe
space provided by the Prophets, they have supported each other through the
stumbling that comes with creating. Looking back, some wonder why they
weren't more afraid? Somehow, the grandfather poets had suspended the
gravity of skepticism and self-doubt just enough to allow their young imagina-
tions to get a foothold. The momentum of belief and fun and ownership had
taken them the rest of the way.

Tests of Will and War

Australia

CHAPTER 14

X-Ray Blindness

They said, "Count down 90 seconds, you'll turn your back to the tower, cover your eyes, shut your eyes, cover your hands," and they count down 10, 9, 8... Vivid flash and even with your eyes shut and you're looking through your hands—you can see an x-ray of your hands—heat hit the back of your neck and, you know, blasts went through.[1]

—Sergeant Peter Webb, present at *One Tree* and *Marco*

IN THE EARLY EVENING hours of September 27, 1956, British scientists detonated a 12.9-kiloton nuclear device at its new Maralinga Proving Grounds in the Great Victoria Desert in South Australia. The sound of the blast could be heard for fifty miles and lasted many minutes. The thermal pulse generated from the bomb's fiery epicenter spread over two miles in a matter of seconds and melted all metal objects within a mile and a half, and incinerated every wooden structure inside of seven miles. The accompanying pressure wave swept across the land faster than the speed of sound fanning fires and toppling structures as far as fifteen miles out. Within an hour, the bomb's iconic mushroom cloud had spewed tons of sand and rock seven miles high. Within hours wind currents had deposited billions of radioactive ash particles more than thirty miles downwind of the test site. Tests later revealed radiation in animals in Western Queensland some 1,500 miles away.

Maralinga (Pitjantjatjara language for "big thunder") lies in the middle of a 25-million-year-old former seabed called the Nullarbor Plain. The vast 77,200 square mile region of sandstone and spinifex grasses is true to its Aboriginal namesake, Oondiri, which means "the waterless." At the time of the blast, the area was home to hundreds of indigenous Pitjantjatjara and Yankunytjatjara tribe members. Unforunately, despite attempts to clear the countryside of its ancestral owners, many remained. Also present at the "One Tree" test were hundreds of British and Australian soldiers like Peter Webb who were there to provide logistical support and, some say, act as human guinea pigs.

The ten-year history of British testing at Maralinga and two other sites in Australia[2] (Monte Bello Islands and Emu Field) is a story of cold war obsession

and national ego. In the aftermath of WWII, the British could see that having the "bomb" was the only way into a very exclusive club whose sole members were the Americans and the Soviets. For the British, the path was obvious. At the dawn of the Cold War, there was no doubt in the minds of Prime Minister Winston Churchill and his successor, Clement Atlee, that the only way the British could retain a prominent place on the world stage was to become the world's third nuclear power.

Despite having played an important supporting role in the development of the American nuclear weapon at Los Alamos, New Mexico, the British were unable to convince their close wartime ally to continue sharing the nuclear genie's secrets after the War. They concluded that their only recourse was to establish their own independent nuclear weapons program, which they did in January 1947, at a secret research facility in London. But building operational nuclear weapons also required testing. This testing, which would, of course, have to take place somewhere else, was the only way British scientists, and the rest of the world, would know if they had, in fact, joined the nuclear club.

That message was delivered five years later on October 3, 1952, near a collection of small uninhabited windswept islets off Australia's western coast called the Monte Bello Islands. Called "Hurricane," the 25-kiloton explosion produced a 3000 meter high "grey-black vertical cloud of water and vaporized ship particles." However, contrary to predictions of minimal drift, the nuclear cloud was pushed by winds over areas of the adjacent mainland occupied by tribal Aborigines. Unfortunately, for both the Aborigines and the military personnel who became involved, this lack of foresight and concern over health and safety matters was to become a hallmark of the decade long nuclear testing program that would ultimately include 12 "major" tests and over 700 "minor" tests in Australia.

The Nullabar Plain streaches for 77,200 miles between Australia's southern coast and the Great Victoria Desert.

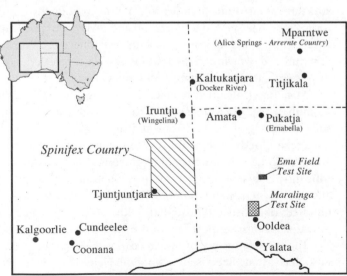

The agreement for use of Australian territory for these tests was concluded in an extremely secret and highly unorthodox negotiation conducted personally by Australian Prime Minister Robert Menzies. Menzie's quick and largely un-consultative decision to accommodate the British set in motion a ten-year saga that would ultimately be characterized as "negligent" and "irresponsible" by the Royal Commission[3] established in 1984 to investigate the enterprise.

Following two more successful tests, the British were eager to create a permanent site for testing that would, in the event of a global war, also become a manufacturing site for atomic weapons. The agreement for the establishment of the Maralinga Proving Grounds, concluded in March of 1956, stipulated that Britain would pay for the construction and the Australians would provide the soldiers needed for the building and maintenance of the facility. The agreement also relieved the British of any liability for injury or death related to the testing program.

The Maralinga construction took place against the backdrop of the Soviet occupation of Hungary and the Suez Canal crisis. The escalating Cold War tensions spurred the British to get back to testing as quickly as possible. When tests did recommence in September of 1956, it was becoming increasingly clear that worldwide public concern over radioactive contamination would

The announcement of the seventh British test (called Taranaki) hyped both the cleanliness and the "advanced" nature of the Britsh nuclear program.

14 *Coventry Evening Telegraph, Wednesday, Oct. 9, 1957*

Nuclear Warhead Tested in Australia

BRITAIN 'AHEAD OF U.S.'

BRITAIN to-day exploded a nuclear warhead for a long-range rocket from a balloon flying 1,000ft. above the desert at Maralinga, South Australia.

The testing of the perfected warhead, called "The Gentleman," was the third and final atomic explosion in the current "Antler" series at the desert proving ground.

Observers said that the successful test made Britain virtually ready to take the offensive against any enemy which began a nuclear war.

Minimum Fall-Out

The explosion was to see what the warhead would do to a target when it was exploded high above it.

The "Gentleman" is designed to wreak the most havoc against enemy installations with a minimum of radioactive fall-out to cause suffering to civilians. Hence its name.

A well-informed Australian source said: "The British are now more advanced than the Americans. They have been able to take advantage of some American research plus their own original research."

Clean Test

United Kingdom, Australian and United States Press representatives watched the test eight miles from where the weapon hung from the balloon.

The test was comparatively "clean." This was mostly due to the distance from the ground and precautions taken to clean away a large amount of loose, powdery desert dust from ground zero—the point underneath the explosion—so that relatively little dust was sucked up to be made radioactive and scattered across the Australian Continent.

Giant vacuum cleaners were used to sweep up the desert dust.

Fiery Death

The balloon from which the weapon was suspended was held in place firmly by a criss-cross of cables anchored securely by means

ducting the test, headed by the Director of the Atomic Weapons Research Establishment at Aldermaston, England, Mr. C. A. Adams, to measure accurately the effects of the explosion on a hypothetical enemy objective.

To the Press observers it appeared that the weapon would bring fiery death, with a minimum of fall-out, to the target.

result in an atmospheric test ban. Therefore, "no delays" was the order of the day. As such, issues of safety took a back seat. The safety question was further undermined by the fact that the Australian Weapons Tests Safety Committee, was manned (literally, as there were no women involved) by scientists whose careers and reputations were dependent on the advancement of nuclear weapons research. It goes without saying that no nuclear skeptics were allowed on the Australian team. Ultimately, the safety aspect was deemed so critical that the Safety Committee was not organized until the first three tests had been completed. Despite being accorded veto power over subsequent tests, the committee never once exercised that power.

"Aborigines "

We are many mobs with many countries, but we have become mixed up. We were put together without thought for our differences… We were taken here and there, sometimes we went voluntarily, other times we were like cattle rounded up, slaughtered and bought and sold. We were made into what are called "Australian Aborigines" … though we were never a single mob.[4] —Mudrooroo

Whenever the white man finds something of value to him in any Aboriginal area the Aborigines are pushed aside. I believe that what is happening to these natives is contrary to the spirit of the declaration of human rights in the United Nations charter.[5] —Walter MacDougall, Native Patrol Officer

In his book *Us Mob,* Australian writer and activist Mudrooroo describes the Australian indigenous kinship structure as a tree branching out in every direction "inscribed on the land"—all connected, but with no supreme head or leader. He contrasts this with the familial and social "pyramids" imposed by the "European invaders", where "the Master at the apex of the pyramid knew what was best for all, especially for us." This paternal attitude was nowhere more obvious than in the callous and dictatorial treatment of the indigenous people who occupied the lands used by the British/Australian nuclear testing program.

It is clear that the impact of the tests on the Aboriginal people who lived on and owned the lands used for testing was not a high priority for those in charge. British research on the people whose lands were to be used for nuclear testing was limited to the *Encyclopedia Britannica.* The Australian record is even more appalling. At the time, the British researchers found that there was far more government information available on the size and condition of cattle and sheep herds in the prospective testing areas than there was on the number and location of Aborigines. For the government of Australia and most of its citizens, the sad fact is, at the time, the original inhabitants of the continent were of no consequence and had no real status legal or otherwise. It went without saying that tribal members were not consulted and had no say in the matter.

Prior to the start of the tests, the principal task of finding and alerting tribal members to the coming cataclysm was given to one person, native patrol officer, Walter MacDougall. Because MacDougall knew the territory and Aboriginal culture extremely well he understood from the onset that it was an impossible task. The testing area was far too vast for one man to cover. Furthermore, because it was a place "of great spiritual significance"[6] for its indigenous inhabitants, many resisted leaving or simply avoided contact. Those who were found were taken to a new settlement in a place called Yalata, some 200 kilometers to the south.

This "relocation" was not a particularly unique occurrence in Australia. Like their cousins in the New World, Australia's Anglo settlers regarded Aborigines, as a "doomed" race, destined to disappear in the face of the superior white civilization.[7] Beginning in the mid-nineteenth century, in concert with the expansion of white settlement, "forced assimilation" became a common practice. Many saw herding tribes onto reserves and the kidnapping of half-caste children to be raised by white families as enlightened alternatives to allowing Aboriginals to succumb to the malnutrition and disease brought on by European settlement. Astonishingly, aspects of these policies continued up until the 1970s.

Beyond the meager outreach provided by MacDougall and an assistant, the project relied on air reconnaissance to locate nomadic tribal members. The technique devised by the British and Australian pilots was fairly simple—fly around and look for smoke from camp fires. Unfortunately, the pilots doing the search were not aware that the indigenous people typically doused their fires when they heard the frightening sound of approaching aircraft. These search patrols also followed the roads which the tribal nomads tended to avoid. Needless to say, by the time the tests were set to begin, the critical areas were not at all clear of people.

The tragic consequence of all this ignorance and disregard was manifold. There is no doubt that members of the Pitjantjatjara and Yankunytjatjara tribes still living or moving through the area received significant exposure to radioactive fallout. In one instance following the detonation of the 10-kiloton device called Totem One, a cloud of highly concentrated radiated dust and moisture moving just above the ground passed through an Aboriginal settlement at Wallatinna station, some 200 kilometers from ground zero. Some there thought it was "mamu" or evil spirit and tried to ward it off with spears. In its wake, the cloud deposited a black sticky substance everywhere. Within a day of its passing, many people reported falling ill, complaining of headaches, vomiting and stomach ailments. As time passed, there were unconfirmed reports of many deaths.

Situations like these prompted the British and Australians to consider how the Aboriginal nomadic lifestyles and lack of clothing could impact the risk of radiation exposure. In 1956, fully four years into the testing regime, new standards for Aborigines increased the radius of the danger zone from 190 kilometers to 240 kilometers from ground zero. This, of course, meant that many "safe" settlements were now considered dangerous.

Ultimately, one of the most significant effects of the tests was not precipitated by the explosions themselves, but rather the building and continued presence of the testing infrastructure. The roads, weather stations, testing structures, the massive influx of soldiers and the forced relocation of hundreds of tribal members simply destroyed the family and tribal cohesion. This devastation was compounded by the fact that residual contamination had rendered ancestral lands uninhabitable for untold generations.

Soldiers

… as the hour approached for the atomic burst, the budgerigars, they all settled in the trees and went completely silent. That was the thing that I can remember, the silence of the parrots. Nature knew that there was to be a disturbance of the natural affairs of life.[8]
—Rev John, Australian nuclear veteran

An important part of Prime Minister Menzies agreement with the British was the provision of support personnel. From 1952 to 1963, over 8,000 Australians joined 20,000 British soldiers at the various testing sites, with the majority assigned to Maralinga during its decade of operation. Rather than assign intact units to the task, the Australian military decided to select individual soldiers they felt would be best suited to the unique mission they were undertaking. It is now known that "suitability" was defined by a soldier's status as an outsider in his regular unit. The reasoning seems to be that these men would be less apt to ask questions and more likely to keep a secret. All personnel assigned to the testing program were required to sign an agreement that prohibited any and all communication regarding their test-related activities.

The Australian soldiers performed a wide variety of duties. These included: air support, food preparation, communications, construction, security services and transport. All personnel, though, were included in a rather bizarre training regimen to prepare them for possible nuclear combat. At the moment of detonation, the soldiers were required to observe the explosions. This exercise entailed standing with their backs to the blast long enough to protect their eyes and then turning to observe the rising mushroom cloud.[9]

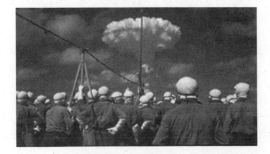

Soldiers were directed to observe nuclear blasts to prepare them for possible nuclear combat. Photo courtesy of British Nuclear Test Veterans Association

A smaller, more intensive exercise, called the Indoctrination Program, was implemented as part of an effort to "discover the detailed effects of the various types of explosion on equipment, stores and men with and without various types of protection."[10] This program involved 250 officers in some highly dangerous activities. These included flights through radioactive clouds without protective gear and the observation of blasts from as close as 2,000 yards from ground zero.[11] Astonishingly, British officials justified the program as a legitimate effort to test "the effects of very low-level radiation fallout on clothing, not personnel."[12]

In the days and weeks following each test, many soldiers were ordered into the blast zone to perform a variety of duties related to the ongoing research and maintenance of the site. Although radiation badges and protective clothing were used in these operations, it appears that strict adherence to the prevailing (now recognized as deficient) standards of radiation safety were not always the order of the day. In later testimony, before the Royal Commission and elsewhere, a number of soldiers recounted the lax attitude that prevailed among officers and enlisted men alike. Of particular concern was the collection and maintenance of data on radiation exposure. Many later complained that they were not properly oriented to dangers of radiation and that the critical task of tracking cumulative exposure was not at all rigorous.

In the years following the tests, many British and Australia nuclear veterans with health concerns were denied access to the medical records and exposure data kept during the tests. The reasons cited, even thirty years after the fact, were bizarrely contradictory. In some cases, the rationale was security. In others, the government indicated that the records did not exist.

A Royal Commission

I'd learned by the bitter path that to touch the pitch of secrecy was to be contaminated for a very long time, that governments and politicians want not men who believed in the integrity of natural knowledge but men who would tell them what they wanted to hear, and that truth has no meaning...if it is politically inconvenient.[13]

—Mark Oliphant, the preeminent Australian physicist who had played a significant role in the development of the American atomic bomb.

On October 9, 1957, the 25-kiloton "Taranaki" was detonated at the Maralinga Proving Grounds. Although this was the last of the "major tests" conducted by the British in Australia, it was not the end of British nuclear testing in Australia. In a direct violation of the 1957 Nuclear Test Ban Treaty, Taranaki was followed by a series of "minor tests" conducted until 1963 on the same site. Although the devices were much smaller (averaging less than one-kiloton) their impact was far from minor. The grim legacy of the over 700 tests was the dispersal of significant amounts of uranium, polonium, beryllium and plutonium on and under the ground's surface. Of these, plutonium, was by far the most toxic.

Both the public and the soldiers involved in the testing were assured that no conceivable injury could result from the British nuclear tests in Australia. Photo by John Walden

Sixteen milligrams of plutonium (0.000 564 383 ounce) in the lungs will cause death in one month. The element has an effective half-life (the time it takes for half of its radiation to dissipate) of 24,000 years.

In 1967, four years after the end of testing, the British sent a cleanup team to Maralinga. The "cleanup" consisted of the layering of topsoil over the affected areas. As part of the operation, the fences surrounding the most contaminated areas were taken down. All of the cleanup and subsequent reporting about its effectiveness were done under the false perception that no one would ever want to go there. This, of course, was not the case. Tribal members began returning to the restricted area as soon as the British left.

In one of his few public statements regarding the testing program, Australian Prime Minister Robert Menzies declared that "No conceivable injury to life, limb or property could emerge…"[14] It is not surprising then that the numerous medical complaints of both the soldiers and indigenous people affected were met by stubbornly deaf ears. Most of the military complainants merely sought access to medical services normally available to war veterans, which, given their hazardous duty, they felt they were owed. But, because of the enormous liability issues involved, both the British and Australian governments put the onus on the victims to show a direct correlation between their "alleged exposure" and their medical conditions. Sadly, the tactic worked. Almost none of the hundreds of claims filed in the decades following the tests were successful.

Another issue that continued to smolder was the condition of the Maralinga Tjarutja lands. The Maralinga Tjarutja are Pitjantjatjara tribal members who traditionally inhabit the Southern Pitjantjatjara lands. The Tjarutja demanded compensation for both the theft and the poisoning of the land. They also insisted that the site was still toxic and that a proper cleanup of the area be undertaken. These claims were firmly resisted until October 1978 when the *Australian Financial Review* (a newspaper) disclosed that half a kilogram lump of pure plutonium and over 360 barrels of other nuclear waste had been discovered buried at Maralinga.[15] The revelation greatly heightened public concern about nuclear contamination and precipitated a protracted political debate on the issue that eventually led to the establishment of the Royal Commission in July of 1984.

The eleven-month series of hearings in Britain and Australia revealed a great deal that had been hidden from the public for over three decades. As the testimony of military leaders, scientists and soldiers unfolded, it became increasingly clear how much cold war passions had both subverted Australian democratic processes and undermined public safety. The Commission found evidence of negligence, incompetence and outright obfuscation on the part of both British and Australian officials in the conduct of trials. Nevertheless, for those still fighting their governments over health claims, the Commission's report was a great disappointment. The findings stipulated that despite the fact that radiation protection measures had been inadequate and were the likely cause of increased disease, the commission could not "quantify the increase in risk" for either the soldiers or the indigenous people affected. This inconclusive finding significantly undercut arguments being put forward in the courts and on the political front by the soldiers and Aborigines .

On the plus side, the report's recommendations regarding the treatment of Aborigines and the taking of their lands were more conclusive. The Commission recommended that another cleanup be undertaken to facilitate "unrestricted habitation by the traditional Aboriginal owners" and that the tribes be compensated "for the loss of enjoyment of their lands resulting from the atomic tests program."[16] Unfortunately, neither the Commission nor its proposals had any authority in either Australia or Britain. Thus, even the most forceful of their findings ended up sidelined for further study and debate.

After a long political and legal struggle, a more thorough, but still inadequate, cleanup of Maralinga proceeded in 1991. In 1994 the Maralinga Tjarutja received a payment of $13.5 million (Australian) in settlement of all claims relating to the nuclear testing. This was followed by another decontamination effort in 1996, which was finally concluded in 2000. The 1994 settlement also formally returned the land to its owners. Unhappily, some parts will never be safe for long-term occupation.

In the years following the British nuclear tests, an abnormally high percentage of Australian and British nuclear veterans manifested medical conditions linked to unhealthful radiation exposure. Sadly, this insidious pattern persisted with children and grandchildren. The continuing struggle for official recognition of their claims and a formal apology was taken up by a few veterans' families and an organization called the Australian Nuclear Veterans Association, created by nuclear vet Ric Johnstone. It was a daunting task, though, given the march of time and their dwindling numbers, history seemed to be passing them by. Theirs was an old and ugly story—there was not much there to attract the public eye.

Art and Community

Near the end of the millennium, new help for the veterans and Aborigines affected by British nuclear testing came from a very unlikely quarter. In 1999, Peter Sellars, the internationally acclaimed producer and director, was appointed artistic director

for the 2002 Adelaide Festival. The largest and most celebrated of the country's international arts festivals, Adelaide typically featured a mix of contemporary and traditional performance and exhibitions geared for mainstream audiences from Australia and overseas. Much to the chagrin of the festival's organizers, Sellars had a different notion. His vision was to use the two-week event to examine and provoke debate about significant issues facing Australia and the globe.

To accomplish this he set about transforming the Festival into a platform for exploring "meaningful ways to create space for ceremony and for engaging with current ethical debates."[17] He further stated, "We're going to use the Adelaide Festival as a point of focus for this country that is going to attract the world's attention, because the issues that need to be discussed need to be discussed everywhere. I would like to think here in Australia and this next generation we have an amazing opportunity to take a leadership role and to face the issues that are urgent all around the planet."[18]

For Sellars, this meant addressing such questions as technology and ethics, ecological sustainability, truth and reconciliation and cultural diversity. It also meant extending the art making and presentation beyond the traditional main stages and exhibit spaces to include people and places that had never had access to the festival's resources and cachet. As the festival developed, many such projects were initiated. Among these were a number of collaborations with the Maralinga Tjarutja community. This, in turn, led to other projects involving the nuclear veterans. These initiatives provided a powerful new venue for telling a long stifled story. A story of betrayal and deceit that was still unfolding.

CHAPTER 15

Half-a-Life

A FEW OF THE community-based arts projects that were conceived during the 2000 Adelaide Festival only came to fruition in the years following. One of these, a theater project called *Maralinga*, tells the story of the Australian and British soldiers deployed in support of the British nuclear tests in Australia. Begun in 2003, and headed by writer Paul Brown, the Maralinga Research Group created a first-voice chronicle of the "incomplete Cold War experiments which continue to play out in the ill health and changed lives of Australian and British nuclear veterans..."[1]

Brown, a geologist by training, has as long a history in theater as he does as a scientist. In the 1970s he and two fellow actors founded a theater collective that eventually became Sydney's Urban Theater Projects (now one of the city's most prominent companies). In the mid-1980s, Brown left the company as a performer to focus more on writing for community theater. On the academic side, this also was a time that he became more intensely involved in environmental studies. In 1988, these twin passions converged in a community theater project that told the story of the degradation of Australia's largest river, the Murray. A few years later, another community centered drama about the physical and psychological damage wrought by the1989 Newcastle earthquake attracted national attention to Brown as a playwright. That play, called *Aftershocks*, also provided him an opportunity to create a large-scale work using verbatim theater methodology.

Reflective of its name, verbatim theater uses people's own words to convey their stories on stage. As such, the script for *Aftershocks* was written using the exact words, syntax and phrasing of the dozens of Newcastle community members who agreed to participate as interviewees. Brown describes the work as "a series of taped interviews" that became "a stage play, a touring production, fragments of radio, the subject of popular and academic writing, and a feature film (in 1998)."

Both the *Murray River* and *Aftershocks* projects also prompted Brown to become even more active in the conservation arena, both artistically and academically. This increased focus eventually led to his becoming the campaign

manager for Greenpeace Australia in the early 1990s. While there, his association with veteran anti-nuclear campaigner Jean McThoy introduced him to Australia's significant, but largely unknown, nuclear history. Near the end of 2000, Paul was asked to share his diverse experience as a member of the artist's Advisory Committee for the 2002 Adelaide Festival. Shortly thereafter the Festival's director, Peter Sellars, was sacked. Despite this, many Sellars-supported projects, like *Maralinga*, not only survived, but thrived.

The following interview with Paul Brown, interspersed with excerpts from the play's script, recounts the story of *Maralinga's* creation. Script excerpts are noted by both scene numbers and titles. Some of the printed dialogue also includes a reference code indicating its originating interview.

WC: The seed for *Maralinga* was planted during Peter Sellars truncated stint with the Adelaide Festival. That must have been a difficult scene for all involved. Did Sellars' emphasis on community involvement surprise a lot of people?

PB: It's a fascinating story that's never been properly told. It was a completely different approach and at odds with the conservative Adelaide establishment. Sellars wanted it to be about ecological sustainability, about cultural diversity, about links between science and arts. He also had an awareness of a range of political issues. He wanted a festival that would tackle the local concerns about black white reconciliation. Most of all, he wanted a community-based, participatory festival that would have outcomes that extended well beyond the immediate life of the festival—the complete opposite of flying in shows and putting them in the festival theatres.

He did a lot of things that sustained the work after he was gone. For the first time, there were two Aboriginal people sitting in the festival office as Associate Directors. People looked at them and said, "Who are they?" He said, "Well, they're well known, established artists and now they've come to help direct your festival." This was hard for some people to cope with. He also brought in people with expertise in particular art forms. One of those was a visual artist named Lynette Wallworth. She had worked before with some of the women from the eastside of Maralinga lands. Lynette had this idea that there could be some Festival projects with communities that had been affected by the nuclear story—the Maralinga bombs, the radioactive waste dump, the uranium mines there—all those things.

Lynette, Alison Page, (an Aboriginal woman from Sydney), myself and another colleague formed a kind of subcommittee to make these Maralinga projects happen. We ended up with about twelve projects. Half of them came to fruition at the festival and the other half were slated for future work. Allison, who is an architect, went over and became an artist-in-residence. The community wanted employment for local people. The older women wanted to do painting, but were not skilled with the materials. The town also had some underutilized buildings. So, Alison

worked with the community to redevelop one of those buildings as a gallery and workshop space. Then two visual artists came in to work with the women to make paintings. We weren't sure whether they would paint the bomb, but they sure as hell did. They painted the mushroom cloud. They painted the animals being affected. They painted the travels of the people escaping the bomb. And they painted people turning back to look at the bomb.

WC: Was the nuclear veteran's project included on that list as well?

PB: Yes, among others. There was a visiting British video artist also in Oak Valley who worked with some of the kids. A version of Scott Rankin and Trevor Jameson's Mamu play (*The Career Highlights of the Mamu*) telling the Aboriginal side of the Maralinga story was performed at the festival. And also on that list, identified as a future project, was the idea of doing a play with the nuclear veterans.

Verbatim

PB: From the outset, our project was conceived as verbatim theatre. The basic "rules" of verbatim require taped interviews carefully transcribed and shaped into scenes to be performed by actors.[2] I had worked in Newcastle on the verbatim play, *Aftershocks*. The veterans' story seemed to lend itself to that kind of treatment, so I said, "I'll stick my hand up for that. When I can I'll start to make that project happen."

Lynette had already had some contact with the nuclear veterans and there were a number of my students at the University of New South Wales who had become interested in nuclear issues as well. And so the logic of it was, okay, we can approach this by setting up a team of people from the university, theatre workers, various others, who would be the inquirers, the interviewers. That would give a kind of center to the project. But from the outset, it was clear that one big problem was that the nuclear veterans are not a community united by geography, they all over the place. It was completely opposite from the Newcastle project. The earthquake story was made by a community that was very tight.

So, for the start of the nuclear veterans project, it was one of those moments where you have an e-mail composed on your computer and a big long list of people to send it to. And you realize that if you press, "send" you could be starting something that will go on for a decade. One important conversation that I had, before pressing the e-mail button, was with Neil Armfield at Belvoir Street Theater to find out whether they would host this. In 1993, Belvoir had produced *Aftershocks* which sparked a lot of interest in verbatim plays in Australia. It was written up as a major turning point in the Australian theater. He was very receptive to the project right from the start.

The project got going with separate meetings with some nuclear veterans and the research team. Then we brought them all together. So we had nuclear veterans talking to the research team trying to steer the thing, to shape it, figure out what to do, figure out who might be involved as participants, who to interview.

WC: Was there any skepticism about a bunch of theatre artists digging into the lives of veterans?

PB: I don't think that was ever a concern. The one and only concern that veterans have had about this project is that they've been very poorly done-by, in terms of compensation claims. This is the whole political context to the project. Unlike in the US, where the Reagan administration, of all administrations, created a procedure for compensating nuclear veterans, the British and Australian governments took the exact opposite view. In the US, if you were at a nuclear test site and presented with one of 22 types of cancer that could be related to radiation, bang, you got compensation. Very simple. The Brits and Australians have made anyone claiming compensation scrape and carry on and go to court. So, just a few, less than ten people in the two countries have managed to get any kind of compensation. And one of the implications for our project is that some veterans have had concerns about any impact our project would have on their potential court cases. They were worried that the transcripts could get subpoenaed.

Interviews

WC: Given this, I would imagine that building trust was a critical aspect of the project.

PB: One of the most important relationships we established early on was with Ric Johnstone, the president of the Australian Nuclear Veterans Association. I had had phone and e-mail conversations with Ric, but now I was able to go to him and say, "Okay, we have put in place a team and we're going to get on with it."

I hadn't met Ric face to face before, and we arranged to meet over dinner in a Thai restaurant. In our initial conversations there was a brittleness that I suppose came from being twice burned—first being exposed to radiation and the resulting physical and psychological problems and then being put through the ringer in his quest for compensation. Beating his head against the wall for over 15 years and facing government committee after government committee had made him very suspicious and very cynical. But over dinner, this came with a sense of humor that was not present on the phone. This happened a lot when we went on to interview veterans. They all had this fantastic mix of a tragic story to tell and a comic way of telling it. Some people say it's very Australian, I just think it's universal. That's just what people do. So that dinner was good

for that but it was also interesting for one other reason. Ric told me about the previous approaches that had been made to develop plays or films.

There had been various documentaries and a feature film called *Ground Zero*, which was made in the 1980s around the time of the Royal Commission. It was a kind of fictional response to the Royal Commission. The veterans, and Ric in particular, were very unhappy with that film because it fictionalized things. It had an almost science fiction feel to it. So he was very skeptical. He'd also had approaches by David Williamson, Australia's best-known playwright and another very well known producer, both of whom wanted to option Ric's personal story to turn into a feature film. The sticking point was how the ownership of the story was to be treated.

This was an issue I knew well. When we made the earthquake play into a film, we were up against the film industry's normal way of doing business. They provide you with a contract which says for the sum of one dollar, you give us the rights to do absolutely anything we like. It's an absolutely appalling sort of thing to read and it's the standard for all documentary films. For *Aftershocks*, we overturned it. We made a very different contract that paid considerably more money to the owners of the story and guaranteed them certain rights over how the material was used. So, Ric had been up against this kind of thing and he basically told them to go to buggery. That dinner was the place where all those suspicions about arts professionals came out. Over the course of the evening, we talked through the approach I intended to take. That was the moment where I think we began to build this precious commodity of trust.

WC: Did Ric Johnstone's buy-in clear the path for you with other vets?

PB: In a sense, but it was ongoing. Another very important meeting took place up at the Return Services League, the RSL club in West Gosford, which is Ric Johnstone's hometown. Neil Armfield from Belvoir Street and I went up there to meet Ric, and Ric brought along his mate, Ian Hamilton, whose nickname is Hambone. We all had lunch in the RSL and talked about the project which we were calling *Half-a-Life*. That was important, not only for spreading that trust to include Belvoir Street Theatre, but also matters of tone came out in that lunch.

Ian Hamilton, who has a number of health problems, was very forthcoming. There were things that he wanted to talk about that he'd never talked about. Again, there was this combination of humor with a depth of feeling about these issues. And, Ric and Ian, they swore like troopers. I mean, that's where the expression comes from.

WC: It sounds like Ric was becoming somewhat of a partner in the project.

PB: Very much so. I made another trip with Ric to Perth, where he had spent a lot of time living. That's where he joined up. We went there because we wanted to get some interviews with veterans there. So we went around the city over a four-day period doing a series of interviews with six or eight veterans.

At one point Ric Johnstone said, "Drive down this street and I'll show you where I used to live." So we went there. I had a video camera, and I videoed Ric returning to his house. Then he got back in the car and he said take this road and take that road and he took me to the main street of Perth, and as we drove along it, he described how he had walked down that street with 900 men, on the occasion of graduating from his training—in uniform, with bayonets on their rifles.

WC: I would assume that Ric's presence validated you when you knocked on someone's door.

PB: Oh yeah. It made a big difference. Ric is a very voluable talker and so each of those interviews was an interview with Ric as well. So it enlarged his story. But yeah it did make for a more trusting, more open conversation. It also created some weird, strange, tragic moments. He was exchanging stories with one of the people we interviewed about their skin cancers, pointing to their arms and saying, "I had twenty last year." "Look at this scar, it's the latest one." And Ric saying, "Oh look at this. They had to take one out of here and stick a piece of skin around like this." And that's a scene in the play, too. Interviews with more than one person can be very valuable in verbatim work because they're already in dialogue. Like with a husband and wife, there's already some kind of drama in the interaction.

WC: How did the wives figure into the story?

They bring a different perspective. Many feel a rather strong sense of duty about carrying the story forward. But they feel that in a different way than the men. So they tell different stories. They overlap obviously. Some women stand in for their husbands (who have died). They retell stories that their husbands eventually did tell them. Other women express it much more personally. The descriptions of death, for example, that some of the widows have contributed to the project are just extraordinary. And there are three or four Australian women and one British veteran's widow who've told these stories of the last years of their husband's lives, dare I say in a way which only women of that generation could do. Men couldn't do it. All of this is kind of spilled out in the research meetings and the readings. This is where our understanding as theatre workers about the distinct types of stories, really start to gel.

7. Death (Kay)

Joyce, Sandy and Ric as witnesses to Kay's story.

Kay: (KB18/19) My name is Kay Burandt. With my husband, they said it was smoking, too, even though he hadn't smoked for thirty years. But when he first got th' cancer of the throat, he, ar, he couldn't clear his throat and he said oh I, I'm having difficulty swallowing. He thought he had a cold. They put a tube down Bob's throat, through his nose and down his throat, and it was like big lumps of fat inside

his throat and he said Bob you've got cancer of the throat... He had nine teeth removed, and um, when they did that they bruised all his face. So we had to wait. He was in the theatre for nine hours... Couldn't talk. And er he was very pale, ar, very weak, and he had all these tubes coming out of him, ah they were feeding 'im through a tube in his neck, and a male nurse knocked it o-out! (laughs) had to go through all that again, and then he had to learn how to speak, how to swallow. And then um (coughs) he ah he came home and all he could have was um, thickshakes, soups, all those sort of things.

(KB29/30) That started ten years ago... I put the food in a tube...

(KB33) And that wasn't us. We've always been independent we've always had a car but because Bob when e first had the first operation and e couldn't work because e was a rep he felt he couldn't speak but he did develop a voice, a really good voice, a clear voice and by just putting is finger, his thumb to his throat he tried (hand near collar bone).

(KB34) But he had so much phlegm and mucous that he couldn't keep it in there long he had to keep on blowing all the time an he had that all the way through. He couldn't go out, we couldn't go out anywhere to eat, or go to friends' places. He felt... too embarrassed to do that so that actually cut off all our life.

(KB29) Then he started to get this... thickness in the throat and not being able to swallow. It used to all come out the stoma tube, and then it would back up and come out the nose, it was terrible, poor bugger. And he really couldn't, you know do anything, he couldn't get it down.

(KB38/39) In the bathroom it'd spray. Out. Everywhere. Um it was it was dreadful to see him like that and he'd say I'm sorry honey and I'd say to him don't worry about it (voice begins to shake). I'll clean it up it's all right ...

(KB29) So we went back and Doctor put him into hospital. (Pause)

(KB35/29) And then when they took these tests, they found out the cancer had gone to his bones, and it had also gone into his bloodstream, so he couldn't have any more chemotherapy. So... he said and it's too far gone he said to operate he said it's... That. Type. That if we do anything it'll just burst out further.

(KB176) He said to me in hospital, he said, don't give me any peas, he said, because I shoot them right across the room (laughs). No peas! (laughs)

(KB177) He had a real good sense of humour, he really did. Mm... he was a lovely man, he really was, not just because he was, my husband, (breath) but he was... everybody spoke very highly of him all his friends and that...

(KB 64): He had such lovely blue eyes you know, they really got me in… They're old blue eyes… Yes they did really get me in but anyway, he was a wonderful dancer too. Very handsome in his uniform… Very handsome without it!

(KB177) He was so bloated with the cancer and they said "Look we think we'll cut back on his food because he's not getting much nourishment out of it now and we're increasing the cancer… the uh the morphine for the cancer." It was pushing his tongue out and… that he got to the stage…

(KB48): And it came out all over his skin like big red lumps on is skin like big… warts. Outside all over here and all on is chest where it was and ah the last lot of morphine that I saw his eyes open, his eyes rolled back in his head, and e went in… into unconsciousness then and he didn't come to. But he… they said that they… he knew when I was there. And I used to go up every day after that and stay with him all day… he was waiting for me to tell him he could go. For the funeral we had given him the photo of all the family and they had that on the pillow lying beside him with the carnation. His tongue had gone back and his face had… all the puffiness had gone. There were no lines on his face it was like… as… he was reborn sort of thing and all those red marks and everything yes had all gone…

The RSL put the flag on the coffin.

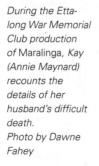

During the Etta-long War Memorial Club production of Maralinga, *Kay (Annie Maynard) recounts the details of her husband's difficult death.*
Photo by Dawne Fahey

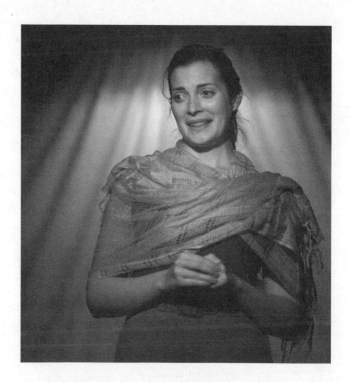

WC: The stories you encountered were harrowing and very intimate. I'm just wondering if you found yourself needing to learn how to interact with a culture, military and otherwise that was very different from your own experience.

PB: At the time of the Vietnam War, I was a conscientious objector. I guess I went into the *Maralinga* project thinking, okay, this is the project where I'll personally grapple with some of this stuff. So I started going to what is called the dawn service here. On ANZAC[3] (Australian, New Zealand Army Corps) Day, the 25th of April, we hold dawn services all over the country to commemorate the landing of the ANZAC forces at Gallipolis.

And, of course, the most obvious thing that came out of the interviews was the incredible loyalty to country and to queen that these guys had. And that gets played out in their families. Many of the nuclear veterans come from military families. Someone who was from a military family was thought to be more able to deal with the secrecy issues surrounding this. The amazing thing is that the sons of nuclear veterans have gone into military services despite their fathers' problems. A guy I interviewed in Britain, his son has Gulf War syndrome, so it's twice visited on that family. The father's got some problems that he ascribes to his time at Maralinga and his son's got problems from the Gulf War. The loyalty, the service to country is quite incredible to behold.

WC: How does an important quality like "loyalty" get addressed in a verbatim script?

PB: If it's important, it usually shows up in the interviews. Like with Joyce Northing who is a British widow who got compensation. When I asked her about whether there'd been discussions between her and her husband about going there (to Maralinga) and what they thought of that, she very quickly passed that off saying, "It was the Cold War." She said it in a way which is matter of fact, with the implication that, it's the Cold War and anyone should understand that if you're in the armed services, you're going to do what the Cold War requires of you.

2. The Majestic

(Joyce, Ann and Malcolm)

Joyce is alone, humming "Blaydon Races" or a 1950s dance hall anthem.

Joyce: (JN62): I'm Joyce Northey, from Mansfield, not far from Leeds. It was the Cold War. Different sorts of fear then, yes. Yes, yeah. Yes, it was. Strange period, very strange period, it was, yes. No the Cold War was entirely different, wasn't it.

(JN10): (laughs) My father said "Yes Joyce, you can, you know, I'll give you permission to get engaged Joyce", he said. "And if you both feel the same way when Joe comes back from Australia, you

can get married", you see, because I was only nine…just nineteen when he came back from Australia. And Oh!…. There was a lot of uncertainty. We didn't feel safe… Leeds 1957.

Research Meetings

WC: How did you begin distilling all this material into a workable script?

PB: We held regular research group meetings throughout 2003. There were lots of them, so, they were kind of a blur. They involved interviewers, theatre workers and Neil Armfield from Belvoir. Sometimes Ric Johnstone or another veteran would come as well. Usually, we had a dozen or so people around the table. We would report back on our document search and our interviews. This is where ideas about what to do with this material started to take some shape.

One particular research group meeting was very important. We had been trying to decide which themes would emerge in the play, searching for some combination of emotions and politics. We settled on five. The first was the sense of "Intrigue", building from stories of secrecy and government inaction. Then "Comedy" as an important antidote, told through stories of wild larrikins (comical or outlandish behavior) in a difficult place; and "Horror and Sadness" arising together from stories about the exposure of the body, and of the land. We then wanted to explore "Hope and Understanding" through stories about families and the next generation and the search for justice; and perhaps most important, to understand "the Feeling of Being Unsafe", and how it first had motivated the Cold War, but then the irony that men had been working in unsafe conditions in a false search for global security. This day focused us and gave us a lot to work on. And that was around September 2003. There were three or four research group meetings within that month that really focused things thematically.

WC: So these meetings are where someone might say, "Hey, here's something I think really encapsulates an idea?"

PB: Yeah. Maybe at each meeting two or three people had done an interview, which was no easy matter, because the veterans were all over the country. We talked about the dramatization of this material and what might work and what might not work. It influenced the next round of questions we went out with. We even practiced how we were going to do the interviews—kind of role-played.

Also, listening to the taped interviews was sometimes difficult, because the subject matter was very emotional. We had one member of our group who was a social worker. She alerted us to how these interviews could negatively impact us. When we started we knew very little about the Maralinga story, so it was all new and interesting and appalling at the same time.

Material was coming out in stories that we just couldn't believe about how these men were treated and the kinds of health problems they've had.

WC: Were there people that were, in a sense, radiated by the toxic energy of the interviews?

PB: That's a good way of putting it. Yeah, I think so. For example, the social worker in our group had interviewed Alan and Marion Batchelor. They live in Canberra, and have done more than anybody to research the files and bring out hidden documents that were needed in court cases. During the interview they went through a pile of files with the Batchelors just commenting on them. And they talked about the 30 different cases they had before them, in a quite matter-of-fact way. That interview brought out a lot of the horror, particularly about genetically impaired offspring—the so called GIOs. Those things had a big impact on us. I don't think any of us were really ready for the story of the genetically impaired offspring.

From what we have been told it is down to the third generation. The evidence from Hiroshima and Nagasaki make clear that these impacts can go on for many generations. This is clearly in the minds of the veterans. We have that as a through line in the play at the moment. That fear is probably more important than anything else. "That as I get older I'm going to see my children affected, and possibly their children."

23. *Offspring*
(Chris, Sandy, Dawn, Jane and Ken, Teri, Jim, Marion, Alan, Ric)

The table is brought forward with piles of files.

Chris: (CR70): When our daughter was a young baby, she had double teeth, teeth growing out of teeth, which the Hospital said they've never seen before, and it turned out since I've met two other veterans who also had, the children had the same thing. If it's a coincidence or if it's a part of that, we'll never know.

Sandy: (SC/rj55): My son was born with a cleft palate, he had um, no hair lip, but he just had the cleft palate. An' when he was twelve months of age, they had to take the skin off his bum which he always laughs about, 'cause he's walkin' around with his bum in his mouth. Ha!

Dawn: (DC37): Both our boys, ah were born with um, high testicles and... hernias, and they reckon that is, one of the effects.

Ken: One of our daughters has got a turned back knee now doesn't she.

Jane: Just different little things in each one of the family.

Ken: Well Mark was epileptic wasn't it, Mark was epileptic, our son, he grew out of that thank God...

Marion: Teri?

Veterans and their wives describing the toxic legacy of the British nuclear tests in Australia. From the Ettalong War Memorial Club production of Maralinga. *This scene from the Ettalong Production of* Maralinga *included the full cast comprised of Richard Healy, Roy Billing, Jason Klarwein, Chris Pitman, Graham Rouse, Tina Bursill, Valerie Bader and Annie Maynard. The play was directed by Wesley Enoch. Photo by Dawne Fahey*

Teri: I've had um bone tumors removed from jaws, feet, I had a breast lump removed when I was 17, I've had… I almost died having my kids, which they couldn't explain. I also had to have a hysterectomy at a very early age, the kids were all born with deformed jaws, my son had hip degeneration at birth. My doctor was quite interested actually when I mentioned that Dad was at Maralinga, and he was asking me if I could supply him with any concrete evidence.

Writing

WC: With verbatim you are not actually writing the script are you? You are picking and culling from the transcripts?

PB: Yes, We had what we called our writing group, which was a slightly moveable feast. In mid-2004, the five of us involved went off to the house of one of the members of the group in the country and spent two nights there. This can be the most stressful process in verbatim work because we were making those decisions about which bits were in and which bits were not. We had most of the transcripts done by that stage so we stacked them up and read them. We marked them up and then we discussed which bits we thought would work and why. Then we tried to cluster them into scenes.

This is where we set up the first structure of the play—not the current structure, but at that stage we went for something very simple. We told the story of the men in the desert in the first half and then we told the story of what happened to them next, including the health impacts and the current illnesses. The first half was the men's stories. In the second half the women played a much more prominent role as they talked about their husbands.

This was where the ethical dilemmas related to dramatization also emerged. For example, we had quite a number of interviews with people who had been at other test sites, particularly Montebello. But eventually, we found ourselves settling on Maralinga. This was extremely hard to do, but we needed unity of time and place to make it work dramatically. We've had the majority of our stories from there and it's confusing to have these other locations. This was a very important decision because it also influenced how we approached the British interviews (which had not been conducted). Namely, we confined ourselves to people who had been to Maralinga.

We also had to deal with stories that are hard to corroborate. We have, for example, the story of an Australian soldier who, when he retired from the army, was given free board at the Holdsworthy military base near Sydney, and effectively locked away. And he, supposedly, was the guy who was given the job of bulldozing Aboriginal bodies into a pit, which was dug near one of the blast zones. As dramatists, we agonized a long time about whether or not to use that story. And we told ourselves that if ever we found a second version of it, we would put it in. If we don't then we're not putting it in, because it was the recollection of somebody else who knew this man. So, it was getting too close to being rumor. But whether the grim detail of it is actually close enough to truth is a big question.

First Reading

WC: How did you get feedback from the people whose lives you are portraying? I assume this is a critical part of the process.

PB: I'd have to say that in every community theatre project I've worked on, the first reading in front of the people whose story you're telling is the most important moment. So, we put together a very humble reading in Belvoir Street Theatre as the first reading. This had been earlier, in December 2003. There were probably 20 veterans or veterans' family members present. We were lucky enough to have a little bit of funding to fly some people in so some of them had traveled a far distance to get there.

WC: Was this done with the cast, with actors?

PB: At this stage not with a paid cast. A couple of our researchers are actors. But you know, even I read a part. And other researchers read bits. Because somebody got sick, we even got the accountant from Belvoir Street Theatre to read a part. You can, to a large extent, do this with verbatim theatre. There is this sense that anybody can perform the work by simply reading it as a storyteller.

We read a version of the script that was in an extremely early stage. We were trying to test out the internal rhythms of some of the stories. We were very much lacking in confidence of the overall structure, but we had a very strong positive reaction. In verbatim theatre some speeches tend to

Ric Johnstone's diary from the fall of 1957 takes note of both, the Taranaki test, and the incessant heat. Photo © Ric Johnstone

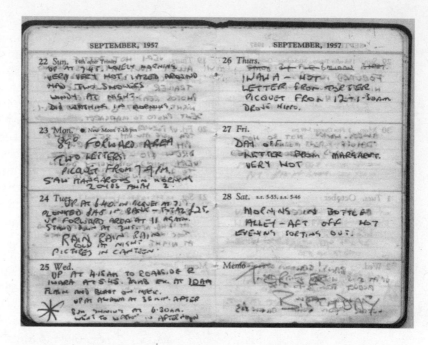

be long monologues. So you worry about holding the audience. But we didn't seem to have that trouble at all. So that was great.

One of the interesting dynamics of that presentation was that the men in the audience started saying, "Oh this is wonderful. You're telling the story from the perspective of wives. And there should be more of it. We don't want so much of our stuff. Why don't you keep going and develop that." But then the women came in saying, "Oh, no, no, the people of Australia need to understand precisely what the men of Australia went through: It's their story that should be developed." I think that kind of modesty about stories is in lots of ways very Australian.

But the other thing that this showed is the strong divide between the women's stories and the men's stories about Maralinga. And that little reading, perhaps more than anything else, brought that out. The men were 19 and 20 and had gone off on a bit of an adventure. They were from different services—Army, Navy, Air Force. Many of them were misfits and rogues who had been recommended in by their commanders. "Off you go. Get out of here and go to Maralinga." They didn't know each other. They weren't established platoons. They were there for six months, nine months, and they'd built relationships there in the desert pretty much from scratch. For the early tests they lived in tents. Life was very hard, so there was a kind of coming together through adversity and hardship. That sort of story.

When they left Maralinga, the men dispersed with very little contact between them until the 1970s when they started to get sick and die and

there began to be some compensation claims. When the Veterans Association formed, these men started to remake contacts with each other. Despite the lack of contact, they were still able to recall their life in the desert and pick up with old friends, like servicemen do—whatever war we're talking about. They had that kind of camaraderie.

But the women were much more atomized. They had very little reason to ever have contact with each other and often were not told anything about this story by their husbands, because of the secrecy agreement. So the men were very self-conscious telling the story, even to their wives. And we began to realize that the project itself was causing men to tell their wives stories, which they hadn't told before, and those women who were widows had quite a different perspective, because they felt they needed to tell their husband's story.

18. *Hot Zones*

(Dawn, Danny, Doughey, Ric, John, Bob, Ann and Malcolm, Albert and Angela, Avon, Rick S, Kevin)

As the men tell stories, the women dig out details.

Dawn: (DC48) With Maralinga, what you can't seem to get through to people…they think that there was a, um a big fence around everything.

Danny: (DM49/51): There were weeks, sometimes months between the bomb tests and you just wandered where the hell you wanted. There were no fences anywhere.

Doughey: (MS55): I assumed that they all thought everything was safe.

Danny: It was very, very relaxed security.

Ric: (RJ/bb): I think some of it was phony. In some cases, they would send guys like Reg out, no protective clothing. Go out and get this, that, or the other and it would actually be just getting out there and getting back to see what (laughs) happened to him...

Malcolm: (MS13): There was equipment left everywhere. I mean all the stuff that they did use up there to like, you know like plant machinery and this sort of thing.

John: (JM11): We worked on vehicles, which had been driving around here, there and everywhere, and we worked on them and underneath them, and obviously all the dust and dirt and so on, er, even to the minor thing like changing a wheel, er, y-you were liable to dislodge dirt and dust from under the vehicle.

Bob: (BS50): We used to race the ferrets, the ferrets had supposedly been, or dingos rather, scout cars had supposedly been decontaminated. We had a racetrack down in the bush.

Malcolm: So, ah, how, how decontaminated they were, I don't know.

*Typical accom-
modations at the
Maralinga nuclear
test site.
Photo by John
Walden*

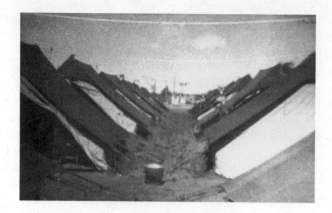

Ann: They cleaned them… didn't they.

Malcolm: Yeah, but ah, I think used to… I think they hosed them down. They, they must check them with the Geiger counter. They don't just, you know…

Ann: Wash them… They must do more than just wash them.

Malcolm: And they put em all in these parks, you know. And ah, we used to get them out and drive em round, you know. When you're young you're not concerned about those things.

Dawn: (DC48): For each, each blast, there was a tower, or something, to be built, so you were, you were passing where this one had been built to build, eh, build the other one so you were passing where it's been…

Avon: So we didn't know, because we weren't told, and we were actually working there for a few weeks before we found out there was even a bomb let off there.

Dawn: (DC33): And what happened at the craters… The scientists and the lawyers will say that there were guards around and you weren't allowed. But I believe my husband 'cause his, his mind was so clear on this…n' he wal, actually walked up to the crater and looked right in, and no-one was around to stop him. They were sorta calling him a liar, or 'disbelieve you', which to me is the same word only, ya-know, saying it different, (laughter) cause my husband said, "Are you calling me a liar?" "No" they said, "We just say we dis-believe you" and I said "Well what"s the difference?" ya know. And they said "There was guards around." There was no guards around the craters.

Maralinga

Second Reading

WC: So, did you continue to write and do readings as well?

PB: Yes, the second reading was also at the Belvoir Street Theatre in the middle of 2004, and it was a chance to play it before 150 people. Some of them were veterans and family members, some were theatre workers. We learned a lot from that reading. We had put a number of humorous things into the script and we learned that the humor was going to work. In fact, the humor worked too well. We learned that by bringing in a lot of the lar-rikin behavior that went on—jokes about playing around and pissing in the desert and that kind of thing—that we created a bit of a blind spot to some of the other stories. There's still plenty of humor in it, but we decided to pull back on some of that larrikin stuff. It also influenced us to open up the structure. And it inspired us to do a couple more interviews to fill in the gaps.

WC: How did you get feedback from that audience?

PB: Several ways. The discussion afterwards for a start, which was noted and partially taped. And the spill out in the foyer. So more informal discus-sion. And then we had some written feedback that people sent us.

WC: Coming out of that, did you generally feel encouraged?

PB: Oh yeah, definitely. And Ric Johnstone was there and took the stage at the end. So you had a kind of closing of the loop. The stories had come from the veterans. There was a sense of lights, action, a professional cast delivering it in a performative way. Trying to entertain. All of that. But then at the end in the discussion, you had some of the owners of stories mak-ing comments that enlarged their story. And of course Ric Johnstone was there filling in political context and telling more of his own story. So, in a reading like that the audience very much becomes a part of the project.

A Trip to Maralinga

WC: I was wondering if, in your research, if you ever made it to the blast zone?

PB: I once flew over Maralinga in the company of the well known Aboriginal leader Archie Barton, who is the Administrator for the Maralinga Tjurutja. That was at a time when the latest stage of supposed decontamination had been completed, and huge furrows of ploughed country could be seen radiating away from what had been the bomb sites. Then in October of 2004, I made a journey to the South Australian desert with a team of academics, and we visited places on the eastern side of Maralinga lands that I've talked about. That's where I met up with some elders from the Kokotha people, one of the Aboriginal groups from the Womera area. We'd been thinking about extending our research to include the Aboriginal stories, and I asked them directly whether it was a good idea to develop another play that took the stories that they had told the Royal Commission and retold in 2003 when they were campaigning to stop a waste dump. Basically, I was asking for permission. They said, "Yes. You can." Which I don't take to be the final negotiation, but it was a starting point for a future effort. Other plays, not least *Napartji Napartji*, have developed from the Aboriginal perspective, and for the moment, we've concentrated on the veteran's story. But that trip was interesting in itself, very interesting to travel that country, which has been bitten three times by the nuclear industry; the bombs—uranium mining nearby and the recent attempts to site a nuclear waste dump on Kokotha land.

But the most moving thing about that trip is that the Kokotha people took us to a place to camp one night. They themselves didn't camp there, they went away, but came back in the morning. That's when they told us we'd been camping on the site of the old hospital that had been a mix of simple huts and tents, hastily erected in the week after the 1953 bombing at Emu, to accommodate Aboriginal people who had been directly impacted by the blasts, who had radiation burns. You could just see the bare concrete slabs now, and a couple of posts left standing.

WC: So were these events a part of the evidence examined by the Royal Commission?

PB: The two thick volumes of the Royal Commission findings were, in 1985, the cornerstone of what I'd call a negotiated understanding about what went on at Maralinga. And that report makes it very clear the efforts undertaken to insure Aboriginal safety were utterly and woefully inadequate. There were just one or two police officers responsible for it. The area is utterly vast. And to think that they could find Aboriginal people who naturally hid from any European car or white airplane was utterly ridiculous. And the

Royal Commission, in great detail, comments on how, not only the lack of personnel, but the protocols for searching and verifying were just completely and utterly ridiculous. There's no longer any doubt about that.

What there remains doubt about is the reality of what happened in the blast zones. There are many eyewitness accounts from Aboriginal people themselves (and this became the basis for a large compensation which was paid to Aboriginal people) of the blast going off, which means they must have been close enough to see; of animals that they found dead and, therefore, ate. Then there are the paintings from Oak Valley that are historical representations of these stories—of their witnessing the blast, of escaping from it, of returning to the country and finding the animals and eating the animals. This is the other story, the Aboriginal story.

WC: How does that story intersect with the story of the nuclear veterans.

PB: It would have been extremely unusual for these Australian soldiers, 19- and 20-year-olds, back in the fifties, to have any understanding or experience of Aboriginal Australia. They would have hardly known that Aboriginal Australia existed. And where they had encountered them, they would have shared the same racist attitudes that everybody else had at that time. So, in large part, these two stories have been very separate. Ironically, it's more linked for the British veterans. The young British men tell their Maralinga stories with incredible passion. They were told to travel in their civilian clothes. They took five or six days to get here. They traveled on the most modern airliners. They stopped over in places like San Francisco and New York. And they were on a spree. It kind of continued once they got to Australia. They saw themselves as tourists. And they were given recreation days when they were trucked down to the coast, and that's where they encountered Aboriginal people. These were the same people who had been shifted off their land for the bombs and had established settlements down the coast. They'd set up these kind of trading posts or souvenir stores. So today, most of the British veterans have boomerangs and spears and other kinds of artifacts that they bought there hanging on their walls. And at least you can say that they had a kind of cultural tourism understanding of Aboriginal Australia that comes through in their stories.

The second thing about the British is, unlike Australians, many of the British servicemen had jobs that were much closer to the bomb zones themselves. And some of the British soldiers we interviewed were men who had been formed into special squads that worked very closely to the scientists making final preparations for setting up bombs and trigger mechanisms and so on. They were the same men who after the bomb blasts were given the detail of going to the craters to make sure there were no Aboriginal people there—and occasionally they found them.

20. *Water Holes* (Albert, Dawn, Rev John, Mal, and Joyce)

Atomised characters in a landscape

Albert: (AM58): At the Taranaki site, most of it was flat, with outcrops of rocks, and apparently those rocks, were sacred, and there were water holes there that the blacks came to.

Dawn: (DC28): Yes, he saw them, my husband said he saw Aboriginal people, they, they came wandering through after one of the blasts…

Rev John: (JW27): I was on picket from 7 to 9 PM. That meant that we were up in the forward area. We had to stop the Aborigines coming in, and so six of us, or eight of us were sent up there. We slept on the ground, but we had to keep the fire going, otherwise the dingoes would attack us, you could hear the dingoes on the edge, and our job was just to be the picket, if we heard or saw any Aborigines, which was impossible anyway because you don't see 'em, do you? And so it was daft, you know, you've sort of got these daft things, there we are 1,000 miles up into the desert, and, and you keep, keep the, keep the, keep the, keep the Aborigines away. Excuse me! Out of the way, you know, I mean, how the… it was all so ludicrous!

Mal: I saw them too. This family of Aborigines came walking through the crater. The Aboriginal man, this woman and two children. He was trying to sell us boomerangs and spears, and we were trying to tell him he'd put himself in danger. They were whisked away in a land rover. I guess they were supposed to be taken to the washroom. The following morning when we got up for reveille, we were all paraded, and our CO said we had signed the official secrets act and there was no way we were to communicate any of this with anybody.

British Stories

WC: It sounds like the British soldiers had a different experience at Maralinga. How did you involve them in the project?

PB: Towards the end of 2004, almost simultaneously, a British theatre company, Bluetongue Theater, and the British Nuclear Test Veterans Association got in touch, saying, "We've heard about the project. How's it going? What kind of collaboration?" Etcetera. And we started to set up the British connection. So, I had to apply for some extra funding to go there. Bluetongue's director in London, Lucy Skilbeck, pulled together a good team of people to do some of the interviews. Some of these people went on to be in the cast of the British reading we did much later.

On that trip, one very important moment happened on a journey that Lucy Skilbeck and I took to Norwich from London on the train to

interview the Reverend John Walden, a prime mover among the British nuclear veterans. He was a member of what was called the balloon unit. One of the bombs was exploded underneath three huge balloons. He and his fellow "balloon specialists" manhandled the bomb into position, inflated the balloon, let the balloons up on winches and set the bombs. They were the last people out and they were the first people back to check what happened.

1. Going Home Balloons (Rev John, Danny, Rick S)

INSERT: Film footage of the men being scrubbed down, wrapping themselves in towels and entering the barracks, as if it's the end of a day's work. They look self-consciously towards us. Then the desert landscape, flattened, sparse, once again waiting.

Rev John: (REVJ76): The last big bomb was suspended from balloons.

Danny: (DM20): We had been waiting on whether to go ahead with the test.

Rick S: (RS17): Meanwhile we lost three balloons. These were barrage balloons, you know, big barrage balloons, like in the Blitz. We lost three in a sandstorm… they blew up, set on fire, just exploded. Hydrogen balloons, yeah. Eighteen thousand pounds just gone up in smoke.

Danny: (RS11): This bomb… Inside its steel cage, the bomb itself was the same size of a football.

Rick S: (RS20): I stuck chewing gum on it. I stuck chewing gum on it but ah there weren't many of us… You had to get on top of wagon, stand on back of winch to, to touch the bomb. And I just stuck my chewing gum on it. We hooked that onto our balloons, and hoisted it up. It were two hundred metres up.

(RS29): But we were told, by our officer, that that bomb would be the first clean bomb in the world. No radiation fallout. Because it were detonated at such a height. Now I don't think that's right from what I've read (laughs).

Rev John: (REVJ76): We blew up our balloons, we let off our bomb, and afterwards we celebrated. Penney bought us a keg of beer. Everyone except me got blind drunk. Then we went home.

PB: It was on that journey that Lucy and I had a core creative discussion about the play's structure and tone. She saw a problem with how we told the stories about the men in the desert. She said, "In the first half you describe them driving around in cars and moving equipment around in all this dust. And in the second half you say, 'Oh, they got sick'." Lucy felt it was very important that the audience understand that their rolling around in

At first, many of the British soldiers assigned to Maralinga regarded the assignment as an exotic adventure. Photo by John Walden

the dust is related to their illness. In structural terms this would work better if the desert stories were intercut with stories of the illness men are experiencing today. This was a very strong and important intervention which caused the structure to evolve in quite a different way. Every project is like that. There are four or five key creative decisions that determine so much.

WC: Were there any British interviews that particularly stood out?

BP: The main highlight I suppose was the interview with Joyce Northey. Her husband had died of a particular type of throat cancer, which in the end, after a long while, the courts had to accept as so specific and so rarely caused by other means, that it must have come from exposure to radiation. Her story was also about proving that her husband was there, which they doubted. She had to appear before the tribunal on four occasions before she won her case. And they kept throwing her out, saying they were not convinced he was there, or not convinced that this illness was related. And that would send her off to find more and more scientific evidence. This is how the British and Australian governments have defeated almost every claimant—by attrition. The effort required to marshal the evidence is so great that they just give up. But Joyce didn't give up.

The way she proved that he was there was twofold. First of all, he had very clear descriptions which he'd given to her of his encounters with Aboriginal people. And the tribunal was moved by that. But the second thing was a photograph of her husband standing with a group of men outside a hut. In one of the early appearances before the tribunal they'd said, "Yes. That just shows he was with a bunch of other Army personnel outside an Army hut. How does that tell us that he was at Maralinga or anywhere close to a danger zone?" So she was sent away and I forget exactly who she'd been talking to. It might have been another veteran or whatever. Someone had sat with her looking at that photograph and looked very hard at it and said, "See that bulge in your husband's pocket? That is most likely his dosometer." This person who'd been at Maralinga recognized the shape in the pocket in the photograph as a dosometer. And so next time she appeared in court she was able to say, "Look at that. That tells you that he must have been in a place where there was potentially radiation."

The most moving thing about Joyce's interview is that she started singing the song that she used to sing to her husband as he was dying. So they had had a history of singing together at night before they went to bed—Old Geordie songs. He was a Geordie. (an old English dialect and region) She started singing this song spontaneously in the interview.

10. *The Old Geordie Songs* (Joyce)

Joyce: (JN23): Even if you get just a small amount…that changes a cell in your body. Right? There's what you call a fault in that cell, and as you know all our cells renew themselves all the time, don't they, constant, constantly, continually. And every time a cell, apparently, is affected by radiation, every time it renews itself, the fault gets bigger. And it can take years and years and years, it can take up to thirty or more years. But that fault will gradually get worse and worse and worse, and it can take a shock or a bad illness…to trigger it off. But the fault's there from day one…affected by the radiation, yeah.

(JN43): For my first Tribunal case I had to go to Birmingham, and if you've seen in those chambers, it's a very, very long table, and there was about six or seven people, sat all in a row, and then ah you're called in, and then you sit in front of them. It's like a courtroom, really. And what I had to do was find evidence and bring evidence forward, about whether, where Joe was at the tests… when he was there, what he did, and how I thought that… the radiation had affected him. And I had to prove that.

(JN30): Salivary gland cancer is a very rare cancer, and that's what my husband had. Salivary gland cancer. He had no saliva at all, in those last weeks. They used to bring boxes from the chemist, of sprays, and he used to have to keep spraying, I used to spray his throat for him. Can you imagine it? Completely dry. No saliva. They said they weren't giving him any more treatment, at the hospital. The doctor said there's no point in any more treatment. I said "Well I want my husband to come home please. Today." And I rung my daughter and she came in the car and we brought him home.

(JN32): The only way I got through was to keep thinking, he's going to get better. And I think if I'd actually faced up to it I don't know whether, how I would have got through, to be honest. Quite honestly…yeah…complete collapse you know… to me. And that, you get no-where do ya. I could, I couldn't have been there for him, could I if I, I'd collapsed. And I just concentrated on making him as comfortable as I could. Each day.

(JN34): We used to, we used to lie at nights sometimes, and couldn't sleep and we'd sing songs together (*laughing*). Geordie songs. Oh yeah…keep us going, kept us both going that did…yeah. An old Geordie song (*singing*) "Keep your feet still Geordie Henny, lets be happy through the nights, for we may not be so happy through the day," that's it (*laughs*). Yeah, we used to sing that quite a bit, lot of the old Geordie songs.

"I used to spray his throat for him. Can you imagine it? Completely dry. No saliva." Joyce Northey (Valerie Bader) from the Ettalong War Memorial Club production of Maralinga. *Photo by Dawne Fahey*

Bumps

WC: So, at this point are you seeing some light at the end of the tunnel?

PB: Yes and no. By April of 2005, I had done that frenetic driving around in the UK. And had various meetings and so on, all crowded into eight days. This was madness. And I'd been there another week for the In Place of War Conference.[1] I came home and I had a mild heart attack. I was in hospital for a few days, having a tiny metal tube, a stent, inserted in one artery. It's not something that greatly concerns me now, but it was certainly greatly concerning back then. But the point is, the next time I rang Ric Johnstone he said, "How are you?" I said, "I've had a heart attack." He said, "Oh yeah? Got any stents?" I said, "Oh yeah, I've got one stent now." He said, "Oh yeah. I had another one put in last month." So suddenly I'm talking to him on a different level.

The men we're talking with are all sick. Seriously sick at an early age. They've had heart attacks, they've got cancers, they've got respiratory illness and they've got skin diseases. Somehow having this stent, having a bit of mechanics done on my own body moved me a little closer to them. So now, when I talk to Ric Johnstone, it's, "How's your stent?"

WC: That was certainly a bump in the road.

PB: Well yes, but probably the most disturbing moment in this whole project was hearing from Ric (Johnstone) and Marion (Batchelor) that they had these concerns about the script as it was shaping up. At their invitation, we'd put the script from the Belvoir reading onto the website for comment. So now they felt that it should be taken off. One of the main worries was

Soldiers on a spree. From the Ettalong War Memorial Club production of Maralinga. *Photo by Dawne Fahey*

that the stories of the young men in the desert needed reworking. We all agreed that the most important elements of the story of the men in the desert were that they were in various ways exposed to equipment and dust and other potential radioactive sources that could have impacted upon their health. But Ric and Marion felt at that stage that the existing play didn't lean heavily enough on that side, having leant too heavily on the background story of the young men on a spree.

I guess it threw me into a kind of shock. But they were right. It caused me to go through the whole thing again within 48 hours of getting on the plane. In the end, the changes weren't hard to make, but it made a big difference in the tone and balance of the script.

Performance

PB: We obtained new funding in 2006 from the Theatre Board of the Australia Council, and that allowed us to mount the first full production of the play, at Ettalong, on the Central Coast north of Sydney. The British readings, at Leeds the previous year, had successfully tested the new version of the play, but we made further changes to prepare for its first Australian audience. Wesley Enoch, one of Australia's most respected directors, brought together the cast and crew, and we embarked on three weeks of rehearsals followed by the season. Wesley's involvement is significant in several ways. Apart from the incredible sensitivity he brought to the staging of the stories, he'd been a member of the artists' steering committee for Peter Sellars 2002 Adelaide Festival. So he'd been present for the earliest discussions about the range of Maralinga projects. In a sense he brought the project

full circle. Then because Wesley is of Aboriginal background, he brought additional perspective to the stories told by the veterans of encounters with Aborigines at Maralinga.

WC: What challenges emerged as the production neared?

PB: We wanted the first Australian season to deliver on several of the community objectives, which the original project put forward. In particular we wanted to "play back" the stories to an audience that included as many veterans as possible. After thinking that through and considering several alternatives, the Ettalong War Memorial Club seemed the most logical. This is one of the largest returned services clubs on the Central Coast, an area where there are many retired people, with a significant number of veterans, including nuclear veterans.

So we played in the hall used for meetings and music concerts, not a space normally set up for theatre performances. The Club helped publicize the show to veterans and its wider community membership, and we ran a campaign to bring theatre goers including critics and potential producers up from Sydney or down from Newcastle. Our timing was good, because 2006 was the fifty-year anniversary of the first bomb at Maralinga. In fact we changed the name of the show, from *Half-a-Life* to *Maralinga* because that linked better with press coverage of the anniversary.

So the Ettalong season became pivotal, because it not only rounded off the community-based phases of the project, but heralded in the entrepreneurial stages of trying to "sell" the show to interested theatres around Australia. And that's pretty much where the project is at right now, with a number of possibilities for new seasons in both Australia and Britain under consideration. Getting it seen by the widest possible audience, and having it taken up in the education system: school performances, for example, or getting it on the high school curriculum. These are high among our current objectives.

WC: What was the reaction of the audience (particularly the veterans and their families) and the press?

PB: The press was interesting because journalists wanted to tie the play into the anniversary, and the veterans association got some great coverage of their compensation campaign. There were plenty of tears, and laughter, during the performance and in the foyer, and high praise all round, which was great. Several veterans and their families traveled a long way to make the show. Kay Burandt, whose long speech about her husband's death from cancer appears in the play, came down from Brisbane with her son, and for her the performance was a kind of closure, because her husband had died only a few weeks before we interviewed her. Ric Johnstone worked his usual magic around the show, bringing in politicians, and his mates, playing host, and pushing it all to the media.

I'd like to say Ric was extremely happy about the whole project, and I know he was, on one level. But when you've fought the kind of struggle he and many others have, it's important to get the play in perspective. It's just one of many ways of bringing this story to light and I know Ric held no romantic view that the play would tip the balance in his fight with the government. His opponents are extremely powerful, and as the curtain came down on the Ettalong season, off went Ric on new stages of his campaign, perhaps with a bit more spring in his step, but still frustrated and very angry at the lack of recognition for nuclear veterans.

27. Exposure (All)

One or two couples holding hands. Others alone. All staring out, eyes unprotected.

Ric: It was totally black and dark out there.

Ken: (KM14): And off she went.

Ric: Suddenly it was the middle of the day. And then the flash would come through your eyes.

Rick S: You actually see daylight through your hands.

Chris: (CRb22): Straight through the back of your head, the light, the flash, and…

Dawn: (DC30): He said his fingers…

Terry: (TH3): It looks like an X-ray.

Maxine: The bones in your fingers.

Ken: (KM14): And *(laughs)* even with your back turned 'n your hands over your face.

Doughey: (BB16): It was just like as though you had no hands.

Dave: Like somebody had put a white mask in front of you.

Shift

Rick S: (RS13): Three Two One… flash, about turn. These are orders, on a, on a speaker.

Dave: (DW15): The flash lasts two seconds…

Dawn: (JM7): Then you're allowed to turn round, and face the explosion…

Jim: By which time the red fireball and the smoke was forming, you know, the ball is forming to go up into the air.

Ken: It's been boring for the last 5 or 6 months and all of a sudden you get this thing and it's "oh that's great, this is better than the movies." It was really, really something.

Rick S: The atomic cloud going up into the sky.

Ken: (KM15): Oh just amazing, the enormous immense, and you wouldn't be wrong to call it beautiful.

Hambone: The mushroom coming up, it was magnificent, colours.

Chris: (CRa67): All the colours of these bombs.

Ken: It really was just this great big billowing cloud with all the colours inside there, the reds and the oranges and blacks, yeah, even though it was midnight. It was, it was just … and then they fire rockets, you see. They fire rockets from each side at an angle, like that, and they can work out by photographs how high it's going. Lke a real huge thunderstorm, and these rockets going up, oh yeah it was beautiful, of course it was.

Doughey: There's this monstrous stem.

Rick S: But you can't bloody move dare you because you, you were red hot.

Doughey: (DB23): Next thing there's all this cheering and clapping and carrying on sort of thing. And the boffins are pattin' themselves on the back!

Rick S: And as soon, as soon as it blew we were jumping up in the air too, 'cause we knew we were going home.

Doughey: Then all of a sudden bloody… the sounds hit ya VRRRRRR!

Ric: (RJ38): It's a big noise but it's not a "Bang" it's like a drawn out noise… It's the sound of about 10,000 locomotives coming across the desert…

Dave: A few seconds later you get the tug on your clothing.

Ric: A warm air hits ya and it rocks ya…

Jim: And it was like someone opening an oven door.

Ken: (KM15): And then you see this thing coming towards you, it was the shock wave. If you've seen mirages, everything's… everything's like jumbled up, it's coming towards you.

They step towards the blast.

Rick S: And the desert were like sea, it was just ballooning up like sea, with the desert and the radiation cloud and the, and fireball.

Doughey: (BP24): like seeing a wind blowing across a calm ocean, you could see it coming up…

Angela: (DC30): The salt bush was whipping, was wavering and quivering.

Hambone: And then all of a sudden it hit "Bang!" the second blast…

Doughey: (DB21,23): You get two explosions with an atomic bomb. You get the initial bang then… The shock wave hit us. Knocked me over, on the face.

Ken: Not everybody fell over, I didn't.

Rick S: You could lay on the blast, and it used to… like a big wind that went through you.

Chris: You could feel the heat… and the crush.

Dawn: (DC30): It was like having a hot bucket of water thrown on your back.

Chris: And all the backs of our necks were seared.

Rick S: And then it's gone.

 Shift

Chris: And then, as if it's created a vacuum… and it blows back towards Ground Zero again… and then the drag back… the debris comes back again to Ground Zero.

Rick S: (RS29): And the planes went straight into it. Went straight into fire, into radiation cloud.

Rev John: (REVJ78): This enormous cloud that's 20 miles high and 20 miles wide…

Maralinga's marketing left no doubt as to the production's subject matter. © Maralinga Poster designed by Linda Dement

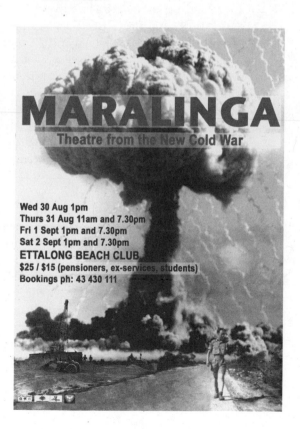

Rev John: Now, this was just an enormous thing to see and to witness, at 19 you don't realise the significance, you're not even thinking that this was something that killed 70,000 people at Nagasaki. That isn't… there's nothing like that ever in your mind, you're not thinking about anything like that, at all. You're thinking oh that's a powerful sight oh and I *did* something.

Doughey: It was good, and y' see it properly, you know, the fireball, the mushroom cloud and that… But the thing that stuck in my mind was those rabbits, you could tell they were blind. All of them just crashing into everything… they were blind, they were just crashing around, just like that.

All turn towards the screen.

FILM SEGMENT: *There is a red line across the centre of the screen, like a horizon. Composite shots of Maralinga blasts rising above the red horizon. Bomb after bomb. A red circle appears around two human figures just below the horizon. They seem to run towards the blast. Freeze.*

Ric: What makes us fight now?

(RJ/MK60): We had formed a little group at Maralinga in '56… a lot of us used to drink in a tent up there, and steal beer from the officers and this and that *(laughs)*… and then in 1972, couple of the blokes were livin' up my way, and we got together… and uh, we started realising y' know, other blokes we had contact with were dying, and we thought, oh, well this will be easy, we'll just sort of uh form a group and tell the government what's goin' on, and the government will help us… But they all decided I had to be the president, said what are we gonna call ourselves? "Ohh we're the Australian Nuclear Veterans Association." So we dreamt up ANVA. The government straight away *(laughs)* became *terrorised*.

They know time is on their side.

(RJ/as3): And now the governments have sort of… both Britain and Australia are falling over backwards trying to find ways to say things like "That wasn't really right you know we weren't testing the *men*, we were testing the *clothes* they were wearing" … So they're spending millions in denial but now it's all coming unraveled for them because we have discovered documents that proved conclusively that a lot of the blokes were used as guinea pigs without their knowledge …

(RJ/as14): But see those silver tankards over there, each one of those, hanging under that shelf, each one of those belonged to a member of the Association in the beginning and I'm the only one still alive… so all the tankards are hung up bar one.

End

CHAPTER 17

Ngapartji Ngapartji

8:00 PM, October 12, 2006, Melbourne International Arts Festival

The house lights dim. The audience settles like hiving bees at twilight. The stage is bare save for a large copper colored monolith, center right. What looks to be a home video flickers to life in the murky grayness behind the burnished edifice. On the screen a boy runs through the bush.

From stage right, Trevor Jamieson enters into the reflected copper light, his footfalls silent on a carpet of black sand. He greets the audience with a smile and turns toward the flickering image of the boy.

His first words are Pitjantjatjara, then English. "For tonight, I wanted to make a video about my brother Jarmen. He is happy in the bush, but lately, he spends a lot of time in prison. I worry Jarmen may not be here long."

Trevor turns to his left, as a keening harmony begins to rise in the darkness there. The tune is haunting. He continues, "So I wanted to make a film about him, but instead my family turned up." While he speaks, a choir of a dozen or so, mostly women, young, old, dark and light-skinned, brings its song into the expanding circle of light at center stage. "I did want to make that film, but I wanted to invite you mob, into our language and culture."

After Trevor introduces his walytja (family), one by one, his sister Lorna steps forward and engages the audience. "I'd like to begin by teaching you a greeting: Wai, Palya, which is the polite way of getting someone's attention." As she enunciates the short phrase, the words appear in the space occupied moments earlier by the video of the running boy. The audience repeats, Wai, Palya. For some, it is clearly not the first time they have uttered these words. An extraordinary journey has begun.

Trevor

TREVOR JAMISON'S LIFE path mirrors the complex amalgam of tradition and modernity that defines Aboriginal culture in 21st century Australia. He is an initiate of his clan's ancient spiritual practices who is as at home on a sound stage as he is sitting around a ritual fire. He is as much

a product of town and city as he is of the vast expanse of Spinifex country that has forged 2000 generations of Pitjantjatjara history. And while educated in Australian public schools, he also knows the old ways, learned at the knees of his elders. Above all, though, Trevor Jamison is a modern day Australian performer who understands the care and reverence with which certain stories need to be treated.

Ngapartji Ngapartji is a story Trevor has been trying to tell all of his life. It is about his family, his people and the power and dignity of their 50,000-year history. It chronicles the triumph of their resilient culture, and the tragedy of their abuse by another. He tells this tale not as a lament or screed, but rather as a way to heal the deep wound of a people torn from the places and the spirits that define them.

At the time of his birth in 1975, in the town of Subiaco near Perth, Trevor Jamison's family had long been displaced from their ancestral lands around Maralinga. As a young man, he heard many stories about their forced exile from these lands to make way for the British nuclear tests. He learned how the complex web of Pitjantjatjara kinship groups had been ripped apart when they were sent to new settlements like Yalata and Giles—settlements that were more like refugee camps than they were communities. And he heard how, after being separated from their semi-nomadic lifestyle, the Pitjantjatjara had adapted quickly to the new ways of the settlements. He also saw that these new ways had not always been good for his people.

One important aspect of Pitjantjatjara culture that did live on was the tribal gathering. At various times during the year, the dispersed clan would come together to perform traditional ceremonies and rituals. Trevor remembers being a part of these ceremonies at a very young age.

So it was the grandfathers who would come down to paint us up and teach us how to perform. We were only shown once and we had to try and imitate the dance steps from our grandfathers. I remember a lot of sand, a lot of corroboree,[1] a lot of fires in the night. I remember dancing alongside the rest of my cousins, accompanied by our grandfathers. The whole community was just beautiful.

Spending time in the desert with the clan was important to Trevor's family, but, small towns like Kalgoorlie and Esperance were the only places that offered opportunities for employment, so they moved quite a bit. Yet, every chance they had, they would return to the desert to visit their extended family members. This moving back and forth between bush and town had a potent effect on Trevor. He grew up with a deep reverence for the history and language of his people. He also became adept at the ways of the dominant culture. As he matured, he began to understand how his facility in both worlds might be of benefit to him and his family.

Stories

For Trevor's parents, another critical reason for settling in towns like Esparance was access to schools. They knew that education was an essential survival tool for their children. As such, they constantly emphasized the importance of both academic and traditional learning. Trevor appreciated his parents' persistence, but attending the predominately white schools in Esparance posed significant challenges, particularly when it came to "fitting in." Although he found it hard to "find a place" for himself socially, he did establish what was to become a lifelong relationship with writing and literature. This was not surprising, given the important role stories and storytelling had played in his early upbringing. As his writing abilities grew, he found that the things he wrote about were intriguing to his classmates. Although some of the complex ideas were confounding to his white peers, he did appreciate their genuine interest.

I just had a passion for writing stories of my family. The only sort of exposure the other kids had to this was me coming back with certain stories. It was fun. Some of it was hard for them to understand, but it allowed me to actually communicate knowledge I'd gained during the holidays from a traditional side. I would talk to the kids and write some more stuff. Before that, none of the rest of my classmates ever knew [our] society.

Of the many stories Trevor shared through his writing and storytelling, those dealing with Maralinga nuclear tests drew the most attention. When he first encountered these stories, as a child on his grandfather's lap, they had been just one part of the larger fabric of his family saga. But, as he approached adolescence, he became more and more aware of the tensions and contradictions roiling beneath the surface. He remembers hearing about "our country,

and how we had to move off it because of the Maralinga tests."[2] Other stories told of the "big black smoke that came through that killed the land, and the lost ones that perished through the blasts."

These stories had a quality that was both intriguing and troubling. Within Trevor's family, this was living history, but for most Australians it was largely unknown, and most certainly, unaddressed. Given this, he not only came to view the Maralinga stories as important, but also ongoing. This, Trevor recollects, prompted him to consider putting them down on paper.

> I was about 12, and had to do a school report for literature (class). I asked for the story from my father first. I wasn't sure about it, but my mother actually pushed it on me. She said, "You should do this." We only had one elder in Esperance, my grandfather Martin Anderson. He was one of the last survivors from Maralinga. He was in the last group to actually come in from the bush. We invited him over, we had a cup of tea and he spoke about it. I just sat and listened. And then I wrote it down in my own words. I kept going back to verify certain things that he had said and to ask if it's okay to say this and that.

> I got high marks with that. And then there was this Aboriginal magazine that they put it in. It appeared in Aboriginal communities all over Australia. People kept praising it up when they read it. "Wow, this story is amazing!" From that point onwards, I was encouraged by my grandfathers to keep writing.

Beyond the praise and encouragement, writing about Maralinga had a strong influence on Trevor's life path. Through his research, he became more and more cognizant of the injustices suffered by Aboriginal people in Australia. He turned to his writing as an outlet for his anger and resentment. His awareness was further heightened when he discovered the work of an Aborigine poet and playwright named Jack Davis.

Born in 1917, in Yarloop, in Southwestern Australia, Davis is often referred to as the twentieth century's Aboriginal Poet Laureate. Much of his work chronicles the devastating impact of colonization on the indigenous people of Australia, particularly his clan, the Nyoongarah. Written in English, his poems and plays such as *The Dreamers* (1980) and *No Sugar* (1985) vividly document the Aboriginal struggle for subsistence survival in the blithely racist Australia of the early and middle twentieth century. Through Davis's writing, Trevor encountered, firsthand, earlier generations of Aboriginal communities that were ripped apart by the state's forced adoption of half-caste children[3] and the removal of families and clans to "native settlements." Trevor was inspired as much by Davis's life as his art. A tireless advocate for the survival and recognition of Aboriginal culture, Davis was active in the struggle for Aboriginal land rights and a harsh critic of what he saw as a genocidal penal system.

The impact that Davis had on Trevor had a personal element, as well. Davis's niece, Lynette Narkle, an actress who appeared in many of his plays, had mar-

ried into Trevor's clan, thereby becoming one of his "aunties." After seeing him in a high school play, she praised his work and encouraged him to continue developing his talent. Trevor's drama and literature teachers also urged him to pursue a similar course. At the same time, Trevor, who had become a standout for his high school football team (Australian Rules), was being pulled in another direction. He recalls the critical moment when his aunt intervened.

> I was asked to play for the West Australia Football League for a team called Swan Districts. They were going to set me up with a job, a car, a house, accommodations and all I would have to do is play football every Sunday. But no, my auntie came along and said, "Look Trevor, I see something in you. Why don't you audition for this six-month tour we have coming up." That's what I did, and it led to all I've done as a performer.

8:25 PM, October 12, 2006, Melbourne International Arts Festival
Thus far, the evening's journey has been gentle and engaging, even humorous. At one point the audience learns the parts of the body through a familiar nursery rhyme as "Heads and shoulders knees and toes" becomes Kata, aḻipiṟi, muṯi, tjina. Moving fluidly between English and Pitjantjatjara, Trevor has led the audience through the fifty-thousand-year-old Pitjantjatjara culture—their long and respectful stewardship of the Spinifex nation (their ngura), "a land the size of Great Britain"—the abrupt arrival of the white man, the strange appearance of desert transport camels and their Afghan drivers, and, then, the coming of the steam train and the missionaries. Along the way,

"Heads and shoulders knees and toes" becomes "Kata, aḻipiṟi, muṯi, tjina." Photo © Jeff Busby

the Pitjantjatjara choir has blazed the trail with ethereal song. Each step has also been underscored with what, at times, appears to be a question and, at others, a statement as Trevor leans toward the audience and whispers, nyangangka kutjuparinyi. Something is happening here.

Now, Trevor is perched like a bird on the great copper structure that continues to dominate the scene. As he says, "It's the 1940s," the stage darkens. The audience is thrust into the twentieth century—Trevor's narrative comes at a furious pace. For Trevor's family, all there is—is change. Tobacco, alcohol, guns, towns and cities. He speaks of the wars, first hot and then cold, and the terrible lingering legacy of the bomb. Down below him, a dim spotlight focuses on a desperate Japanese mother as she tells her story. Japan, Australia's neighbor, Australia's enemy, Hiroshima, Nagasaki. "Blue wind shrapnel rain, skin dripping, people, not people" daughter lost, generations sickened.

In these few moments, the Bomb has become a central character in the unfolding saga. Trevor's narrative travels an all too familiar path. As the story unfolds, the Americans, the Soviets, the British—the post-war nuclear fathers, coveters, and protectors—invisibly populate the stage. The seduction and shame of this degenerate power inhabits the theater as Trevor describes how post-war Britain, "upper lip quivering," descends on the Australian outback in search of its own nuclear genie.

And now, this deadly story and Trevor's own family journey weave inexorably together into one bitter tale. He tells of the dismemberment and bombing of his people, the Spinifex nation. He recounts his family's transformation from a proud people into "refugees" and his grandfather Tjamu Jack's struggle to save them, keep them together. He describes the coming of the soldiers, the fences, and the halfhearted effort to clear the land of "abos." He tells of the tests, the poison wind, the sickness and the death.

On the left side of the stage Trevor kneels next to a mound of white parched bones. He uses the bones to build a circle around himself in the sand. Looking at the audience he says the words that have become familiar.

"Something is happening here. Strange dust, sticky cloud, ulpurul-ulpuru. Feel it touch their kata." The audience responds, kata. "Feel it touch their alipiri. Feel it touch their tjina." As they repeat the parts of the body learned earlier in the nursery rhyme, each word takes on a different weight. Trevor says, "When we pass on, we don't say their names, out of respect. So when we were asked if people died out there, we didn't talk about it. This made it easier for the government to pretend."

Then, Trevor's grandmother steps forward from the space occupied by the sitting choir and faces the audience. At once powerful and vulnerable, she speaks in Pitjantjatjara. Trevor translates.

"I was a little girl when I saw the big smoke and my family got sick from it. They got sores all over their bodies and their eyes were sore. And some went blind. My mother passed away from it."

Mamu: (bad spirit or evil shadow)

In 1991, Trevor's first role in Jack Davis's play, *Honey Pot*, under Lynn Narkles's direction, gave him his first real taste of professional theater. He loved the intensity and camaraderie of the work. Most of all, he loved being on stage. For Trevor, there was no question; this was the right path for him. Within eighteen months, he had completed a musical theater training program and landed a role in a musical called *Bran Nue Dae*. Written by renowned Australian Aboriginal playwright and composer Jimmy Chi, *Bran Nue Dae* tells the story of an Aboriginal boy's flight *home* from the city of Perth to his homeland at Djarindjin in western Australia. Trevor's work in that production was the beginning of a long and fruitful relationship with Perth's Black Swan Theater. During the nineties, as Black Swan developed into one of Australia's most respected theaters, Trevor appeared in a number of plays there. He also found work in a number of films and TV projects, including The Australian Broadcasting Corporation series *Heartland* and the award-winning film short, *My Bed Your Bed*.

As he gained more exposure, critics and peers alike came to recognize Trevor's significant talent as an actor. They also acknowledged that he had a large dose of that intangible, but no less compelling, quality, charisma. Despite the availability of work and positive feedback, Trevor often worried about whether the kinds of things he was being asked to do on stage conflicted with his cultural traditions. To make sure, he had regular conversations with the clan elders to "ask for guidance."

> Stuff like, a scene I was supposed to do naked. I wasn't sure. They said, "Its OK, you're representing us well." That's what they kept saying. "You're representing us."

Trevor was also frustrated with the fact that he had not found an outlet for his community's stories on stage. He had continued writing about his life and family and very much wanted to use theater to counteract his community's invisible status in the broader culture—particularly with regard to the injustices that the Pitjantjatjara people had suffered to make way for the Maralinga bomb tests.

That opportunity came in 1999, when Leah Purcell, one of his cast-mates from *Bran Nue Dae*, referred him to writer-director Scott Rankin, one of the founders of a community arts organization called Big hART. Scott had recently worked with Leah as co-writer and director of her semi-autobiographical production called *Box the Pony*. The one-woman show had gone very well, garnering critical praise and a number of awards. Scott recalls how one thing led to another with Trevor.

> We did *Box the Pony* when indigenous work was going through a renaissance in Australia. Leah, who is a great indigenous performer and activist, recommended that I have a chat with Trevor. Trevor was interested in doing

something about his family story in the Maralinga context. We talked a bit and ended up working on a show for the 2002 Adelaide Festival (with the Black Swan Theater). It was quite a conservative commission. With no process attached to it other than me talking to Trevor to see if we could get something like the one-person story format that had worked with Leah and others. The idea was that it would be easy to sell, cheap to do, the festivals would love it, and the public would clap.

As the project moved forward, it became increasingly clear that a solo work, like *Box the Pony*, was not going to accommodate Scott's and Trevor's vision. As part of their research, they met with Pitjantjatjara elders to document clan stories. While most dealt with the time of the nuclear tests, others stories veered off in tangential, but intriguing, directions. There were many accounts of how outsiders had impacted the clan over the past 200 years. These referenced not only missionaries but also the Afghan camel drivers brought to Australia by British merchants who married into Trevor's clan. They talked at length about the soldiers and scientists involved with the nuclear tests and about more recent exchanges with anti-nuclear activists from around the world, most notably from Hiroshima and Nagasaki. Confronted with the richness and delicacy of the material, Trevor and Scott began considering involving the clan members themselves onstage. They also recognized that Trevor's family history had ripples that extended far beyond the tragedy at Maralinga. From that point, the project, which came to be called *The Career Highlights of the Mamu*, escalated in both size and subject matter.

In the end, the sell-out festival production included half a dozen actors and musicians and 17 members of Trevor's family. With the nuclear testing as its foundation, the eventual storyline branched out to encompass some of the other stories they had heard, such as the negative impact of white missionaries and the nuclear bombing of Japan. Trevor describes the pride he felt sharing the stage with his fellow clan members.

> It was really about displacement and connection—about how our clan survived in this small corner of the desert. But on top of that, it showed the beauty of what we have. It was about how to survive in any culture I suppose—keeping your culture, but also keeping guard. Because, you see, these are very, very generous people—very open and vulnerable. You really get that notion of them when you see them perform. They are amazing people and I love them to bits.

Given its growing size and varied themes, it is not surprising that the show's script became more of a framework than a formal book. As a result, the show ended up being a semi-improvised amalgam of music, media and storytelling. It goes without saying, that no two performances of *The Career Highlights of the Mamu* were the same. In spite of this, or possibly because of it, the show was well received. Here is how reviewer Helen Grehan, saw it.

… The production combines oral history and docu-performance … with its use of video footage, live filming, storytelling, rock numbers, dance and song. As spectators, we are invited to occupy a position of closeness to the performers and to the stories being told. The mood … shifts between joy and despair … presenting a collage of stories that map the importance of country, belonging and community to the Spinifex people of the Great Victoria Desert.[4]

Critic Jeremy Eccles called the play both "powerful" and "dangerous," and went on to recount a particularly poignant scene involving "Trevor's Auntie" who told "of her parents and two siblings dying from radiation poisoning and… how the men of the tribe had attacked the rolling radiation cloud with spears, identifying it as a Mamu Devil Spirit."

After a week long run at the Adelaide Festival, Trevor and his family members took *The Career Highlights of the Mamu* on the road. Over the next year the show played the Perth Arts Festival and, then, in August of 2002 traveled to Germany where *Mamu* was presented at the Hamburg Festival. Again, the response from audiences and critics was positive. The success of his initial foray as a playwright was heartening to Trevor. He had translated his family's stories in a way that both honored their origins and connected to non-Aboriginal audiences. He had involved his family to the extent that they ended up deciding what was appropriate to share and what was not. In the process, stories and dances that had never been seen outside the community had became a part of the performance.

On their return from Germany, Trevor's family thanked him for including them in the production. Most indicated though, that given the rigors of theater life and travel outside of the country, they needed a rest. Trevor understood and was thankful that they had had the opportunity to work together. But he himself was far from finished with the truth-telling mission he had taken on with *Mamu*. Both he and Scott felt that the story deserved more and could be greatly improved upon.

9:20 PM, October 12, 2006, Melbourne International Arts Festival
 The second act of Ngapartji Ngapartji *begins innocently enough with Trevor's recitation of Winnie the Pooh's "Chapter 7: In which Kanga and Baby Roo Come to the Forest." The audience titters as Rabbit, Piglet and Pooh decide how to deal with the "strange animal" that has invaded their special world. But as Trevor shares the particulars of the "plan to steal baby Roo," there isn't a person in the audience that does not feel the specter of Australia's shameful history of "stolen children" enter the theater.*
 Two very different children's stories follow. One is told by Najeeba, an Afghani mother of two whose husband's family drove camels in the Spinifex desert one hundred years earlier. But now, she is fleeing Afghanistan to rescue her children from the misogyny and violence that has descended on her

"Something is happening here."
Photo © Jon Green

homeland. Whispering to her children, she refers to their destination, Australia, as, "your father's promised land."

The other is Trevor's. The audience sits silently as he tells about the murders of his two grandmothers, one by his own grandfather, Jamu Jack Jamieson, and the other by a rapist on his mother's wedding day. He describes Jack's son, his father Arnold, as "the first of a new breed, living in two worlds…mother murdered father in prison, family bombed, everyone refugees …all alone."

The story proceeds. Trevor, accompanied by the Pitjantjatjara choir, dances and sings his way through his parent's mission settlement romance. He goes on to describe his own coming of age as "Trevor," the town boy, and as Kanmatju (swift as a spear) in the bush. And as his ngura (nation) struggles to retrieve its fractured spirit he discovers that the bomb's fallout extends far beyond the horror of poisoned land and genetic mutation. Alcohol, chronic sickness, separation from the land, all turn his refugee home in Cundalee into "one big sorrow place." He looks out into the darkness, the audience, and asks, "Why did you bother saving the people from the bombs… only for this to happen."

Big hART

As the *Career Highlights of the Mamu* had neared production, Scott Rankin had found himself less and less comfortable with the project. He loved working with Trevor, but he felt the play's traditional festival-focused format was missing a great opportunity to extend the value and impact of the work for the community that had provided its content. As a mainstream contemporary theater, Black Swan was not focused on what was happening beyond the confines of their building. But for Scott and Big hART, using art for the sustained benefit of communities, particularly marginalized communities like the Pitjantjatjara, *was* the real work.

Big hART had been born in 1992, when playwright Scott Rankin and activist John Bakes joined forces to help the small Tasmanian town of Burnie deal with the social impact of a severe economic downturn. Seeing that the town's youth were a principal casualty of the slow death of the local paper mill, the two thought theater might be a good way to help them tell their stories. The resulting play, called *Regardless*, alerted the town to their kids' struggles with drugs and violence and sparked a community renaissance of sorts. According to Scott, "It really changed the … economics … and the family life of the town." It also won an Australian Violence Prevention Award which eventually let to Big hART going national.

Incorporated as an NGO in 1996, the organization grew to become, using their own words, "one of Tasmania's biggest arts and social policy exports." What this has meant in practical terms is that Big hART has created arts programs in over 30 small, mostly rural, Australian communities to tackle such diverse issues as domestic violence, drug misuse, suicide prevention, literacy, and homelessness. Through these initiatives (most last for three years), thousands of people in these communities have joined together to create original poetry, plays, television shows, visual art and even movies in support of social change. Put simply, Big hART helps communities use their often unrecognized creativity to tackle community problems.

Considering his long history of community-centered work, it is easy to understand Scott Rankin's ambivalence about the Black Swan production. Interestingly, *Mamu* did ultimately produce a benefit to the Pitjantjatjara beyond the on-stage airing of their story. Around the time the play was getting under way, the Pitjantjatjara were engaged in a struggle to establish title for a tract of land near Maralinga called Oak Valley. Trevor recalls how stories unearthed during their research for *Mamu* ultimately contributed to that effort.

> This research that Scott and I became part of helped show people's historic presence on the land. Their stories really spoke about the place where they lived. And all those stories and paintings and dances helped them win title to the land. They were the record. I think this was the largest native title claim and only the second that was successful. But, there's much more to be claimed and the people up there are still fighting for their land.

Knot @ Home

Despite his success with *Mamu*, Trevor still had to scramble to make a living as a performer. Few significant parts were available for Aboriginal actors in the big city theaters. Much of the available work involved quasi-traditional Aboriginal performances presented out of context with characters that verged on stereotype. Because of his striking good looks and powerful stage presence, Trevor was regularly called for these types of roles. While he was not adverse to the work, he was much more interested in the stories and themes he had begun to explore in *Mamu*. In his periodic encounters with Scott, he found they were of a similar mind. They agreed to keep in touch and see what opportunities arose. Scott describes his own motivation and what happened next.

> My interest was still there in the amazingly diverse story we had in the material that was collected (for *Mamu*). Trevor and I continued our friendship and sort of sporadically kept our interest going.
>
> Eventually, I took the Afghan story through-line and Trevor's family through-line, the things that didn't play out in *Mamu*, and put them in one episode of what became an eight-part (documentary) TV series for Australia's SBS Television around the theme of being, "not at home."

Trevor's family displaced and not at home in the country. The Afghan cameleers who laid out the railways and the telegraph lines which connected Australia in the early twentieth century not home in the desert near Woomera. And then Woomera, which is not far from Trevor's country, being a detention center for refugees (Afghani and others) who were certainly not at home. It was during a 2003 presentation of *Knot @ Home* that Alex and I met. Alex came in to assist us when we were all going insane on this project.

Alex, Scott and Trevor

Born in 1979, Alex Kelly grew up in what she calls a "social activist" family. She cut her teeth as a community organizer as a teen through involvement in a variety of political and environmental campaigns. At age nineteen, Alex joined environmentalists who were working to support the Mirarr Gundjeihmi Aboriginal people in their effort to block uranium mining at a place called Jabiluka. That campaign, which was ultimately successful, is now recognized as a watershed of the "black and green alliance" that continues to fight for traditional land rights and environmental protection in Australia. It also provided Alex with what she describes as a "formative" lesson.

Director Scott Rankin thought Trevor Jaimison's story was more far reaching than the one told in The Career Highlights of the Mamu. *Photo © Beth Sometimes*

The big headline that came out after the Jabiluka blockade was "Interstate ferals go home!" It was very frustrating being at the blockade, being arrested and then generating all this media that had no reflection of what we were really trying to do. Later, I saw a documentary, by Pip Starr, who subsequently became a friend, that really reflected what Jabiluka was about. That was a revelatory moment.

After that, I got heavily involved in community media. … I was very interested in using community media to give people space to tell their own stories. It made sense—the more voices we hear in our community, the more diversity that we accept, the richer and stronger our world will be.

In June of 2003 Alex met Scott and landed a job as a production assistant on the *Knot @ Home* production in Melbourne. The year before, she had been heavily involved in a tumultuous campaign in support of a refugee hunger strike at Woomera (Woomera 2002).[5] While there, she had had a chance to observe Scott's work with the young people there. It had left a strong impression.

It clicked with me in a really simple, yet deep, way. For years I had been uneasy with the subcultural patterns that a lot of activism can have… (I was) concerned that there was too much internal conversation and not enough

engagement with the broader community. But I was impressed …with the conversations that Big hART was catalyzing—within the project teams and … with the audiences, then, again, through the media and … with policy engagement. I was … inspired by the use of the arts as a tool for storytelling and social change. The Big hART belief that "If you know someone's story it's harder to hurt them" really struck me.

In January of 2004, Alex moved to a desert outpost called Coober Pedy to work on an antinuclear campaign with Kupa Piti Kungka Tjuta, which means "the senior Aboriginal women from Coober Pedy." These women, all in their seventies and eighties, were campaigning to stop a nuclear waste dump from being established on their land.[6] They were also a part of the Maralinga nuclear Diaspora. Given their history, they were very determined not to get burned, literally, a second time. They called their campaign, *Irati Wanti* (The Poison, Leave It). Living and working with these women, Alex gradually came to learn how difficult it had been for them to step into the political arena.

In Anangu culture, grave events are often treated with silence out of respect and out of a shame for how horrible they were. So these women had never really talked about Maralinga. They had never talked about the fact that they got sick or had to bury their parents. Not a word about their deformed children or that they were unable to give birth. They had never talked about how their grandchildren had deformities. They were silent about the terrible legacy of the bombs. But as soon as they heard about the proposal for the dump, with the same poison, they called on Greenies to come and support them in their campaign.

As time passed, Alex also learned about some of the other underlying issues affecting the town. Coober Pedy, known as the opal capital of the world, is a desert town of 3000, seven hundred miles north of Adelaide. In the 1990s, the collapse of the opal market had hit the town hard. Given this, Alex was not surprised to find the young people in the town both disaffected and running amok. This led her to think that it might be worthwhile talking to Big hART about doing some work there.

I give you something, you give me something.

In February of 2004 Alex made her way south to Adelaide where Scott was working on a show. After hearing about the *Irati Wati* campaign and the difficulties being faced by the town, he suggested she meet Trevor. Some months later, the three met in Wagga Wagga, near Australia's capitol, Canberra. Over the course of that conversation, it became clear that "Pedy's old ladies" had direct links to the stories that Trevor and Scott had been exploring together over the previous two years. In fact, it turned out that some of the Kupa Piti Kungka Tjuta were Trevor's grandmothers (great aunts). Over the course of the evening, they talked

about Trevor's story and their experiences with *Mamu* and *Knot @ Home*. This led to some brainstorming about how this complex amalgam of venerated stories could become more than just an improved version of the *Mamu* stage show. How, they mused, could they engage audiences in a new way that bridged an age old cultural divide? Scott relates how their meandering conversation led to an intriguing answer.

> So we talked about Trevor's stuff, the *Knot @ Home* stuff, the Afghan stuff, the waste dump stuff and how it all came together. And then we said, what if we made a show and required an audience to learn Pitjantjatjara before they saw it? So you create a new kind of revered moment—a moment of importance beyond mere entertainment. A moment that is the opposite of the place that Australian indigenous theatre has occupied. We were going to put the audience on its back foot and give them some tools to get into this other world. We would use language learning as another way of exploring Pitjantjatjara reality. This was one of those times when you go, "yeah, this is good." It was a really potent young seed that was ready to grow. And from that moment, we were working on it.

From that point on Scott, Trevor and Alex started operating as a team. The first thing on Scott's agenda was to pass the idea by potential supporters. Number one on their list was Robyn Archer, the former Director of the Melbourne International Festival. She responded enthusiastically, remarking that it was "the biggest ask of an audience I've ever heard of." She also helped pitch the idea to her peers in the Australian festival community, which provides the lion's share of support for new work in the country.

As they began to consider the details of the language course, they confronted some daunting questions. How do you teach such a course? And who should teach it? Drawing on Big hART's model of community engagement, they concluded that it was possible that the least likely candidates could be the best. Scott elaborates:

> We thought, what if you got the most marginalized young people, with literacy problems and everything—kids who had few skills, but who could very quickly pick up the visual literacy skills... the digital thing... and go for it. What if they were the teachers through video online? And what if they were supported by and connected to their elders—a connection that has been falling apart, that we could help strengthen. But, the foundation for all this was still going to be Trevor's ability to use the language to take you into his story.

10:00 PM, October, 2006, Melbourne International Arts Festival
A pale blue light isolates Trevor at center stage. This is the day his grandfather, Tjamu Jack, returns home from prison. It is, of course, a good thing that he is back with the (walytja) *family, but also, hard to be reminded of why he had*

been away, so long. It's hard for Jack too. The changes he sees all around him, "everything gone"...'"old people, sleeping in parks," (maniku patani) waiting for handouts. Trevor's tall frame seems to shrink and wither as his grandfather's spirit inhabits his body. Jack asks to return, "one last time" to the old home place at Cundalee. The ominously fateful request is upsetting, but they go. In a stac-cato mix of Pitjantjatjara and English Trevor describes the strange homecoming.

"Took him back, one last time, to see Cundalee. That night we (ngura tjunu) camped there, and we (ngamu ngaringu) slept real close (ngura mamutjara). Cundalee was haunted. Heard stones, thrown on the tin roof of the tumble down mission. Stayed close to Tjamu Jack... (wati rawa witulyangka) powerful man still. Through the trees, (waru tjuta kampanyi) campfires burning, no one there, stayed in close.

"In the morning we wake, cold. Tjamu Jack was gone... Found him standing at the (kuri palumpa kurultjunkulala) foot of the grave of his wife, by the gate, at Cundalee. He knew he (wiyaringu) was finished. Word gets around. He's out of prison... Her people coming, payback, Ngapartji, (walpangka ananyi palunya ngurintjikitja) travelling on the wind to find him... He knew, he'd never see the red manta (lands) of his homelands, his ngura where he'd rescued the walytja from the Cold War. He knew then, all the (yangupala tjuta ananyi) young people were drifting. The (tjukurpa irititjaku ngurparingu) old ways forgotten, feeling shame speaking Pitjantjatjara... not speaking Pitjantjatjara, wondered why he'd bothered bringing the walytja out."

Trevor bows his head as a low harmony rises up from the choir deep in the shadows. Slowly, almost imperceptibly the hymn, "Old Rugged Cross" fills the theatre. When the song begins to fade, Trevor looks up.

"Few months later (palunya kurultjunu). Buried him on top of his wife, my grandmother, the woman he killed, by the gates at Cundalee."

Ngapartji Ngapartji

Ngapartji Ngapartji is a Pitjantjatjara expression that has many meanings. It can mean "square," "square" or "same same." It also means "I give you something, you give me something." —*Trevor Jameson*

According to the 2005 National Indigenous Languages Survey, the situa-tion of Australia's indigenous languages is "very grave and requires urgent action" and Australia has been identified as the place with the most rapid and widespread loss of indigenous languages anywhere in the world over the last one hundred years.

Let's change the story together! —From the Introduction to the
Ninti Ngapartji language learning web site.

As 2004 came to a close, Scott, Trevor and Alex were eager to begin what they felt was going to be a long and exciting journey. As they conceived it, the project would have three distinct, but interlocking, elements.

267

- Capacity building with and reengagement of marginalized young people working closely with Pitjantjatjara elders and linguists;
- development of an online Pitjantjatjara course;
- and the production of "an internationally touring cross-cultural performance work.

The "big idea" for the performance was to get audience members to actually study and be familiar with the Pitjantjatjara vocabulary incorporated in the script. Selling tickets for live theater is always a challenge, but building a "bilingual" audience from scratch is another matter all together. To make this happen the team decided that they would tour a short, introductory version of the show to recruit audience members into the project. The full, bilingual production would then be presented many months later after audience members had gained some language proficiency through the on-line language course.[7]

The first operational question the team faced was where to base their work. Given Alex's contacts there, Coober Pedy seemed like a logical choice, but it soon became clear that the community lacked the linguistic expertise and networks that would be needed to support both the language course and script development. The nearest place with those resources was Mparntwe (Alice Springs) in Arrernte Country.

In January of 2005, Alex moved to "Alice," and started to work. One of her first tasks was to build the team of artists, language experts, and community activists who would guide the project over the coming months and years. Lorna Wilson, a Pitjantjatjara descendent and language expert was an early recruit. She became a principal language teacher and advisor to the project. When singer and teacher Pantjiti McKenzie signed on, her reputation as a Ngangkari (healer) and community television pioneer not only added needed media expertise, but also provided a large dose of credibility. Artists like Suzy Bates (Batsey) and Adam Fenderson came with specific technical skills in video production and web design. Over the spring, the project grew rapidly. Many of the more than 40 artistic and support roles ended up being filled by locals. The largest contingent was the indigenous artists and students whose creativity and everyday life experiences formed the language lesson content of the *Ninti Ngapartji* web site which was launched in April of 2006. *Ninti* means to know, to be competent at, to be able to do, to be experienced with.

Then, in October of 2005, the introductory version of the production premiered at the 2005 Melbourne International Arts Festival to critical acclaim and sold-out houses. Although each performance of the show differed somewhat, the reaction was the same—audiences were enthralled, and wanted more. And many were delighted to find out that much "more" was readily available at www.ninti.ngapartji.org.

Given the complex, process-intensive nature of the project, it occurred to the *Ngapartji Ngapartji* team that the web site they were building should be a window into *Ngapartji Ngapartji*'s own creation story. As such, they decided to produce an

Pitjantjatjara language expert Lorna Wilson works with Ninti Ngapartji staffers (sitting on floor) Left to right: Lorna Wilson, Thomas Holder, Suzy Bates (scribing) and Dani Powell as they map out a new online lesson. Photo © Alex Kelly

online journal to give site visitors a running account of life in the Pitjantjatjara community and the multi-faceted work involved in creating *Ninti Ngapartji*. The following journal excerpts cover the period from the spring of 2006, to presentation of the full *Ngapartji Ngapartji* production at the 2006 Melbourne International Arts Festival twelve months later. The "launch" described in the first entry refers to the April 2006 launch of the "Ninti" online language and culture site.

Friday, 28 April 2006 It's been a busy week up here in the Ngapartji Ngapartji office in Alice with Alex and Stacey back from the (website) launch in Melbourne, bringing Trevor back with them, and all of us sitting down together for the first time in our new office. Just so you know, by "office" we mean a "demountable" (small mobile home) in the grounds of the Institute of Aboriginal Development (IAD)… The biggest news after the launch, of course, is that the first lesson is up! …Meanwhile, it started raining last night after Pitjantjatjara class with the lovely Lorna Wilson. …We don't have a flowing river yet, but there's a sense of change and loveliness about with the colour of the ranges coming up purple and blue and puddles all about.

Monday, 08 May 2006 Tom's been getting the second lesson up and continuing to talk with the old people, such as Simon McKenzie and Lena Taylor, about their lives and experiences, particularly in relation to what the "ngangkari" way means to them. This weekend he's heading down to Coober Pedy to do some recordings with two famous ngangkari men (traditional doctors)…

Monday, 15 May 2006 Stacey's been buying carpet, hiring scaffolding, booking flights and accommodation for 25 people, negotiating with Japanese performers, booking Afghani musicians and working out how to fit the Ernabella choir onstage, running production meetings, riding her bike through the Todd mall late at night, enjoying the shades of purple only to be seen in the desert… and Tom, having recovered from acquiring two flat tyres and a fuel leakage driving to and from Coober Pedy last weekend, has been busy with lesson production as well as translating old people's stories as well as songs from the script into Pitjantjatjara.

Friday, 02 June 2006 Wai palya? Nyura pukulpa? Palya nyura nintir-inganyi? Palya nyura kulini? Nganana mukuringanyi nyura ngananala tjakultjunkunytjaku. Ngulala wangkanyi nyurala. Palya.

Hey, how are you going? Are you all happy? Are you all learning well? Are you learning and understanding well? We would love for you all to tell us how you're all going. We'll talk with you all again soon. Palya.

Monday, 19 June 2006 Apologies that time has stood still on the website for the past 2 weeks as we've been swept up in the Alice production of Ngapartji Ngapartji ……! The response has really been incredible with descriptions like "outstanding," "brilliant," "breath-taking," "powerful," "deadly" and "palya" repeating themselves on the forms, along with sentiments like "it would be good if everyone in this country could see this" only to be outdone by "the world needs to see this!"

It can be a strange feeling coming down after the intensity of a show. We've needed to sing the songs from the show a few more times as we … sit down together and laugh about the things that didn't quite go as we'd imagined and acknowledge the things that blew us all away, like Julie walking across the stage to help tell the story of Trevor's grandmother heading to new hunting grounds, and Iris doing "sexy dancing" (as we call it here) on cue.

Friday, 14 July 2006 … Davo and Batesy and Tom have been making heaps of videos with young people, Trevor and the ladies, the contents of which will be included in future lessons.

We all went out east on my first day back for a picnic… The theme of the day was "walytja" (family)….We found a camp in an awesome riverbed, collected wood and started making small fires to cook the malu wipu (kangaroo tail). We sat in small groups and talked, we played football in the river, we took photos and Batesy and Davo filmed stories. We ate a lot. Kids ran up tree trunks and back flipped into the sand. I went walking with the little kids thinking I had a team of wood collectors only to find they were looking for the honey-like substance in the trees which the elders enjoy as it comes but the younger people scrape off and dip in sugar to chew. We got home late and happily exhausted.

*Three young filmmakers from Pukatja (Ernabella) shoot a scene for new language lesson video under the tutelage of Suzy Bates.
Photo © Alex Kelly*

Tuesday, 22 August 2006 Damian and Stacey joined us on Saturday to start rehearsals with the ladies—Dora Haggie (Amani), Rhoda Tjitayi and Nami Kulyuru (which went on into the night on both Saturday and Sunday, interspersed with many cups of tea, malu wipu (kangaroo tails)... The women sounded awesome even with so much new material to go through and Sunday night Damian was able to record a CD for everyone to continue practising.

Monday, 04 September 2006 With four weeks to go before the first contingent of the Ngapartji Ngapartji cast takes off for Melbourne, there's a lot of preparations going on both in Alice and Pukatja (Ernabella). News from Pukatja is that rehearsals with the choir are going really well. Last week one of the songs apparently turned into a reggae number much to the amusement of Nami, Rhoda and Amanyi, who laughed imagining what everyone would say, seeing older women playing reggae!

Monday, 11 September 2006 I wish you could hear what's happening here as I write. ...the demountable is rocking with the Pitjantjatjara version of Bad Moon Rising (Kinara kura pakani) and lots of lively debate about translations and how to get all those wonderfully long Pitjantjatjara words into the original melody ...Last week Julie worked with Batesy to create the voice over for a video about cooking malu wipu (kangaroo tail). ...Generally we're all getting pretty excited about Melbourne. Three weeks to go!

Monday, 25 September 2006 With a week to go before the full company comes together, rehearsals are underway with key performers at the MTC

studios in Melbourne, young people in Alice Springs and singers and young musicians in Pukatja. Duncan, Mervin, Chriswell and a group of young women from Pukatja made a film clip for their new song, which apparently involves some very "tantalizing" dancing. Duncan and Beth also made a short film down in the creek with Amanyi talking about her experiences of the Maralinga bombings as a child and the circumstances surrounding the event.

Monday, 02 October 2006 We'll try to get the news to you when we're in Melbourne but can't make any promises as we'll be flat out with rehearsals. Hope you're all coming to see the show. We trust your steps to learning Pitjantjatjara and getting to know some of us through the Ninti site will make seeing the production a rich experience for you.

10:15 PM, October 12, 2006 Melbourne International Arts Festival
 Trevor rises into the spotlight illuminating the monolith, which by now nearly everybody realizes is a map of the Spinifex country. He speaks of birth and death and sacred spaces.
 "Before birth your spirit shimmers across the manta *(land) searching for your unborn body to rest in. This is* tjarrinpa. *Tjarrinpa gives you a certain* tjukurrpa. *Tjukurrpa gives you certain responsibilities to look after your* ngura *And so, you were born."*
 Now, Trevor climbs down the face of the map onto the sand below. He holds a white shard in his hand. As he gently places the shard into the soil he says, "And when your mother first lets you touch the earth, you have a very special responsibility to look after it. Now your mother is strong, and you're still tiny, and she may walk a long distance away from your birthplace. But then, it's more responsibility, for all the land in-between is yours."
 As he speaks, members of his family bring shard-filled bowls to the base of the map and begin escorting members of the audience onto the stage. They all start placing shards on the map and sand while the narration continues. "It could be a water hole, a sand dune, or a rock. And tjukurrpa *won't let you forget your duties for your land. Tjukurrpa is real. Now, if you can't be where you belong, you'll fret deep within. And if you can't look after your* ngura *it will suffer."*
 The stage is filling. After stepping forward to make room, Trevor goes on.
 "You also have your Walytj, *big family! You have the places your Dad was responsible for—your Mama's* ngura, ngura panya palumpa ngura walytja *(the country to which he belongs). More* atunymananyi *(responsibilities). And your* Ngunytju *and her* Ngura, *you have to look after these too. And then there's your* malanypa *(brothers) and* kangkuru *(sisters). You have to look after* tjanampa ngura *(their places)... And then... you get* altiku *(married),* piruku *(more) to look after!*
 Smiling, Trevor adds, "You wonder why we never get a job—It's because we are always looking after country." When the laughter settles he looks thoughtfully at the transformed map.

The stage begins to fill with members of Trevor's Walytj (family). (Left to Right) Sadie Richards, Lorna Wilson, Najeeba Azimi, Saira Luther (at back), Rhoda Tjitayi, Trevor Jamieson (at back), and Pantjiti McKenzie. Photo © Jeff Busby

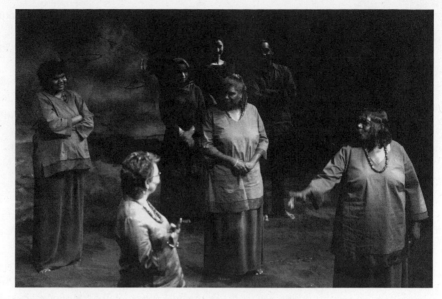

"Its funny isn't it. For tonight, I wanted to make a film about my brother Jarmen and now we've got all this."

The lights dim and Jarmen appears again on video with his kids, laughing and playing. The choir's voices rise as the video fades. Although the song is in Pitjantjatjara the melody to Bob Dylan's "I Shall Be Released" is familiar to many. Trevor sings in English as his walytja gathers round.

They say every man needs protection
They say every man must fall
I swear I see my reflection
Somewhere high above this wall
I see my light come shining
From the west down to the east
Any day now, any day now
I shall be released.

Post Script

Saturday, 21 October 2006 Apologies for the absence of news these past two weeks - it's been a busy but amazing time with so many of us down in Melbourne working and living together, with each day revealing something new. Night after night audiences have been moved to standing ovation, which has been incredibly gratifying for the ensemble cast, some of whom were performing on a stage of this scale for the first time

30th November 2006 Ngapartji Ngapartji kunpungku kanyintjaku anangu tjutangku. Yangapala tjuta nintiringkuntjaku malatja malatja, nganampa pakali tjuta munu puliri tjuta kunpungku wirura kanyintjaku Ngapartji Ngapartji pulkaringkuntjaku.

People want to keep Ngapartji Ngapartji going strong. It is so that our young people, the ones that come after us, can learn to look after our grandsons and granddaughters properly, effectively—that's why we want Ngapartji Ngapartji to grow bigger.

Munula kulini, nganampa pakali tjuta wirura nintiringkuntjaku pitula wantira problem kutjupa kutjupa tjutangka ngaranytja wiya. Nintiringkula kunpu ngarantjaku.

And we're thinking that it would be great for our grandsons to learn in a good way [like this] and so leave aside the petrol [sniffing] and stop being involved in the various other [anti-social] problems. [We want them] to learn and grow strong and disciplined.

Iritiya picture wiyangka nyinanyi palu kuwarila ngangana cameratjara ka nganana mukuringanyi warka nyangaku palyantjikitja. Pulkarala mukuringanyi warka nyangaku. Kulinmalanya! Mulamulangkula nyuntula tjapini. Anangu tjuta mukuringanyi Ngapartji Ngapartjinya pulkaring-kunytjaku. Nganana wantinytja wiya warka nyanga palunya.

Long ago we lived without pictures but now we have cameras and we want to do this work. We are really wanting to do this work. Please hear us! We are sincerely asking you. People want Ngapartji Ngapartji to grow. We don't want to finish with this work. —Pantjiti McKenzie

Singing in the Dark

Serbia

Angels in the Square

In my language "Dah" means breath, spirit and movement of the air. For us in my theatre, it also means to gather strength, to persevere, to be spiritual and to create. If one reads it backwards, it becomes "Had or Hades", the underworld in Greek mythology.　　　—Dijana Milosevic

This Babylonian Confusion

Beograd, Yugoslavia, July 20, 1992. The afternoon is steamy. The hot concrete on the Trg Republike (Square of the Republic) is thick with workers intent on the journey home. Dijana and Jadranka shuffle back and forth in the art gallery on the edge of the square watching the rushing river of people through the windows. Arms crossed, staring out into the square, they try not to look like novice theater directors waiting for their first curtain. But this is impossible. There is no curtain and they are literally sweating with worry—worry and fear. What did they think they were doing? Years of training for the stage, only to debut here on the street in the middle of rush hour—bearing witness to an epidemic of not knowing, speaking words that have been disappeared, forgotten?

They had all agreed, this performance was unavoidable. This war that "does not exist" is destroying their country. The Bosnian, Serbia and Croatian men who are "not" being pulled from their beds in the middle of the night, never to return, can no longer be ignored. The cries of children who are "not" being cleansed from the cradle of their homelands must be heard. The mothers with "no" tears can not remain invisible. In this interminable year of these things "not" happening the noxious cloud of denial has obscured the Serbian sun. Someone must speak.

It is time. The actors shed the coats that cover their black costumes and golden wings. One by one they begin the action, first in the gallery, and then, stepping purposefully into the square. Solo journeys merge and break apart, then merge again. The surging crowd changes course to avoid the black forms moving against and across the flow. A few slow, glancing haltingly at the incongruous wings springing back and forth on the crude harnesses attached

to the actor's backs. Slowly, one of the actors, Maja Mitic, begins singing the lyrics culled from Bertold Brecht's anti-war songs.

> "In the dark times, will there be singing in the dark times?
> Yes, there will be singing about the dark times." [1]

The sun's last golden glow mingles with the glint of street lights. Jadranka holds her breath as the angels maintain their circuitous journey across the square to the empty fountain at the center. The singing continues.

> "When evil doing comes like falling rain, nobody calls out stop!
> When crimes begin to pile up they become invisible.
> When sufferings become unendurable the cries are no longer heard.
> The cries, too, fall like rain in the summer." [2]

The actors move more intensely, trading lines that ring out across the square. Though Brecht's lyrics are sixty years removed, they are shocking to hear.

> "When the leaders speak of peace
> The common folk know
> That war is coming.
> When the leaders curse war
> The mobilization order is already written out." [3]

There is no mistaking what is being said here. This romance of blood and soil is an obscenity. With each passing line, the ugliness of the war is materializing in the Square. And now, as more people stop and cluster, the congregation of angels is accorded the space they need to complete their mission.

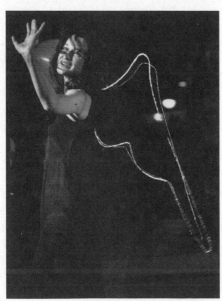

"Yes, there will be singing about the dark times." DAH "angel" Maja Mitic performs in This Babylon Confusion *Photo by Goran Basaric, © DAH Teatar*

Dijana scans the crowd. There are people in suits, mothers and children, students with their book bags and, yes, men in uniforms. Slowly it dawns on her that there are soldiers everywhere, watching the action, glancing nervously at each other, cradling their weapons. She feels like an acrophobic on the edge of a cliff, anticipating the gust of wind that will tip the balance one way or the other. She is both exhilarated and terrified by the danger of the moment and what she is sure will be its premature conclusion. But as the actors continue, nobody moves. They are all listening.

The Road to Babylon

DIJANA MILOCEVIC had always been interested in theater. As a child, she was constantly making up stories, inventing characters and appearing in school plays. Yet, in 1978, when she entered the University of Belgrade as a seventeen year old, her practical side led her to a program in special psychology, which, upon completion, would prepare her for work with people with disabilities. During her time at Belgrade University, she also spent time at Belgrade's Academy of Dramatic Arts. While she enjoyed her studies, she discovered these forays into the world of theater aroused her imagination in ways that academic life did not. Her interest in human nature and in serving the greater good had led her to psychology, but she saw that theater also had an important mission—one that could "bring people together and heal and pose important questions." For her, the fit was inescapable. As graduation neared, she recognized that the fulfillment of her own potential would be tied to a future in the theater.

Soon after receiving her degree in psychology Dijana entered the theater directors' program at the Academy. Like many Eastern European schools of theater, the dominant influence there was the work of Konstantin Stanislavski, the Russian director and acting teacher whose work had become the basis of the "method acting" techniques taught by Lee Strassberg and used by many actors and acting teachers in the United States. The "Stanislavski system" required actors to research scripted situations so that their responses on stage were based on both their character's motivations and their own experiences. Ideally, the actor's motivations would meld with those of the character in the script producing a more genuine performance.

Dijana excelled in her classes but her critical nature led her to question the orthodox nature of the training she was receiving. Why, she wondered, was this approach considered the only way to make theater? In many ways, she felt that this lack of critical exploration violated Stanislavski's insistence on thorough research as basic to effective acting and theater. This concern was further reinforced by the fact that the only opportunities for directorial work after graduation were with state run theaters, operated by Academy graduates who only supported directors working in the same tradition.

Few of Dijana's fellow students shared her concerns. For most, it was reassuring that the Academy was the only path to a career in the theater. Eventually, though, a few other contrarians began to surface. One was a directorial student named Jadranka Andjelic, who, like Dijana, was interested in a theater that was more than just entertainment.

As a young girl, Jadranka had been attracted to the arts, especially painting and drawing. Coming of age in the late 1970s and early 1980s in Belgrade's relatively permissive cultural environment had exposed her to a vital mix of artistic influences from both East and West. A production of *Oedipus Rex* left an especially strong impression on her. She vividly recalls a scene where "red

flowers flowed from the king's eyes after he blinded himself." As she matured, the sculptural and kinetic qualities of the human form embodied in both dance and the martial arts also drew her interest, as did the abstract character of contemporary theater, particularly the work of Samuel Beckett.

In 1984, after two years studying world literature at Belgrade University, Jadranka entered the Drama Academy to study directing. Like Dijana, she found herself disappointed by the stodgy nature of the curriculum. She had expected a more open environment and struggled to keep from becoming disillusioned. She was relieved, though, to have found a kindred spirit in Dijana.

Their mutual interest in exploring different approaches to making theater forged a strong bond between Dijana and Jadranka. It also provoked a journey to Holstebro, Denmark, in 1986, to visit Odin Theater. Odin had been established in 1964 by Eugenio Barba, a student and colleague of Jerzy Grotowski, the director and theatrical theorist who is considered by many to be the father of modern theater. Grotowski's Polish Laboratory Theatre, which he established in 1959, advanced the concept of a "poor theatre," functioning "without make-up, without autonomic costume and scenography, without a separate performance area (stage), without lighting and sound effects, etc."[4] In this kind of stripped down environment both Grotowski and Barba felt it was possible to establish a sacred connection between actor and audience. It was through this relationship, they felt that audience members could transcend spectatorship and become participants in a transformational event.

During their three-week stay in Holstebro the classmates encountered what Dijana has characterized as "the true creative potential of theater." A potential she had imagined but did not know actually existed. "I felt, This is it! In Belgrade, at the Academy, every production, every collaboration was a temporary thing. Odin was a community, a family dedicated to creating a truly transformational theater."

Jadranka, too, was inspired. "Their dedication and discipline was amazing. The idea of a group working together over a long period of time, in a carefully organized and designed theatre space, was exciting. Their abstract, kaleidoscopic performances impressed me like nothing else before. The performance of *Oxyrincus Evangeliet*[5] introduced me to a new model of theatre that I wanted to follow and learn more about."

Dijana points to seeing *Oxyrincus* "as one of the most important points in my life. It pushed me towards this way of working and devoting myself to theater for life. But at the time I had no idea how they made this play, how they worked and the structure of it all. I knew I would have to come back to actually understand the craft behind the work."

In the months after their return to Belgrade, Dijana and Jadranka continued their studies. Dijana also began accepting invitations to direct in some of the city's mainstream theaters. While her productions met with considerable success she became increasingly dissatisfied with the temporal nature of the work. "I would start to get along with actors and really to go very deep into the creative

A scene from Odin's Anabasis, *a production which typifies the Odin Teatret's unique use of the urban environment as a theatrical space. Photo by Tony D'Urso, courtesy of Odin Teatret & CTLS Archives.*

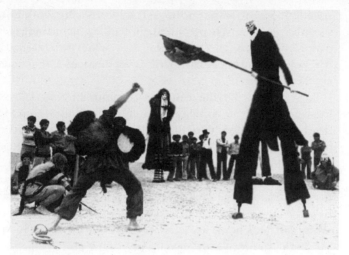

process. But, in no time, we would have to interrupt all that and push for quick results and the performance. And then I would go to another group theater and have to start over again."

Recognizing more and more that she was not cut out for a career in Yugoslavian institutional theater, Dijana returned to Holstebro in 1989 to assist Barba in the final stages of a new production called *Talabot*. During this time she immersed herself in the company's processes and techniques. Barba's approach maintained many of Grotowski's underlying principals. He, too, felt that the actor, using little more than the physical gifts of voice and body, could make even the most unadorned space sacred and transformative. Like Grotowski, Barba saw the audience/actor relationship as essential to the creation of performances that moved beyond entertainment to understanding and learning. What most impressed Dijana, though, was his insistence that the integrity of the work did not arise from the company's adherence to particular techniques but rather from their relationship with the community outside the rehearsal hall. What defined a company practicing what Barba called the "third theater" was artists responding to their real world environments.

Taking this to heart, Dijana tried to conceive of such a situation back in Belgrade. But this seemed impossible in conservative Yugoslavia which had no tradition of support for alternative or experimental theater. When she described her frustration to Barba, he gently chastised her for her lack of imagination. She recalls that the simple truth of his admonition provoked a significant shift in her sense of herself and her future. "He said, 'You know, if you really believe that it's impossible then you will just keep the impossibility'. From that point on, I began to think differently about creating a company."

That summer Jadranka and Dijana went to work with a small theater company on the Croatian island of Sipan. Working summer productions gave them needed experience and an opportunity to enjoy the beautiful Croatian

coast during the warm months. They found the work both rigorous and stimulating. They were perplexed, though, by their strange reception by local officials, who insisted on searching them when they reached the island. Both had visited this part of their country over the years and had never encountered anything like it.

Near the end of the season, their confusion gave way to fear when some locals accosted them, cursing and yelling for them to go back to Serbia. As stones began to fly they concluded that their summer vacation had come to an unceremonious end. In shock, they bid their colleagues a hasty good-bye and made their way to the ferry-boat where they spent a sleepless night. The next morning, as the picturesque island faded on the horizon they agonized over what they had discovered about their country and themselves. They were appalled at the ethnic hatred their presence had provoked. Terrible things were afoot in Yugoslavia. Worse still, back home few knew, or cared.

In the spring of 1991, near the end of their final semester at the Academy, a professor, who was also an artistic director of a local theater ensemble, asked Dijana and Jadranka if they would be interested in directing a play together. Neither had ever considered co-directing, but both thought it was an interesting opportunity, so they agreed. Their work together went extremely well, and the production was favorably received by local critics. In the process, they also discovered that they had similar ideas about what they wanted to do after graduation. Inspired by their experience with Odin, they both wanted to work in a theater laboratory with a committed and permanent group of actors and directors. The freedom to take whatever time they felt was necessary for the development of original work was equally important. Given Belgrade's traditionalist theater environment and the volatile political environment, they also knew that could not happen without an extraordinary effort from both of them.

Despite their complete lack of resources and organizational experience, it seemed obvious to Dijana and Jadranka that the next logical move for their nascent partnership was to establish Belgrade's first independent theater company. They began searching for the "right actors." The process was intense. After a month of six-day-a-week working auditions a group of twenty actors and dancers was pared to four. And, as the summer of 1991 approached, they set to work. DAH Teatar was born.

A Legacy of Blood and Crime

That fall, as Dijana and Jadranka were beginning to work with their actors in a small rehearsal studio in Sarajevska Street in Belgrade, Yugoslavia was nearing a turning point in its relatively short history. After World War II, Josip Broz, the partisan leader who called himself Tito, had established a communist government in Yugoslavia. After a break with Stalin in 1948, his thirty-five years in power was characterized by a firm, and sometimes brutal hand, at home and

a "non-aligned" approach to foreign policy. Tito's independent approach to foreign affairs allowed for significant trade and scientific and cultural exchange with the West. He also promoted equilibrium among the nationalities contained within the Yugoslav borders by dispersing political power among the Federation's six republics.

Since Tito's death in 1980, the country had suffered from weak leadership and steady economic decline. Then, starting in 1987, the President of the Serbian Republic, Slobodan Milosevic, had become an increasingly dominant political force nationally. Milosevic's rapid rise had been propelled by his opportunistic championing of Serbian nationalists in the province of Kosovo who were protesting repression by the province's Albanian majority. Over the next few years, he used these events to position himself as the principal defender of Serb interests throughout the increasingly fractious state. Many Serbians saw him as the forceful reformer they needed to hold the country together.

In June of 1991, the province of Croatia, under the leadership of nationalist strongman Franjo Tudjman, declared its independence from Yugoslavia. Slovenia quickly followed suit and after a quick rebuff of the Yugoslavian armed forces, successfully seceded. As the summer of 1991 waned, Milosevic

The Vukovar water tower became a symbol of resistance during the three-month siege that killed 3,210 and wounded 17,393.
Photo Daniel Zollinger IV

decided that the situation had gone too far. He authorized the Yugoslav Army to take military action to defend Serb communities in Croatia from alleged Croat aggression. Milosevic also began providing clandestine support for paramilitary groups being formed in Serb-dominated towns in the southern region of Croatia. Very quickly, these "protective actions" became a full-fledged war, pitting a makeshift army of provincial police officers against the combined, but often undisciplined, forces of the Yugoslav army and Croatian Serb paramilitaries.

In November of 1991, the strategic town of Vukovar on the southeastern Croatian-Serb border fell to Serb forces after a three-month siege. In the aftermath of the battle, the town was "cleansed" of ethnic Croats. In what would become a pattern repeated time and time again over the next four years, over 300 civilian men detained by paramilitaries went missing. By early 1992, two thirds of Croatia was under the control of Serb forces. Responding to the widespread death and destruction, and the displacement of nearly a million people, the United Nations finally brokered a ceasefire and established a peacekeeping presence along the existing truce lines.

Incubation of Angels

For the six members of the newly formed DAH Teatar Company the latter half of 1991 was strangely surreal. The economy was in freefall and soldiers were mobilizing. Due to a lack of credible information and the volume and hyperbole of the rumors, it was very hard to tell what exactly was happening. But there was no doubt that Yugoslavia was careening towards civil war. All the while, the members of DAH were trying to build an alternative theater company.

They responded by putting all of their energy into their work. For their first production they began with a text by Serbian magical realist, Momcilo Nastasijevic, exploring Balkan myths and folktales. The directors and actors threw themselves into a 12-hour-a-day-six-day-a-week regimen using techniques and exercises adapted from the Odin repertoire. The process was slow. Everything was new and they were learning how to work with each other. But they were in no hurry. In fact, the mix of physical training, improvisation and personal narrative they were employing was purposefully deliberate. The measured pace allowed time for the patterns and themes emerging from movement and text to form the critical mass of DAH's first new work.

In the early spring of 1992, the brief respite from Balkan bloodletting brought about by UN intervention in Croatia began to disintegrate. Talks between Bosnian President Alija Izetbegovic and Bosnian Serb leader Radovan Karadzic aimed at avoiding a military clash in the Republic of Bosnia-Herzegovina broke down. A few months earlier, the multiethnic republic, where Catholic Croats, Orthodox Serbs, and Muslim Slavs lived side by side, had passed a referendum for independence. Unfortunately, after Bosnian Serb communities who disagreed with the outcome requested Serbian protection, Slobodan Milosevic responded by once again surreptitiously sending arms and paramilitaries to support them. In a clever move aimed at avoiding direct involvement in the conflict, he also transferred a contingent of 80,000 Bosnian Serbs from the Yugoslav Army to the newly formed army of the self-proclaimed Bosnian Republika Srpska. This force, dubbed the Army of the Serbian Republic, would operate under the authority of General Ratko Mladic and Radovan Karadzic. By the end of April, this force had captured and ethnically cleansed three-quarters of the Republic and begun a deadly siege of its capitol, Sarajevo.

As the war raged, reports of mass killings, forced dislocation and the systematic rape of women by Serb forces began surfacing. Trying to head off threatened UN sanctions Slobodan Milosevic began an intensive campaign of obfuscation and denial. In a BBC interview broadcast around the world he stated unequivocally that his government was "not supporting any military action in Bosnia." He also banned public discussion of the topic in the news media and the street.

This made for strange times in Belgrade where, despite the news blackout, evidence of the conflict was unavoidable. Jadranka recalls the bizarre incongruence of the situation. "Young men in uniform were on every street corner. Nearly everybody knew someone who had been conscripted or wounded or

killed. Worse still, we had friends and colleagues in Bosnia in the war zone a few hours away that were being attacked by our government, yet we were supposed to pretend that nothing was happening."

The growing horror of the war had a particularly strong impact on what was going on daily in DAH's rented studio. "What," they wondered, "was the sense of theater when there is so much suffering?" Given the bizarre theater of denial taking place on Belgrade's streets, "how could art change anything?" Dijana recalls the twists and turns of what became a pivotal conversation in the company's short history.

> We were scared. We were in horror. We were sad. We questioned whether the theater we were committing our lives to had a place in this nightmare. We questioned the project we had been developing. We questioned whether we had a right to work everyday in our theater room while people were being killed by our government so near? Confronting all this, I think, totally made us the theater group that we are today. In the end, we decided that we needed to make something that was more direct as a response to what was going on around us.

Zoran Lazovic, a friend and dramaturge who had been working with the group, suggested they take a look at the work of legendary German playwright and lyricist Bertold Brecht. In the years leading up to World War II, Brecht, an ardent communist and anti-fascist, had penned many poems and songs protesting the nationalist fervor gripping his country. When Dijana and Jadranka began to review the dozens of pieces Brecht had written about what he dubbed "the dark times," they were amazed. "It felt as if he was speaking directly to us as a contemporary."

With the impetus provided by this text they immediately got to work making a piece framed by the Brecht lines: "Will there be singing in the dark times? Yes there will be singing about the dark times."

The work that eventually became *This Babylonian Confusion* was in many ways a reversal of the path Jadranka and Dijana had set out on twelve months earlier. They had created the company with the intention of making nuanced non-political art for small audiences interested in alternative theater. But to truly confront the epidemic of denial that had infected Beograd, they knew that their anti-war message would have to be both unambiguous in intent and publicly presented. This meant that DAH's debut would have to be a street performance. This was a far cry from the safe, intimate presentations they had envisioned 12 months earlier.

From DAH's perspective, the premiere performance of *This Babylonian Confusion* on Republike Square on July of 1992 was a success. They had hoped to attract an audience and finish without being disrupted. They had accomplished this and more. Many people stayed for the full performance. Some had even approached them afterwards to thank them. In these moments, apprehension gave way to exhilaration. This was new territory for young artists reared on the

Angels Maja Mitic, Petar Rajkovic, Slobodan Bestic circle the square with song in This Babylon Confusion. *Photo by Goran Basaric courtesy DAH Teatar*

institutional stages of the Yugoslav theater establishment. In the flush of their achievement, they decided to continue with more performances.

The first run of *This Babylonian Confusion* closed, so to speak, after fifteen performances, all of which took place in the Belgrade streets during the summer of 1992.

By the time of their last performance, the play had been seen by thousands of citizens who had stumbled across it and stayed to see what was going on and, also, what might happen. Some had even become "regulars." The company knew that not everyone shared the anti-war sentiments expressed in the play, but throughout the run no one had given them any problems. Many saw this alone as a significant victory for free speech.

The audaciousness of their performance also put them in good stead with kindred spirits in the arts and academic communities. This was a great way to introduce Yugoslavia's first experimental theater company to its natural constituency. Many artists and writers who would later form the nucleus of Serbia's dissident arts movement coalesced around DAH's initial effort.

Not so obvious were the enemies the performance attracted. While they neither desired nor expected any support form the state sponsored theater world, *Confusion* made it impossible for anyone affiliated with the state to have anything to do with DAH. More disturbing were the threats and innuendos they received from anonymous sources. As these became more regular, they came to realize how lucky they had been to have completed the run unscathed.

During the time that DAH's angels had taken to the streets the intensity of both the military and political situations in the country increased considerably. The brutal siege of Sarajevo and the discovery of concentration camps

in Bosnia had turned world opinion squarely against the Serbs. In Belgrade, the imposition of UN sanctions was beginning to make life more difficult for most citizens. This, in turn, had provided new fodder for Milosevic's political adversaries. All of this had precipitated a new wave of arrests and the harassment of organizations perceived to be a threat to the state.

It was a very dangerous time to be speaking out in Belgrade. Yet, like the angels they had portrayed, they felt that they may have been blessed in some way. Dijana also believes that their naivety and idealism may have protected them.

> We were not aware of how dangerous it was. Day after day we performed in front of the Belgrade Cultural Center, a state institution. Hundreds of people surrounding us were pro-war. Down the street were people rallying in support of the war and playing nationalistic music. But somehow we were protected. If someone tried to react violently others would reach out to stop them. It was not agitprop—we used angels. We had focus and skill in the performance so that the actors were completely and totally involved in what they were doing. In the end we saw a need in our country for other voices. Most importantly, we felt very deeply that we could create change with theater.

CHAPTER 19

Darker Still

CONFIRMING SPLIT, LAST 2 REPUBLICS PROCLAIM A SMALL NEW YUGOSLAVIA.[1]
—*New York Times*, April 28, 1992

U.N. VOTES 13-0 FOR EMBARGO ON TRADE WITH YUGOSLAVIA; AIR TRAVEL AND OIL CURBED[2]
—*New York Times*, May 31, 1992

MILOSEVIC DENIES INVOLVEMENT OF BELGRADE IN WAR IN BOSNIA[3]
—*New York Times*, June 6, 1992

THE CLARITY OF PURPOSE that the members of DAH Teatar found in the aftermath of *This Babylonian Confusion* was in stark contrast to the growing chaos that had engulfed their country. In less than 18 months, what had looked like a stable, multi-ethnic federation of six republics, had become a fragmented war-ravaged region torn by ethnic hatreds, nationalist fervor and economic decline. And, there was no end in sight. The bloody siege of the Bosnian capitol, Sarajevo, had degenerated into a chronic hell of civilian slaughter, a terrible symbol of the war's obdurate and deepening inhumanity.

In Belgrade, political intrigue and betrayal were the order of the day. There, too, heroes were in short supply. In the polluted swirl of rumor, propaganda and deceit, passions raged and, for the most part, ruled. Information, truth and debate were all casualties. For those who dared to speak, repression and reprisals came in many forms: lost jobs, pressure on loved ones, subtle threats, and, the trump card, the seemingly capricious, but very real use of violence. Many were so disheartened and confused that they simply withdrew into cocoons of escape and denial—looking for respite from any reminder of their fragmented lives.

For many in Serbia, the worst symptom of their country's precipitous decline was the harsh impact of the sanctions. In May 1992, the UN had imposed a wide array of economic, trade and travel restrictions on the newly minted, and significantly diminished, Federal Republic of Yugoslavia. The intent had been to punish Serbian aggression and weaken its war resolve. Yet, with Milosevic still denying any involvement in what he consistently characterized as a local conflict, the likelihood of his bending to this kind of pressure seemed remote. To make matters worse, the shortages beginning to emerge on the street had created a robust black market. Dominated by Milosevic's cronies, this perverse marketplace had produced a glut of luxury items and a scarcity of essentials like insulin, antibiotics and petrol. DAH company member Maja Mitic remembers how quickly "the cost of basic items like bread, milk and meat become a problem. But the government didn't care because it only affected average citizens."

As time passed, the country's isolation began to have a deeper and more troubling effect. Restricted cultural and social contacts lead to intellectual and scientific isolation. The members of DAH understood how dangerous this was. As contact with the outside diminished, Dijana and the others could see how "being cut off from the rest of the world increased the power of disinformation and fearfulness in the streets." They knew that, as the country's isolation deepened, so to would the virulence and currency of Serbian nationalism. And, for Milosevic, this was according to script.

Surviving

THE PRODUCTION OF INSANITY

In the last few years official politics have, through institutions under its control, the state media above all, managed to enforce stereotypes which have become part of public opinion. These stereotypes include the following: Croats are genocidal, Muslims are suicidal, independent journalists and opposition leaders cooperate with foreign intelligence agencies, certain nations hate Serbs, the New Order, and the international conspiracy against Serbs. These stereotypes now have the authority of the Ten Commandments. Anyone who thinks, writes or acts outside their framework becomes a traitor, enemy of the people or a member of the "fifth column"...

—*Vreme*, April 11, 1994[4]

Access to the outside world was very important to the members of DAH. As artists, they needed input and critique from colleagues. More importantly, as creative dissidents, they needed access to accurate information and divergent ideas. Prior to the conflict, Belgrade had been a lively crossroads for Eastern and Western European artists and intellectuals. Now, the combined impact of the war, the embargo and the repressive regime had rendered the once cosmopolitan metropolis a city in exile from the world.

The effect was both stifling and dangerous. Belgrade was awash in government propaganda and rumor. Outsiders were distrusted. Leaving was particularly difficult. Ironically, this was not because of overly restrictive travel policies. The plain fact was that very few could afford to leave. The depressed economy had literally closed the borders for DAH and most of their fellow citizens. As the political situation worsened, actors and directors from other parts of the world were less likely to attempt a visit. DAH was, in essence, cut off from the outside world.

Beyond issues of isolation and repression, DAH and their counterparts in the state sponsored theaters were all struggling to keep going. Given their independent status, DAH might have been considered particularly vulnerable, but, as proponents of Grotowski's and Barba's notion of the "poor theater," the company was, in a sense, built for hard times. It wasn't just that they could do without all of the bells and whistles considered essential for mainstream theater—their aesthetic demanded it. Another of DAH's unlikely advantages was their marginal status. Their commitment to an autonomous, anti-Milosevic, anti-war enterprise had created a powerful bond within the small company. This, and their understanding that popular support would not be forthcoming, gave them the resilience and resourcefulness they needed to survive.

The company's adversarial profile had also helped them build a relationship that was critical to their survival. In 1994 a wealthy American financier named George Soros established a foundation aimed at supporting the development of open and democratic institutions throughout the world. As a former Hungarian refugee, he had a particular interest in fostering democratic reform in post-Soviet Eastern Europe. Soros's grants were typically made to both governmental and non-governmental organizations (NGOs) promoting "democratic governance, human rights, and economic, legal, and social reform."[5] In Yugoslavia, though, where the government was actively suppressing such efforts, Soros was forced to become more creative.

Anti-government graffiti was a regular feature of the Belgrade landscape during the Milosevic regime. Photo by Jelisaveta Mihajlovic

Early on, Soros had recognized that art and culture could be powerful tools for fighting the forces of nationalism in the Balkans. He was also aware of how effectively they had been used in Eastern Europe to manipulate public opinion and foment ethnic hatred, particularly in Yugoslavia. Though Soros saw groups like DAH as a powerful antidote to this kind of cultural poisoning, providing direct support to these already marginalized groups would make them even more vulnerable to government repression.[6] To avoid official scrutiny, Soros funneled money through the back door, so to speak, via intermediaries. This process was used to support DAH and other groups such as Radio B92, and the independent publication *Nasa Borba*.

The Soros funding was critical to the company's survival. First and foremost, it provided

the company members with the minimal resources they needed for food, clothing and transportation. Without it, they would have spent their days scrounging odd jobs or working the black market. Under these conditions, DAH Teatar would have been impossible; the work would have slowly suffocated. Soros's support also made them less vulnerable to the pressures to keep quiet or disappear.

Eventually, the foundation provided another vital lifeline—support for performances outside of the country. Soros-sponsored visits to Western Europe and the US gave their work a broader audience and fostered a much needed collaboration and exchange with colleagues. Given their meager resources, it also forced them to create theater that was not only "poor," but extremely portable. Jadrenka remembers how proud they were that they were able to "design sets and costumes that, along with our personal belongings, fit into the baggage they allowed on coach flights." According to Maja though, the most important aspect of touring was that "it allowed us to share the other, hidden story of our country—to expose the voices of opposition so people outside knew that people in Serbia were questioning and resisting the insanity infecting our land."

Ironically, their survival was also aided by the earlier actions of their principal adversary, Slobodan Milosevic. Early in his regime, when he was trying to solidify his tenuous grip on power, he passed a law that made it possible for long-time residents of state-owned housing to purchase their apartments at a very low cost. Many took him up on the offer, including the families of Dijana and Jadranka. This, and Serbia's cradle to grave state supported healthcare system, meant that shelter and healthcare would not be issues for DAH and many others in the city struggling to get by. As reassuring as this was, finding transportation or even getting food on the table were persistent problems. In these difficult circumstances, company members often turned to their network of family and friends and the continuing tradition of helping and sharing intrinsic to Balkan culture.

Sava

One result of the embargo was frequent and widespread power blackouts aimed at saving fuel. To minimize impact most blackouts were implemented in the evenings. While this was clearly the best practice for businesses, it crippled the city's performing arts venues. In this unpredictable environment, most of the state operated theaters and music halls found it impossible to book acts and rehearse, let alone attract audiences. Theaters began to shutter their doors. In an ironic twist, though, the state's dilemma became an extraordinary opportunity for DAH. Incredibly, in April of 1993, one of the managers of the largest state facilities that had gone dark, the Sava Center, offered space to DAH. Dijana describes how they responded.

> It was really a very hard time. We had no rehearsal space and people were leaving the group. When the invitation came from the Sava Center it was

a shock. This is our big art center, like Lincoln Center. Usually they would have nothing to do with a small group as ours. But, because of the situation they couldn't have an international program and they knew we were connected internationally. So, they asked us to try to make something happen. It was just a bizarre situation. They knew we were anti-war and anti-Milosevic. But they asked, and we took the opportunity.

We also decided to broaden our program. So we stopped being DAH Teatar and became the DAH Teatar Research Center. We invited people from all over. We held workshops, we organized festivals, we had our performances. One time, even Torgair Wethal came from Odin Theater to give his workshop. It was one of the worst times economically, like in Berlin in the thirties, where you needed a sock full of money to buy a newspaper. Anyway, he came in the middle of that madness thinking it would be very grim. And then suddenly we were in that big, huge, fantastic space with dozens of people. It was great.

All of the work we did there was very oppositional, so, we knew it would not last. But, it was vital for the artists and the people that we make the best of it. Most importantly, we wanted to create a safe space for the community to come together with the art. Many artists came from all over the world for little or no fees. They could see that it was important to be there, not because of Milosevic, but to touch the people who really longed for a hopeful connection. Many people, they told us it was the light in the darkness. This is literally true, because the electricity was so bad in the city people would be coming into the Sava out of complete darkness. But it also brightened their lives because, for the time they were there they were not so alone.

In early 1993, the momentum and enthusiasm generated at Sava Center gave birth to the Art Saves Life Festival. The festival, which was repeated in 1994, was designed to foster exchanges among Serbian and European independent, experimental theatre groups. Over the event's seven days, dozens of performances, workshops and seminars were presented on the Sava Center stages. For both DAH and their audiences the raising of troubling, if not forbidden, questions through the performances taking place on the state's stages was a beacon of sanity.

Jadranka saw the visits of performers from outside the country as particularly important at the time. "Communication with artists from all around the world broke the barriers of borders and prejudices and created the sense of love, artistic solidarity and human understanding that opposed the destruction and violence by our government and many others as well."

The magnet of the Sava Center also brought an important new member into the DAH family. In September of 1993, dancer Sanja Krsmanovic Tasic impulsively decided to spend her meager savings to attend a DAH workshop.

It was rigorous and demanding. It was also her first theater training experience. Within hours though, she felt she had found her artistic home. It had certainly been a circuitous route.

Sanja was not a typical dancer. From the moment she could walk, it had been obvious that she was meant to move. Like many little girls in Belgrade, she had started her instruction in a classical studio where she became a star pupil. Then, at the age of eight, her diplomat father was posted to India. In Delhi, the only serious instruction available had been in the Indian classical tradition. She had been attracted immediately to "the freedom in the beautiful precision of movement." Returning to Belgrade as a teen she had re-joined her contemporaries in the classical ballet studios, but found herself feeling out of place. Eventually, she had found a home studying with Smiljana Mandukic, the septuagenarian doyen of Yugoslavia's much maligned, and often repressed, modern dance movement. By the time of her encounter with DAH, her eclectic experiences had made her a truly modern dancer. Unfortunately, in conservative Belgrade, "modern" meant no work and no future. She was primed for something entirely new. The mix of form and freedom inherent in DAH's process fit her like a glove. She likens the feeling to "love at first sight." "I felt they were reading my mind. We all recognized it. It was just like when you feel that you know a person all your life and you just want to stay with them."

Both Sanja's arrival and the resources at Sava Center facility allowed DAH to expand their activities to include workshops, seminars and education work. Given the hard times in Belgrade, this was surprising. As a fringe operation with no official support, DAH should have withered and died, but, instead, the company was growing.

Creating

SHELL KILLS 66 AND WOUNDS 200 IN SARAJEVO MARKET— TOLL IS THE WORST IN 22 MONTHS OF ATTACKS; THE BOSNIAN SERB MILITIA DENIES THAT IT FIRED A DEADLY MORTAR ROUND.

—*New York Times,* February 6, 1994

It's the most important time to create things when things are being destroyed.
—Sanja

DAH's process for creating new work had continued to evolve during the development of their first three productions. *The Gifts of Our Ancestors,* the work they had been developing when they jumped into *This Babylonian Confusion,* was eventually presented in September of 1992. Based on the writings of

Serbian magical realist Momcilo Nastasijevic, the piece combined a structure of scripted movement with an improvised text.

Their next piece, *Zenit* (Zenith), was inspired by the lives and work of Serbian writer Ljubomir Micic and a group of Yugoslavian avant-garde artists from the 1920s who espoused a uniquely Balkan aesthetic. Zenitism, as it was called, proposed a rejuvenation of Europe by the "Barbarian" Slavs, whose fresh approach to art and new ideas would regenerate the dissipated hulk of a civilization ravaged by the First World War. The movement's fire, fueled by enormous creativity and optimism, raged for a few short years, but died precipitously as key members succumbed to addiction and suicide. DAH's *Zenit* was prompted by their own deep questioning of their role as artists caught in the streams of history. Should they, like the Zenitists, allow the swirling currents of their circumstances to dictate the direction and flow of the work? They felt that an exploration of the intense, but short-lived Zenit movement, might shed some light on their own perilous situation.

Unlike traditional theater, they did not engage this question by finding a story or historical event to dramatize. Instead, *Zenit* was built on improvised and directed explorations of their own personal histories and themes introduced by Dijana and Jadranka. The process, which started in October of 1993, took six months to complete. Over the course of this time, the company, which had grown to eight, worked daily in their Sava Center studio, applying a variety of techniques to develop raw material from which the play would be created.

Each day in the studio, the work began with a series of rigorous vocal and movement exercises designed to sharpen each actor's physical and mental capacities for the task at hand. These exercises comprised the language of movement and voice that would eventually become DAH's signature. After this preparation, they set about the daily job of crafting the production. The work was built using increasing focused layers of ideas, gestures and sound. Despite a company structure that clearly defined roles, the story-making process was both nonlinear and nonhierarchal. While the company worked fully as collaborators, the directors began by framing the questions or themes addressed by the piece. Was the Zenitists demise unavoidable? Can creators safely navigate these toxic waters? In order to explore these questions they prompted each actor with theme related material. The actors would then use this material to improvise a unique movement and vocal "score." Prompts included Zenitist images, poems and biographies. The directors also asked the actors to explore personal questions, childhood experiences or turning points in their lives.

The actor's job at this point was to go as deeply as possible into these improvisations. In the weeks and months that followed, they worked this raw material over and over, moving back and forth between practicing and improvising, insinuating the evolving material slowly into their body memory, all the while knowing that each perfected element would likely be modified or discarded somewhere on the long journey to the finished work. Sanja elaborates on the process.

DAH company member Tina Milivojevic on a poster advertising DAH's performance of Zenit at the Sava Center. Photo by Ivan Sijak, courtesy DAH Teatar, 1995

Everything that I say and sing I support with a gesture. But we don't work just with gestures. We then move to physical improvisation, which we make into a score. Then we improvise to make vocal score. Then we link them. The physical score alone takes a couple of months. It is very important to be open and present all the time because through this process you learn how to learn again and again and again.

As these scores built and matured, Jadranka and Dijana began to combine them into the amalgam of dialogue and action that eventually comprised the completed *Zenit: The History of the Passion*. Part sculptors, part conductors, they coaxed the work into focus and form, removing bits, adding some, altering the flow, creating new juxtapositions, looking for patterns of symbol and meaning. Like poets, they prodded, watched, and even waited, willing the work to reveal itself.

Zenit premiered on April 19, 1994, at the Sava Center. Using excerpts of the Zenit writers as a jumping off point, the piece considered the fate of avant-garde thinkers and artists in post-WWI Yugoslavia and Europe during the 1920s and, by extension, war torn Serbia seventy years later. They did this by juxtaposing Zenit's visionary credo, "not to live out of duty, but to live out of inspiration,"[7] against the repression the Zenitists faced and the tragic circumstances of their lives.

The central questions posed by the work rose directly from DAH's circumstances at the time. Prior to coming to the Sava Center, they had been essentially homeless, in constant search for rehearsal and performance space and funding. The company's survival was always in question, and, given the deteriorating political situation, so was their safety. With this as a backdrop, *Zenit* asks: Is the fate met by the Zenitists an inevitability for us, too, or are there ways of responding to repression that don't play into the hands of the repressors? Answering their own question, the piece made the assertion that there *is* another way of not being silenced and not becoming a victim, and this is it!

End of the World

THE EXPULSION OF MUSLIMS: THE WAVE OF HATE[8]

The UN Security Council has adopted a presidential resolution (September 2) in which the Bosnian Serbs are required to immediately cease ethnic cleansing operations in the Bijeljina region. —*Vreme*, September 12, 1994

> It would be very difficult for me to avenge all those who should be avenged,
> because my revenge would be just another part of the same inexorable rite.
> I have to break that terrible chain. I want to think that my task is life...
> —Isabel Allende, from *House of Spirits* used in
> *The Legend About the End of the World, 1995*

Throughout 1994, what had become known as the Bosnian War seemed to personify the senselessness of the times. The conflict continued to rage on various fronts. What had once been the Yugoslav republic of Bosnia, had become a fragmented two-part war zone; the Bosnian Serb controlled and ethnically cleansed Republic of Serbska and a still shrinking Bosnia proper. While the Bosnian Serb leader Radovan Karadzic regularly proclaimed victory, Bosnian President Izetbegovic pleaded with the West for intervention and more arms. Sadly, in the face of a massive refuge crisis and daily reports of ethnic cleansing and atrocity, NATO members squabbled about the proper response. A lack of resolve that was, in the words of former Deputy Secretary of State Richard Holbrook, "the greatest failure of the West since the 1930s."[9]

In Serbia, the specter of the war had evolved from an open secret to a festering sore. Beyond the borders all Serbians, it seemed, were being portrayed as war mongers. Although dissatisfaction with Milosevic was growing, so too was the siege mentality being whipped up by the Nationalists. No matter where you stood, enemies were everywhere, and, as the paranoia spread, moderation had become a forgotten path. The only common ground was poverty. Everybody but the Socialist Party insiders and the black marketeers scrambled to put food on the table. Survival was paramount.

By the spring of 1995, the Sava Center had become an uneasy home for DAH. It had been an unlikely partnership from the beginning—a strange marriage of convenience, that they had exploited to the fullest. As their activities increased, so had the patently anti-government tenor of their work. In addition, the Soros connection was becoming too obvious for officials to ignore. Anybody that was even mildly dissident, who was publishing, performing or broadcasting, was assumed to be on the dole from the West. It was unfortunate, but inevitable—their lifeline had made them a target.

So, Dijana and Jadranka were not surprised when the director of the Sava Center asked them to end their relationship with Soros. They had expected worse, and knew that when they said that they would do no such thing, that the next move would be eviction. So, they left., Along with them, dozens of other artists who had taken courage from their audaciousness and who had risked speaking out, dispersed into the city—potent spores in a hostile wind.

For DAH, this meant scrambling for work space again. Given the difficult times and their growing notoriety, this would be a challenge. In the midst of the eviction, they sustained another hard blow. During their time at Sava, the company had grown to five actors. With their meager resources, this had been a stretch. Nevertheless, they had managed, held together by their strong sense of

purpose and the exhilaration of the work. The quick exit from the Sava Center was hard on the group. In its aftermath, two of the actors, Nenad Colic and Tanja Pajovic, found the financial pressures were too much. After weeks of agonizing, Nenad and Tanja announced that they would have to leave.

Coming and going is not uncommon in the theater, but, during their time at the Sava, DAH had gone beyond being a theater company. In the middle of the madness and devastation, they had created a safe space for confronting the impossible questions rising up around them. It had been their dream to create a laboratory, like Odin, but this was far more. In the shadows of the dark times, DAH had become both a sanctuary and a family. Now it appeared that family was falling apart. Dijana describes their feelings.

> It was a very difficult period. The war was at its peak. The country was torn apart. Our intention was to create a group that would stay together for many, many years. At that time, staying together was very important—it protected us. Now we were surrounded by destruction, in the country, and inside the group. It was very painful.

They responded by doing the only thing they knew. Dijana and Jadrenka started to work, "with no idea of whether it would become a new performance." Dijana recalls that everything that surfaced was about ruin—"the ruins of our own country and the potential ruin of our own group, the ruins of somebody's house, of a church, a library or of the inner space and inner life." In the midst of this destructive imagery, they also confronted an obvious reminder of what had endured. There, on the rough floor of their borrowed studio, Jadranka and Dijana watched the three actresses, Sanja, Maja, and Tina Mililojevic—still moving, still working.

As they continued to work, new, more hopeful images started to flow—three female figures foraging through the rough terrain of history—three women, the grandmother, mother, and daughter, powerful archetypes of the past, present and future, of fertility, of creation. These potent visions spurred them on. Once again, the company's dedication and discipline became an antidote to the toxic terrain that surrounded them. They kept at it, every day, patiently building their creative stamina. As weeks stretched into months, the two directors and three actors found themselves again on the journey to a new work. What began to take shape was conceived in the story they were living, in the studio and on the street. Out of the ruins, new life will rise up. Dijana was struck by the simple power of what they were experiencing day after day. "It is possible to oppose destruction by creating!"

This idea became the foundation of a nascent theater piece. As new ideas came and went, so did the source material Jadranka and Dijana used to stimulate the work. Jadranka remembers pouring through apocalyptic literature from around the world—stories of death and rebirth and the feminine. "We looked at the Balkan tales first, but we realized we needed more, so we turned to Indian myths, to Tibetan legends, to different Scandinavian stories." Over the months,

the directors and actors worked patiently, melding the myths with their everyday lives into a growing web of narrative collage—seeking a delicate balance between pushing the material into place and waiting for something to emerge. Out of this fragile dance of will and receptivity *The Legend of the End of the World* was born.

The work opened to an audience at the Edinburgh Festival in August of 1995. Titled after the Tibetan myth of the same name, the piece included texts from that story, the Tibetan Book of the Dead, the Bible, and Isabelle Allende's, *The House of Spirits*. In the first scene, three women wander a room in ruins. They begin with lines of resignation and anguish from "The City" by Greek poet, Constantine Cavafy.

> You said, "I will go to another land, I will go to another sea.
> Another city will be found, better than this.
> Every effort of mine is condemned by fate;
> and my heart is—like a corpse—buried…"[10]

They recite a terrible litany of human destruction back through the ages: Sarajevo-Belgrade-Pakrac-Leningrad-Harkov-Moskow-Alexandria-Carthage-Athens. Despite the evidence and their own ruinous state, they are driven to find a way to make life from the wreckage that surrounds them. Feeling their way through the darkness of despair, they sift through the rubble for antidotes to the poison of history. On their journey they evoke fellow travelers, three women from Greek myths, three Hindu goddesses and the daughter, mother and grandmother from the *House of the Spirits*.

As the women push on, they are confronted by wisdom rising up from the ancients—the cleansing necessity of death, the endless and inevitable cycles of creation, destruction and resurrection and, most importantly for them, on this perilous quest, the high wire dance of the celestial fates and human will. The text they recite from the Tibetan Book of the Dead speaks to this.

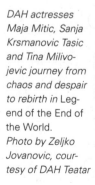

DAH actresses Maja Mitic, Sanja Krsmanovic Tasic and Tina Milivojevic journey from chaos and despair to rebirth in Legend of the End of the World. *Photo by Zeljko Jovanovic, courtesy of DAH Teatar*

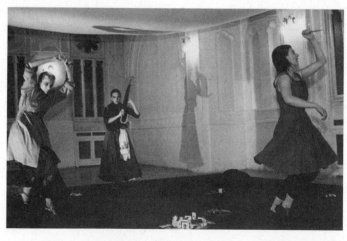

The boundary line between going upwards or going downwards is here now....This is the moment. Hold fast to one single purpose. Persistently join up the chain of good acts.

Finally a vision of renewal emerges as one of the women quotes from the *Tibetan Legend of the End of the World*.

Once more the winds will blow, a crust will form once more from the oceans, and a new world will be created, and the people who were saved from the previous world will become stars in the sky.

The audiences attending the performance were both astonished and enthusiastic. Despite its abstract form, it was provocative and outspoken. It was also an affirmation, an acknowledgement of their every-day journey over this same harsh landscape. Most importantly, though, was the unsentimental glimmer of hope delivered by the piece. Critic Aleksandar Milosavljevic characterized the work as "honest ...and true, a performance that we need greatly."[11]

Street Theater

PEACE IN BOSNIA

If the commitments made yesterday in Dayton, Ohio are honored in Balkan cities and villages in the months ahead, Europe's worst conflict since World War II will come to an end. It will not be a moment too soon. As President Clinton said in announcing a peace agreement, "the people of Bosnia finally have a chance to turn from the horrors of war... —*New York Times*, November 22, 1995[12]

After the signing of the Dayton peace accords and the cessation of hostilities, both Milosevic and NATO leadership assumed the Balkan crisis would begin to fade from its seemingly permanent position on the world's front pages. Given his "peacemaker" role in the negotiations, Milosevic also calculated that he would be left to his own devices on his own turf. He was right. When, in early 1996, he took control of Serbia's last independent TV station; indicted opposition leader Zoran Djindjic for the crime of "damaging the reputation of the Republic of Serbia"; and quite literally, hijacked the local and federal elections; neither his onetime NATO adversaries nor the perpetually fragmented Serbian opposition, objected.

"Fragmented" is probably too mild a term to accurately describe the fractious state of the half dozen or so parties that constituted the Serbian opposition in 1996. But after nearly six years of SPS (Socialist Party of Serbia) political dominance, the hard truth of their political impotence was beginning to sink in. There was a growing recognition among opposition leaders that the only way they could ever hope to change the status quo was to join forces.

In the months prior to the announcement of elections, leaders of three of the leading opposition parties formed a loose partnership to leverage the growing anti-Milosevic sentiment that had been building across the country. Considering their past behavior, it was widely assumed that the hardheaded leaders of these factions would have a falling out in the early going. But then, on September 2, 1996, they came together to form the Zajedno alliance. On September 28, a fourth party, the Democratic Party of Serbia, joined Zajedno, which means "together." Almost overnight, with a ticket headed by the well respected economist Dragoslav Avramovic, an opposition effort seemed to have a real chance. It may be that Milosevic began to feel the heat as well, because shortly thereafter Avramovic mysteriously withdrew his name from the ticket citing "high blood pressure."[13] Dijana recalls a joke going around at the time that "high blood pressure" was Serbian for "socialist threats." Nevertheless, on November 3, there was a great anticipation that a change was in the offing.

Unfortunately, for those with high hopes, the results of the federal phase of the elections were very disappointing. Although there were irregularities reported, Zajedno's decisive defeat left no doubt about the Socialist dominance of national politics. With the majority of seats under his control, Milosevic would again have his way in the Parliament. Diehard optimists could only look to local elections taking place four days later for a better outcome.

Given the growing discontent in Serbia's urban centers, there was some reason to think that Zajedno might fare better in the local contests. The results of the first round of local elections held on November 8 seemed to confirm this view. Alliance-sponsored candidates led by substantial margins. Ten days later, the second-round returns continued the good news, as Zajedno candidates prevailed in all fourteen of Serbia's largest cities. That evening at a massive Zajedno rally in Belgrade's Republic Square, DS (Democratic Party of Serbia) leader and mayor-elect Zoran Djindjic proclaimed that "Serbia's friends will be able to say that Serbia is neither Cuba nor Korea." GSS (Civic Alliance) head Vuk Draskovic added, "We won with both our hands and feet bound."[14]

In the complex labyrinth of Balkan history and politics, winning and losing are often not what they seem. In fact, the devastating defeat of Prince Lazar Hrebeljanovic by the Ottoman Turks at Kosovo Polje, in 1389, is Serbia's most celebrated and enduring historical moment. Considering the regularity with which Slobodan Milosevic had managed to turn disastrous outcomes into victory, it did not come as a surprise to many in the opposition when election officials in Belgrade and elsewhere refused to certify the election, citing "irregularities."

Shortly thereafter, the government decreed that yet another round of voting would be necessary. Tactics like this had always worked for Milosevic, but with this election something had shifted in the Serbian political landscape. Instead of being cowed or turning on each other, Zajedno's fragile coalition of unlikely allies acted with firmness and resolve. On November 27, their boycott of the third round of voting held the turnout to only 20 percent. Then they took to the streets.

To salvage the election, Zajedno's leaders knew these demonstrations would have to be more than a symbol of defiance and outrage. Not only would they have to put unprecedented pressure on Milosevic, they would also have to capture the imagination and sympathies of the international community. In the first few days of the demonstration, anger roiled among the thousands filling the streets of Belgrade and dozens of other Serbian cities. Along with the signs and chants, the release of pent-up anger translated into thrown rocks and broken windows of government buildings. As cathartic as this was, the Zajedno leadership knew that violence would discredit their democratic gains and give the government an excuse to respond in kind. This recognition precipitated the first act of what became the uniquely imaginative street theater of the Serbian opposition. So, rather than completely stifling the crowd's need to express their ire, they encouraged the use of non-violent projectiles. In no time, eggs became the missile of choice and the "Egg Revolution" was born.

As days became weeks, the size and energy of the demonstrations ebbed and flowed, but there was always a critical mass of both stalwarts and newcomers intent on keeping up the pressure. In the beginning, most in the crowds in Belgrade were students and Zajedno supporters. Then, as it became clear that the government was going to continue trying to steal the election, the makeup of the protests became increasingly diverse. By the middle of December, middle class professionals, trade workers, and even government employees and members of rival parties had joined the throngs trying to stay warm in Republic Square.

But the opposition's greatest weapon, so to speak, was the extraordinarily creative and nonviolent character of the protests. In one instance, people showed up with herds of sheep festooned with placards bearing slogans such as "We support the Socialists" and "The whole world is against us." On another day the protestors took on Milosevic's wife, Mira Markovic, a hard-line communist who habitually referred to the "lost blood of patriots" in her nationalistic speeches. In response, a "Give Them the Blood" campaign was launched in Republic Square where people could donate blood to Slobodan and Mira so they could leave the country.

These imaginative strategies became a critical counter to the provocations of an increasingly nervous and impatient government. As the courage and originality of the protests began to catch the attention of the international media, the protest coordinators encountered more and more plainclothes police officers and paramilitaries trying to stir up violent incidents. One artist who showed up with a huge puppet of Milosevic dressed in a convict's uniform was arrested and severely beaten by the police. Dijana describes how this incident impacted the members of DAH.

When we saw this abuse, we were shocked and angry. We wrote a letter under the signature of DAH stating that this was an outrage against a kind of theatrical expression that had been a tradition throughout history. We

*Exuberant demon-
strations like this
were a daily (and
nightly) event in
Belgrade during
the Egg Revolution
of 1996.
Photo by Milena
Sesic*

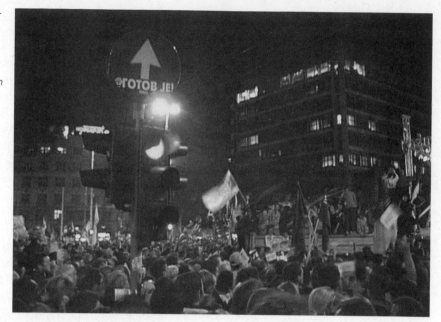

sent it to the officials and published it. We invited the Union of Drama
Artists to stand with us, but they were afraid and they declined. But the
overall response was overwhelmingly positive. Once again we learned
how important it was to speak out.

In most cases, though, the protester's creativity seemed to trump the
government's crude attempts at incitement. Many of the most interesting
ideas for making political points and defusing tensions came from the grow-
ing ranks of artists who were taking part in the protests. Dijana describes the
demonstrations' evolution as "incredibly theatrical."

The performance venues were shut down, so the artists were out in force.
Each evening, when the official news came on, we would blow whistles
and bang pans to drown out the lies being spread by the government. We
took part every day. And every day we would be surrounded by thousands
of policemen in different uniforms brought in from all over the country.
It was very tense and dangerous.

At some point we realized that we needed to do something to reduce
the confrontive energy building up. Somebody suggested that we could
wear uniforms too. In a few days everyone was in uniform. Some worked
for the government, carrying guns and wearing helmets. And the rest of
us combined old army jackets with things like wigs and strange hats.
With that, the protest started to take on a kind of a carnival atmosphere,
which I think made all the difference.

Someone made the point that Milosevic was so bad that even animals understood that he needed to go. The next day thousands of people showed up with their pets—dogs and cats, birds in cages, even a horse. We knew we had to oppose violence and destruction with humor and creativity. These great ideas neutralized the police. They knew how to react to violence, but they were not prepared for these kinds of creative, humorous responses. Another time, a group of visual artists brought hundreds of mirrors and set them up in front of the line of officers. Hour after hour all they saw was themselves.

These tactics were doing more than irritating the government. Many of the officers from provincial police forces found themselves unprepared for the often friendly and humorous "war" being waged by these so called "fascists."[15] One provincial commander complained that when his officers returned home they had been "ideologically polluted by the subversive cosmopolitanism of Belgrade."[16]

As the New Year approached the momentum of events intensified further. On December 24, an SPS organized "counter-demonstration" backfired when government supporters were filmed beating and shooting at Zajedno demonstrators. This attempt to manufacture a full-scale riot only served to further discredit the Socialists. Three days later, an investigation by the Organization for Security and Cooperation in Europe (OSCE) concluded that the disputed election contests had, in fact, been won by the Zajedno candidates. On January 6, 1996, over half a million people joined a procession to Belgrade's St. Sava Cathedral led by the Serbian Patriarch Pavle to celebrate Orthodox Christmas eve and express their disfavor with the government.

The tide had clearly turned in favor of the opposition. In early February, the ever practical Milosevic began to look for a way out of the crisis without appearing to cave in to his adversaries. On February 4, he urged Parliament to draw up a bill recognizing the Zajedno victories, for the purpose of "promoting

For Serbia's opposition parties, the post election celebration marked the highpoint of the 1997 election. Photo by Milena Sesic

the country's good relations with the OSCE and the international community." He made no mention of the legitimacy of the election. A week later, the quickly drafted legislation passed the Parliament. On February 21, a joyous crowd of 130,000 gathered in Republic Square to celebrate Zajedno's win and toast the triumph of imagination and courage that had produced it.

Many in the crowd that day felt that the tide had turned and the regime's days were numbered. In the midst of the euphoria, Dijana recalls thinking that it would take a lot more than one election victory to rid the country of Milosevic.

From that year till 2000, his dictatorship became more visible and stronger. He would jail anybody who opposed him. Some people were disappointed, because they expected more from the protest and the election. At DAH we believed these events were very important seeds—seeds that would have to be nurtured, and would eventually grow.

CHAPTER 20

Bombs and Salt

A few weeks into the bombing I decided that maybe I should continue the dance classes for the kids from this area because they don't go to school, they are strained…they are so afraid. One day, there was the siren, in the middle of class I wasn't sure where to go so we just continued. When I came home, and my husband asked: "What did you do during the sirens?" and I said: "Nothing, we just went on. We are in a school in the middle of Beograd; nothing will happen…It's very important to give some sense of art and life to the kids." And he said: "You are crazy; you are just the right target. Not for NATO, but for Milosevic, because he will make big propaganda when the dance teacher is killed with her little group of kids." And he said: "How do you know it's safe? You know that they are using lots of schools for antennas for radar." And I said: "No this is stupid; this part of the city will never be hit. Never!"

That night, two bombs fell just one hundred meters from the school in the Maruliceva neighborhood. One day it was just a little street nobody knew about, next, it was everywhere: in the newspaper, on the TV. There were causalities and people who lived there were killed. They said maybe there was a radar. Nobody knows.
　　　　　　　　　　　　　　　　　　　　　　　　　　　　　　　　　　—Sanja

Night Sirens

DURING THE FIVE YEARS (1991–1996) of the Croatian and Bosnian conflicts, Kosovo, with its majority Albanian population, remained under the relative control of the Beograd government. Although the movement for a sovereign Kosovo actually pre-dates those in other areas of the former Yugoslavia, the international community was reluctant to acknowledge its legitimacy. Given Serbia's already significant contraction, and the near sacred status that Kosovo held in the Serbian nationalist mythos, many feared a confrontation over the territory could be worse than Bosnia.

But the Kosovar Albanians kept up the pressure. In the early 1990s, they had conducted unsanctioned elections and set up parallel civil administrations,

schools, and healthcare facilities. Gradually, these institutions had begun to exert more control over affairs in the province. The moderate faction of the movement, lead by Kosovo president Ibrahim Rugova, felt these nonviolent tactics would convince Milosevic that Kosovo's independence was inevitable. Unfortunately, when Kosovar Albanian concerns were effectively ignored by the Dayton Peace Agreement in 1995, the more militant approach of the Kosovo Liberation Army (KLA) began to gain more credence in the region. As KLA resistance activity escalated, so had retaliation by FRY (Yugoslav) army units. By 1997, a low-grade civil war raged in the province.

In the fall of 1998, UN and NATO leaders recognized that the conflict they had been trying to avoid was on a fast track to full out war. In October, after being threatened with NATO air strikes, Milosevic acquiesced to the introduction of unarmed representatives from the Organization for Security and Cooperation in Europe (OSCE) to monitor the deteriorating human rights situation and quell the growing violence. Unfortunately, the presence of the OSCE monitors seemed to make matters worse. Not only did the violence continue, but the incidence of ethnic cleansing of hundreds of Kosovar Albanian towns and villages dramatically increased. In March of 1999, after last ditch efforts to negotiate semi-autonomy for the Kosovo region broke down, it appeared that talk had run its course.

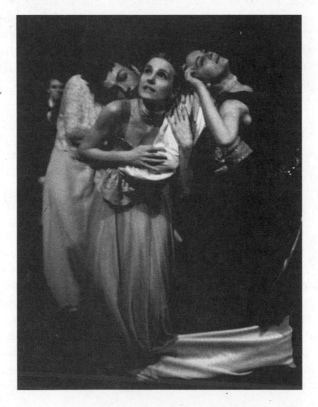

(From left) Alistair O'Loughlin, Sanja Krsmanovic Tasic and Maja Mitic in a scene from The Helen Keller Case, *Photo Vincent Abbey © DAH Teatar*

In March of 1999 DAH took a new work called *The Helen Keller Case* to New Zealand. As the shadow of yet another bloody conflict descended on their ravaged land, it is no surprise that this production continued down the same road as *Legend of the End of the World*. In *Legend*, they had, in essence, presented their theory of the alchemy of faith—the transformation of desolation into hope. By the play's end its three female figures had collected enough evidence to justify an expedition into the future to find out if this "hope" could be found.

The Helen Keller Case was like a communiqué back from that quest. Incorporating text from Keller and her teacher Annie Sullivan as well as William Blake, Percy Bysche Shelley, and Emanuel Swedenborg, the piece uses Keller's journey from "dark to light" as a metaphor for the human struggle for freedom. Though the way forward is perilous and daunting, the performance is an announcement of a sighting—rebirth is a real possibility; they can see its vague form on the horizon.

In the time period in between the creation of these two pieces, much had happened to the company. In the summer of 1996, they had traveled to the US to present *Legend* for the Olympic Arts Festival at the 7 Stages in Atlanta. Upon their return, they had created *Angel's Memories,* an outdoor piece about heaven and earth and "taking sides" that reprised the angels of their first performance. Shortly thereafter, Jadranka made the difficult decision to leave the company to work with Theatre OM in Denmark. Still homeless, and under pressure from the government, DAH pressed on. In the September of 1997, American Kathy Randels and Brit Alistair O'Loughlin joined DAH in Belgrade for extended residencies. They both figured prominently in the development of the *Helen Keller Case,* which was Dijana's first as DAH's solo director.

Despite all the changes and the gathering war clouds over Kosovo, the company was strong. Of necessity, they had become even more resourceful in the years since they had been forced out of the Sava Center. Beyond survival, though, their ordeals had taught them that they could transcend victimhood—that they had the power to generate their own light in the darkest times. Like Helen Keller, with grit and imagination, they had rediscovered a sense of the future.

Early in the morning of March 24, 1999, Dijana was roused from a deep sleep by the distinctive ring of Telecom New Zealand. It was a Wellington reporter calling to get their reaction to the "situation back home in Belgrade." Bewildered, she asked, "what situation?" The reporter responded by telling her to turn on the television. Dijana woke the others. Sanja remembers her terrible feelings of helplessness and panic as they watched NATO bombs light up the Belgrade cityscape on the TV screen. "It was eight in the evening in Belgrade and eight in the morning in New Zealand. We were watching the direct footage of the horror on the morning news."[1]

The company agreed that they would return home as soon as possible. After anxious calls home to loved ones and ticket agents, they decided to go on with the performance scheduled for that night. Sanja recalls the evening's

singular intensity. "We dedicated the piece to all the innocent people in Yugoslavia—sleepless under the bombs…At the end, everybody in the theater was crying and a Maori priest made a ritual on stage for our safe return home. I believe this ritual helped us survive—both us and our families."

For one member of the troop, Vladar Avramovic, returning home posed more of a dilemma. While in New Zealand, he had received word from his family that he had been called up for duty by the army. While he felt loyal to his country, he knew full well what the government was doing in Kosovo and he wanted no part of it. He was not alone. Since Milosevic had come to power, more and more of Serbia's draft eligible men had been sleeping in beds other than their own to avoid being carted off in midnight raids conducted by army "recruiters." Vladan knew that if he returned he would be introduced to his new uniform the minute he crossed the border. Given New Zealand's strong opposition to the Milosevic regime, he stood a good chance of being granted asylum if he chose to apply. It was a hard decision but when the DAH bid adieu to the land of the "long white cloud" they said a sad good-bye to Vladan, as well.

Of necessity, their route home was circuitous, taking them to Frankfurt and then Budapest. There, they found an elderly man who was willing to drive the "crazy folk" north, into the war zone. It was a difficult trip. Along the way, they passed hundreds of Serbs fleeing the country. As they neared Belgrade, their driver became increasingly concerned that despite his advanced age he would be stopped and forced into a uniform.

Hundreds of Belgrade's buildings were destroyed during the 76 days of NATO bombing. Photo © Daniel Zollinger IV

By the time the members of DAH set foot back in Belgrade, NATO forces were in their second week of a bombing campaign that was targeting government and military positions throughout Serbia and Kosovo. From the beginning, it was clear that this was more than a symbolic demonstration of military superiority. NATO's goal was to end the forced migration of Kosovar Albanians by crippling the Serbian army. Government buildings, roads, bridges, communication networks, transportation facilities, and energy plants throughout Serbia and Kosovo were all targets. Night after night, in Belgrade, the sound of air raid sirens, anti-aircraft fire, and bomb and missile concussions filled the air. Each time the sirens sounded, most of the city's 1,625,000 citizens rushed to the basements and subway tunnels that had been designated as bomb shelters. Needless to say, during the spring of 1999, a full night's sleep was hard to come by in Serbia's capitol city. Basics like heat, light and transportation also became scarce. As the weeks went by, more and more of the city's essential services were cut off or curtailed.

During one brief and surreal interlude the scent of cooking meat from thousands of impromptu barbecues swept across the city as citizens did what they could to salvage thousands of pounds of abruptly thawed meat.

Since his brief rehabilitation in Dayton in 1996, Milosevic's stock with the Western powers had plummeted. As such, he had very little to lose by digging in his heals and testing NATO's resolve. But, as Dijana recalls, the people of Serbia had a lot to lose.

> We were so confused and angry. This is the insanity of war. You decide you have to kill more people to prevent killing. We were never so desperate. All these years of working against destruction, and here we were the targets in a high-tech war where, without any warning, any building can explode and your neighbors and friends can be killed. We couldn't understand anything. It was dangerous and unreal, but we kept on working. We needed to be doing something more powerful than the bombing.

Forgiveness

The unreal became very real for DAH when the bombs fell a few doors down from their rehearsal space in the school on Maruliceva Street. Rather than use this as an excuse to quit, they immediately found another space and continued their work. They had a commitment to perform at a festival in the northern city of Novi Sad. Despite the chaos and destruction, they were bound and determined to keep it. They also had a fervent need to create something in response to what was happening all around them. But, for the first time in the company's tumultuous history, Dijana was at a total loss as to where to begin.

> We went to rehearsal each day after sleepless nights. Each time, we would say to ourselves, "Today we will not rehearse, it's not possible." We were scared and tired and wanted to stop. But people were dying. There was no excuse not to work. Unfortunately, I had no starting point, no theme. Here is where our experience with obstacles served us well. We trusted each other enough to just begin and see what happened. And then a little miracle happened out of all the turmoil.

The miracle was, essentially, born of the confusion itself. Nothing made sense any more. And the harder they pushed to come to terms with the incongruence of their situation, the crazier it seemed. Then, according to Dijana, in the midst of all this "an overwhelming vision of two very old ladies" began to insinuate itself into their work. "These old ladies were the carriers of knowledge and memory. They represented our struggles to understand. I saw them going up and down the stairs to the archives searching for answers."

The premier of *Documents of Time* took place on the steps of Museum of Vojvodina in Novi Sad two weeks after the end of the 86-day NATO bombing campaign. In it, two old women carry books containing the collected memory of humankind up and down the stairs, all the while chattering about bygone

DAH actors Sanja Krsmanovic Tasic and Aleksandra Jelic rest on the stairs of the Museum of Vojvodina in Documents of Time
Photo by Dijana Milosevic © DAH Teatar

times and lost memories quoting Helen Keller, Bertold Brecht and even Jack Kornfield's *Chicken Soup for the Soul*. On their back and forth journey, the air is filled with the detritus of contradictory wisdom and the stairs with dusty tomes. A story of battlefield pacifism in Viet Nam is followed by a cold reminder of Hitler's contemporary shadow. Round and round they go, each hint of hope offered by one crone is followed by a note of despair from the other. True to form, though, when the cycle slows, they lay the hardest questions at their own feet. The final lines, pulled from Brecht's *War Primer*, harken back to those spoken by four angels seven years earlier on the Republike Trg (Square) in *This Babylon Confusion*. It will always be the creator's job to forge the healing story.

> One day they will say: "It was then when the chestnut tree shook in the wind."
>
> No, they will say: "tyrants crushed the innocent."
>
> One day they will say: "It was then when the child skimmed a flat stone across the water."
>
> No, they will say: "When the great wars were being prepared for."
>
> Well, maybe they will say: "It was then when the women walked into the room."
>
> No, they will say: "When the great powers joined forces against the peoples."
>
> But they will not say: "The times were dark."
>
> Rather, "why were their poets silent?"

Documents of Time reflects the heartbreak and confusion of a city being bludgeoned into "liberation." Dijana describes the finished piece as "the testimony of reality dissolving in front of us." But somehow, over the course of their up and down dance, the old women eventually stumble into a territory that transcends the understanding they seek—a place called "forgiveness."

Darkness Lifts

As Lenin observed, authoritarian regimes eventually fall when the people at the top are incapable of ruling in a new way, and the people at the bottom can no longer bear to live in the old way. A decade later than most of the European countries that practised Lenin's creed, Serbia seems to have reached that point.

—*The Economist* October 5, 2000

From the point of view of many in the Western world, the NATO war with the truncated Federal Republic of Yugoslavia was a success. Surprisingly, after almost three months of bombing, Milosevic capitulated and began removing his troops from Kosovo. With the Serb departure and the end of hostilities, the mass exodus of Kosovar Albanians from their homes and villages was halted and the slow process of repatriation had begun. But, the province, still nominally a part of the Serb Republic, was now a war-ravaged landscape under the supervision of NATO peacekeepers. The NATO presence meant little to Kosovar Serbs who, fearing retribution by their Kosovar Albanian neighbors, had begun pouring into Serbia. The influx of these refugees on top of the sanctions rendered a bomb-riddled Serbia even more of an economic basket case. Despite this, or more likely, because of it, Slobodan Milosevic was still in power and in some ways even strengthened.

Nevertheless, in early 2000, as a new round of federal elections approached, the Serbian opposition parties again sensed an opportunity to end the insanity. Still, the hard lessons of the 1996 election still continued to resonate. Milosevic had beaten the Zajedno alliance in the national elections and nearly stolen their hard won victories in the major cities. In the aftermath of that partial victory, the alliance partners had returned to their usual divisive squabbling. In 2000, Milosevic still remained a formidable foe despite the fact that he had presided over the disintegration of Yugoslavia, bankrupted the economy and been indicted by the War Crimes Tribunal in the Hague. Thus, with world opinion no longer in play, everybody knew that "Slobo" would stop at nothing to hold on.

The glue that would finally hold Serbia's eighteen opposition parties together in the 2000 election was Vojislav Kostunica. Like Milosevic, he was a nationalist, but unlike the President, he had a record of following the law. More importantly, he pledged to bring what was left of Yugoslavia back into the community of nations. As with 1996, the face-off between the opposition, under the banner of The Democratic Opposition of Serbia (DOS), and Milosevic's

SPS was intense. The government used its media monopoly to pump up the fear factor. In some regions, threat and intimidation were the order of the day. Finally, as September 24, election day, approached, all indications were that the people of Serbia and Montenegro were about to end Slobodan Milosevic's thirteen-year reign of corruption and greed.

Predictably, on the morning of September 25, the election commission, headed by a Milosevic crony, announced that the results would be delayed. In the meantime, a nongovernmental election monitoring body reported a 54 percent victory for Kostunica. This differed significantly from the commission's eventual verdict, which cunningly gave Kostunica a 49 percent to 39 percent edge, but also required a runoff two weeks hence.

While not unexpected, the obvious manipulation of the election results produced a quick and furious response. Kostunica immediately announced that as the legitimate winner he would not participate in the October 8 runoff. By the evening of September 28, the streets of all of the country's major cities were filled with hundreds of thousands of protesters demanding that the government step down. As they sang, "Slobodan, Slobodan! Save Serbia and kill yourself!" it appeared that the people power that had rescued the opposition victories in the 1996 local elections was back in force. Once again this strange game, more akin to "chicken" than chess, was being played out in the ministries and on the streets.

This time, the chemistry of conflict was even more volatile. The country seemed to be unraveling further with Milo Djukanovic, the president of Montenegro, Serbia's only remaining partner in the once proud Federal Republic, pushing for independence and Kosovo still occupied by foreign troops. In Belgrade, the obvious scars of the NATO bombing reminded Serbs that they were no longer safe in their own homes. The most incendiary factor, though, was the economy. The struggle to make ends meet had gone from grim to desperate. Even Milosevic was having a hard time keeping his "friends" in line with bribes and sweetheart deals. In essence, the war that "didn't exist" had come home. And, as the election showed, Serbs were fed up and angry and ready for a change. Therein lay the dilemma for Mr. Kostunica.

Just before the election, General Nebojsa Pavkovic, the army chief of staff, stated that he would respond in kind if the opposition attempted to force their will on the government. It was assumed by opposition leaders that Milosevic would welcome any opportunity, manufactured or not, to declare a state of emergency, thereby annulling the election. Despite a question as to whether

The entrance of the Serbian Parliament after its occupation by protesting citizens on October 5, 1999. Photo © Aleksandar Brkic

the army rank and file would fire on Serbian civilians, Kostunica did not want to play into Mr. Milosevic's hands by provoking a popular uprising.

In the end, neither Milosevic nor Kostunica was able to control the chaotic course of unfolding events. On September 29, five days after the election, over 4,000 coal miners in the city of Kolubara, just south of Belgrade, conducted a work stoppage to protest the hijacked election. The strike shut down half of the country's electricity and produced massive blackouts throughout Belgrade and the surrounding areas. The situation quickly escalated as police were called in and arrest warrants issued for eleven union leaders. But the workers, and a growing crowd of supporters, held fast, demanding that Milosevic step down. The President responded by threatening "special measures" and reinforcing the police presence with hundreds of officers from Belgrade.

Unlike 1996, when the drama of the election standoff played out slowly, the pace of current events seemed to accelerate with each passing day. By October 3, telecom, postal and electricity workers were preparing to join the strike. The next day, Milosevic's hand-picked Constitutional Court nullified the election results. With power cuts lasting as much as six hours at a time, the President sent General Pavkovic to the Kolubara coal fields to end the standoff, one way or another. The moment of truth came on the next evening, when the general's efforts to cajole and, eventually, threaten the miners into acquiescing failed. Reluctant to confront the likelihood that the police would refuse to fire on their fellow citizens, he returned to Belgrade empty-handed. The miners had won the day.

On October 5, emboldened by their momentous victory at the mines, crowds of protesters from both the city and surrounding countryside poured into the streets of Belgrade. The city was paralyzed, as over half a million people marched toward what would be a decisive confrontation with the government. Ignoring Kostunica's calls for calm and tear gas fired by police, they stormed the radio and television stations. By evening, after the thousands of police that had been deployed had disappeared into the night, the Parliament building was occupied and then torched. Two days later, as Vojislav Kostunica was being inaugurated as the new president of Yugoslavia, Marko Milosevic, "Slobo's" hated son, was seen hastily boarding a flight to Moscow with his family. His father was nowhere to be seen.

The Salt Factory

The fall of Milosevic in 2000 brought many changes to Serbian society. Some were dramatic. In short order, Milosevic's most feared lieutenants disappeared from sight. When restrictions on the press were lifted, underground media outlets like Radio B-92, and the newspapers, *Vreme* and *Borsa Nova* became "mainstream." Most importantly, the fog of obfuscation and fear that had shrouded the nation for over a decade cleared. For DAH and other "outlaw

organizations" this meant more than a just an end to the intimidation. In 2002, for the first time in their history, they began receiving government funding.

The members of DAH had always prided themselves on their ability to adapt to constantly changing circumstances. As such, they wore their nomad status as a badge of honor, at times describing themselves as a "theater without walls." Yet, their rigorous practice also required a stable work space, free from distraction. When they began receiving government support, they also started thinking about finding a permanent home for the company. Given their circumstances, this was totally unrealistic. They were only just squeaking by and had no credit. Their government funding didn't begin to meet their everyday needs. Nonetheless, they began looking. As it happened, they would not have to look far.

In addition to their ongoing creative work, DAH devoted significant energy and time to the education of young people. Their students generally came from the neighborhoods surrounding whatever rehearsal venue they were using at a particular time. One such site was the Kralj (king) Petar II Karadjordjevic School, a first through eighth grade facility located in the Maruliceva neighborhood in the northeast section of Belgrade. The concrete and stone four-story building had been built in the 1930s when Belgrade was expanding into the hilly areas surrounding the central city. Over the years this neighborhood of modest houses and apartments had been home to many people just starting out in the city.

By 1996, when Sanja began teaching an after-school class, the area was a mix of low income families, many of whom were Roma. Although the Roma, or Rom (often referred to as Gypsies) have been a part of the Serbian cultural mix since the late 1300s,[2] they have always been an oppressed minority there. At the time, the Milosevic regime was making matters worse for Roma by actively promoting an atmosphere of intolerance and mistrust towards ethnic minorities. Scapegoating the Roma was an easy way to distract a population feeling increasingly restive over the war and the ruined economy.

Sanja had inaugurated the classes with Aleksandra Jelic, also known as Beba, a dancer who eventually (in 2002) became a member of the company. The two worked extremely well together. The students and teachers loved their no nonsense approach and effervescent spirit. As the classes became more regular, a spare room on the top floor was designated as the school's "studio." Eventually, DAH started to use the very small eleven- meter by six-meter space for rehearsals. Through their ongoing presence, DAH began to be seen as a regular part of the community. This sense of connection had deepened during the bombing, when DAH had continued to conduct classes for neighborhood kids in an effort to try to help them cope. They had only canceled when they were warned that Milosevic's use of public buildings for anti-aircraft batteries and radar installations made the school a potential target.

While there were no cannons on the roof, the building was more than just a school. A few years earlier, the school's principal had been told by her

superiors in the Ministry of Education that the building's basement was to be converted for industrial use. During the Milosevic era, it was not uncommon to find private factories operating in public buildings, particularly schools. These highly illegal, and often dangerous and polluting, operations were but one of the many schemes Milosevic used to exploit public resources to enrich himself and his confederates.

The factory in the basement of the Karadjordjevic School was typical of these shadowy operations. While the under-resourced primary school made do in the three floors above, a dozen or so men in the basement processed sodium chloride into water softening tablets to be sold under contract to government agencies and on the black market. The factory was noisy and dirty and operated twenty-four hours a day, seven days a week. Needless to say, it was not at all compatible with the primary school activities taking place upstairs.

One morning, shortly after the dramatic events of October 5, 2000, Karadjordjevic's principal noticed something strange as she unlocked the school's front door. The building was uncommonly quiet. The incessant clanging of machinery that had tyrannized the building for so long was silent. She rushed to the basement to find that the workers had gone. It was a hopeful sign. By weeks end, she knew they would not be coming back. It was a blessing. The factory had stopped, but, the disaster in the basement remained.

A few days later, when the members of DAH peered into the space, it was just as the workers had left it—the dusty, jerry rigged equipment, the piles of unprocessed salt, even the coffee maker remained. It was a museum of corruption—an ugly reminder of the crooked and cynical nature of the men and women who had ruled the country for over a decade. It was a hazard and a blight, but the actors saw something else, as well.

DAH's new studio space in the Karadjordjevic School's old salt factory opened new possibilities for the company. Photo coutresy DAH Teatar

Soon after, Dijana sat down with the Karadjordjevic's principal with a proposal. If the school would accept DAH as rent-free tenants, they would clean and renovate the space as a studio and administrative facility for the company. It was a win-win situation—the mess would be gone, they could resume classes for Karadjordjevic's students and DAH would have its first home. After the principal agreed, the company came together to consider how they were going to actually accomplish what they had just agreed to. According to Sanja, they approached the project as they would any production.

> We just started to work one room at a time. These offices were in a very bad shape. We had no money. Nobody gave us money. But then, we went on tour in the USA (a collaboration called *Maps of Forbidden Remembrance* with 7 Stages Theater in Atlanta) and instead of sharing the fees, we invested all the money into this. And we did many things ourselves, like painting walls, floors, some handy-work; also friends, husbands, everybody came and helped. When we moved in it was a big thing for us. And not just for us. We were the first independent company in Serbia to have a permanent space.

September 2004

The obsidian bare-bulb glow from the nearby basketball court washes gauzy twig shadows across the playground of the Karadjordjevic School. A cluster of two dozen women and men queues up and then passes through the side door entrance to the small DAH theater space. The four bleacher-style rows at the back of the square box studio quickly fill.

As the small audience settles, their low voices seem to mingle with the theater's grey light. They have come for what DAH calls a demonstration—this time a retrospective performance, a look back at the company's history through the eyes of one actor called Inner Mandala. *In the first breath of silence, the lights dim further.*

Maja Mitic first appears as a shadow, moving diagonally out of the back right-hand corner of the stage—then as a spectral voice.

> *It all started as a great love and passion for dedicated work in theatre, long rehearsals, silence, training, interesting books, afternoons spent watching videos of the great masters of the twentieth century theatre. Endless, endless questions and self-rediscovering through that kind of work...*

She speaks in English. This is not uncommon when DAH performs for foreign visitors. This time the audience includes a group of British actors and directors and an American writer who will spend the next ten days with the company.

As Maja approaches the audience, she speaks directly, almost casually, acknowledging their presence. It is disarming and, for some, confusing. They

are expecting a performance, not a lecture. But then, with tilt of the head and a step back, her voice begins to slide deeper—her body follows, moving more formally, repeating patterns along with the words.

I became stronger. The precision of the physical training, where the only thing that mattered, in the beginning, was not to fall down, doing hard physical elements and avoiding physical injuries, made me stronger on many different levels.

As she migrates across the stage, her movements slow down and become less repetitive. When she speaks next, she is inhabited by another Maja from another place and time. It is the summer of 1992. DAH is taking its first tentative breaths—being born in This Babylonian Confusion on Republike Square.

I was a witness to madness stopped for a moment, while performance was going on; I was a witness to the quitting of voices and lightheaded conversation. I was there crossing eyes with people who found their own words, their salvation and their cure in that act of theatre. In these times the theater starts to be indispensable and ultimately needed. It becomes bread for the hungry one, water for the thirsty. By asking questions and speaking personally, it gave us the possibility of our own healing.

The audience leans forward, joining the journey. For the Serbs it is a return to the early days of their long dark struggle. For the visitors it is both new and vaguely familiar—a shadowy glimpse at an obscure and confusing history.
Maja sheds a cloak. Wings emerge—a fragile armature in flickering light. As the angel flies across the stage she recites a verse in Serbian.

Sve se menje sve se menja,
Sto je bilo bilo je.
I vodu koju si u vino usuo ne mozes vise iz njega isuti.
Sve se menja sve se menja sto je bilo bilo je
Iznova poceti mozes sa poslednjim dahom.

Then she translates.

Everything changes everything changes
what has happened, has happened
And the water you have poured into the vine cannot return as water.
Everything changes everything changes
what has happened, has happened
But, you can start from the beginning with the last breath.

A pattern emerges. It is a performance, but a lecture, too. Layers of history and memories and documents of DAH mingle and collage on the stage. One after another, characters appear, first from Zenit and then Angels Memories. In between, Maja returns adding bits of history and personal reflection.

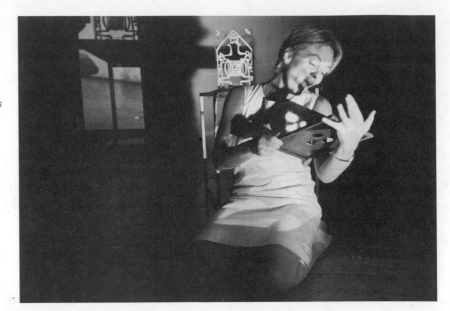

In her retrospective work Inner Mandala, *Maja Mitic opens a big red book spilling a cascade of alphabet characters onto the floor. Photo: Djordje Tomic courtesy DAH Teatar*

In some indefinable way, each new character looks and sounds different. Maja's costume mutates as various pieces drape and then fall to the floor. She does the same with her voice.

At one point she speaks of life's "pleasures," listing them one after another. For each, a different character seems to speak. Still reciting, she bends and plucks a big red book from a small table; a cascade of alphabet characters spill onto the floor. She pauses and turns to the audience.

In 1998, my country was blind and deaf. Working in this performance (The Helen Keller Case) we believed that it was possible to find the way out of isolation like Helen Keller did with the help of Annie Sullivan.

Annie Sullivan steps slowly to center stage. She pulls a red dress from a hanger and moves to cover her face with it. But, as she does, the dress seems to resist. It is alive. The more Annie pulls, the more defiant the dress becomes. As she struggles she cries out.

I believe in the immortality of the soul, because I have within me immortal longings. I believe that the state we inhabit after death is wrought from our own motives, thoughts and deeds. I believe that when the eyes within my physical eyes open upon the world to come I will simply be living consciously in the country of my heart. Without this faith my life would have little meaning.

The specter seems to be gaining strength, but as they wrestle, Annie continues.

*My faith never wavers that each dear friend I have lost is a link between
this world and the next. My spirit is for the moment bowed down with
grief when I cease to feel the touch of their hand or hear a tender word
from them.*

Slowly, the fighting subdues. When the dress is still, Annie turns it inside
out and returns it to its hanger. It is blue.

*But the light of faith never fades in my sky, and I take heart again, glad
that they are free. Immured by silence and darkness, I possess the
light that will give me vision a thousand fold when death sets me free.*

Kneeling, she turns her attention to the alphabet scattered on the floor.
When she rises she stares intently into the folds of the dress. All that remains
at its foot is "H E L E N."

*Does not love, true love, suffer all things, believe all things, hope all
things, endure all things. Love suffers long and is patient. It gives without
stint, without measure and asks for nothing in return. It expects only
good from the dear one through all trials and disillusionments, I know
now that you have not killed my love and you never can.*

As these words hang in the muted light, Maja subtly reemerges.

*DAH Teatar is a place where I have no limits. My shelter is there, as well as
my power, my salvation, because by accepting responsibility of what and
how we work, our thoughts, memories and longings return to their real
origin, and in that way transforming ourselves into better humans beings .*
 *That way, the circle is regular and closed, and the exchange is
established.*
 *As an artist, I chose to correspond with the time in which I live in,
but the cruel historical circumstances of my country, increased that
responsibility, and that responsibility through time became a healing one.*
 In the recent performance, Maps of Forbidden Remembrance, *we
asked ourselves, as we did in the first one: "How long a vigil does histori-
cal violence impose on us? How far can or should my personal responsi-
bility extend for injustices I did not commit?"*
 Searching for that answer in theatre has a healing power by itself.

Notes

PART 1

Chapter 1

1. *Irish News, Mixed Marriage Family Petrol Bombed Again,* September 9, 1996.
2. From the Community Arts Forum Webpage, http://www.caf.ie/index.asp

Chapter 2

1. *Marching Season Violence Figures Down, BBC News,* Wednesday, July 14, 1999.
2. Gerri Moriarty, *The Wedding Community Play: A cross-community production in Northern Ireland,* from *Theatre and Empowerment: Community Drama on the World Stage,* Richard Boon and Jane Plastow, eds., Cambridge University Press, 2004.
3. Ibid.

Chapter 3

1. Ian Hill, *Classic Tale hits troubled city streets, Belfast News Letter,* November 10, 1999.
2. *Flies in the soap, The Irish Times,* November 10, 1999.
3. Mic Moroney, *Community Spirit, The Wedding, The Guardian,* November 27, 1999.
4. Gerri Moriarty, *The Wedding Community Play: A cross-community production in Northern Ireland,* from *Theatre and Empowerment: Community Drama on the World Stage,* Richard Boon and Jane Plastow, eds., Cambridge University Press, 2004.
5. From correspondence with author, May 2003.

PART 2

Chapter 4

1. Martin Woollacott, "US abandons Saigon to Communists," *The Guardian,* April 30, 1975.
2. Henry Kamm, *Cambodia: Report from a Stricken Land,* Arcade Publishing, 1998.
3. Robert Turnbull, "Reconstructing Khmer Classics From Zero," *New York Times,* Arts and Leisure, July 25, 1998.

4. Teeda Butt Mam, from *Children of Cambodia's Killing Fields,* Yale University Press, 1994.
5. Ben Kiernan, *Children of Cambodia's Killing Fields,* Yale University Press, 1994.
6. Sophiline Cheam Shapiro, *Songs My Enemies Taught Me,* from *Children of Cambodia's Killing Fields,* Yale University Press, 1994.
7. Thai/Cambodia Border Refugee Camps 1975–1999, Information and Documentation. Website, http://www.websitesrcg.com/border/border-camps.html
8. At the time, most of the refugees from the camps along the Cambodia-Thailand border were going to Malaysia, Indonesia and the US.
9. Denis D. Gray, "A Tale Of Friendship In Cambodian War," *Philadelphia Inquirer,* October 9, 1983.
10. *Asylum Applications in Industrialized Countries: 1980–1999,* UNHCR Population Data Unit, Geneva, 2001.

Chapter 5

1. William Branigin, "Royalists Win Plurality In Cambodia Election Results Point To Rule by Coalition," *The Washington Post,* June 3, 1993.
2. *"Towards the 21st Century": National Strategy for Education for All. Phnom Penh: UN Working Group on Poverty and Education,* UNESCO. June, 1998.
3. Keith B. Richbur, "Coup Ousts Cambodian Prince," *The Washington Post,* July 8, 1997.
4. Ingrid Muan, *Citing Angkor: The "Cambodian Arts" in the Age of Restoration 1918–2000,* Columbia University, 2001.
5. This catalogue was for the Inaugural exhibition of Fukouka Asian Art Museum. The recently completed museum was the first in Japan devoted entirely to contemporary Asian art. The 1999 exhibition organized under the theme "Communication—Channels for Hope" was comprised of contemporary artworks by 55 individuals and groups from 21 Asian countries.
6. Continuity and Transmissions, Exhibition description, Reyum Institute for Art and Culture, Phnom Penh, 1999 http://www.reyum.org/exhibitions/exhibit2/exhibit.html

7. *The Cambodia Daily*, "Local Artist Depicts Nation's History on Canvas, Victoria Stagg Elliott, Im Sophea," May 7, 1999.

8. http://www.kasumisou.org/index.html

9. Along with the Mahabharata, the Ramayana is one of the two great epic poems arising from oral traditions (circa 1500 BCE) that have had a major influence on Indian and other Hindu civilizations.

10. *Bryn Mawr Alumnae Bulletin*, "Notes on Alumnae," http://www.brynmawr.edu/alumnae/bulletin/notes.htm-

Chapter 6

1. http://www.hrw.org/press/1999/dec/camb1210.htm

2. *Try the Khmers Rouges*, The Economist, Jan 7th 1999

3. http://www.legacy-project.org

4. In 1997, the main Cambodian opposition leader Sam Rainsy barely escaped a grenade attack at a political rally outside the National Assembly that killed 16 of his supporters. He accused Prime Minister Hun Sen of being behind the attack. Prior to the 1998 elections his Khmer Nation Party changed its name to the Sam Rainsy Party but won only 14 percent of the vote. From a BBC Profile of Sam Rainsy http://news.bbc.co.uk/2/hi/asia-pacific/138764.stm

5. Angkar was the name the Khmer Rouge used for the new social order they imposed on Cambodia .

6. Sarah Stephens, *The Legacy of Absence: Cambodian Artists Confront the Past*, Persimmon: Asian Literature, Arts, and Culture, Summer 2000, www.persimmon-mag.com

7. Ibid., *The Legacy of Absence: Cambodian Artists Confront the Past*

8. Ibid., *The Legacy of Absence: Cambodian Artists Confront the Past*

9. "Ceramics from Lor Pok," December 2000, This exhibition presented ceramics and methods of Phnom Penh's famous Pok Kiln. http://www.reyum.org/exhibitions/exhibit8/exhibit.html

10. According to the Economist Magazine's World in Figures, 2005 Edition, the median age in Cambodia in 2002 was 17.5. To put this in perspective, the median age in nearby Thailand for the same period was 27. In the US it was 35.

11. *Education Sectorwide Approach*, "Cambodia Education Case Study," Asian Development Bank, 2003.

12. The Asparas are female spirits of the clouds and waters in Hindu and Buddhist mythology.

PART 3

Chapter 7

1. *South Africa's Truth and Reconciliation Commission Report*, 1998.

2. US Census Bureau, International Database: http://www.census.gov/ipc/www/idbnew.html

3. Frank W. Ukadike, "African Films: A retrospective and a vision for the future", Critical Arts, vol. 7: Durban, 1993.

4. Steve Biko founded South Africa's Black Consciousness Movement. He was murdered on 12 September 1977 while in police custody.

5. Nelson Mandela, *Long Walk to Freedom*, Little, Brown & Co., 1994, p.238.

6. *InMotion Magazine*, "Windybrow Centre for the Arts," March 2006.

7. Nelson Mandela, *Long Walk to Freedom*, Little, Brown & Co., 1994, p.556.

8. On November 6, 1962, the United Nations General Assembly passed Resolution 1761, condemning South African apartheid policies. On August 7, 1963, the United Nations Security Council established a voluntary arms embargo against South Africa. Following the Soweto uprising in 1976 and its brutal suppression by the apartheid regime, the arms embargo was made mandatory by the UN Security Council on November 4, 1977.

9. In 1991, the *Weekly Mail* together with *The Guardian* in London broke the "Inkathagate" scandal, which described how police funds were being secretly channelled to Inkatha to block the ANC. Two Cabinet ministers fell from grace in the wake of the scandal and the weakened National Party government of FW de Klerk was obliged to reopen its stalled talks with the ANC. *Mail and Guardian Online*: http://www.mg.co.za/articleflat.aspx?articleid=555&area=mg_flat

10. The Goldstone Commission of Inquiry Regarding the Prevention of Public Violence and Intimidation and the Truth and Reconciliation Commission found that this situation was further complicated by the violent actions of a "third force", a faceless group of state-sponsored *agents provocateur* engaged by elements in the government to fuel the conflict.

11. "Chris Hani was gunned down on Easter weekend 1993 at his home in Dawn Park by Januzs Walus and Conservative Party MP Mr. Clive Derby-Lewis. Both applied to the TRC for amnesty for the killing. Hani's death led to fears of widespread reprisals and counter-reprisals that could derail the negotiations, and an international team was set up to probe his assassination. Both Walus and Derby-Lewis were convicted and sentenced to life imprisonment. Allegations still abound that a wider conspiracy was involved in the assassination." (from *Truth and Reconciliation Commission Report*, vol. 2, Chapter 7

12. *InMotion Magazine*, "Windybrow Centre for the Arts," March 2006.

13. Bessie Head, *Maru*, Heinemann International Literature & Textbooks, 1995, p.3.

14. Nadine Gordimer, *The Essential Gesture: Writers And Responsibility*, The Tanner Lectures on Human Values delivered at The University Of Michigan, October 12, 1984.

15. The Funda Art Centre was established in 1979 by Soweto artists and community leaders "to promote social upliftment through cultural activities and the arts."

16. Although civil war was avoided in the four years prior to the 1994 election, a campaign of destabilization by the government and pro-apartheid forces exacted a significant toll. "By the time the liberation struggle had run

its full course and a democratically elected government was installed, the human cost, in the simple terms of loss of life, reached the appalling total of around 21,000 dead. What was of particular significance was the fact that of this total, 14,000 lives were lost in the four years immediately preceding the elections, i.e., during the destabilization era. In other words, twice as many people died during the four years of destabilization as died during the preceding 40 years." (From *A Crime Against Humanity—Analyzing the Repression of the Apartheid State*, Max Coleman, Ed., Human Rights Commission of South Africa, 1997)

Chapter 8

1. The Botha administration's "total strategy" program consolidated internal and external security functions and eliminated some of the statues restricting the rights of non-whites. Its most lasting effect was the increased militarization of both internal police activities and relationships with neighboring countries.

2. From a speech by Marcella Naidoo, National Director of the Black Sash, June 2005.

3. The Durban Detainees Support Committee provided assistance to South African political prisoners and their families. As such, their activities were monitored closely by the government. Membership in a banned organization was grounds for imprisonment. http://www.sahistory.org.za/pages/mainframe.htm

4. In 1961 both the ANC and PAC established anti-apartheid guerilla movements. From that point on intermittent non-lethal bombings of public infrastructure became a part of the anti-apartheid campaign.

5. The Congress of the People was convened in June 1955 by a coalition of anti-apartheid organizations to voice opposition to the rising tide of racially based oppression in South Africa. Although the meeting was broken up after two days by state security forces, its principal product, The Freedom Charter, articulated the human rights framework that guided the next thirty-five years of the anti-apartheid struggle.

6. Rorkes Drift was "one of the few places at which black artists could study" as was the Evangelical Lutheran Church Art and Craft Centre at Rorkes Drift in Natal. Established in 1962 as a textile center for local women, it soon became a facility for training printmakers. (From the catalogue for the exhibit, *Reclaiming Space: Post Apartheid Art from South Africa*.)

7. Founded in 1970, the Ruth Prowse Arts School offered training for its multicultural student body throughout the apartheid regime. The school's Outreach Program provides free training for adults from disadvantaged communities to develop design and craft skills, which in turn enables them to create marketable products.

8. William Zulu, from the catalogue for the *Images of Human Rights Portfolio*, Artists for Human Rights, 1996.

Chapter 9

1. In South Africa, Human Rights Day is celebrated on March 21, in remembrance of the Sharpeville massacre.

Elsewhere, Human Rights Day is çelebrated on December 10 to commemorate the UN's adoption of the Universal Declaration of Human Rights on that date in 1948.

2. *Nkosi Sikelele" iAfrika"* ("God Bless Africa" in the Xhosa language) was composed by Enoch Sontonga, a Methodist mission teacher in Johannesburg in 1897. In 1925 it was adopted by the African National Congress (ANC) as its anthem. The words of the first stanza were originally written in Xhosa as a hymn. In 1927 seven additional Xhosa stanzas were added by the poet Samuel Mqhayi. Solomon Plaatje, one of South Africas greatest writers and a founding member of the ANC, was the first to record the song in London in 1923.

3. Alexandra Township has had a long history of resistance and violence. In the early 1960s, the government decided to demolish all family accommodation in Alexandra and replace them with single-sex hostels. By 1979 widespread resistance and protest led to a cancellation of the scheme. In 1980 a Master Plan for Alexandra was introduced, which aimed to transform Alexandra into a Garden City with a completely new layout. The execution of the Master Plan was permanently stopped by the violent Alex Six Days uprising in February 1986, during which 40 people were killed. In its aftermath the city suffered through a cycle of demolitions, disruptions and displacement as well as two treason trials involving 13 Township leaders.

4. Umkhonto we Sizwe (MK), Spear of the Nation, was the active military wing of the African National Congress in cooperation with the South African Communist Party in their fight against the South African apartheid regime. MK launched its first guerrilla attacks against government installations on December 16, 1961. It was classified as a terrorist organization by the South African government and media, and subsequently banned.

5. *Resistance and Renewal: Selected Work from 1985–2005* was organized in collaboration with the 2006 symposium, *The Politics of Fear*, presented by Tufts University's Education for Public Inquiry and International Citizenship Program (EPIIC). Kim was a participant in the inaugural EPIIC colloquium in 1985–86. In 1986, her print of a murdered activist was selected as the graphic for the inaugural EPIIC international symposium on International Terrorism. In 2006, she was awarded the 2006 EPIIC Distinguished Alumni Award.

6. "Benzien was particularly adept at the use of the wet bag, in which a cloth placed over victims' heads brought them to the terrifying brink of asphyxiation, over and over again. Few withstood more than half an hour." Susanne Daley, "Torturers Testimony Gives South Africa a New Lesson in the Banality of Evil," *New York Times*, November 9, 1997.

7. Pamela Allara, from the exhibit catalogue for *Kim Berman Resistance and Renewal: Selected Work from 1985–2005*, Brandeis University, 2006.

8. Kim Berman, from *Print Studios And Print Politics*. A speech presented at the Impact International Print Making Conference, Boston, August 28, 2005.

9. Kim Berman, artist's statement for the exhibition "Fires" 2004.

10. Kim Berman's journal entry (August 2003) from *Artist Proof Studio: A Journey of Reconciliation,* A working paper of Recasting Reconciliation through Culture and the Arts, Kim Berman, Stompie Selibe, Brandeis University, 2004.

11. UNISA (University of South Africa), *Report of the Bureau of Market Research, July 2000.* Pretoria: University of South Africa Press, 2000.

12. CIA World Fact Book, 2006. http://www.cia.gov/cia/publications/factbook/geos/sf.html

13. In 2000, the percentage of South Africa's total income earned by the richest 20 percent of the population was 65 percent while the percentage earned by its poorest 20 percent was 3 percent. Development Data Group, The World Bank, 2002. Washington, D.C.

14. "The oldest printed matter existing in the world are the "One Million Dharani Charms" of Japan. In the year 764, the Empress Shotoku, praying for peace throughout the nation, sanctioned the printing of a million paper prayers on paper strips (Tanzaku); each prayer to be enshrined in its own individual three-storied wooden pagoda with a height of 13.5 centimeters and a diameter of 10.5 centimeters at the base. Printed Buddhist prayers called Dharani were placed in a hole in the center." JPC Corporation, Information From JPC. http://www.jgc.co.jp/waza/b4_washi/washi01.htm

15. "The Japanese made the first authenticated prints, wood-block rubbings of Buddhist charms, in the late-middle eighth century… The first paper produced in Europe was in Játiva in Spain in 1151. The first woodcuts printed on paper were playing cards produced in Germany at the beginning of the fifteenth century." The Artist.org, History of Printmaking, http://www.the-artists.org/search/prints-h.cfm

16. "For centuries,… the people here (in Getsemani) have cultivated sisal…to make coffee sacks and rope until synthetics displaced it. In 1994, papermakers from the Center for Innovative Print and Paper at Rutgers's Mason Gross School of the Arts began helping aid agencies teach villagers how to use the fiber to create and sell high-quality, handmade paper products… In collaboration with the Dieu Donne Papermill, in New York City, the Rutgers center has mounted similar projects in Peru, India, the West Bank, and the Yanomami rain forests of Venezuela." Peter Monaghan, "Rutgers Project Hopes to Turn Andean Peasants Into Master Papermakers," *The Chronicle Of Higher Education: Notes From Academe,* March 10, 2000

17. Dr. B. S. Ngubane M.P, *Budget Speech of the South African Minister of Arts, Culture, Science and Technology,* National Assembly, May 24, 2002

Chapter 10

1. *The Associated Press,* "HIV Positive S Africa Woman Murdered," Monday December 28, 1998. http://www.aegis.org/news/ap/1998/AP981219.html

2. Alex Sudheim, "Reality Hits the Road," *Mail and Guardian,* September 8, 2000.

3. Sabine Marschall, *"Break the Silence":* A Unique Print Portfolio/ Billboard Project In The Fight Against AIDS from the catalogue for *Break the Silence,* the *HIV/Billboard and Print Portfolio,*

4. Billboard leasing was supported through sponsorship and in-kind donations by billboard companies.

5. Surviving HIV: The Right Of A Child, from the catalogue for *Break the Silence,* the *HIV/Billboard and Print Portfolio.*

6. *Through French Canadian Eyes,* from the catalogue for *Break the Silence,* the *HIV/Billboard and Print Portfolio,* Artists for Human Rights, 2000.

7. From the catalogue for *Break the Silence,* the *HIV/Billboard and Print Portfolio,* Artists for Human Rights, 2000.

8. Joy Kitsnasamy and Jan Jordan, Assessing the Effect of Fine Art Printmaking Based, HIV/AIDS Posters on the Durban Institute of Technology Community With Specific Reference to the *Break the Silence* Project Evaluation of Art as Advocacy on HIV/AIDS Poster, 2004.

9. *ubuntu* is a Zulu word that means "I am because you are."

PART 4

Chapter 11

1. Robert Conot, *Rivers of Blood, Years of Darkness,* William Morrow, 1967.

2. The Governor's Commission on Los Angeles Riots, *Report of the Governor's Commission on the Los Angeles Riots,* 1966.

3. Ibid.

4. Robert Conot, *Rivers of Blood, Years of Darkness,* William Morrow, 1967.

5. Ibid.

6. Schulberg would later come to understand the difference between the place where one lives and a true sense of community ownership which, because much of the area was owned by outsiders, was largely absent in Watts.

7. Budd Schulberg, *From the Ashes, Voices of Watts,* New American Library, 1967.

8. This story of Charles Johnson's encounter with Budd Schulberg was recounted by Otis O'Solomon who later came to know Johnson at the Watts Writers Workshop.

Chapter 12

1. Richard Dedeaux, *Rappin Black in A White World,* Dedeaux Publishing, BMI.

2. Amde Hamilton, *The Black Voices: On The Street In Watts,* Classic Cut Music, BMI.

3. Tom Wolfe, *Radical Chic & Mau-Mauing the Flak Catchers,* Farrar, Straus and Giroux, 1970

4. Roger Rapoport, *Meet America's Meanest Dirty Trickster, Mother Jones Magazine,* April 1977.

5. Ibid

6. In December 1975 and March 1976 Perry testified about his activities in a California court.

7. Intelligence Activities And The Rights Of Americans Book II, Final Report Of The Select Committee To Study Governmental Operations With Respect To Intelligence Activities United States Senate (Church Committee). United States Senate. APRIL 26 (legislative day, April 14), 1976

8. Ibid.

9. The prophets performed a skit penned by Otis, as well as an original tribute poem by Amde called "Quincy Jones, Music Man."

Chapter 13

1. Roger Epstein, "Watts Writers Workshop: A Blueprint to Fit Today's Needs?", *The Los Angeles Times* May 5, 1992. p. 1

2. Scott Sonner, "Poets Proffer Self-Esteem to Troubled Youth," *The Los Angeles Times* (Record edition), January 2, 2000. p. 1

3. U.S. Census 2000 Summary Files, Households and Families

4. Diane Haithman, "Across the Pond, and Beyond", *The Los Angeles Times*, October 17, 2000. p. 1

PART 5

Chapter 14

1. *Secret Documents Detail Plan to use Servicemen in Atomic Tests*, Australian Broadcasting Corporation, 2001-05-21.

2 .In addition to the Maralinga site, British nuclear tests were conducted at Emu Field, about 200 Km north of Maralinga and at the Monte Bello Islands off Australia's western coast.

3 .The Commission's formal name was the Royal Commission Into The British Atomic Tests In Australia.

4 .Mudrooroo, *US Mob, History, Culture, Struggle: An Introduction to Indigenous Australia*, Angus & Robertson, 1995.

5 .Walter MacDougall, Native Patrol Officer from a newspaper interview quoted by Milliken, ibid., p. 103.

6 .P. N. Grabosky, *A toxic legacy: British nuclear weapons testing in Australia in: Wayward governance: illegality and its control in the public sector*, Australian Institute of Criminology, 2006, pp.235-253.

7. N. Loos, *Aboriginal-European Relations in North Queensland 1861–1897*. Ph.D. Thesis, James Cook University, 1976, p.456.

8 .*Maralinga*, Paul Brown, et al, Ettalong Performance Script, 2006

9 .Michael Perry, *Nuclear Veterans Seek Radiation Study*, Reuters, December 29, 1997, Cited by Robert Varney, *British Nuclear Tests: Was the Policy Indifferent to Human Suffering?* University of New England, 2000.

10 .The guideline describing the purpose of the nuclear test Indoctrination Force cited by Varney, op. cit.

11 .*The Report of the Royal Commission Into The British Atomic Tests In Australia*, Volume 1, 1985, p. 338

12 .Colin Wilson, "We were testing uniforms not their bodies; Mod's Bizarre Nuke Excuse," *Sunday Mail*, May 13, 2001.

13 .Letter from Mark Oliphant to Dr. Hedley Marston, September 1956, quoted by Milliken, op. cit. p.. 90

14 .Ibid. p. 57

15 .Ibid. p. 264

16 .*The Report of the Royal Commission Into The British Atomic Tests In Australia*, quoted by Milliken Ibid.

17 .Adelaide Arts Festival, Program overview 2001

18 .Peter Sellars, *Cultural Activism in the New Century*, broadcast on Australian Broadcasting Corporation Television, August 19, 1999. http://www.abc.net.au/arts/sellars/default.htm

Chapter 15

1. From "Maralinga: Theatre which communicates knowledge from a Place of War'" Paul Brown, Ellise Barkley and Gordon Murray, 2004

2. From "Maralinga: Theatre which communicates knowledge from a Place of War'" Paul Brown, Ellise Barkley and Gordon Murray, 2004

3. Anzac Day commemorates a WWI military campaign on the Turkish Gallipoli Peninsula during which 25,000 members of the Australian, New Zealand Military Corps were killed or wounded. "The Dawn Service observed on Anzac Day has its origins in an operational routine which is still observed by the Australian Army today. The half-light of dawn plays tricks with soldiers' eyes and from the earliest times the half-hour or so before dawn, with all its grey, misty shadows, became one of the most favoured times for an attack. Soldiers in defensive positions were therefore woken up in the dark, before dawn, so that by the time the first dull grey light crept across the battlefield they were awake, alert and manning their weapons. This was, and still is, known as "Stand-to." It was also repeated at sunset." The preceding quoted text is from The Australian War Memorial website www.awm.gov.au

Chapter 16

1. Based at the University Of Manchester, Oxford, UK, *In Place of War* documents and produces performance work by artists at sites of armed conflict and in communities displaced by war. www.inplaceofwar.net

Chapter 17

1. A *corroboree* is a ceremonial meeting of Australian Aborigines . The word is derived from the European settler's mispronunciation of the Aboriginal word *caribberie*. At a *corroboree* Aborigines interact with the Dreamtime through dance, music and costume. Many of the ceremonies are sacred and people from outside a community are not permitted to participate or watch.

2. Trevor Jamieson, Arts Hub Australia, October 11, 2006. http://www.artshub.com.au/au/news.asp?sId=102 550#contributor

3. This policy was vigorously promoted by A. O. Neville, whose story is chronicled in the movie *Rabbit Proof Fence*. Beginning in 1915, Neville, with the title of Chief Protector, was charged with implementing the government's "White Australia" policy. His vigorous commitment to the movement of Aborigines to "native settlements" and the forced removal of mixed-race children had the ultimate goal of the biological elimination of Aborigines .

4. Helen Grehan, 'Recovering histories of joy and sorrow in The Career Highlights of the MAMU' in Choo & Hollbach, *History and Native Title,* pp. 220-21.

5. In 2002 working with the online activist news source, *Indymedia,* Alex joined a mass protest at an Australian Immigration Service Detention Centre in Woomera. Located 300 miles north of Adelaide in the barren desert, the facility held 800 Afghan and Middle Eastern "boat people" who had been seeking asylum in Australia. The facility (operated under contract by a subsidiary of the American owned Wackenhut Security Corporation) had been cited by Amnesty International as *"doing further damage to individuals who have fled grave human rights abuse."* During the fall of 2002 detainees who complained of being beaten and abused by guards staged a hunger strike. In the days prior to the protest other detainees had sewed their lips together, drank antiseptic and even tried to hang themselves to protest at the long application process to enter Australia and the condition of the centers.

6. The Campaign is described in detail on the http://Irati Wati web site. www.iratiwanti.org/home.php3

7. From the *Ninti Ngapartji* language course website: http://ninti.ngapartji.org/index.php?option=com_content&task=view&id=24&Itemid=47

PART 6

Chapter 18

1. Bertold Brecht, *In the Dark Times*

2. Bertold Brecht, *When Evil-Doing Comes Like Falling Rain*

3. Bertold Brecht, *A German War Primer*

4. Jerzy Grotowski, *Towards a Poor Theatre*, Simon & Schuster, 1968, p.19

5. *Oxyrincus Evangeliet* was produced by Odin Theater from 1985 to 1987. With a text that is mostly Coptic, Greek and Yiddish, the production challenges the notion of a benevolent god and a peaceful Messiah.

Chapter 19

1. John F. Burns, —*New York Times*, April 28, 1992, p. A1

2. —*New York Times*, May 31, 1992, p. 1

3. Michael T. Kaufman, —*New York Times*, June 6, 1992, p.1

4. Filip David, *Vreme*, No. 133, April 14, 1994

5. Open Society Institute website, About Us, http://www.soros.org

6. An article appearing in the pro-regime, *Vecernje Novosti* on March 21, 1995, by Dijana Dimitrovska entitled "Soros' Mask Drops Off" had this to say about Soros. "The Soros Foundation, which, like the people around it has never supported peace, but the breaking up of the former and the present Yugoslavia, has remained consistent in one thing: to be against the Serbs. The multimillionaire of Hungarian origin who has decided that he must establish a New World Order and be the pioneer of 'democracy' in Serbia and Yugoslavia…"

7. Zenitists called for a rejuvenation of Europe by the "Barbarian" Slavs, whose fresh, pagan blood would revitalize an ageing civilization. A "Balkanization" of Europe was needed, in which Western capitalism would be replaced with traditional Balkan culture. Zenitism drew on all modern forms of artistic expression, seeking to fuse their individual insights at a higher level. As theorist Ljubomir Mici wrote in *The Zenitist Manifesto* (1921): "Expressionism, Cubism, Futurism are dead. / We are an extension of their lineage—to higher ground." From: *Between Worlds: A Sourcebook of Central European Avant-Gardes, 1910–1930,* Timothy O. Benson and Éva Forgács, editors. MIT Press, 2002.

8. Filip Svarm *Vreme* No. 155, September 12, 1994.

9. Scott Lamb, *Genocide Since 1945:Never Again? Der Spiegel,* January 26, 2005.

10. C. Cavafy, *The Complete Poems of Cavafy*, translated by Rae Dalven, Harvest, 1948, p. 27.

11. Aleksandar Milosavljevic, *DAH Teatar: The Dance on the Remains of the World, Vreme,* December 4, 1995.

12. —*New York Times*, November 22, 1995. p. A22.

13. Avramovic's letter is reprinted in *Vreme*, October 12, 1996

14. Beta, November 18, 1996, quoted in *Serbia Under Milosevic,* Robert Thomas, Hurst & Company, 1999.

15. On December 1, 1996, Dragan Tomic, the president of the Serbian Parliament branded the demonstrators as "destroyers and violent individuals with all of the characteristics of pro-facist groups."

16. Robert Thomas, *Serbia Under Milosevic,* Hurst & Company, 1999, p. 309.

Chapter 20

1. Sanja Krsmanovic-Tasic: From the demonstration performance, *Dancing With Darkness.*

2. "Les Tziganes" by Jean-Paul Clebert, 1961

Index

About the Author

WILLIAM CLEVELAND has been using the arts to build caring and capable communities for more than 25 years. Along the way he has provided leadership for California's Arts-In-Corrections Program, the California State Summer School for the Arts and the Walker Art Center's Education and Community Programs in Minneapolis,

As founder and director of the Center for the Study of Art and Community, he works to integrate the arts into all aspects of community life. His organization helps communities and social institutions create and learn from arts-based community development programs and partnerships. His collaborators include artists and arts organizations, schools, human service and criminal justice agencies, local and state governments, and business and philanthropic organizations.

Mr. Cleveland sits on the boards of Art In the Public Interest and The Pomegranate Center and is a member of International Solidarity Committee at Freedom House. He has served as a panelist and consultant for the National Endowment for the Arts, the Presidents Committee on the Arts and Humanities and the US Office of Juvenile Justice Planning and as an advisor to The Center for Creative Communities, The Great Turning Initiative Creative America, Bauen Camp and the Greek Ministry of Education

A gifted and prolific writer, William Cleveland has authored seminal works in the field of arts-based community building, among them *Art In Other Places* and *Making Exact Change*. A subsequent book to *Art and Upheaval* will be *Between Grace and Fear: The Role of the Arts in a Time of Change.*

Artistically, Mr. Cleveland has a 30-year history as a professional musician and songwriter, touring the United States and Canada to perform in concert and on radio and television. Look for the latest recording from Bill's group, Cleveland PlainSong, with songs inspired by *Art & Upheaval.*

For more information on the Center for the Study and Community and the CD go to: www. artandcommunity.com.

new village press

 THE BOOK you are holding was brought to you by New Village Press, the first publisher to serve the emerging field of community building. Communities are the cauldron of cultural development, and the healthiest communities grow from the grassroots. New Village publications focus on creative, citizen-initiated efforts—good news and good tools for social growth.

If you enjoyed *Art and Upheaval* you may like other books we offer:

Undoing the Silence: Six Tools for Social Change Writing, by Louse Dunlap

New Creative Community: The Art of Cultural Development, by Arlene Goldbard

Works of Heart: Building Village through the Arts, edited by Lynne Elizabeth and Suzanne Young

Beginner's Guide to Community-Based Arts, by Mat Schwarzman, Keith Knight, Ellen Forney and others

Performing Communities: Grassroots Ensemble Theaters Deeply Rooted in Eight U.S. Communities, by Robert H. Leonard and Ann Kilkelly, edited by Linda Frye Burnham

Building Commons and Community, by Karl Linn

Doing Time in the Garden: Life Lessons through Prison Horticulture, by James Jiler

Upcoming titles include:

Arts for Change: Teaching Outside the Frame, by Beverly Naidus

Asphalt to Ecosystems: Design Ideas for Schoolyard Transformation, by Sharon Gamson Danks

New Village Press is a public-benefit enterprise of Architects/Designers/Planners for Social Responsibility **www.adpsr.org**, an educational nonprofit working for peace, environmental protection, social justice and healthy communities.

NB: Many of the works of art presented in *Art and Upheaval* were originally in color. To see the color versions go to our website: **www.newvillagepress.net**